AMERICAN ART NOW

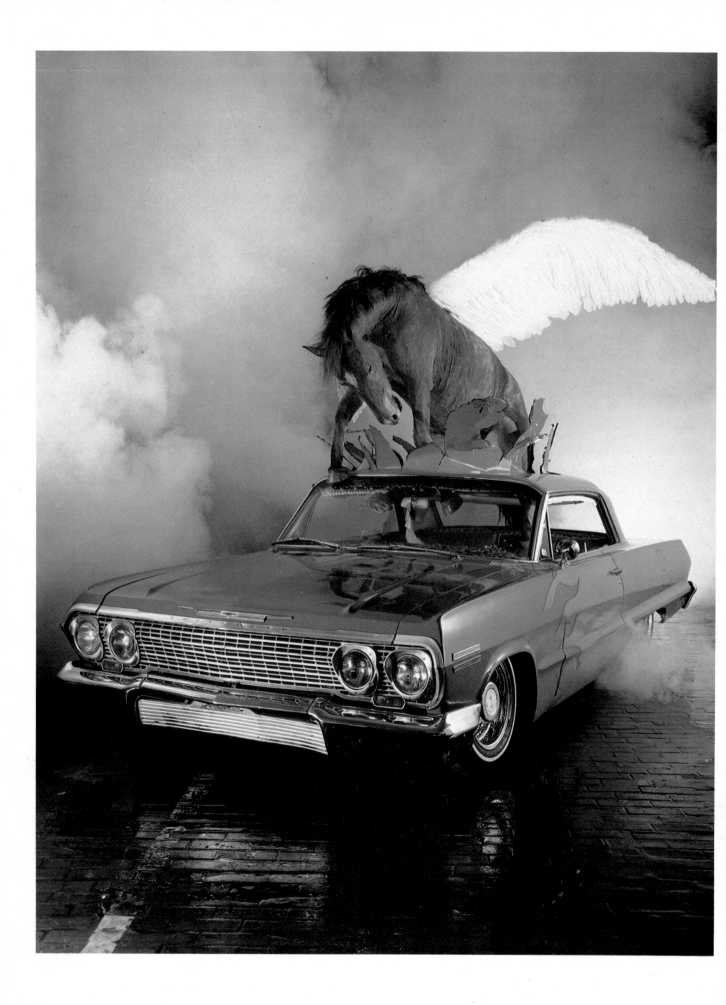

AMERICAN ART NOW

Edward Lucie-Smith

Phaidon · Oxford

for Arnold Ashkenazy

Phaidon Press Limited, Littlegate House, St Ebbe's Street, Oxford, OX1 1SQ

First published 1985
© Phaidon Press Limited 1985

British Library Cataloguing in Publication Data:

Lucie-Smith, Edward
 American art now.
 1. Art, American 2. Art, Modern— 20th
 century—United States
 I. Title
 709'.73 N6512

ISBN 0–7148–2344–9

Typeset by Keyspools Ltd, Golborne, Lancs.
Printed in Great Britain by Blantyre Printing and Binding Company Limited, Glasgow

FRONTISPIECE: James Croak, *Pegasus: Some Loves Hurt More than Others*, 1982. Mixed
media, life-size. Courtesy the artist.

CONTENTS

INTRODUCTION

Perhaps more than at any time in its development, American art is at a crossroads. It finds itself there for three reasons. The first is that it has recently recuperated an important part of its own past. The huge psychic explosion which gave Abstract Expressionism much of its force obliterated a large slice of what had happened earlier in the twentieth century. These events are now slowly being rediscovered by art-historians investigating matters such as the Regionalist Movement, the urban Socialism Realism of the 30s and the European-influenced abstract art produced during the same epoch, and they can now be linked to all the things which have happened since Abstract Expressionism – movements which form part of every American artist's own living experience, even if he is too young to have witnessed their actual first appearance. The American art scene is now stylistically plural. This pluralism is reinforced by the fact that there are a number of senior artists still creating vital work with its roots in movements which date back to the 50s and 60s.

Secondly, a very important additional factor has recently entered the calculation – the resurgence of European art. Since Abstract Expressionism established itself internationally, Americans, and indeed the whole art community, have become accustomed to the idea that the United States, and New York in particular, has been the prime generator of new styles. America has produced a number of artists closely associated with the triumphant new movement, variously labelled Neo-Expressionism, Bad Painting or the art of the *Neue Wilden*, but the centre of gravity has undoubtedly been elsewhere. The artists most typical of this development have been either German or Italian – Kiefer, Penck, Baselitz and Fetting; Paladino, Cucchi and Chia. Though these foreigners could not have succeeded at international level without the help of the New York art market, the turn of events seems nonetheless to have struck a blow at American self-confidence. Some American artists and exhibition curators have reacted by inflating the currency of American art. Recently there have been a number of exhibitions in important museums focusing on 'big-name' painters and sculptors and marked by a kind of rhetoric, both of monumental scale and of aspiration towards the consciously heroic. Examples are 'The Heroic Image', presented at the Contemporary Art Museum in Houston in the Fall of 1984, and 'Olympian Gestures', shown at the Los Angeles County Museum from June to October of the same year. The Houston exhibition featured such current favourites as Julian Schnabel, David Salle and Robert Longo. The choice in Los Angeles was more conservative – the show consisted of a handful of very large works (comparable in scale to the huge history paintings by David and his school in the Salle Mollien in the Louvre) by Ron Davis, Jim Dine, Nancy Graves, David Hockney, Sol Lewitt, Roy Lichtenstein, Robert Rauschenberg and Frank Stella.

Hockney's presence in this exhibition, and the fact that he spends most of his time in Los Angeles, raise the question not merely of foreign influence on American art but of the possible dialogue between visiting foreigners and residents. Except in terms of one ego massaging another, this seems surprisingly unimportant. Though Hockney's Los Angeles landscapes, done soon after his arrival, have certainly affected the way in which the rest of the world sees the city, there is no evidence that either his photographic experiments, or the Picasso Revival style that succeeded them, have had any effect on the Californian art scene. In New York, haunt of leading European Neo-Expressionists, who often remain there for long periods, the situation is only marginally different. The rapid success of Jean-Michel Basquiat owes something to the help and encouragement of Sandro Chia, but the two artists could hardly be more different. Rainer Fetting has used some of the more lurid aspects of New York night-life as part of his source-material, but it still remains easy to make a distinction between his work and that of American rivals like Julian Schnabel and David Salle. Fetting is more focused and closer to the pre-modern tradition. Schnabel and Salle are often preoccupied with a play of overlapping and intermingled images which derives from native American experience of the media, and which can be referred to predecessors otherwise as different from one another as Robert Rauschenberg and James Rosenquist.

The third important factor – one which may strike me the more forcibly because I am a foreigner – is the increasing regionalization of American art. A Chicago figurative school has long been recognizable. Now it is possible to speak, in addition, of Chicago abstractionists, Los Angeles abstractionists, and of various regional schools in the West and South West. New York is still a market-

place and forum for American artists, but proportionately fewer and fewer of them actually live and work there. Some of the causes are economic. It is hard for artists to find or afford suitable studio space, especially in Manhattan. Many artists depend at least partly on teaching, and teaching posts are much easier to obtain elsewhere. The growing wealth of the West and South West of the United States has brought with it an increasing sophistication, reflected in turn in a new sophistication about modern art. Artists do not find it necessary to take themselves or their wares to New York when there are good galleries and informed collectors right on their own doorsteps.

Some of the causes of the retreat from New York are also psychological. Manhattan, with its intense urban pressures, makes a difficult working environment for artists. Even those who initially come to New York to make their fortunes tend to take themselves off to more tranquil surroundings once success is assured. Robert Rauschenberg's career, recounted in unsparing detail in Calvin Tomkins's *Off the Wall: Robert Rauschenberg and the Art-World of Our Time*, is a case in point. New York itself is too impersonal, just as America itself is too vast, for many artists to identify with the one or the other. Artists living and working outside New York do find identity in the region immediately surrounding them. The creative nourishment offered by such an identity is often the positive reason, in addition to all the negative ones, for choosing to live and work away from the hub.

Not that the New York art world is in any danger of being supplanted by a centre or combination of centres located elsewhere. American artists still feel that the real success, the ultimate recognition, is to be found only in and through Manhattan. But they are often insistent on stressing regional commitment in a fashion which is new.

Given that the new stylistic pluralism and increasing regionalism are the twin themes of this book, I have tried to find a way of reconciling their competing claims within its structure. At first sight, the best solution might seem to be to put the emphasis on the regional aspect – to create not merely a narrative account, but an actual map of where American art is happening. But such a structure would confront not only the writer but

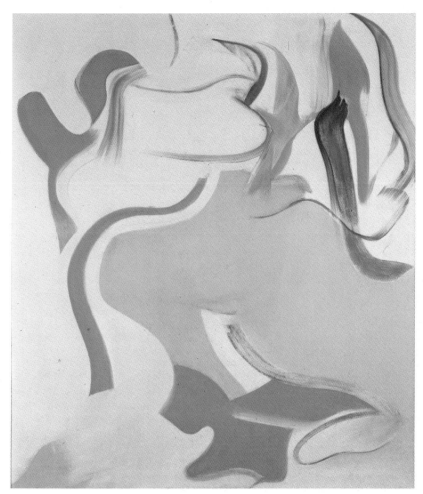

1 Willem de Kooning, *Untitled V*, 1983. Oil on canvas, 88 × 77 in (223 × 195 cm). Courtesy Anthony d'Offay Gallery,

the reader with huge difficulties, chief among them the need for hammering repetitions, within each section, of identical points about style. America may be a country where art is rediscovering its regional roots; it is also one with the best system of communications in the world, and the liveliest and best illustrated art press. No artist in America, however remote the place where he chooses to live, needs to be isolated from what fellow artists are doing or thinking. As one travels from region to region one constantly encounters new versions of familiar ideas, as well as things which are novel because wholly characteristic of the particular locality.

My solution to the difficulty has been pragmatic and practical, rather than logical in the strict sense. The reader will find a series of chapters where the categories are broadly speaking stylistic, followed by three which try to sketch the character of the three most important areas of artistic activity outside New York – Chicago and its surrounding territory, Texas and California. I admit this immediately perpetrates not one but two injustices. First, the sections devoted to different styles and ways of making art have robbed the regional chapters of important local heroes. In addition, no attempt has been made to deal with secondary but still important regions where many artists have settled, and which seem to have developed a distinctive character of their own. The examples which spring to mind are New Mexico and the area round Seattle. I can only plead the practical difficulty of fitting what is already a huge mass of material within the covers of a book of average size.

Both the categories I have chosen and the way in which artists have been alloted to them are likely to arouse disagreement – which indeed is part of my intention. But it is fair to say a little more than this about the methods I have adopted, first looking at them from an ideal point of view, then from a purely practical one. The basic tool of art criticism is comparison, and this is what my categorizations invite. In trying to make sense of a great mass of material, one must first begin by sifting it. One tries to see what certain artists or works of art have in common, and one also tries to see how works of art which have a general air of resemblance nevertheless differ from one another. Through a

consideration of these resemblances and differences one gets a glimpse of the inner essence of the individual artwork. The judgement thus formed takes into account not only the artist's conscious intention in making the work of art, but anything one can perceive of his or her unconscious intention. It also involves trying to reach a tentative conclusion about how far these intentions have been fulfilled and whether they were worth pursuing in the first place. In reaching his conclusions the responsible critic listens not only to the promptings of experience (and most of all consults his memories of other art works encountered previously), but also to a perhaps delusive inner voice which whispers that there is indeed some ideal standard against which all works of art can be measured.

My categorizations and my comparisons do imply judgements, but there has seldom been room to spell them out in minute detail. I have preferred to use my necessarily limited space to give as much information as I can about the sheer activity of present-day American art. In any case, an art book is not merely a text, but a complete visual object, and I hope that in this one the illustrations, both by their choice and their arrangement, will make many of my points for me. My aim has been to illustrate as many as possible of the artists mentioned, choosing recent work wherever possible.

Having said all this, I must also issue a warning that the categories I suggest are in my own mind strictly provisional, and the choice of artists does not imply a fixed hierarchy. The book includes many artists who are already very well-known, and one or two who are almost unknown. Some artists with well-established reputations are omitted, usually because I could not find a way of describing or illustrating their work without reiterating things already said elsewhere, but also, on occasion, because I could not convince myself that the talent deserved its prominence. Any book of this sort must leave a wide margin for the uncertain factor of personal taste.

Many readers will wonder why the book does not contain a bibliography, in addition to the brief biographies of artists included as an appendix. The truth is that such a bibliography would either be very short and extremely one-sided,

or unmanageably huge. If I confined myself to books alone, the bibliography would be heavily biased towards a few established artists. On the other hand the list of relevant exhibition catalogues, articles in magazines and major newspaper reviews would fill a volume many times this size. Direct quotations of statements made by individual artists come for the most part from three main sources – statements in catalogues, interviews in magazines and newspapers, and xeroxed statements issued by commercial galleries in connection with one-person exhibitions. Artists' resumés have been supplied in some cases by the artist concerned but usually by his or her main dealer – any reader whose interest is aroused by the work of a particular artist is advised to go first to the dealer concerned. The best source of information about artist-dealer relationships is the annual *Guide to Galleries, Museums, Artists* published by *Art in America*. As can be seen from the photographic credits, dealers have been outstandingly generous in providing material for illustrations. They have also been lavish in giving me slides for use as background information, catalogues (many otherwise impossible to obtain), and copies of important articles. Leading dealers have also been generous with their time, and a number have provided perceptive over-views of art activity in a particular region or of artists working in a particular style.

I have been helped in making this book by many other people as well, and I should like to end by naming three individuals to whom I owe a particular debt of gratitude. One is Howard Fox, of the Hirshhorn Museum and Sculpture Garden, who almost missed a flight out of Washington in order to give me an immensely stimulating interview. The second is Ann Harithas, who made my visit to Houston possible, and whose intensely individual ideas about contemporary art were a challenge and stimulus to my own. The third is Arnold Ashkenazy, to whom this book is dedicated. He was my kind host in Los Angeles and a delightful travelling companion elsewhere. If my enthusiasm for this project ever flagged, it was immediately revived by his energy and curiosity, as well as by his habit of asking unexpected questions which immediately set off quite new trains of thought.

CHAPTER ONE

THE OLD MASTERS

The rapid development of American art within a comparatively restricted time-span means that representatives of all the chief post-war movements are still actively at work. Indeed, it is among their ranks that we find the artists best known to the American public at large. Celebrity and influence are not, however, the same thing. When we try to analyse the position of these artists in relation to the current scene, we find that painters and sculptors of exactly the same degree of reputation enjoy very different positions. In some cases the work that they do seems directly influential, in other cases it is they who are being influenced by their juniors, and in other cases still an artist whose work remains perfectly valid in its own terms finds himself almost isolated. I would like to deal briefly in this chapter with some of these senior figures, though what I have to say about them will not be a complete account of careers which, in many instances, have been long and complex.

Abstract Expressionist survivors

The senior generation of American artists is now largely that of the creators of Abstract Expressionism, led by Willem de Kooning and Robert Motherwell. High though their prestige is, one cannot trace any solid link between their present performances and current New York art-styles. If there is a link it is, strangely enough, with the artists who have been presented as the newest and rawest phenomenon the American art-world has to offer – the young Graffiti Painters who have graduated from

2 Sam Francis, *Untitled*, 1984. Colour monotype, $58\frac{1}{4} \times 83\frac{1}{2}$ in ($147 \cdot 5 \times 212$ cm). Courtesy Brooke Alexander, New York.

defacing subway trains to prestigious galleries uptown – indeed, one of their main supporters is the Sidney Janis Gallery, which once represented Pollock. The gestural markings made by the Graffiti Painters' aerosols are not unlike the markings Pollock achieved when dribbling paint straight from the can. Pollock, pouring paint, did not touch the surface directly. Nor do the Graffiti Painters, spraying pigment. Their swinging lines, like Pollock's, often seem to float in mid-air.

A major second-generation Abstract Expressionist, Sam Francis, is associated not with the New York scene, but with California and France. In his work one finds intermingled the influence of ori-

ental calligraphy, which remains subliminally important in much West Coast painting, and the French tradition of *belle peinture*. The late *Waterlilies* of Monet seem to have had a good deal of significance for Francis's art. Yet, if this is the case, what he presents is Monet dematerialized, robbed of any remnant of earthy substance. There are no really distinguished direct imitators of Francis's work, though his reputation is perhaps higher than ever. On the other hand one does detect in a great deal of Californian work done by younger artists a powerful urge to get rid of the material element. Francis thus appears as an important ancestor of what is being produced on the West Coast.

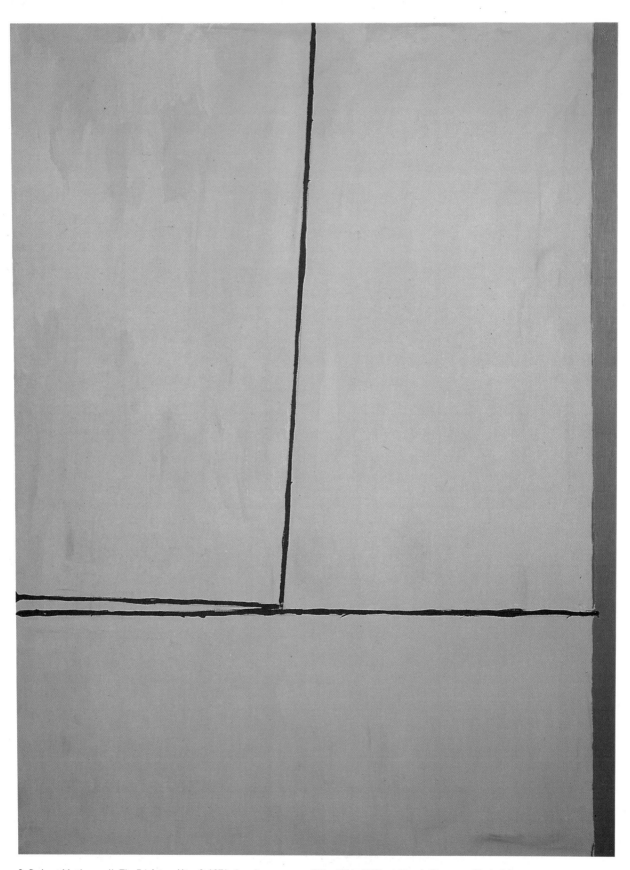

3 Robert Motherwell, *The Edelstone View 2*, 1971. Acrylic on canvas, 74$\frac{1}{4}$ × 55$\frac{1}{4}$ in (187 × 140 cm). Courtesy Christie's.

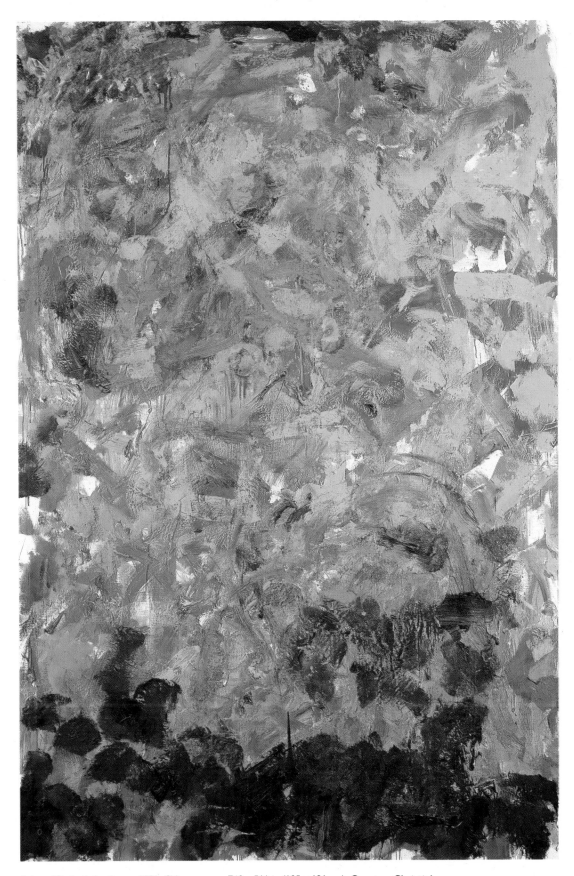

4 Joan Mitchell, *Sunflower*, 1981. Oil on canvas, 76¾ × 51½ in (195 × 131 cm). Courtesy Christie's.

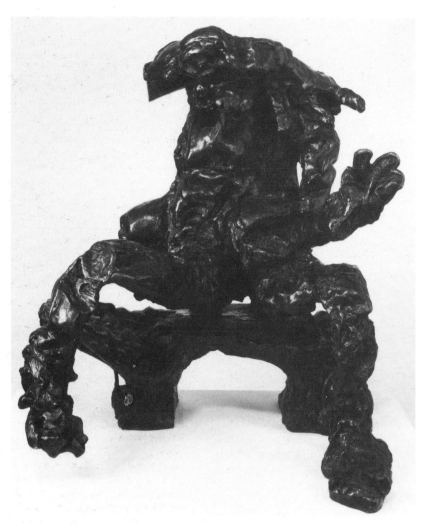

5 Willem de Kooning, *Seated Woman on a Bench*, 1972. Bronze, 37½ × 37 × 30 in (95 × 94 × 76 cm). Courtesy Anthony d'Offay Gallery, London.

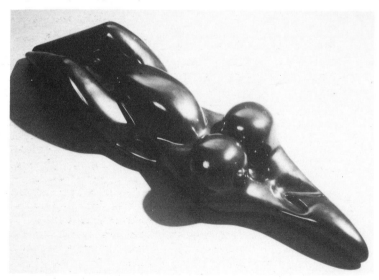

6 Louise Bourgeois, *Femme Couteau*, 1982. Black marble, 5½ × 30½ × 8 in (14 × 77·5 × 20·3 cm). Courtesy Robert Miller Gallery Inc., New York.

It is interesting to compare Francis's work with that of an artist who is in some ways very similar, Joan Mitchell. Mitchell, born three years after Francis, made her debut in the New York Abstract Expressionist milieu, and during the early 50s frequented the Cedar Tavern together with de Kooning, Philip Guston and Franz Kline. In 1955, however, she moved to France, and became as identified with the Paris scene as she had previously been with the New York one. Mitchell's powerful paintings move much closer to recognizable figuration than those of Francis. It is possible to see in them echoes of nature – trees, rocks, ponds, streams, hills. Their art-historical sources are to be found not only in Monet but in Cézanne, whose close-meshed brushwork has obviously influenced her. The romanticism of her work seems generically American, but it is difficult to see what specific influence she exercises. American art has perhaps lost the complete confidence in nature as an overriding force which was inherited by the Abstract Expressionists from the nineteenth-century landscape painters who first tried to depict a new continent. Or if they retain any traces of it, they have returned to more specific kinds of representation.

Abstract Expressionism was not a style which functioned as powerfully in three dimensions as it did in two. The only artist who provided convincing solutions to the problem of translating the essential fluidity of Abstract Expressionist brushwork into the more intractable materials which sculpture requires was David Smith. In old age, de Kooning has tackled the problem again, and his strange, almost wilfully expressionist sculptures are the things which bring him closest to Neo-Expressionism – the relationship between the celebrated series of paintings of *Women* and some Neo-Expressionist imagery seems to be more or less coincidental. Another sculptor with roots in Abstract Expressionism is Louise Bourgeois. She did not move to the United States until 1938, when she was already a mature artist, and her sculpture is a kind of compromise between American ideas and the biomorphic surrealism elaborated by artists such as Tanguy. Powerful and subtle, with a strong current of feminist feeling, Bourgeois is a well-respected but also in a sense a neglected figure – this is the more

surprising because she has spent much of her career as a teacher. Her work is less spectacular than that of Louise Nevelson, who retains her position as the Grand Old Woman of American sculpture without having made any very substantial progress in her later work, which for the most part is a slightly weary repetition of things done better previously.

Robert Rauschenberg and Jasper Johns

The break from Abstract Expressionism came with the work of Robert Rauschenberg and Jasper Johns, still two of the most prestigious artists now working in the United States. Their respective fates, since the time of their initial success, have been interestingly different. One of the points to emerge from Calvin Tomkins's biography is that Rauschenberg's period of greatest public visibility during the late 60s was neither his best for creative work nor (more surprisingly) his best for sales of what he was currently producing. Since his retirement to a base on Captiva Island, Florida in 1971, Rauschenberg has been only intermittently in touch with the New York art world which once lionized and exploited him. He has, however, evolved into the American 'official' artist *par excellence*, the creator without whom no major celebration of American art would seem complete. One of the most striking contributions to the *Olympian Gestures* exhibition was Rauschenberg's vast *Dirt Shrine: South* in high-fired ceramic. This piece had a number of significant characteristics. It was interesting, for example, that Rauschenberg had chosen to express himself in a material new to himself but closely associated with recent artistic developments on the West Coast. But it was also interesting that Rauschenberg had returned to a technique intimately associated with his own beginnings – the use of stencilled imagery. The vast scale of *Dirt Shrine: South* (it measures 120 × 179½ × 75 inches) makes it suitable only for an institutional setting. Its total impact (and here I can only report a personal impression) is that of something impressive in itself, but strangely fossilized in terms of the surrounding context. If Rauschenberg exercises any influence on current American art it is because of his refusal to acknowledge

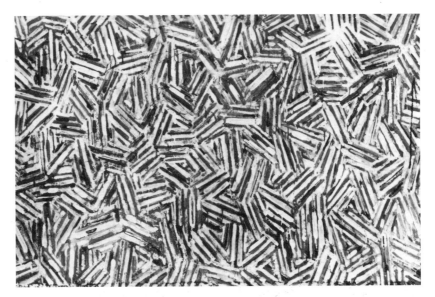

7 Jasper Johns, *The Barber's Tree*, 1975. Encausic and collage on canvas, $34\frac{1}{4} \times 54\frac{1}{4}$ in (87 × 138 cm). Collection Ludwig, Aachen. Photo courtesy Arts Council of Great Britain.

any boundaries in what the work of art can do, or any prescriptions about either material or format.

Johns's recent critical fortunes have perhaps been more uneven than those of Rauschenberg. Paintings done in the 70s have been almost ignored on the one hand, and fulsomely praised on the other. The main difficulty with Johns's work is well summed up by Barbara Rose:

It is this element of negation – an intractable commitment to going against the grain instead of with the traffic – that identifies Johns as a radical conservative intent on preserving, with exceptional clarity in the midst of aesthetic and moral confusion, the dialectical ethos of modernism. Johns' modernism is implicit in his fidelity to the central modernist themes: reflexiveness, autonomy and self-sufficiency of the work of art, aesthetic distancing and unresolved complexity leading to a condition of permanent doubt. ('Decoys and Doubles: Jasper Johns and the Modernist Mind', *Arts Magazine*, vol. 50, no. 9, May 1976.)

There are other difficulties as well, notably the hermetic nature of many of the artist's references. Johns alludes to fleeting experiences – the flagstones from a wall glimpsed in Harlem, 'the hatchings that were an epiphany of a summer's drive on Long Island, a memory

snatched from the decorative painting of an oncoming car' (Richard S. Field, *Jasper Johns: Prints 1970–1977*, 1978, p. 26). Recently there have been signs that Johns was allowing his work to become more open. Already linked by many critics to the American *trompe l'oeil* tradition, he is allowing his references to this to become more and more overt, as can be seen from an important painting now in the Houston Museum. Johns here accepts influence from the nineteenth century, and also from much younger artists than himself.

The evolution of Pop

The development of the major Pop artists during the late 70s and the 80s has been different enough in each case to demonstrate that the apparent coherence once possessed by this group was an extremely fleeting phenomenon, if indeed it ever truly existed. James Rosenquist and Claes Oldenburg, for example, have not evolved in any significant way, though Oldenburg has benefited in practical ways from his now major reputation, in the sense that he is now given the means to translate into reality projects which would previously have remained on paper. A spectacular recent example is his *Stake Hitch*, commissioned for the new Dallas Museum. Chosen for its specifically Texan significance, this overweeningly huge version of a commonplace object occupies the

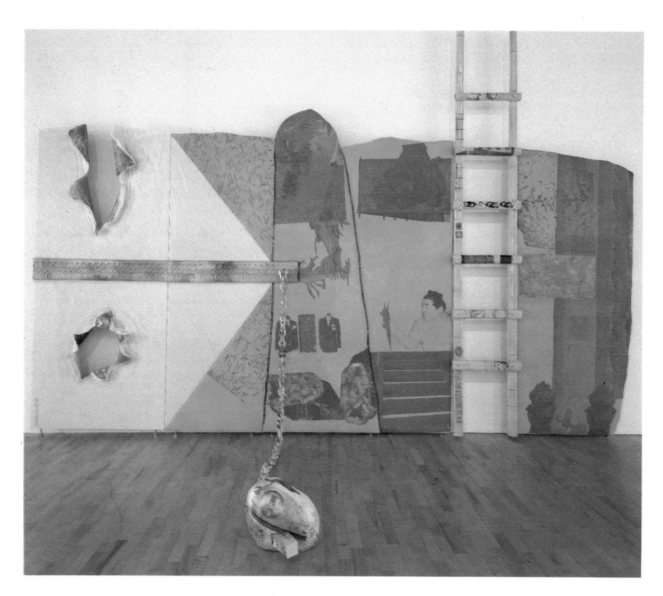

main hall of the building, and makes a piquant contrast with the official quality of the architecture surrounding it.

Andy Warhol's art also seems, at first glance, to have altered very little. A closer examination shows that profound changes have in fact taken place. In 1965 Warhol announced his retirement from painting, on the ground that it was 'so boring painting the same picture over and over again'. In the 70s he returned to the task, and in 1979 he presented an anthology of re-created works under the title *Retrospectives*. This seemed to show his intention of clinging to the formulae he had already established. Accompanying the *Retrospectives*, however, was another series called *Reversals*. In these the silk-screens used to produce the familiar Warhol imagery had been deliberately 'reversed', so as to print the photographic negative, rather than its positive. Nor was this the only change. The cold, hard look of classic

Warhol was here replaced by sumptuous, painterly washes of colour. As Charles F. Stuckey wrote, with reference to Warhol's 1980 exhibition at the Galerie Bischofberger in Zurich:

> The *Reversals* recall Warhol's rationale for choosing to exclude personal feelings and meaning in his first exhibited pictures: 'Pop Art took the inside and put it outside, took the outside and put it inside.' The *Reversals* express the emotional 'inside' in terms of gestural brushwork, and the 'inside out' in terms of image. (*Flash Art*, Jan.-Feb. 1981, p. 16.)

It is one of the ironies of the history of Pop Art that Roy Lichtenstein and Andy Warhol began their public careers as artists using very much the same kind of material, and yet have now diverged so widely from one another. Having established the validity of the comic strip convention he began with, Lichtenstein

8 (*Above*) Robert Rauschenberg, *Dirt Shrine: South (Japanese Clayworks)*, 1982. High-fired ceramic, 120 × 179½ × 75 in (305 × 455.5 × 190 cm). Courtesy Leo Castelli Gallery, New York.

9 (*Opposite above*) Andy Warhol, *Multicoloured Retrospective Painting* (reversal series), 1979. Acrylic and silk-screen on canvas, 51 × 70 in (129·5 × 178 cm). Courtesy Galerie Bruno Bischofberger, Zurich.

10 (*Opposite below*) Roy Lichtenstein, *Landscape with Figures*, 1984. Oil and magna on canvas, 50 × 70 in (127 × 178 cm). Courtesy Richard Gray Gallery, Chicago.

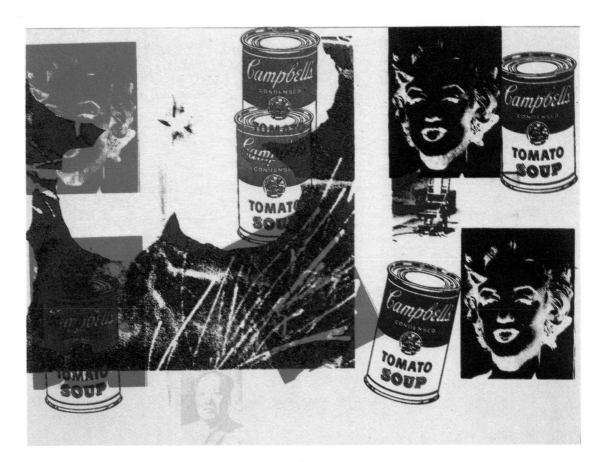

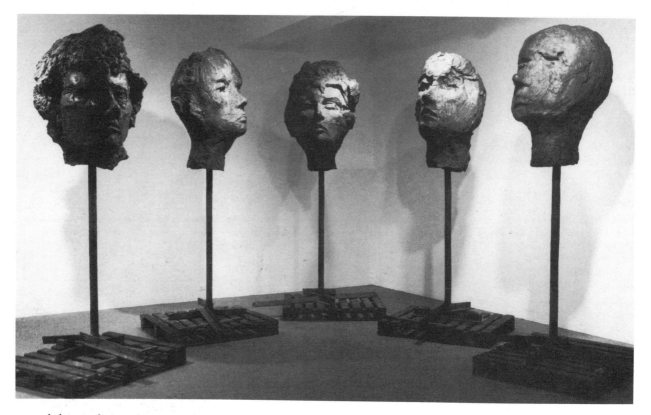

proceeded to apply it to an ever wider variety of subject-matter, instead of using the same images over and over again. If Warhol's recent work is art-about-art in a philosophical sense, Lichtenstein has mostly concerned himself with art-about-art of a critical and quasi-historical kind. He has used his rigid but unfailingly recognizable style to comment on everything from Abstract Expressionism to Art Deco. Since he is so keenly attuned to changing fashions in the art world, it now comes as no surprise to find him turning his attention to German Expressionism. A recent series of landscapes paraphrases the work of artists like Nolde and Schmidt-Rottluff, and here, for the first time, Lichtenstein makes a stylistic concession to his models, and the familiar rigid outlines are partly or wholly replaced by freely brushed paint. In this respect at least he and Warhol have been moving in the same direction. This new freedom of handling shows the influence on two established artists of the new climate created by Neo-Expressionism.

Jim Dine and George Segal

Neither Jim Dine nor George Segal fitted comfortably into the Pop movement, and in each case their development has taken them further and further away from anything which could justifiably

be described as Pop. Perhaps the only exception one can make to this generalization is Dine's persistent use of the heart-symbol – but then I believe I am not alone in feeling that the works which feature it are the least interesting part of his oeuvre. On the other hand, Dine has recently emerged as a sculptor, and in this role, though uneven, he is occasionally very impressive. The sculptures included in an exhibition held in 1984 at the Sidney Janis Gallery in New York varied widely in style, and also apparently in intention. Some made use of found objects, in a way familiar from Dine's earlier paintings; others – paraphrases of the Venus de Milo, with a saw attacking her knees – seemed to embrace the tradition of Dada. The most impressive were a group which seemed to propose a wholly unexpected link with Giacometti. Five very large portrait heads of Dine's wife Nancy, placed on tall supports like precious relics, seemed to echo, despite the huge difference in scale, the portraits which Giacometti made of his brother Diego. For all their size, these heads were not bullying or rhetorical but radiated a genuine human presence, not exempt from anxiety and unease.

Segal today is a more confident artist than Dine, more obviously secure in his command of what he can do and wants to do. He has refined the technique he began with – which involves making

11 Jim Dine, *Five Heads in London*, 1983. Bronze, left to right: $112 \times 59\frac{1}{2} \times 47\frac{1}{2}$ in ($285 \times 151 \times 121$ cm); $115 \times 55 \times 46\frac{1}{2}$ in ($292 \cdot 5 \times 140 \times 118$ cm); $113 \times 53\frac{1}{2} \times 47\frac{1}{2}$ in ($287 \cdot 5 \times 134 \times 121$ cm); $118 \times 61\frac{1}{2} \times 39$ in ($300 \times 156 \times 100$ cm); $116 \times 55 \times 47$ in ($295 \times 140 \times 119 \cdot 5$ cm). Courtesy The Pace Gallery, New York.

12 George Segal, *Cézanne Still Life No. 4*, 1981. Painted plaster, wood, metal, $57 \times 48 \times 24$ in ($144 \cdot 5 \times 122 \times 61$ cm). Courtesy Sidney Janis Gallery, New York. Photo Allan Finkelman.

direct casts from the human body – to the point where the viewer is scarcely aware that this is the method which has been used, instead of some more conventional form of modelling. Segal is now willing to tackle the great mythological themes of western art – for example, in the recent *Jacob and the Angels* – in addition to new versions of the everyday scenes which made him famous. He also reveals himself to be a learned artist, deeply interested in conventions of pictorial presentation, and in what occurs when these are translated from one medium to another. New subjects have included *Picasso's Still Life with Violin and Grapes*, and a version of a Morandi *Still Life*. These projects have involved an analysis of three-dimensional forms in their relationship to real and imagined space which is a long way from the apparent literalism with which Segal began. Altogether, he is now the most distinguished figurative sculptor now working in the United States. He is also proof of the fact that it is still possible for an artist to undertake a long slow process of maturation, resistant to all the pressures of the American art world.

13 Frank Stella, *St. Michael's Counterguard*, 1984. Aluminium, fibreglass and sheet metal, 156 × 136 × 108 in (396 × 345 × 274 cm). Los Angeles County Museum. Courtesy M. Knoedler and Co., New York.

Frank Stella

One artist who came to the forefront in the 60s, and who continues to exercise considerable direct influence over American artists some twenty years later is Frank Stella. Stella sees himself as an artist formed by the experience of modernism. His decisive encounter with a contemporary was with the work of Jasper Johns, when he moved to New York in 1958. Johns's *Flags* and *Targets* were the inspiration of the 'Black' paintings which made Stella's reputation. With these Stella began an exploration of the relationship between the support – its size, shape and proportion – and what is painted on it. For the first fifteen years of his career his work was stringently geometric. This changed in 1975, when Stella produced the first of the *Exotic Birds* series. Here the structure became a free structure in full relief, and the paint itself, instead of being applied in the severely disciplined way that Stella had used previously, was now scribbled and calligraphic. The effect of opulence, even gaudiness, was further enhanced by the use of materials such as broken glass and glitter mixed into the

paint. In the 80s Stella has been taking these painted structures further and further, in actual size and in complexity of form. *St. Michael's Counterguard* (1984), owned by the Los Angeles County Museum, and shown in their exhibition *Olympian Gestures*, rivals Rauschenberg's *Dirt Shrine: South* in scale, and is perhaps even more complex in effect. The intricacy and gaudiness of Stella's recent painting can be found again in the work of artists considerably younger than himself, though few, if any, have dared to work on anything like the same scale.

Richard Diebenkorn

Richard Diebenkorn was born the year before Sam Francis, and is thus more than a decade older than Stella. In terms of his influence over recent American art, however, Diebenkorn ranks as Stella's equal – indeed, one may even venture to claim that it is Diebenkorn's example which has had a more widespread effect. One reason for this is that both abstract and figurative artists have found something to learn from him. The foundation of Diebenkorn's art, what-

ever other experiences he has passed through, is his youthful experience of the masters of the School of Paris, notably of the paintings by Bonnard, Matisse, Braque and Picasso which he studied during the 1940s at the Phillips Collection in Washington. Beginning as a painter of still-lifes and interiors, Diebenkorn then passed through the experience of Abstract Expressionism, and returned to figuration again in the mid-50s, trying to marry the things he had learned from the New York School with lessons drawn from Matisse. By the 70s he had evolved a highly original compromise between these two modes, pushing ideas taken from Matisse's severer compositions – for example the *Piano Lesson* of 1916 in the Museum of Modern Art in New York – still further towards abstraction. 1975 saw the beginning of Diebenkorn's *Ocean Park* series, which still continues. These paintings suggest a picture-space, but fill that space only with shifts of tone and light – the planes shift and recede with subtle effects of transparency. Diebenkorn taught at the University of California, Los Angeles, from 1966 to 1973, and the results are very visible, both in

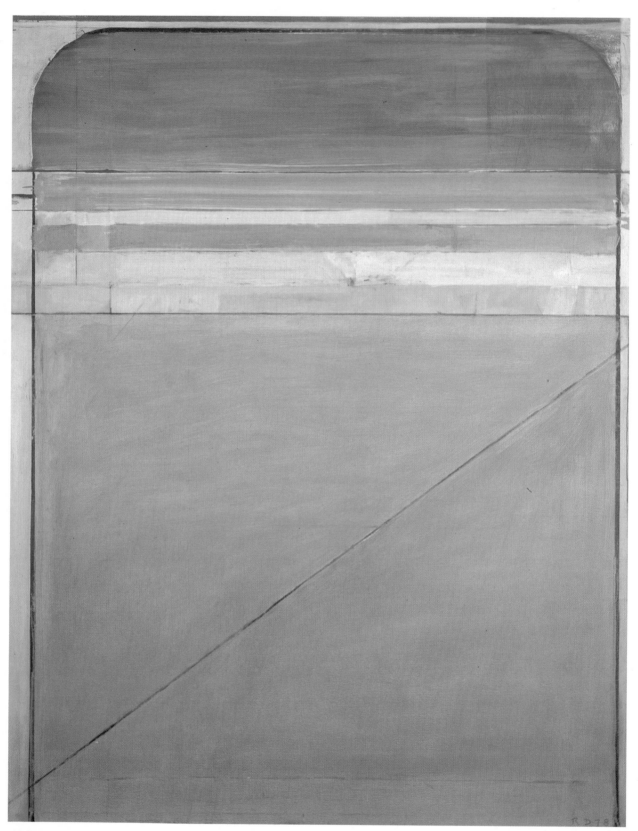

14 Richard Diebenkorn, *Ocean Park No. 108*, 1978. Oil on canvas, 78 × 62 in (198 × 157 cm). Private collection, New York. Courtesy M. Knoedler and Co., New York.

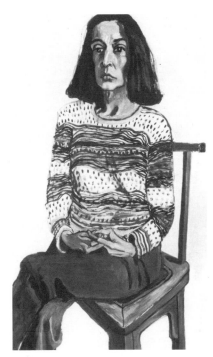

15 Alice Neel, *Marisol*, 1981. Oil on canvas, 42 × 24 in (107 × 61 cm). Courtesy Robert Miller Gallery, New York.

the work of those who studied under him, and in that of his students' students.

Alice Neel and Alfonso Ossorio

In American art, as in all other schools, outsiders can on occasion be transformed into insiders. The two most conspicuous examples of this in the 80s are Alice Neel and Alfonso Ossorio, two artists who otherwise seem to have little in common apart from a certain intransigent individuality. Neel, who lived a turbulent and colourfully Bohemian life, began to attract increasing attention in the 60s, when already in her sixties, and was finally given a retrospective at the Whitney Museum in 1972. Even as late as this, however, she seemed something of an oddity, a painter going utterly against any prevailing tide. Indeed, her own self-description was that she was 'an old-fashioned painter. I do country scenes, city scenes, portraits and still life.' Her declared admirations were Soutine, Goya and Munch. At the end of her life, she was in fact probably the most trenchant portrait painter working in America, an artist whose concern, not merely for the image but for its human content, made her the true forerunner of many of the things happening in American art in the 80s.

Alfonso Ossorio comes from a prosperous Philippino family, and was originally associated with the first generation of Abstract Expressionists, in particular with Jackson Pollock. In 1949 he went to Paris and met Jean Dubuffet, who converted him to Art Brut. These influences led Ossorio to the discovery of a personal synthesis. He became a collagist on an ambitious scale, using a wide variety of materials – bones, glass eyes, mirrors, bits of wood, plastic beads – to make barbaric-looking objects which he dubbed 'congregations'. Despite the popularity of assemblage in the late 50s, Ossorio's work aroused uneasy reactions, and continued to do so until very recently. Critics concentrated on its barbaric aspect, rather than on its well-concealed sophistication. It has taken very recent developments in American art to move Ossorio from a peripheral to a central position. At a superficial level, the resemblance between Ossorio's work and some of the constructions of Julian Schnabel is becoming increasingly obvious. Schnabel often uses the same range of materials, and seems to employ them in a very similar way. More important is Ossorio's innate Hispanicism. His constructions, instead of looking barbarous, now seem exuberantly baroque, in the same fashion as certain kinds of Mexican church decoration. The emergent Hispanic strain in American art finds in Ossorio an ancestor of some importance.

Ossorio and Alice Neel are significant figures, not only because of their own achievements, but because they symbolize what may be a general tendency for former outsiders in American art to move towards the centre, whereas artists once considered absolutely central to the American post-war achievement are suffering a loss of influence if not one of esteem. The most conspicuous exceptions to this rule are Stella and Diebenkorn. Stella remains ahead of the game because of his gift for constant self-transformation. His impact on recent West Coast abstraction has been especially clear. Diebenkorn's work and his professional example have alike had a fundamental effect on the way that art is taught.

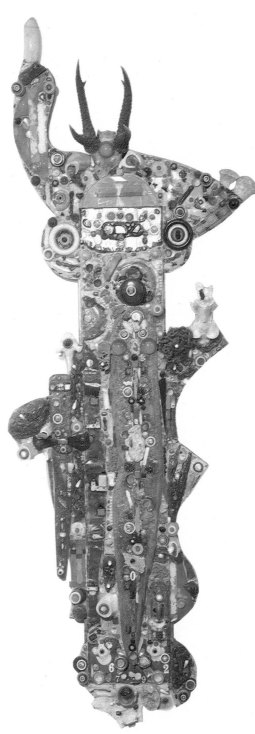

16 Alfonso Ossorio, *Old Lovers*, 1962–79. Mixed media, 77 × 31 × 10 in (195 × 79 × 25.5 cm). Courtesy Oscarsson Hood Gallery, New York.

CHAPTER TWO

THE FATE OF ABSTRACTION

The American critical climate has been consistently friendlier to abstraction than the European one. With synchromism, which was an offshoot of Robert Delaunay's Orphism, abstraction found a foothold in American art as early as 1913. By the 1920s the American public was habituated to the idea that abstract art was an integral part of modernism, and even perhaps one of the dominant factors within it. It is of course true that abstract painters had to fight hard against the prevailing climate until after the Second World War. But the triumph of Abstract Expressionism made a commitment to abstraction the chief means of identification with the new – so much so that the residual figurative elements in the work of painters such as Willem de Kooning and even upon occasion Pollock were largely ignored.

In America, abstract painting has developed without a break from the 40s to the present day. The main outlines are well-known. Abstract Expressionism, after producing a second and even a third generation, was supplanted by the Post-Painterly Abstraction supported and indeed named by Clement Greenberg. The great expanses of flat colour which typified the work of some practitioners of this style seemed like a cooler and more chastened version of the work already being done by Rothko. More innovatory were two other aspects – the use of the so-called 'soak–stain' technique, with washes of extremely dilute pigment on an unprimed surface; and the employment of repetitive and often symmetrical patterning, Kenneth Noland's targets, stripes and chevrons being cases in point.

Minimal painting

Frank Stella's earliest works of the 60s were accepted as part of this tendency, but were seen, correctly, as being yet more stringent. Though Stella himself did not continue to follow this particular path, a number of American painters did. Some of the most distinguished were Agnes Martin, with her faint, regular grids, almost impossible to photograph satisfactorily, Robert Ryman and Brice Marden. Ryman's work, even more than Stella's 'black' paintings, is an exploration of the formal possibilities offered by the medium – the activity which takes place on a particular surface is in fact his only subject. In order to focus attention on this, Ryman limits himself severely. All his paintings are square, and the majority are predominantly white. By contrast, he allows himself to employ a wide variety of different surfaces – not only canvas, but plexi-glass and sheet steel. Paint is carefully selected according to the kind of texture or density required, and Ryman also uses a wide variety of different kinds of brushes. The way in which the painted surface is fastened to the wall also becomes part of the work – Ryman has used tape, wet paint and special clips invented by himself, which are exposed on the surface of the painting and therefore form part of its 'composition'.

Brice Marden paints monochrome canvases in subdued colours, grouping the canvases together so that they create subtle contrasts and harmonies. In the artist's mind, these harmonies are linked to memories of things observed and experienced – experiences of nature, for example the feeling he had when flying over the ocean, and ideas

suggested by looking at Old Master paintings. In 1977 Marden began work on a series based on the five emotional states of the Annunciation, a tribute to his long-standing fascination with the work of Spanish artists such as Velazquez, Goya and Zurbarán. The problem with Marden's work, as with that of other Minimalists, is that the information omitted from the painting has to be supplied elsewhere – in a catalogue-note or other text – if the painting is to be fully understood and enjoyed by the vast majority of those likely to come in contact with it. His most extroverted works are the paintings on marble, where the sensuous nature of the material gives the painting immediate impact.

A more forthcoming Minimalist, especially in recent painting, is Robert Mangold. Mangold's work shows the influence of Mondrian's Neo-Plasticism, and also more directly American influences, particularly that of Frank Stella. But he is able to build on what these artists have done, and create something distinctive and personal, just as Stella did during one phase of his development. Mangold has been experimenting with the idea of the painting as a 'frame' for empty space. In his case the frame is made up of separate canvases, each painted a different hue. These are then united by a single line, which links them all together.

Mangold's work shows how thin the line is which now divides painting from sculpture, even if we define the word sculpture in a fairly conventional fashion. This tendency is equally noticeable in the delicate webs created from vellum paper by Dorothea Rockburne. Like

Mangold, she creates a vocabulary from the interplay of arcs and right-angles, and like Mangold she questions conventional ideas about format.

Minimalism in three dimensions

One of the most stringently minimal American artists, and certainly one of the best-known in this field, is Carl Andre. He has been widely exhibited in recent years outside America, and in a certain sense he has come to represent the European image of American art. A photograph of a recent work by Andre, installed outside Mies van der Rohe's Seagram Building in New York, reinforces the impression that he is particularly representative of a certain 'cool' current in American culture – the tendency now being challenged by European and American Neo-Expressionists. Andre's granite blocks, placed together to make a regular form, seem like a miniature version of Mies's reticent architecture. Yet Andre is fundamentally more romantic than classical. In a radio interview I once did with him, he declared that he would like to be remembered as 'the Turner of matter' – a fine phrase which suggests his long-standing preoccupation with the idea that the work of art attempts to contain the whole cosmos. *Fermion*, the piece illustrated, is, like many of Andre's sculptures, infinitely extendable – an excerpt from an impractically huge sculpture which exists in the artist's mind, and also in that of the spectator.

Other artists connected with the Minimal tendency in American sculpture show interesting signs of change. Robert Grosvenor's creosoted wooden baulks of the 1970s have given place to equally bulky and menacing steel forms, but instead of resting directly on the floor these are separated from it by a pad of wire mesh, which suggests a certain blurring of relationships which formerly were absolutely clear cut. Jackie Winsor's work is much more delicate than Grosvenor's. She translates the cubes beloved by so many Minimal sculptors, from Tony Smith onwards, into unexpectedly fragile materials, and emphasizes their fragility by piercing their sides or even, in one instance, by subjecting them to the effect of fire.

Perhaps the most unexpected development in the work of established mini-

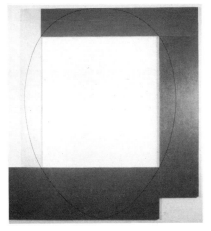

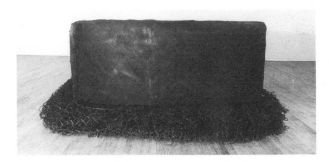

17 (*Top left*) Brice Marden, *Marble*, 1981. Oil on marble, $12\frac{3}{4} \times 7 \times 11\frac{1}{8}$ in ($32.5 \times 18 \times 28$ cm). Courtesy The Pace Gallery, New York.

18 (*Centre left*) Robert Mangold, *Four Color Frame Painting*, 1983. Acrylic and pencil on cavas, 111×105 in (283×267 cm) over-all. Courtesy Paula Cooper Gallery, New York.

21 (*Below*) Robert Grosvenor, *Untitled*, 1981–3. Vinyl-coated steel and undercoating, $3 \times 8 \times 7$ in ($7.5 \times 20 \times 17.5$ cm). Courtesy Paula Cooper Gallery, New York.

19 (*Top right*) Dorothea Rockburne, *Arena III*, 1978. Coloured pencil on vellum. Courtesy HHK Foundation for Contemporary Art Inc., Milwaukee.

20 (*Centre right*) Carl Andre, *Fermion*, 1981. Quincy granite, 100 units, each $18 \times 6 \times 6$ in ($46 \times 15 \times 15$ cm), $18 \times 60 \times 60$ in ($46 \times 152.5 \times 152.5$ cm) overall. Installation, Seagram Building, New York, facing Racquet Club. Courtesy Paula Cooper Gallery, New York.

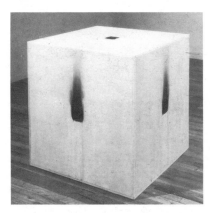

22 Jackie Winsor, *Burnt Paper Piece*,
1981–2. Paper reams, wood, hydrostone,
$32\frac{1}{8} \times 32\frac{1}{8} \times 32\frac{1}{8}$ in ($81 \times 81 \times 81$ cm).
Collection Robert Hoffman, Dallas.
Courtesy Paula Cooper Gallery, New
York.

23 Joel Shapiro, *Untitled*, 1982. Bronze,
approx. $73 \times 59 \times 43$ in ($185 \times 149 \times 109$ cm).
Stockholm, Moderna Museet. Courtesy
Paula Cooper Gallery, New York.

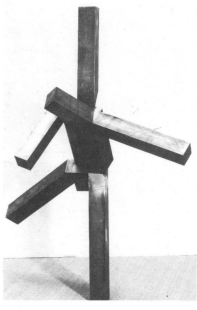

24 Sam Gilliam, *Kimono*, 1977. Acrylic on
canvas, 90×120 in (228×304 cm). Courtesy
Fendrick Gallery, Washington DC.

mal sculptors is to be found in the work
of Joel Shapiro. It is true to say that his
Minimalism was never whole-hearted,
in the fashion of Andre. There was often
a residual figurative element. His small
sculptures in cast bronze (the unexpec-
tedly minute scale was part of a strategy
of disorientation) might be rudimentary
house-like shapes. In a series of much
larger sculptures made recently Shapiro
takes this tendency much further. In
one untitled piece rectangular elements
are assembled to create what is unmis-
takably a dancing figure.

Non-Minimal abstraction

There is some evidence that many ab-
stract painters working in America dur-
ing the 80s feel persecuted and suppres-
sed, deprived of an artistic heritage
which was once theirs by right. It is a
variant of an emotion felt, with much
greater reason, by the American ab-
stractionists who battled against social

realism, yet today it remains possible for artists to use a wide variety of abstract styles, and to garner much respect for doing so. Some of these styles have strong regional connections, with Chicago and California in particular, and will be dealt with in their proper place. But it is also worth trying to give examples of some of the alternatives which exist for American abstract artists nation-wide.

The black artist Sam Gilliam, for

instance, has his roots in the Washington Colour Painting of the 60s. Like Morris Louis, who has clearly been an influence on his work, he manipulates the canvas off-stretcher to obtain the results he wants. Some of his paintings are shown unmounted, some mounted. The strongly decorative quality of his work, and its ripe saturated colour, prompt a comparison with Robert Natkin. There are technical similarities as well. Both Gilliam and Natkin get some

25 Robert Natkin, *Hitchcock Series*, 1983. Acrylic on canvas, 94 × 84 in (237 × 213 cm). Courtesy Gimpel Fils, London.

26 Ed Meneeley, *Untitled*. 1982. Acrylic on canvas, 86 × 62 in (218 × 157 cm). Courtesy the artist.

27 Al Held, *Bruges II*, 1981. Oil on canvas, 84 × 84 in (213·4 × 213·4 cm). Courtesy Juda–Rowan Gallery, London

characteristic effects by using techniques akin to monotype, squeezing or imprinting one still-wet surface on another. In both there is a kinship to surrealism which appears only at second glance. Gilliam speaks of the importance of metaphor in his work and says: 'I am interested in the inner landscape of things.' Where Natkin is concerned, an essay by the British critic Peter Fuller (a great admirer of the artist) offers further clues as to the content of the paintings. Fuller points to a link between Natkin's work and the movies the painter enjoyed in his Chicago childhood: a decorative lushness which reminds one of old movie-houses, and an intrinsically theatrical quality. Natkin's decorativeness also suggests a link to some artists with whom he is not usually compared, the so-called Pattern Painters such as Brad Davis and Kim MacConnell.

Equally decorative are recent paintings by Ed Meneeley and Al Held. Meneeley has suffered unfair neglect, partly because of a long absence in England at a crucial moment in his career, partly because he has been in any case a slow developer, only gradually freeing himself from the example of mentors such as Barnett Newman. Recent works use a wide range of zinging colours, each main element being separated from the background and given additional colouristic energy by the use of a narrow, slightly ragged border in a contrasting hue. The forms are angled in a way that simultaneously suggests and denies perspective.

Al Held makes paintings with a much more strongly illusionistic character. A good description of his recent work has been given by Willy Rotzler:

Above all, the picture loses its last vestige of two-dimensionality. It becomes a prospect of a richly hued space-situation, dominated by coloured bars or beams that form closed systems and are in their turn hemmed in or called in question by other systems. This produces a spatial maze of colours and forms that the observer can adventurously explore, though without attaining any clear idea as to how the bodies and spaces are really organised.

The illusionism and complexity of Held's work make it a complete contrast to that of Thornton Willis. Willis enjoys a special standing in current American

28 Ron Gorchov, *Tancredi*, 1983. Oil on linen, 84 × 49½ in (213 × 126 cm). Courtesy Marlborough Gallery, New York.

painting, symbolized by the fact that he was one of the very few purely abstract artists included in the survey exhibition which the Museum of Modern Art in New York mounted for its re-opening in May 1984. He employs simple forms – recently a zigzag and a kind of house-shape – but uses the brush to animate the surface in a way which amounts to a denial of Minimalism. In a recent statement Willis described the effect his work was intended to have:

I think of my paintings as objects; they are, however, objects of a *special nature* ... they ideally contain information conveyed visually on a two-dimensional plane. The content is a result of the way the painting is made, that is in a sense to say, the paint itself. The degree to which I am able to respect the two-dimensional nature of painting is relevant to the degree of purity in my work. ... The painting must ultimately stand upon its own merit or fade because of its lack of meaningful content. It's a human condition.

Part of the 'purity' of Thornton Willis's work comes from its respect for conventional formats. A number of American abstract painters have become increas-ingly dissatisfied with the limitations which this imposes upon them. One is Ron Gorchov, who uses a curved support which he describes as 'a very general realization of my ordinary experience in space. So painting continues to be, for me a space, as well as an object. ... On one hand I am attempting to materialize states of mind that are often no more than floating episodes and yet they require more than a sign, a symbol or even an image. On the other hand the episodes I am speaking of are associated with certain settings and are therefore unrepeatable, although I am sure they are common enough as types of inner-feeling.'

More decorative than Gorchov and much more varied in format is Elizabeth Murray. Murray appeals to a wide spectrum of spectators, despite the fact that her work is sometimes described as 'eccentric' or even 'bizarre'. She has figured in some of the most stimulating 'theme' shows of the early 80s, among them the Hirshhorn Museum's *Directions 1983* and the Whitney Museum's touring show *American Art since 1970*. Murray's canvases are extravagantly curvilinear. These shapes are complemented with sonorous colour. One obvious influence on her art is the later work

of Frank Stella, but the figurative references hover far closer to the surface than they do with him. As she herself admits: 'There are shapes and figures in my painting which refer to forms in nature and to the human body.' But she adds, 'the shapes are not identifiable with a specific thing. They feel like transformations.'

Murray is not the only American abstractionist who transforms nature in this way. Katherine Porter's current paintings seem to refer chiefly to landscape. Sean Scully, who once painted severely abstract canvases, is now making paintings which allude distantly to primitive architecture. The architectural effect is enhanced by the fact that the paintings are made of several sections joined together, with some parts in relief.

Joan Thorne would not deny that her work contains specific references to nature, in fact she cites Georgia O'Keefe and Milton Avery's landscapes among her influences. She asserts:

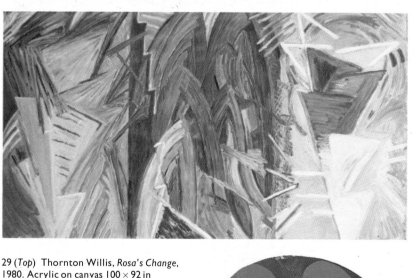

29 (*Top*) Thornton Willis, *Rosa's Change*, 1980. Acrylic on canvas 100 × 92 in (253 × 233 cm). Denver Museum of Art. Courtesy Oscarsson Hood Gallery, New York.

30 (*Centre*) Katherine Porter, *Spring*, 1984. Oil on canvas, 42 × 77 in (106 × 195 cm). Courtesy David McKee Gallery, New York.

31 (*Bottom*) Elizabeth Murray, *Fire Cup*, 1982. Oil on canvas, each canvas 92 × 82 in (233 × 208 cm). Courtesy Paula Cooper Gallery, New York.

32 Joan Thorne, *Zer*, 1976. Oil on canvas, 104 × 74 in (264 × 188 cm). Courtesy Christie's.

33 Sean Scully, *Tonio*, 1984. Oil on canvas,
72 × 96 in (182·5 × 244 cm). Courtesy Juda–
Rowan Gallery, London.

34 Bill Jensen, *Chord*, 1982–3. Oil on
canvas, 24 × 28 in (61 × 71 cm). Courtesy
Washburn Gallery, New York.

I am not interested in metaphor; I am
interested in vision. My painting has
something to do with visions or
images that have spiritual energy
(not religious), having to do with the
spirit being alive as opposed to being
dead. The visions, images, come into
the painting and occupy a space
which is always shifting, they are
inseparable from the space they occu-
py. These images are conceived as the
painting happens, they are not pre-
conceived. One could say there is a
spirit in the image.

Bill Jensen might be less emphatic. He
is an innovator in many ways. One is in
choice of format, for while most Amer-
ican abstract paintings are extremely
large, Jensen's are small and intimate.
Into them he puts a host of observations,
dreams and memories: 'I see too many
things. I walk down the street. I see an
airplane or a shoe. I saw things when I
was a little kid. They all come back
when I'm working.' But he also says: 'I
start searching for the awesome quality
in the painting. It can become very
frightening, very threatening.' The end
result, though quite different from
Gilliam and Natkin once again, has a
strongly surrealist quality, and this is
something which is beginning to enter

American art in other ways, as a chal-
lenge to the Expressionist revival. It is
only a small step from Jensen's work to
the kind of New Image painting which is
fully and recognizably figurative, even
though what is shown is treated in a
deliberately rudimentary way. Jensen's
work has had a powerful influence on
the new generation of abstract painters
who are just beginning to show their
work in New York. The reason why he is
widely imitated is that he has occupied
the middle ground – he combines Ex-
pressionist handling, hints of Surrealist
transformation of known objects, and
the formalism of 'pure' abstraction.

In the 80s there has been a tendency
among American critics to see abstrac-
tion as something which is 'fighting
back' – making renewed progress
against what seems an irresistible tide of
figurative art. But a major transform-
ation has nevertheless taken place.
Minimal Art, which at one point in the
70s asserted its supremacy by virtue of a
puritan myth of moral and intellectual
as well as visual purity, has been suc-
cessfully challenged by a kind of abstract
painting which descends from a very
different tradition – one which is rooted
in a response to nature, and whose
ancestors are Surrealism and Abstract
Expressionism.

CHAPTER THREE

NEW FIGURATION

Much figurative painting in America currently goes under two different labels – 'New Image' and 'Bad Painting'. No one seems to know what precisely these phrases mean, or whether they are to be regarded as interchangeable. The situation is further confused by the fact that the adjective 'bad' is used in a double sense – to suggest that here is art which has been deliberately made ugly, and in an ironically admiring way drawn from street talk ('That's one *bad* mother!'). But one thing is clear: the artists to whom they are applied are thus implicitly designated as part of the American response to the triumph of European Neo-Expressionism. Some people might take the view that the simplest way of defining New Image is to see it as an extension of Neo-Expressionist style – the currently fashionable artistic language spoken with an American accent. This does not sustain close examination.

Philip Guston and Malcolm Morley

The American ancestors most often cited for New Image are the late Philip Guston and Malcolm Morley. Guston, who had been a leading Abstract Expressionist, in the 1960s turned to figurative expressionism of a particularly brutal kind, laced with things which seemed to be taken from Pop sources, such as strip-cartoons. He continued to develop this new manner until his death in 1980. At first his new direction was not well received. Guston became an outsider, almost an unperson. The situation was not helped by his outspoken dislike of the kind of reductive art-about-art which was then in

vogue. However, the sheer eccentric stubbornness of Guston's new paintings attracted attention among younger artists, and before he died he had become something of a cult figure. It is easy to see what attracted these disciples from an interview with Mark Stevens published in *The New Republic* in the last year of Guston's life. Guston said:

A lot of what's written and painted now is about there being nothing to write or paint, and it becomes boring after a while. I've always had the feeling that art is nourished by the common and ordinary. Picasso drew constantly from the common. I have a feeling that in America a lot of good art may come out of this impulse. I'm not talking about proletarian art, because that's as bad as being an esthete. But I love the self-taught artists. Just as strong in my memory as the old masters is once seeing an old-fashioned ice-truck in Manhattan which had a bucket painted on it, with the grain of the wood and everything, and spilling out of it these cubes of ice. Sometimes, when my painting is getting too artistic, I'll say to myself. 'What if the shoe salesman asked you to paint a shoe on his window?' Suddenly everything lightens. I feel not so responsible and paint directly what the thing is, including the necessary distortions.

Morley is a more complex case, though sudden changes also feature in his development. Born in Britain (he still has a British passport), he settled permanently in the United States in 1958, after a three-year gaol-sentence for housebreaking and a spell at the Royal

College of Art. In New York he moved abruptly from abstraction to Photo-Realism – the literal copying of illustrations found in brochures. But a personal crisis leading to nervous breakdown and eventual psycho-analysis later led Morley to break away from the smooth, impersonal coldness of the manner for which he was known. He has now espoused what looks like its diametrical opposite – an apparently free and painterly style. In some ways the difference is more apparent than real. Technically, Morley's manner of painting remains close to the method of his Photo-Realist days. Then, the chosen illustration was squared up and turned upside down, with every square covered but one. It was this visible square which the artist laboriously copied on to his canvas, without reference to any image it might contain. Now a drawing in watercolour precedes the finished picture, but this is treated in the same manner as chance-found illustrations used to be. The dreamlike jumble of imagery on the canvas is often partly derived from mass-produced toys. A mounted cowboy or a redskin brave will be based on a tiny plastic figure. Every painting is thus the product of an elaborate strategy whereby the artist distances himself from his original inspiration. In a sense, this makes his work the very opposite of any kind of Expressionism. But it also suggests that the dreamlike atmosphere of Morley's recent paintings is rooted in something which their creator finds threatening and dangerous. The surface facetiousness and frivolity of what he paints are a denial of the pain and desperation he actually feels.

Guston's search for the common

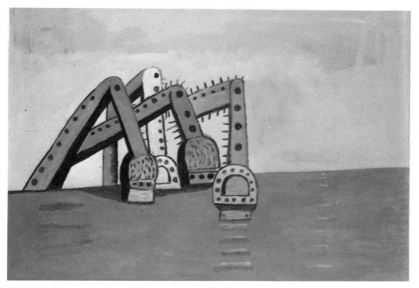

35 Philip Guston, *To J.S. (Jules Supervieille)*, 1977. Oil on canvas, 68 × 104 in (173 × 264 cm). Courtesy David McKee Gallery, New York.

touch and Malcolm Morley's obliqueness are both things which appear, in varying proportions, in the American figurative art of the 80s.

Hermetic figuration

In a number of New Image works figuration appears in a peculiarly curt and laconic form. One could go so far as to say that these are figurative paintings done as though they were purely abstract. The most extreme example of this is the work of Gary Stephan, where the very existence of an image is only just discernible to the instructed eye. Stephan is a pictorial dandy, who keeps

36 Malcolm Morley, *Day Fishing in Heraklion*, 1983. Oil on canvas, 80 × 90 in (203 × 228 cm). Private collection. Courtesy Xavier Fourcade, New York.

37 Gary Stephan, *The Four Last Things*, 1979. *Acrylic on canvas, 94 × 58 in (239 × 147 cm)*. Courtesy Christie's.

38 Robert Moskowitz, *Thinker*, 1982.
Pastel on paper, 108 × 63 in (274 × 160 cm).
Courtesy Blum Helman Gallery, New
York.

a fine balance between the demands of
depiction and the maintenance of the
picture-surface. 'Giotto's struggle with
illusion,' he remarks, 'redeems the
work, limiting the power of illusion to
the integrity of the painting as an ob-
ject.' Less stringent, but still in the same
camp, are painters like Robert Moskow-
itz, Susan Rothenberg, Louisa Chase
and Donald Sultan.

Moskowitz is almost as hermetic as

Stephan. Extremely rudimentary
images now make their appearance in
work which embraces most of the values
of pure abstraction – and Moskowitz
was indeed an abstract painter for a
large part of his early career. 'The
images are just recognisable enough,'
the artist says. 'If you looked at it long
enough you would be able to see it.' An
unexpected comparison suggests itself –
to the later work of Nicolas de Stael.
There, too, the figurative image is an
incident in a configuration which can
otherwise be read in a purely abstract
way.

Ten years younger than Moskowitz,
Susan Rothenberg has not lived
through so many years when abstrac-
tion was sacrosanct, at least to its pract-
itioners, and when the line between
what was abstract and what was figura-
tive was clearly drawn for every one to
see. Her work is correspondingly more
relaxed in its attitude to imagery – its
presence or absence. Now one of the
most celebrated younger artists in
America, she is chiefly associated with a
long series of paintings, begun as long
ago as 1974, which feature the rudi-
mentary image of a horse. She claims
that its presence was not a matter of
rational choice, but that the image
manifested itself unbidden. 'For years I
didn't give much thought as to why I
was using a horse. I just thought about
wholes and parts, figures and space.'
Whatever the image used – and recently
her repertoire has become much more
varied – Rothenberg's work impresses
by a combination of delicacy and vigour
in the actual handling of the paint. The

40 Louisa Chase, *Pink Cave*, 1983. Oil on
canvas, 84 × 72 in (213 × 182·5 cm). New York,
Metropolitan Museum of Art. Courtesy
Robert Miller Gallery, New York.

horse paintings, where the figure floats,
and often appears overlaid by or inter-
mingled with other images (a pair of
upside-down legs, a bone), are like mod-
ern equivalents of the cave paintings
made by Palaeolithic artists. There is the
same sense that the imagery has been
not so much made as dreamed.

Susan Rothenberg has a great deal in
common with Louisa Chase. They share
a desire to keep faith with inner ex-
perience. Chase describes it thus: 'Paint-
ing for me is a constant search to hold a
feeling tangible. The experience "calls"
it. The painting "recalls" it. It allows me
to hold it in my hand.' But there is a
marked difference in the way the paint-
ings come out. Earlier works by Chase
had a flat, forthright, graphic quality.
They relied on unmodulated areas of
bright colour in a way foreign to
Rothenberg's technique or way of think-
ing. More recently, Chase's technique
has become more fluid, with rudimen-
tary images overlaid by a flurry of
scribbled marks which give the feeling
that the surface of the painting is in
constant movement – a flux, in the
midst of which the image is coming to
birth. One still gets the impression that,
for this artist, drawing and painting
remain somewhat separate activities. In
addition, there is a difference in the type
of picture-space the two painters em-
ploy. Rothenberg's is a surface with little
hint of illusion. Chase uses the 'shallow
space' of Analytical Cubism, which was
inherited by Pollock.

39 Susan Rothenberg, *Withall*, 1982. Oil on canvas, 65 × 122½ in (165 × 311 cm).
Courtesy Willard Gallery, New York.

The art of Donald Sultan has a harsher, more impersonal edge than that of Chase or Rothenberg. The harshness comes partly from his technique. He works with non-art materials, fixing linoleum tiles to masonite, drawing on the tiles, then using a blow-torch to soften parts of the surface, so that it can be scraped away. The scraped portions are then filled with either tar or plaster and painted over. But Sultan's imagery is harsh too. His repertoire includes urban smokestacks, rendered in a simplified way which is reminiscent of Georgia O'Keeffe. These smokestacks have also been transformed into smoking cigarettes (reminiscent not of O'Keeffe but of Guston), and the fire-breathing guns of a battleship. Metamorphosis is very much part of Sultan's method. His work demonstrates that New Image painting, even at its most simplified, is not necessarily introverted. His images are not rooted in personal obsession, but in an attempt to assess the state of American culture.

Anti-reductive painting

The two most discussed new figurative painters in America, more so even than Susan Rothenberg, are Julian Schnabel and David Salle. Schnabel's assertive personality and huge financial success have made him one of the most visible figures in contemporary American art. He is best-known for what are commonly called the 'plate-pictures', where the paint is applied to broken crockery imbedded in plaster paste – the original inspiration for these came from a visit to the Parque Güell in Barcelona, designed by the great Catalan architect Antoni Gaudí, but there is no specific reference to Gaudí's aesthetic. Schnabel uses this and other difficult surfaces, such as velvet, tarpaulin, sisal rugs and carpet underfelt, primarily as a means of preserving spontaneity. Working close to the broken surface the artist is working more or less blind, and must trust his instinct as to which is the right mark, without giving way to timidity.

Schnabel's art is the very opposite of reductive. It is crowded with visual incident and embraces a very broad spectrum of cultural references. Some of this are taken from the art of the past (Duccio, Caravaggio, Jackson Pollock); some from literature (Antonin Artaud and William Burroughs), and some from

41 Donald Sultan, *Lemons and Pears Nov. 6,* 1984. Oil and spackletar on vinyl tile over wood, 12½ × 13 in (32 × 33 cm). Courtesy Blum Helman Gallery, New York.

films (Werner Herzog and Jean Vigo). There is often a sense that Schnabel is competing with the other creators to whom he refers, pitting himself against past champions in the same way that Hemingway did.

Though he is frequently classified as an Expressionist, this does not seem to be Schnabel's own view of his work. As he said in an interview with Hayden Herrera published in *Art in America* in December 1982:

My painting comes out of the continuum of art that has been. It's not antiart in any way. It's just art that can get up and stick its head out the window and do things that were maybe impossible before. ... I'm not distorting things in my paintings. I'm selecting things that have already been distorted in life, and painting them pretty true to their contour. It's not interpretive. My brushstrokes are not emotional. It's the way they configure together that becomes emotional. ... My painting is more about what I think the world is like than what I think I'm like. I'm aiming at an emotional state, a state that people can literally walk into and let themselves be engulfed by.

Unlike traditional Expressionists, Schnabel does not insist on personalizing. 'It is feelings that are important,' he says, 'not necessarily my feelings.' His search is not for individual, but for collective subjectivity. And while he paints in a deliberately untraditional way, he is in fact aiming at a completely traditional effect – he wants to produce

an immediate sense of identification between the spectator and what is happening on the picture's surface which precedes understanding of the images. It could be said that a great baroque altarpiece operates in the same way. Schnabel's ambitions are huge, and so too are his self-created difficulties. He is trying to create a universally viable mythology in the midst of a notoriously fragmented culture. He is also trying to project 'romance' and 'optimism' to an audience which has good reason to be cynical and pessimistic. His sometimes strident claims for himself inevitably attract hostility. Yet it must be said that his energy, his ambition and his omnivorous appetite for experience, as well as his sheer technical inventiveness, are things that command respect.

David Salle's work is much closer to the Pop of the 60s than Schnabel's, and Salle himself admits the kinship. 'In all my images,' he says, ''there's a notion of complicity and covertness that makes you think about popular culture – but they're not "pop" in the sense that they are celebrating anything, that they are in love with anything like that. In my work an image is not a "criticism" or a response. Even if it's borrowed, it must feel primary.'

Salle's work seems to centre on an examination of the relationship between images and their generally accepted meanings. It assumes a wide knowledge of facts, objects and conventions of representation familiar to Americans of Salle's own generation, but not necessarily so either to non-Americans or to people senior to him. These are the *données* for his work, things taken entirely for granted. The press release for Salle's first English one-person exhibition, held at the Anthony d'Offay Gallery, London, December 1982–January 1983, described the situation rather better than such documents usually manage to do. Salle's painting, it claimed, was redolent of a fridge-raiding, corner-cutting, head-shrinking, violent, messy, clean, sexually obsessed, verbally articulate, urban, quintessentially youthful society.' While the huge size of many of Schnabel's paintings seems a genuine reflection of his ambitions, Salle's frequently seem overblown for their actual content. This is a weakness he inherits from his two most obvious exemplars, Rauschenberg and Rosenquist.

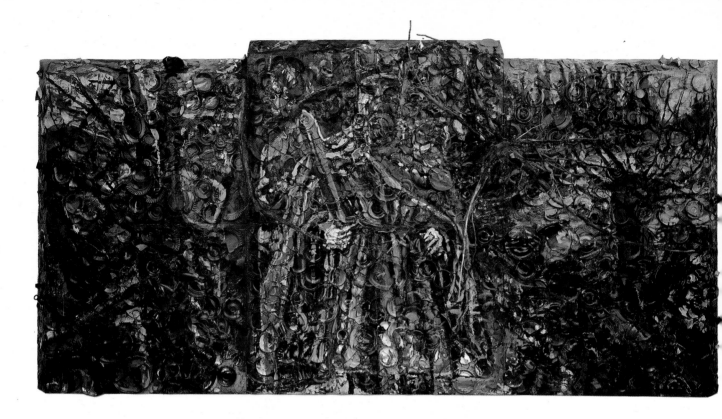

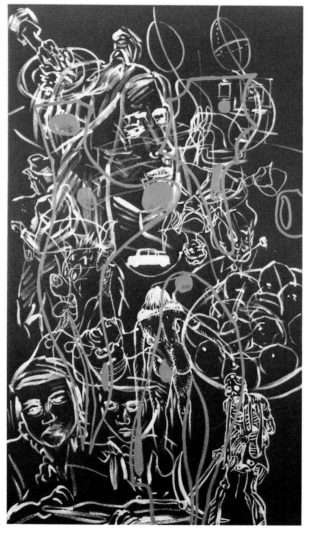

42 Julian Schnabel, *King of the Wood*, 1984.
Oil, bondo and spruce roots on wood,
10 × 19½ in (25 × 49·5 cm). Courtesy The
Pace Gallery, New York.

43 David Salle, *Normal Sentences*, 1982. Oil
and acrylic on canvas, 86 × 168 in
(218 × 426 cm). Courtesy Anthony d'Offay
Gallery, London.

Contemplative and narrative painting

One of the disconcerting things about the so-called New Image movement is the sheer diversity of the artists who have been brought together under the same banner. There could hardly be a more striking contrast than that between Jennifer Bartlett and Nicholas Africano. Bartlett makes huge paintings – often so large as to be complete room-size installations. Her imagery is one step away from Photo-Realism, since the artist bases her work on snapshots she has taken herself of particular places: houses where she has lived and their surroundings. By repeating, varying and overlapping a particular view she makes a summary of what she feels. Though the literalism of the camera provides a basis, the final effect is abstract rather than figurative. Bartlett says: 'My interest is to show how it can be done rather than what the imagery is.'

Africano is quite the opposite – imagery and narrative based on imagery are the primary things in his paintings. The narrative is conveyed by means of small personages, very much reduced in scale in relation to the space they occupy, and built up from the surface. These personages appear dramatically against a plain ground, and the picture with its frame becomes a kind of stage where a mysterious or humorous drama is being enacted. It is only the hint of ironic caricature which makes Africano different from the narrative painters of the nineteenth century.

Another artist with an interest in narrative a painter less established than Africano, is Mark Schwartz. In

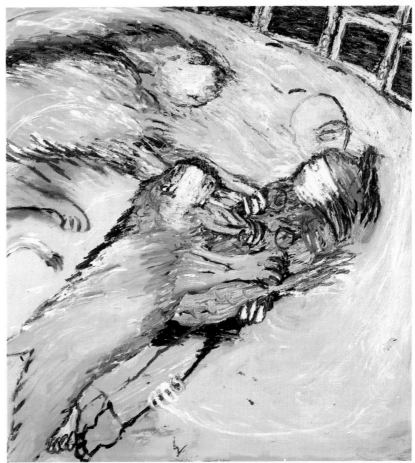

44 (*Top*) Jennifer Bartlett, *Shadow*, 1983. Oil on 4 canvases, each 7 × 5 in (18 × 13 cm), 7 × 20 in (18 × 52 cm) overall. Collection Chase Manhattan Bank. Courtesy Paula Cooper Gallery, New York.

45 (*Below*) Mark Schwartz, *Eric's Relationship IV*, 198. Oil on canvas, 72 × 68 in (182·5 × 172·5 cm). Courtesy Peter Miller Gallery, Chicago.

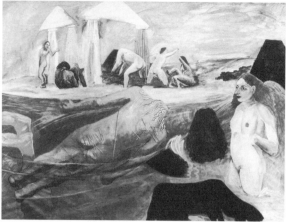

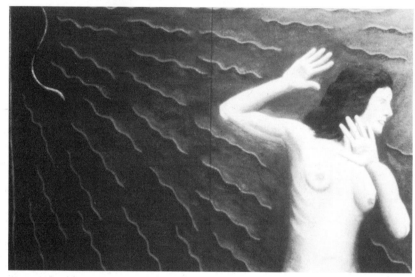

46 (*Above left*) Nicholas Africano, *Metamorphosis I*, 1982. Mixed media, 56 × 79 in (141 × 200 cm). Courtesy Holly Solomon Gallery, New York.

47 (*Above right*) Charles Garabedian, *Island, No. I*, 1982. Acrylic on canvas, 72 × 96 in (182·5 × 244 cm). Courtesy L.A. Louver Gallery, Venice, California.

48 George Rodart, *Temptation of Eve*, 1981. Oil and wax on canvas, 45 × 70 in (114 × 178 cm). Courtesy Ulrike Kantor Gallery, Los Angeles.

some of his showings, Schwartz has been firmly classified as an Expressionist. The rough painterly handling of his pictures – the paint is smeared on with the fingers – certainly suggests a link with traditional Expressionism. But there is a *joie de vivre* about these works, a relish for incongruity and outrageous parody, which suggest that Schwartz belongs elsewhere. A recent series of gladiatorial scenes and related classical subjects, for example *Hercules Fighting the Cyclops*, are treated in a style which derives from comic strips, but the rapid, graphic quality of the images takes them a long way from the classic Pop of the 60s, which used similar source-material.

New Image in Los Angeles

New Image painting is usually thought of as a New York style. Nevertheless, an equivalent exists in California, and one or two artists based there can even be said to have anticipated some of its characteristics before it surfaced on the New York art-scene. One painter who falls into this category is Charles Garabedian, who completed his undergraduate studies at the University of Southern California as long ago as 1950. Garabedian's reputation grew slowly, and it was only in the 70s that he began to win real recognition. In 1981, when he was given a 12-year retrospective at the La Jolla Museum, Marcia Tucker described him in terms which showed how much the critical climate had changed:

Garabedian's work is wonderfully perverse, since he is completely uninterested in abiding by the rules of good taste, draughtsmanship, appropriate subject matter, formal composition or stylistic consistency.

A decade earlier, these would hardly have been terms of approval.

Garabedian's recent paintings are scenes which seem to guy the classical ethos in a way which is reminiscent of late work by Giorgio de Chirico. Nearer home, he has an affinity with his much younger West Coast contemporary George Rodart. In Rodart's work, which is often based on designs found in astronomical star-charts, the affectionate parody of classicism and its values is taken a step further, with the definite intention of subverting stylistic identities. Here the wheel comes full circle, as Rodart's affinity with the Italian allies of Neo-Expressionism, Trans-avantgarde painters such as Sandro Chia, is extremely clear.

What many of the new figurative painters seem to have in common, whether their work is hermetic or greedy to include as wide a range of experiences as possible, contemplative or narrative in tone, is an extreme self-consciousness about style. The deliberate inelegance of much of their work scarcely conceals a paradoxical dandyism. With New Image painting it is not the content but the way that content is expressed which really matters. In this sense it is almost as self-referential as the Minimal Art which it has now elbowed from the limelight.

CHAPTER FOUR

AMERICAN EXPRESSIONISM

It is difficult to make an absolutely firm division between New Image/Bad Painting and mainline Expressionism, as has already been shown in the case of Mark Schwartz, whose work, though included in the last chapter, has almost equal claims to be discussed here. One reason for the difficulty is that Expressionism, though it now has the spotlight again thanks to its recent revival in Europe, is not a style like other styles. One can even say that the new champions of Expressionism have seriously misunderstood its nature, and that this misunderstanding is revealed by their emphasis on stylistic quirks. Rigid stylistic codification is the very thing to which Expressionism has always been opposed. The Expressionist artist makes feeling primary; form and colour respond immediately to changes of emotional tone.

Artists who are impatient with the prevailing stylistic rules have always found Expressionism sympathetic, and, despite its occasional emergence as a dominant mode, it is easiest to perceive it as the eternal anti-style, the alternative to whatever happens to be dominant at the time. Expressionism has been anti-Symbolist, anti-Cubist, anti-Futurist, anti-Constructivist; and later anti-Pop and anti-Minimalist. It is also the only tendency with a continuous history since the very beginnings of modern art, somewhere in the 1880s. One can trace the line of descent from Edvard Munch to artists such as Fetting and Baselitz, working at the present day, and there is never a real hiatus.

Expressionism as an imported style

Some American Expressionists of the present time are native-born and educated, but nevertheless fit easily into a European framework. The senior figure among these is George McNeil, born in 1908. After a long period of comparative obscurity when he was regarded simply as a minor Abstract Expressionist, McNeil has now re-emerged as a significant influence on a new generation of American artists. Interestingly enough, he made his way to this position of influence by moving towards figuration, rather than away from it, thus reversing the development of first generation Abstract Expressionist artists such as Jackson Pollock. The harsh, eccentric, deliberately grotesque figurative style he now uses seems to owe something to European artists such as Jean Dubuffet and the members of the COBRA group, especially Asger Jorn. The COBRA painters have been consistently undervalued in America, where they are usually regarded as echoes of the German Expressionists of the period preceding World War I. McNeil mines from their work a satiric as well as a mythic element, but he also retains something specifically American – a zany humour which may have its roots in strip-cartoons, and which is akin to the often-overlooked humour in Dubuffet's series of 'Women'.

Somewhat younger than McNeil is Robert Beauchamp, born in 1923 in Denver, Colorado. Beauchamp, like McNeil, owes some of his formation to the teaching of Hans Hofmann, but, unlike McNeil, was always a figurative painter. What contact with the Abstract Expressionist Movement did for him was to loosen both his drawing and his brushwork, so that his figures have a vitality and intensity which comes from the very movement of the brush. They also have a directness and rawness, a kind of naïveté, which prompts a very different comparison. Beauchamp's paintings have an eerie resemblance to those of an artist who at first glance appears to be his opposite – the American Regionalist Grant Wood.

On the whole, the artists whom I would describe as belonging to the European wing of American Expressionism merit that description because they received an important part of their formation on the other side of the Atlantic. Coming to the United States as almost mature artists, they have reacted to the American experience in similar ways. Two of the most talented painters who fall into this category are Richard Bosman and Roger Herman. Bosman is the

49 Robert Beauchamp, *Untitled*, 1978. Oil on canvas, 50 × 50 in (127 × 127 cm). Courtesy Monique Knowlton Gallery, New York.

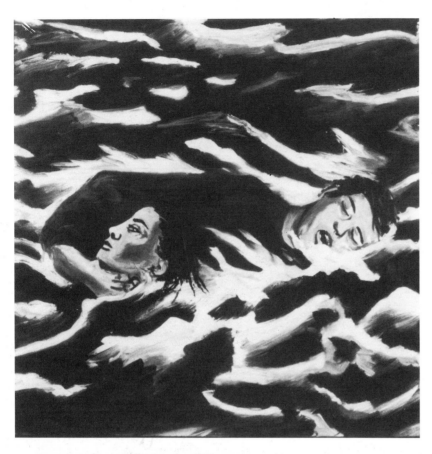

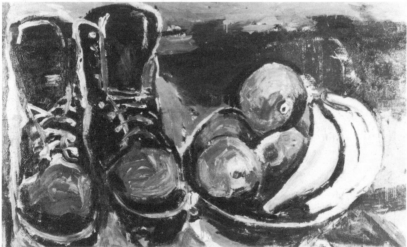

50 (*Top*) Richard Bosman, *The Rescue*, 1983. Oil on canvas, 60 × 60 in (152 × 152 cm).
Courtesy Brooke Alexander, New York.

51 (*Below*) Roger Herman, *Fruits and Boots*, 1984. Oil on canvas, 72 × 120 in (182·5 × 305 cm).
Courtesy the artist.

son of a Dutch sea–captain. He was born in Madras and travelled widely as a child – among the places he visited were Suez, Singapore and Perth, Australia. He had several years of art training before settling in the United States in 1969.

To anyone who knows classic German Expressionism, Bosman's work is simultaneously familiar and disconcerting. It is true, for example, that he uses both standard Expressionist techniques and standard Expressionist themes. The *Totentanz* motif, which he has employed effectively, was a favourite with the painters of *Die Brücke*, and had been inherited by them from Holbein. Similarly, Bosman's large woodcuts inevitably summon up comparisons with artists such as Erich Heckel. Yet there are elements in Bosman's work which make certain that it cannot be compared to that of his German predecessors in any very exact way – things which come from the American mass-media, from the covers of paperback detective stories, from B-movies and comic books. Bosman's Expressionism has passed through the experience of Pop.

Roger Herman was born in Saarbrucken, and had the first part of his art education in Germany before settling in California, living first in San Francisco and then in Los Angeles. Just as Bosman's paintings sometimes recall incidents from his childhood, so many of Herman's are connected specifically with his parents. They celebrate and at the same time distance the German bourgeois milieu of his adolescence. Other works are tributes to the heroes of his youth, among them Van Gogh and Artaud. Van Gogh has been particularly important to him, and he has re-created Van Gogh's self-portraits on a scale far larger than the originals. Even the boots in the still life *Fruits and Boots* are an oblique tribute – an indirect quotation from his exemplar.

Herman is a powerful painter, bold and sometimes brutal in his use of the medium. His large woodcuts are equally bold – in general they are closer in style to those produced by members of *Die Brücke* than those done by Bosman. But one thing which immediately marks them off as American rather than European is their vast scale – far bigger than anything the original Expressionists attempted. Herman claims that he was inspired to do these woodcuts, not by a desire to emulate German print-making,

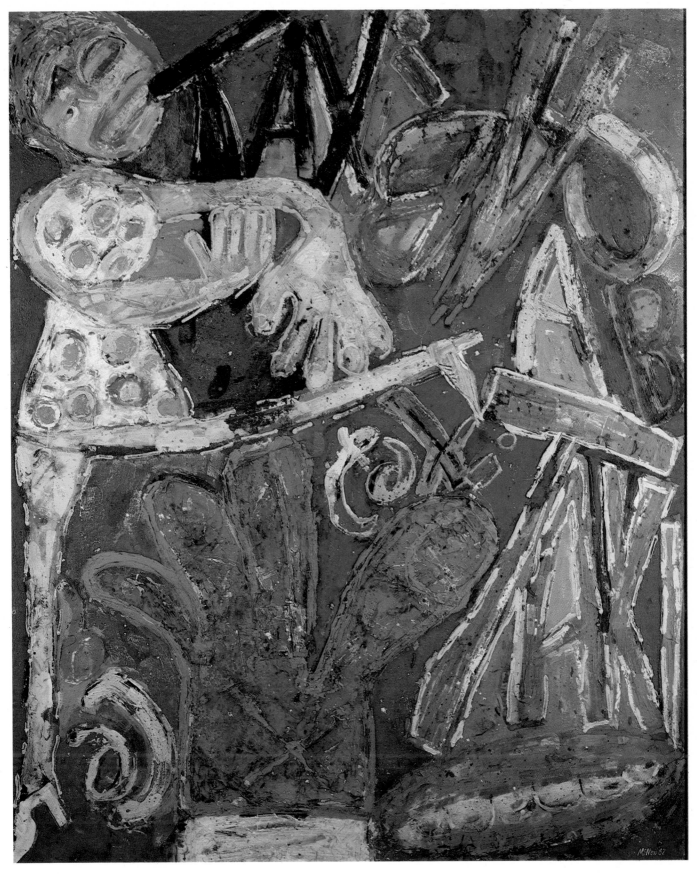

52 George McNeil, *Park Avenue: 5 a.m.*, 1982. Oil on canvas, 78 × 64 in (198 × 162·5 cm). Private collection. Courtesy Gruenebaum Gallery, New York.

53 Laurence Dreiband, *Dog Drawing*, 1984. Unfixed charcoal on paper, 65 × 100 in (165 × 254 cm). Courtesy Janus Gallery, Los Angeles.

54 Earl Staley, *Triumph of Galatea*, 1982. Acrylic on canvas, 58½ × 61½ in (148·5 × 156 cm). Courtesy Phyllis Kind Gallery, New York.

born, should seek to adapt Expressionist ideas to American conceptions. Sometimes these adaptations are both simple and radical. It seems unlikely, for example, that one of the original Expressionists would have treated the image of a dog in quite the same fashion as Laurence Dreiband, in a series of very large charcoal drawings devoted to this subject in 1983–4. The reiteration of the image can be referred most easily to similar iterations in the American art of the 60s, and once again especially to Warhol. But are these dogs Expressionist at all? The answer seems to me to be 'Yes', even though the style here is very tempered. What makes me stress the adjective is an intensification both of seeing and feeling which carries the subject beyond the boundaries of conventional realism. Interestingly, Dreiband was a Photo-Realist at an earlier point in his career.

Americans on the whole tend to intensify Expressionism rather than mute it. Using a borrowed style, they heighten it but at the same time often subvert it in order to make it their own. Earl Staley, an artist born in Illinois but now part of the flourishing art community in Houston, uses Expressionist form not for the intensification of feeling but to create a bathetic parody of the aspirations of high art. Gregory Amenoff, living and working in New York after a period in Boston, lacks this edge of sardonic humour, but still stretches the style to the point of disintegration. Specifically, he takes landscape figuration to an extreme where the subject-matter threatens to become unrecognizable. Kenneth Baker, in his preface to Amenoff's 1983 exhibition at the Robert Miller Gallery, New York, commented that 'every painting of [the artist's] that succeeds presents us with the feeling of not knowing exactly where we belong, or whether we belong, in what we see.' At first sight there seems to be little difference between Amenoff's work and that of an 'abstract' artist like Bill Jensen, until one recalls that there is also a close resemblance between these paintings and Soutine's vertiginous Ceret landscapes, themselves the paradigm of a certain sort of figurative Expressionism.

Will Northerner, based on Chicago, has been described by a reviewer in that city as painting 'a coherent babble'. His work, not surprisingly, has much in

but by seeing a large Jim Dine print using the same technique being proofed in 1981. This claim serves as a useful reminder of his important differences from the original Expressionists, some of which, such as his use of scale, are not so clearly seen in reproduction. There are too his use of the iconic image (Van Gogh becomes an icon to him as Marilyn Monroe did to Warhol), and the pervading nostalgia for a past and place which have been deliberately abandoned. Classic Expressionism puts the emphasis on raw emotion, and nostalgia is not usually part of its repertoire.

Expressionism adapted

It is only natural that artists rooted in America, no matter where they were

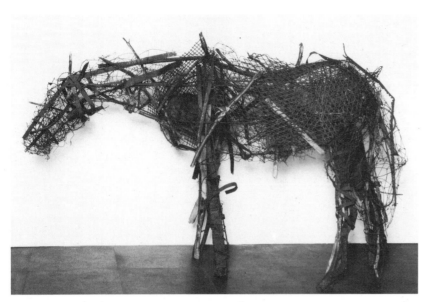

55 Deborah Butterfield, *Large Horse*, 1979. Steel armature, wiremesh, sticks, 77 × 124 × 33 in (195 × 315 × 84 cm). Courtesy O.K. Harris Works of Art, New York

common with that of Chicago Imagist painters of a generation somewhat senior to his own (he was born in 1954). What separates his art from the established local idiom is its brash painterliness – the feeling for paint as 'stuff', material with its own physical presence. Even more important is the fluid quality of the imagery formed from this paint, the way in which it simultaneously solidifies and dissolves before the spectator's eyes.

Expressionism translated

Sculpture is not generally considered the strongest element in the classic Expressionist movement. It took a fascinating exhibition organized by the Los Angeles County Museum in 1983–4 to call attention to a number of previously neglected German sculptors working just before and just after the First World War. It is with some hesitancy that I put forward the remarkable sculpture of Deborah Butterfield as a contemporary American equivalent of these, as the stylistic kinship is not at first sight obvious. The German Expressionist sculptors were carvers and modellers, with the emphasis on carving. Butterfield assembles her sculptures from found materials – they are ramshackle accumulations of twigs and wire mesh supported precariously by a steel armature. The elusive Expressionist element in her work comes from the fact that

these are sculptures which seem to be made like paintings. The fragmentary elements she uses, and the way they are brought together, suggest a pattern of broad Expressionist brushstrokes, Expressionist painting translated into three dimensions. The emotional atmosphere of her pieces, strangely tragic, supports the comparison.

A group of currently fashionable younger artists, the most interesting among them represented by the Tony Shafrazi Gallery in New York, have good art-historical claims to be counted among the new American Expressionists, but the Expressionist element has suffered a sea-change which is even more marked here than with the other artists discussed in this chapter. The closest to Expressionism as it is generally understood is the youngest of the group, Donald Baechler, born in Connecticut in 1956. In 1978 he studied for a year at the Hochschule für Bildende Kunst in Frankfurt. While in Germany he became friendly with Jiri Georg Dokoupil and the circle of German Neo-Expressionist painters in Cologne. Baechler now produces art which is a mixture of German and American concerns. Characteristically American of the present time is his interest in taking the image through several stages of removal. Baechler selects one of his own throw-away sketches, perhaps going through several hundreds to make the choice. He then enlarges it to create a full-scale painting,

56 (*Top*) Donald Baechler, *Stations of Impressionism – (My Soul)*, 1983. Tempera and collage on paper, 90½ × 104 in (230 × 264 cm), Courtesy Tony Shafrazi Gallery, New York.

57 (*Below*) James Brown, *Woman in Pink Hat*, 1984. Oil and enamel on canvas, 56 × 50 in (142 × 127 cm). Courtesy Tony Shafrazi Gallery, New York.

one which will preserve 'the proper degree of imbalance . . . for it to have the decisive factor of authenticity'. There is an obvious parallel with the strategies adopted by Malcolm Morley, though the results are puritanically subdued rather than icily manic. Yet the emphasis on authenticity – the uncensored rendering of spontaneous insights – also places Baechler within the main historical tradition which forms the framework for this chapter.

A slightly older artist, James Brown (born in 1951), spent eight years in Paris, using the city as a base and travelling extensively, often to remote and primitive places. During this period he made a number of site-specific works in an idiom which now seems typical of the avant-garde of the 70s. His current

work reverts to traditional formats. It is heavily influenced by tribal art, which has previously been a source of inspiration to Cubists and Surrealists as well as a long line of Expressionists. For the modern artists of the pioneering period tribal objects represented an ideal of truth to feeling rather than of truth to appearances as western eyes had been trained to perceive them. Brown takes things a step further: he wants the painting itself to be a fetish object, a repository of power for members of the urban tribe.

Brett de Palma is a more complex case. In common with many American figurative artists of the younger generation, his painting is an eclectic mixture of ingredients. *Cyclops' Head with Still Life*, for example, experiments with Synthetic Cubist devices, prominent among them the use of collage. But the atmosphere of the picture is different from anything we might expect from Cubism. The painting is hot in colour, heady and unrestrained in atmosphere, while the head which is its most prominent image has a distant kinship to Munch's *The Scream*. For De Palma the history of modernism is no longer something experienced externally, but something fully integrated with his own subjectivity. His dissonant mixture of different stylistic conventions both registers his own emotional state, and makes a direct assault on the emotions of the spectator.

The dissonance in de Palma's work is, however, shared in varying degrees by nearly all the artists included in this chapter. It springs from the conflict between Expressionist subjectivity – the insistence that the individual is paramount – and a consumer society which relies on standardization for its economic good health. There is a significant irony in Roger Herman's heroization of Van Gogh, since Van Gogh's fame is now spread less by his original paintings, locked away in museums, than by cheap department store reproductions which have taken his images, falsified and distorted, into millions of American homes. Herman's recreations are a homage not only to Van Gogh himself, but to what America has done to him. His pictorial outcries have been industrialized and turned into icons of mass-culture.

60 Brett de Palma, *Cyclops' Head with Still-Life*, 1983. Acrylic and collage on canvas, 76 × 78 in (193 × 198 cm). Courtesy Tony Shafrazi Gallery, New York. Photo Ivan Dalla-Tana.

58 (*Opposite top*) Gregory Amenoff, *Tempest*, 1983. Oil on canvas, 78 × 62 in (198 × 157 cm). Private collection. Courtesy Robert Miller Gallery, New York.

59 (*Opposite below*) Will Northerner, *Bait and Fancy*, 1984. Acrylic on canvas, 58½ × 55½ in (148·5 × 141 cm). Courtesy Zolla/Lieberman Gallery, Chicago.

CHAPTER FIVE

TWO NEW YORK STYLES

61 Ned Smyth, *Like Father Like Son* (*Influence*), 1982. Poured concrete with pigment, 82 × 36 × 14 in (208 × 91 × 35·5 cm). Courtesy Holly Solomon Gallery, New York.

It is a commonplace to say that the New York art world has been heavily dependent, in the years since Abstract Expressionism, on the discovery and promotion of new art-styles. The mechanism is frequently denounced as contrary to the artists' interests and to the health of art in general. Paintings and sculptures become (it is said) purely commercial products, and their makers are forced into a mould which simultaneously deprives them of a large part of their individuality and threatens to stultify all possibilities of future development. All this is founded on an assumption that styles are artificially created, and those primarily responsible are dealers and critics rather than the artists themselves. Yet there have also been cases where a genuine stylistic coherence was discernible from the first, long before the artists concerned had found their way on to the commercial gallery scene. From time to time groups of artists do exhibit in New York in circumstances which suggest that there is indeed some kind of common basis for their work – a genuine shared aesthetic. During the 70s two new styles emerged in New York which seemed to have genuine coherence of this sort. It is a sign of the artistic pluralism which now prevails that they could hardly be more different from one another.

Pattern Painting

The more prestigious movement is Pattern Painting, also known as Dekor, which made its appearance around 1974. Pattern painting has strong links to New Image (one or two of the artists connected with it were included in early New Image exhibitions, notably that held at the Whitney Museum in 1978). In a broader sense, it is part of the general rebellion against minimalist severity which took place during the second half of the 70s. Underlying this was an uneasy questioning of the basic assumptions of the Modern Movement itself. Pattern Painting in particular can be seen as an offshoot of the Post-Modernist tendency in architecture. The connection is made very clear by the work of Ned Smyth – architectural constructions and fragments, often decorated with mosaic. In addition, Smyth makes pictorial mosaics in a style which hovers between Ancient Rome and Late Deco. Like his architectural fantasies, the images in these mosaics only half-conceal an impulse towards parody, though the medium is a cumbersome one in which to make jokes.

One striking characteristic of the style is the reliance on irony. Another is the way in which it roots itself in the decorative. Where it alludes to classic modernism, it often makes the allusion not directly to central figures like Matisse and Léger, but to the way their ideas were used, altered, misunderstood and often debased by the anonymous designers who stole from these masters. The most literal of the Pattern Painters is Robert Zakanitch, whose paintings look like reproductions of patterned stuffs. Kim MacConnel's work is also linked to fabric design. He revels in the jazz modern designs which flooded the market between 1930 and 1950 – outline drawings of matadors who were bastard children of Léger; tumbling jars which are crude versions of fabric designs created by Raoul Dufy. These

62 Robert S. Zakanitch, *Dragon Fire*, 1983. Acrylic on canvas, 109¾ × 85¾ in (279 × 218 cm). Courtesy Robert Miller Gallery, New York.

figurative motifs are collaged together with purely abstract patterns of the same epoch – sometimes these are actual 'found' fabrics.

In addition to the influences already cited, Zakanitch and MacConnel clearly owe something to the kind of art they rebelled against. Pattern Painting, in their hands, remains surprisingly close to the Post-Painterly Abstraction of the 60s, with its insistence on the unity of image and surface.

Robert Kushner started by making free-form fabric pieces which could either be worn as garments or hung on the wall. His work is now a little more conventional in format. He has made himself a master of post-Matisse design, and there is also more than a hint of the decorative work done by the English Bloomsbury painter Duncan Grant for the Omega workshops founded by Roger Fry in 1913. Like Brad Davis and Joe Zucker, Kushner inflects the image in a slightly more conventional way than Zakanitch and MacConnel. Davis, too, has been influenced by Matisse, and he has also gone to Matisse's sources, notably Persian miniatures. By using designs adapted from these miniatures on a huge scale he changes their nature, giving them the decorative, dream-like quality of tapestries – slightly out of focus for the viewer because they are painted (often rather broadly) rather than woven.

In this grouping, Joe Zucker is now something of an odd man out. His work has changed radically since the late 70s. At that time, he was making paintings with tight, careful imagery on a tufted cotton surface. The content was often narrative; one series of paintings was devoted, appropriately enough, to the theme of 'Eli Whitney and the Cotton Gin'. Zucker is now a much bolder, wilder artist. He passed through a phase of near-abstraction before returning to narrative with a series dedicated to Ponce de Leon, the Spanish conquis-tador. In these Ponce himself is reduced to a slashingly drawn stick-figure, not so far from the stick-figures of the German Neo-Expressionist A. R. Penck. But the decorative impulse is still very much present: Zucker uses sumptuous colour against black, and enlivens the surface with aluminium foil.

The Graffiti Painters

Graffiti are probably as old as writing itself, and art based on graffiti has surfaced from time to time during the development of post-war modernism. A distinguished American exponent is Cy Twombly, once closely linked to the Abstract Expressionist movement. Twombly's interest in calligraphy is linked to a parallel interest in the Surrealist technique of automatic writing. What has never been in doubt, at any stage in its evolution, is the 'high art' content of his work. Twombly is one of the most rarefied and aristocratic of American artists.

The new generation of New York Graffiti Painters comes directly from the popular urban culture of the city, though there are also one or two artists connected with the movement who have some kind of conventional art training as well. The fact that many of the Graffiti Painters are now represented by the Sidney Janis Gallery, once famous for its promotion of Jackson Pollock and other leading Abstract Expressionist

63 Kim MacConnel, *Best Wishes*, 1979. Acrylic on cotton, 104 × 101 in (264 × 256 cm). Courtesy Holly Solomon Gallery, New York.

64 Robert Kushner, *Song of the Sphinx*, 1981. Mixed media, 96 × 130 in (244 × 330 cm). Courtesy Holly Solomon Gallery, New York.

65 Brad Davis, *Autumn Twilight*, 1979. Acrylic and fabric on canvas, 74 × 54 in (188 × 137 cm). Courtesy Christie's.

66 Joe Zucker, *Ponce's Ghost Rises from his Grave in Palm Beach*, 1983. Aluminium foil and acrylic on rhoplex, 16 × 24 in (40·5 × 61 cm). Courtesy Holly Solomon Gallery, New York.

67 Cy Twombly, *Anabasis*, 20 November 1983. Mixed media on paper, 39½ × 27½ in (100 × 70 cm). Courtesy The Mayor Gallery, London.

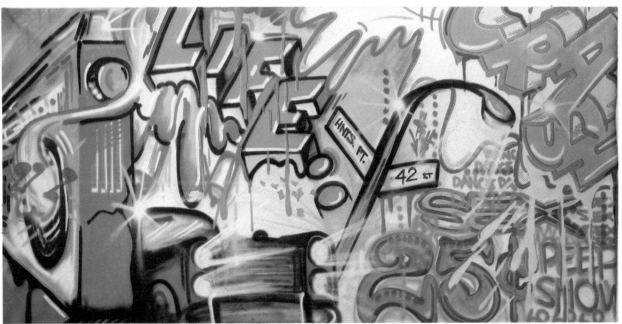

68 John 'Crash' Matos, *Life*, 1984. Spraypaint on canvas, 72 × 144 in (182·5 × 365·5 cm). Courtesy Sidney Janis Gallery, New York. Photo Allan Finkelman.

70 Futura 2000, *Untitled*, 1983. Spraypaint on canvas, $53\frac{1}{2} \times 71\frac{1}{2}$ in (136×181.5 cm). Courtesy Tony Shafrazi Gallery, New York.

69 Chris 'Daze' Ellis, *Cotton Club*, 1984. Spraypaint on canvas, $104\frac{1}{2} \times 68$ in (265×172.5 cm). Collection Ludwig, Aachen. Courtesy Sidney Janis Gallery, New York. Photo Allan Finkelman.

artists, nevertheless has an ironic resonance of its own.

Graffiti painting in its pure form had a considerable underground history before it began to be hung in art galleries. The custom of 'tagging' – writing one's name or pseudonym in as many different locations as possible – caught on with New York pre-teens and teenagers during the 60s, and subway trains gradually became the most popular places to put these graffiti. As the competition between young graffitists grew fiercer, more and more elaborate styles of lettering developed. Local styles, such as 'Broadway elegant' (long, thin closely packed letters standing on platforms) and 'Brooklyn-style' (free-flowing letters embellished with hearts, arrows and curlicues) became recognizable. The inscriptions became increasingly larger and more colourful. By the early 70s New York graffitists were capable of decorating whole subway cars with unified designs. While lettering remained the main element, whole-car murals began to contain caricatures and cartoon-characters as subsidiary elements.

The city authorities waged a prolonged, expensive and finally ineffective war against the graffiti-writers, the majority of whom were between eleven and sixteen years of age. Being juveniles they could not be severely punished even when they were caught. One reason why politicians such as Mayor John Lindsay were so obsessed by graffiti was that they knew that many of their constituents, especially the older ones, regarded these ever-burgeoning inscriptions as symbolic of the increasingly dangerous nature of the urban environment. Their inability to find a cure also came to symbolize the severe financial crisis which New York was then experiencing.

But there were others who thought differently. In March 1973 *New York Magazine* not only condemned the anti-graffiti campaign as useless, but declared the graffiti themselves to be 'the first genuine street culture since the fifties'. In the same issue, the magazine presented a 'Graffiti "Hit" Parade', and reproduced selected examples in full colour. Pop artist Claes Oldenburg was quoted in praise of graffiti:

I've always wanted to put a steel band with dancing girls in the subways and send it all over the city. It would slide into a station without your expecting it. It's almost like that now. You're standing there in the station, everything is grey and gloomy and all of a sudden one of those graffiti trains slides in and brightens the place like a big bouquet from Latin America. At first it seems anarchical – makes you wonder if the subways are working properly. Then you get used to it. The city is like a newspaper anyway, so it's natural to see writing all over it.

Graffiti-writers had already started to attract attention from people involved in various projects for helping the socially disadvantaged. In 1972 an organization called United Graffiti Artists was founded by a teacher working for the Queens College Summer Programme. An initial exhibition was held at City College; the graffitists belonging to the group collaborated with the choreographer Twyla Tharp on the successful ballet *Little Deuce Coupe*, and finally in 1973 UGA presented an exhibition of graffiti-style canvases at the Razor Gallery in SoHo. This was Graffiti Painting's first appearance in a regular gallery situation. It was a success. The works were priced at between $200 and $3,000 and a number, including some of the more expensive ones, were sold.

The process was completed by the

rapid growth of the East Village art scene during the late 70s. The SoHo galleries had begun as a challenge to Madison Avenue and 57th Street. Now they themselves were challenged by an increasing band of store-front galleries in one of the most rundown areas of Manhattan, the Lower East Side. Here the new gallery owners – enthusiastic and under-capitalized – found Graffiti Painting very much to their purpose. It was young, it was lively, it was amusing, it was visibly rebellious. Certain locations, such as the Fun Gallery, marketed the Graffiti Painters successfully to up-town collectors, who were fearful of missing a new bandwagon. From here it was only a short step to acceptance – sometimes, however, rather grudging – by the mainstream of the New York art world.

Graffiti Painting remains isolated from the American mainstream. It has a large number of peculiarities which mark it off from other contemporary American art styles. Its resources are limited, and it remains dependent on the conditions in which it was originally created. Its rapid slashing graphism is the direct result of the hit-and-run methods of the original graffitists working in yards and lay-bys. It has an independent technical tradition, based on such recent inventions as the magic marker and the aerosol spray. Its range of allusion is within its own terms quite complex, but its cultural base is narrow. Its imagery is the imagery of the teenage culture of the 70s, even though its practitioners are now young adults, gradually losing touch with the rules and rituals, jokes and private allusions, which originally formed the substance of their work. Graffiti Painting, unlike the Pop Art of the 60s, began as a genuine folk-form, and must now find ways of adapting itself to very different requirements. In a real sense it is like the artifacts from the Third World which are found in the bazaars of most western cities. Made in one culture, they find their main consumers in a very different one.

Post-Graffiti artists

The term 'Post-Graffiti' has generally been applied to Graffiti Painters who have made the transition from subway surfaces to canvas. It was employed in this sense, for example, in the catalogue for the exhibition of Graffiti Painters and other related artists organized by the Sidney Janis Gallery in 1983. Nevertheless it seems more sensible to reserve it for the work of certain painters who are connected with the Graffiti movement in one way or another, but who have remained independent.

Keith Haring does not come from the same background as the main group of graffitists and did not even live in New York as a teenager. He arrived when he was twenty to study at the School for Visual Arts, where one of his teachers was the well-known Conceptual artist Joseph Kosuth. He moved his art into the streets as a conceptual gesture, in response to the graffiti he saw around him while living in Times Square. In 1980 (very late in terms of the indigenous New York Graffiti Painters) he began to draw in the subways, but even then not on the insides or outsides of the trains themselves, but on the empty black panels where advertisements were due to make an appearance. For this he used chalk, as the quickest and most economical medium, and it led him to evolve a large vocabulary of graphic signs, bluntly effective, and quite unlike the playfully calligraphic style of his predecessors. Haring's work has the virtue of instant recognizability, and in addition to this his graphic vocabulary can be used on almost any surface. Everything, from a large painting or environment to a T-shirt, at once proclaims his authorship. But the personal language he has invented leaves little place for nuance, delight in the medium or any kind of apparent painterliness. Roy Lichtenstein has survived similar limitations very successfully; it remains to be seen if Haring can do the same.

Jean-Michel Basquiat is another extremely prolific painter, with a more authentically New York background than that of Keith Haring. Born in 1960 in Brooklyn, the son of a mother who was a first-generation Puerto Rican immigrant and a Haitian father, he was educated at a series of New York public schools, dropping out in the 11th grade after 'putting a box of shaving cream in the principal's face' at graduation. In his teens he was a genuine graffitist, using the name 'Samo'. At school he did a little life drawing (but failed the course).

Basquiat says that his first ambition was to be a fireman, his second to be a cartoonist. He lists Alfred Hitchcock's face, Nixon, cars, wars and weapons among his early themes, and also cites some influences from popular music: *West Side Story*, the Watusi and the score of the film *Black Orpheus*. Words often appear in his paintings, as do skulls and skull-like heads. Recently he has started to introduce a number of high cultural references, for example, to Leonardo's anatomical drawings. Basquiat uses paint chiefly as a medium to draw with – the same of course can be said of Picasso at many periods of his career. As a draughtsman he is naturally gifted, able to charge apparently crude and brutal marks with meaning.

When one compares Basquiat's work to that of the rest of the Graffiti Painters shown in leading New York galleries, its superiority readily becomes apparent. Unlike his rivals, with their continuing dependence on aerosols and magic markers, he is able to use the marks of the brush to articulate the surface and turn it into a coherent whole. His range of imagery is much wider, and his feeling for pictorial dynamics – the balance of one form against another – is more sophisticated. Basquiat's art is in large part the vehicle for a familiar personal myth – that of the swaggering bad boy who mocks the society which panders to him. The image is more alluring to some people than it is to others. It depends on one's degree of cultural masochism. But it does have a long and paradoxically respectable history. A very similar myth powers Brecht's early play *Baal*. Basquiat's force and comparative density of meaning tend to highlight weaknesses in the other more orthodox young artists who have been given the same label. Basquiat is the only one, apart from Haring, who seems both more limited and more self-conscious, to have taken the familiar doodles of the urban environment and to have turned them into the kind of flexible stylistic vocabulary which Dubuffet forged from similar Parisian materials in the years immediately after the Second World War. At the same time as he reveals the imaginative poverty of the Graffiti Painters of his own generation, Basquiat contrives to make Cy Twombly look arch and over-refined. His work is at the moment wildly uneven, but he is certainly one of the most striking new figures in American art. Every exhibition of his work seems to open a new range of possibilities.

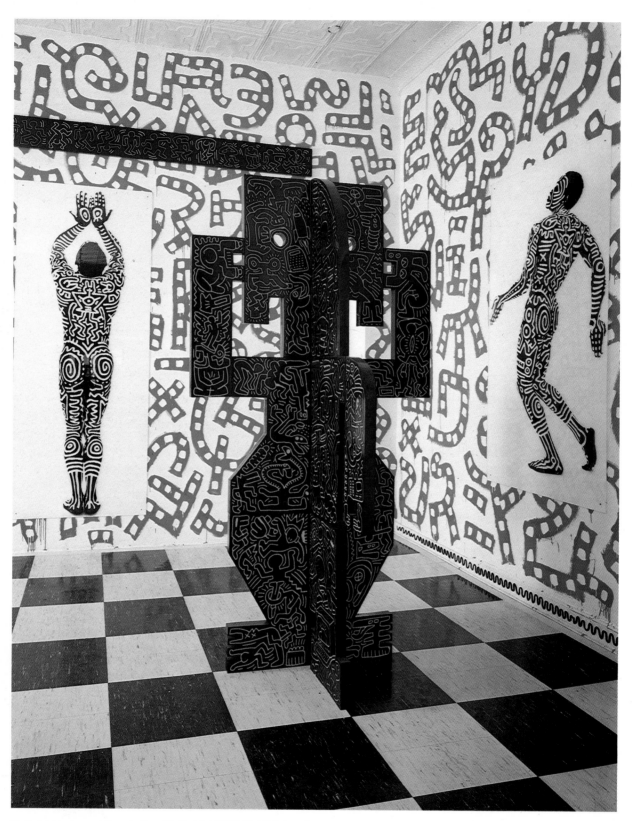

71 Keith Haring and Kermit Oswald, *Untitled (TOTEM)*, 1983. Installation, enamel on wood. Collection Keith Haring. Courtesy Tony Shafrazi Gallery, New York. Photo Ivan Dalla-Tana.

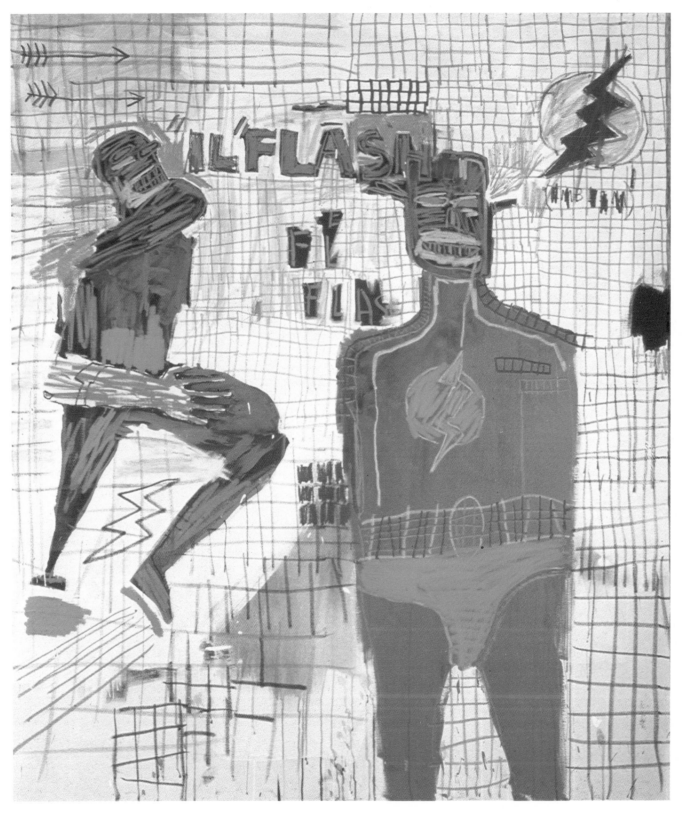

72 Jean Michel Basquiat, *Flash in Naples*, 1983. Mixed media, 66 × 60 in (167·5 × 152 cm). Courtesy Mary Boone Gallery, New York.

CHAPTER SIX

POP SURVIVAL AND POP REVIVAL

Pop art is now assessed as a closed episode, a historical style which can be ranked with other historical styles, such as Futurism and Cubism. Yet anyone who attempts to survey the American art of the present must soon recognize that Pop has not ceased to exist. It is not merely that leading Pop artists such as Warhol, Lichtenstein and Dine are still busily at work; it is also that the mass-culture which produced Pop still vigorously survives as part of American life. The difference is that this culture is once again taken for granted, after a period during which it was studied and analyzed with obsessional interest.

West Coast Pop Survival

West Coast Pop never achieved the sharp sense of identity that was characteristic of a small group of New York-based artists. The reason is simple enough: in the East there was a clear intellectual division between the artists and the culture they were celebrating; in the West pop culture was no big deal, and the artists saw themselves quite unselfconsciously as being an integral part of it. For the same reason Pop Art proved to be much more durable in Los Angeles than it was in New York – the culture survived, and artists continued their dialogue with it throughout the 70s. Many of them use the same materials at the present day, modifying and varying the way in which they treat it, but not essentially deviating from lines of development which can be traced back to Pop's heyday in the 60s. Because of its lack of self-consciousness, West Coast Pop is seldom 'pure'. It usually contains undertones and

overtones of something else – Funk and Surrealism in the case of Ed Kienholz, Conceptual Art in the case of Ed Ruscha.

Kienholz's best-known environmental sculpture of the 60s is now an established part of Los Angeles folklore. People point out the original of *The Beanery* as you drive past it, in the same way that they point out the Hollywood sign. Though he now divides his time between Hope, Idaho, and West Berlin, Kienholz thus remains a powerful if ghostly presence on the Los Angeles art scene. After a period when his work veered in the direction of Surrealism (the *White Easel* series of the late 70s), Kienholz is once again experimenting with Pop literalism. His recent *Night Clerk in the Young Hotel* is very close to *The Beanery* in style. It can be compared to similar works by George Segal and Duane Hanson. The difference lies in the feeling of unease which it generates; it is sleazy with an undercurrent of menace. The neutrality of true Pop is missing – Kienholz moulds the spectator's emotions in the same way as a film director does.

A willed neutrality is the essence of Ruscha's art, and he thus lies at the opposite end of the Pop spectrum. Like a number of other Los Angeles artists, Ruscha began his career in advertising. He does not idealize the world of commercial art because it has no mystery for him. He has retained in his own painting many of commercial art's most striking characteristics – its impersonal sleekness, its obsession with the word. In Ruscha's painting, a single word or a brief phrase is often the primary image. These are presented in a way which deliberately drains them of emotion, if

not perhaps of meaning. Ruscha wants to mirror the dream-like state which many people find typical of California living, to give the feeling that there is no longer any hierarchy – of ideas, emotions or events. He is the essence of California cool.

Pop and the search for identity

Pop images and Pop-derived methods often seem to be one of the ways in which artists of the 80s discover a sense of their own identity as Americans. Mass-produced everyday items, products of the mass-catering industry such as Coca-Cola and the hamburger, are imbued with mysterious totemic power. The results can be strikingly different from one another, but the spectator is aware of a unifying sensibility based on nostalgia for shared experiences in childhood and adolescence. For example, there is not much in common at first sight between William Christenberry's *Southern Monument XVII* and Don Nice's *Statue Totem*, and yet it is immediately clear that both are rooted in the same culture. Christenberry makes casual use of the Coca-Cola logo; and Nice produces something that looks like a cross between a religious picture and an old-fashioned poster. The main subject of Nice's painting is the kind of trophy a keen athlete might have won at school. In the 'predella' are, among other things, a hamburger 'to go', the kind of apple a child might take with him in his school lunch-box, and a cup-cake with the traditional glacé cherry on top.

One of the most individual examples of the use of Pop ideas in the American

73 Ed Kienholz, *Night Clerk at the Young Hotel*, 1982–3 (detail). Courtesy L. A. Louver Gallery, Venice, California.

74 Edward Ruscha, *Horses*, 1981. Oil on canvas, 56½ × 54 in (142·5 × 137 cm). Courtesy Christie's.

ukioy-e prints. Shimomura recognizes the kinship which these prints have with the comic books he collected as a child and indeed well after that:

> The style of the paintings relates back to the times when I avidly collected comic books as an early teenager. When I look back now on those comics I collected I can see a visual continuity to the ones I enjoyed the most. Disney comics, Orphan Annie, Superman, Wonder Woman, Captain Marvel, Batman and in particular Dick Tracy all had a graphic clarity and cleanness that subsequently affected the work I did in college when I studied graphic design.

A new Pop generation

For younger American artists, Pop-culture is the larger part of their history, the bulk of the experiences they have had and the things they have known. They use Pop sources in an intimate, personal way, for humorous or moral-istic ends, and produce art which is subtly different from that of the pioneers. Ronnie Cutrone (born in 1948) is the senior member of this new generation, with attitudes towards popular culture formed by his long personal contact with Warhol, whom he met when he was sixteen. He hung out at the Factory, worked as a dancer for the Velvet Underground, and held his earliest exhibition (at an uptown gallery) in 1969. He largely stopped making his own art in the 70s, because he felt oppressed by the triumph of the Conceptualists, but served as Warhol's 'art assistant' and also co-edited *Interview* magazine – very much the Warhol house organ. He now professes a great interest in comic books and in all kinds of popular imagery – but also in Picabia and the Bible. The moral indifference of classic Pop is replaced in his current work by a concern with 'messages of value'. The images themselves he regards simply as 'packaging' for what he wants to say.

Kenny Scharf is ten years younger. His work has a zany inventiveness which makes him one of the most striking figures on the current New York art scene, and one of the most interesting of the younger generation of American artists. Scharf has been closely associated with Haring (with whom he

painting of the 80s can be found in the work of the Japanese-American artist Roger Shimomura. He and his family were among the many Japanese-Americans exiled from the West Coast and sent to internment camps early in 1942 after the outbreak of war with Japan. Inspired by the diaries his grandmother kept at the time, Shimomura painted his *Journey to Minidoka* series, which tells the story of their internment in paintings modelled on Japanese

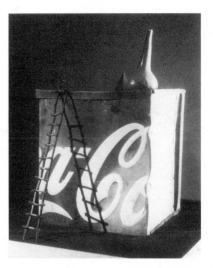

75 W. Christenberry, *Southern Monument XVII*, 1983. Mixed media, 24¼ × 23 × 28 in (61·5 × 58 × 71 cm). Courtesy Moody Gallery, Houston.

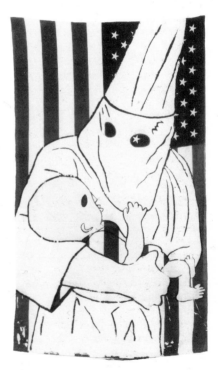

76 Ronnie Cutrone, *Hate*, 1982. Acrylic and encaustic on an American flag, 10 × 6 in (25 × 15 cm). Courtesy Tony Shafrazi Gallery, New York.

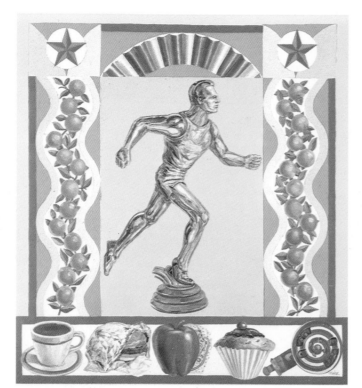

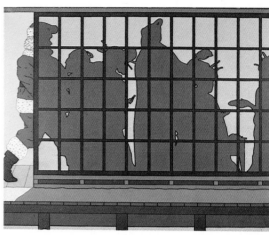

78 Roger Shimomura, *December 25, 1942*, from *The Journey to Minidoka* series, 1983. Acrylic on canvas, 50 × 60 in (127 × 152 cm). Courtesy the artist and Sebastian Moore Gallery, Denver.

77 Don Nice, *Statue Totem*, 1984. Oil on canvas, 84 × 78 in (213 × 198 cm). Courtesy Nancy Hoffman Gallery, New York.

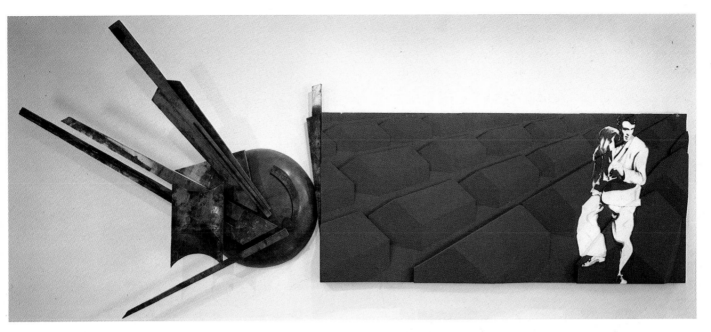

80 Robert Longo, *Heads Will Roll*, Lacquer
and acrylic on canvas, epoxy on
fibreglass and aluminium, 144 × 313 × 46 in
(365 × 795 × 117 cm). Courtesy Metro
Pictures, New York.

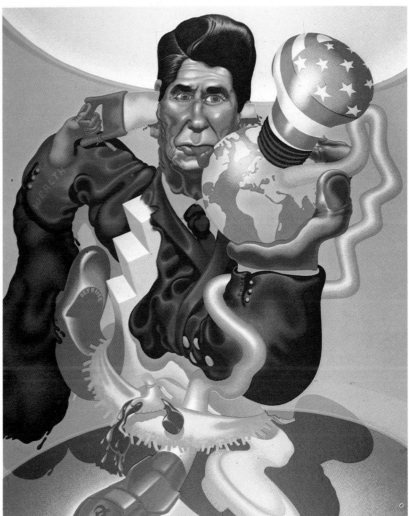

79 (*Opposite*) Kenny Scharf, *Controlopuss*,
1983–4. Oil and spraypaint on canvas,
59½ × 72 in (151 × 182·5 cm). Collection Mr
Eli Broad, Los Angeles. Courtesy Tony
Shafrazi Gallery, New York.

81 Peter Saul, *Ronald Reagan*, 1984. Acrylic
on canvas, 90 × 73 in (228 × 185 cm).
Courtesy Allan Frumkin Gallery, New
York.

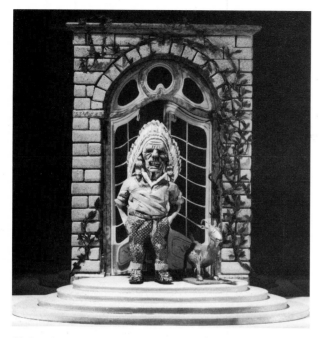

82 Red Grooms *Picasso in the South of France*, 1984. Mixed media, 31½ × 32 × 19¼ in (80 × 81·5 × 49 cm). Courtesy Marlborough Gallery, New York.

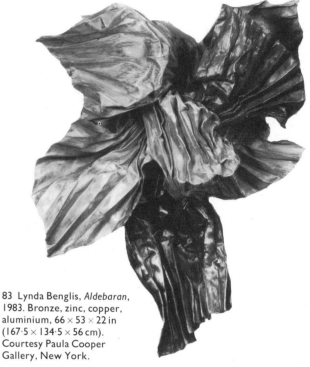

83 Lynda Benglis, *Aldebaran*, 1983. Bronze, zinc, copper, aluminium, 66 × 53 × 22 in (167·5 × 134·5 × 56 cm). Courtesy Paula Cooper Gallery, New York.

once shared a loft) and has sometimes found himself classified among the Graffiti Painters. This is partly due to his link with Haring, and partly to one with the Fun Gallery (which he named – the name reflects his own attitude towards art and it was his show that opened the space). His true links are with Lichtenstein, and also with the Pattern Painters. The best of Scharf's current work has the impact of Lichtenstein's early paintings of comic strips, when these were still new and shocking. It is not going too far to see Scharf's manic *Controlopuss* as an 80s equivalent of *Whaam!*. His affinity to the Pattern Painters becomes the more obvious when one looks at Scharf's decorated objects – customized appliances, such as telephones, televisions, refrigerators and clocks. The resemblance encourages one to re-read Pattern Painting as a whole, and to see it, too, as part of the continuing evolution of Pop.

Another artist most easily understood as second generation Pop is Robert Longo, though the suggested comparison is with Rosenquist rather than Lichtenstein. But this is Pop become sour and heavy. It is something of a mystery why this clumsy and grandiose artist should have been raised to his present position of eminence in the

American art world, and still more of a mystery why his lifeless allegorical images should often be regarded as Expressionist. Longo's work does have this much in common with Morley's and Schnabel's: it is the product of an elaborate technique of distancing. Longo first makes a photograph, then makes an outline based on the photograph which is turned into a drawing by a professional illustrator. Last of all, the illustrator's work is rehandled by the artist himself and his numerous assistants.

Pop affinities

There are many artists now at work in America who are by no stretch of the imagination fully Pop in style, but where it is clear that their work would be altogether different if the Pop movement had never existed in the first place. I should like to conclude this chapter by looking briefly at some of them. One is Peter Saul, who habitually uses the hard outlines and glaring hues of classic Pop, but who twists and bends his forms in a way which is reminiscent of Salvador Dali. These deformations are not a response to subjective need but are a calculated commentary on the chosen subject-matter. Sometimes Saul, follow-

ing in Picasso's footsteps, chooses to make his own versions of established masterpieces, such as *The Death of Sardanapalus* by Delacroix. At other times he is a savage social and political commentator, one of the best artists of the kind that post-war America has produced. There is a curious echo in some of his paintings of this type of the leader of the Regionalists in the 30s, Thomas Hart Benton.

Red Grooms, celebrated in the late 50s and early 60s as a creator of Happenings, has re-emerged in the 80s as a prolific painter and maker of three-dimensional objects. These little tableaux have a painterly roughness, a 'hand-made' quality which distances them from Pop at its most typical. They also possess great verve and are the product of an extremely quick eye both for human foibles and for visual eccentricities of all kind. But, in an age where much art has again turned moralistic, they are curiously lacking in the moral weight the subject-matter often seems to require. The sharp observation is not clinched with a judgement on what is seen.

Lynda Benglis's current work seems to have a half-concealed relationship to that of Claes Oldenburg. Oldenburg, in making his soft light-switches and egg-

beaters, enlarged familiar domestic objects and at the same time transformed them. Benglis's sculptures look like similarly enlarged versions of the cheapest department-store costume jewellery – knots and rosettes of metallized plastic ribbon, slick, irridescent tributes to the 50s baroque which is now coming back into fashion. The comparison can be taken further – both artists are deeply interested in sexuality and sexual symbolism. Oldenburg's drooping flaccid forms become emblems of impotence. Benglis's rosettes are successors to an earlier group of sculptures in the shape of giant dildos or penises. If we read what she is doing in the context supplied by Oldenburg's work, she still seems to be concerned with sexual issues – her comment is no longer one about men's fears of female aggression, but about women's need to adorn and at the same time 'cheapen' themselves, because they live in a man's world.

Pop meets kitsch in the miniature Michelin-men and Michelin-women of Tom Otterness, notorious as the maker of a film which showed a dog from the New York City Dog Pound being deliberately shot to death, and one of the heroes of the Times Square show of 1980, an artist-organized challenge to the conservatism of the leading commercial galleries, which radically altered the New York art scene. Otterness's miniature figures, cast in plaster, are assembled to make long architectural friezes of a quasi-traditional kind. Examined closely, these friezes offer the spectator one twist – or several – on the traditional range of subjects for heroic sculpture. There are lines of toiling labourers, triumphal processions, and a violent and successful revolution. Ethnography and art history are here put through a meat-grinder and spewed out in homogenized form. Otterness's beautiful drawings, with an Old Master flavour, show the long consideration that goes to produce this particular result.

Otterness's sculpture, so simple on the surface, is deeply ambiguous. It applies Pop irony to the kind of thing Mussolini put up in the Foro Italico in Rome, but in the end leaves us uncertain about the artist's real attitude to totalitarian art.

The wall drawings by Jon Borofsky which in the late 70s seemed to affiliate him to the sophisticated end of the Graffiti movement have now developed into ambitious installations with free-standing silhouette figures in addition to drawings. The human image is again standardized, but in a very different way from the one Otterness adopts. Borofsky seems to be in the process of changing from his first preoccupation, which was to make at least a fleeting record of personal dreams and fantasies, often using images borrowed from the popular media, to wish to make something more spectacular and also more impersonal. His installations stand just on the frontier between Pop and Surrealism – they simultaneously call to mind the elaborate environments created by artists at the beginning of the Pop boom, and the richly suggestive settings which the Surrealists devised in the 30s for their group exhibitions.

The new Pop springs from the West Coast rather than the East Coast tradition because it is invariably mixed in style. Pop culture is not something that artists 'discover', in the way that Dine and Oldenburg and Lichtenstein discovered it at the beginning of the 60s. It is something they cannot escape from, which forms part of the very air they breathe. They know that their audience is in the same situation. Pop has thus shifted from being a style to being something more like a large and rich vocabulary, which can be inflected in different ways according to the whim of the individual creator. It is also a fruitful source of allusions which almost everyone in the audience is bound to recognize, a shared corpus of myth. It is not going too far to say that, whereas in eighteenth-century England everyone recognized a classical tag or an allusion to a Greek deity, in late twentieth-century America the common ground is pop culture and the pop artifact. Even the most elitist cannot wholly escape some knowledge of them.

84 (*Above*) Tom Otterness, *Installation: Lanann Foundation*, 1983. Courtesy Brooke Alexander, New York. Photo eeva-inkeri.

85 (*Right*) Jon Borofsky, *2,845,318 Molecule Men*, 1982–3. Painted aluminium, 120 × 109¼ × ¼ in (305 × 277 × 0·6 cm). Courtesy Paula Cooper Gallery, New York.

CHAPTER SEVEN

NEO-SURREALISM

Ever since Abstract Expressionism sur-
realist ideas have played an important
role in the development of American art.
The first real challenge to the Abstract
Expressionists – that made by Johns and
Rauschenberg – was made within the
surrealist context: what they did was to
take one step backwards, basing their
initiative on ideas found in Dada, which
had spawned Surrealism itself. At the
end of the 60s there was a surrealist
revival, mixed with a good dose of what
was purely American, not in New York,
but in and around San Francisco. It was
canonized under the name of Funk Art.
'Funk' was the name given to an exhibi-
tion organized by Peter Selz in 1967, at
the University Art Museum, Berkeley. In
the context of the 80s Selz's preface to
the catalogue makes fascinating read-
ing. At one point he tries to establish the
difference between Dada, Surrealism
and Funk:

Dada set out to attack and combat the
moral hypocrisy of the public; Sur-
realism in its prodigious publications
and manifestos and programs helped
to establish a new and irrational order
based on the revolutionary but con-
tradictory doctrines of Marx and
Freud, but Funk does not care about
public morality. Its concerns are of a
highly personal nature; the Funk
artists know too well that a fraudu-
lent morality is a fact of their world,
and they have no illusions that they
can change it. If these artists express
anything at all, it is senselessness,
absurdity and fun, they find delight in
nonsense, they abandon all the
straight jackets of rationality, and
with an intuitive sense of humor they

present their own elemental feelings
and visceral processes. If there is any
morality, 'it's for you to find out.'

Today Surrealism is still strong on the
West Coast but is by no means confined
to it. There are signs of a strong re-
surgence of surrealist ideas throughout
American art. Surrealism has left strong
traces in the work of a number of the
New Image painters, some of whom
seem at least as much Surrealist as they
are Expressionist. In the volatile New
York art world a 'new' Neo-Surrealist
movement is already being talked of,
and in 1984 a well-established gallery
in SoHo devoted a theme exhibition to
the subject – a sure sign that a band-
wagon was beginning to roll. But this is
only the currently most visible part of
something larger, a shift which is also
making itself felt elsewhere.

West Coast contrasts

The so-called Funk artists largely went
their separate ways, as soon as the
short-lived 'movement' which Selz had
identified was over. In fact, an im-
pressive number of the artists included
in his catalogue made major reputations
for themselves. Quite a number of his
team are discussed in other chapters of
this book. But Funk did not rise out of
nothing. The way had already been
prepared for it by a more orthodox kind
of Surrealism. For example, some of the
participants had been taught by Frank
Lobdell, who is the most distinguished
American follower of Miró – if one
makes an exception of the work of
William Baziotes whom in some ways
he strongly resembles. Lobdell is still at

work today, and is one of the most
creative of senior American painters.

Perhaps the best-known of all his
pupils is William T. Wiley, Wiley is a
unique mixture of European and Amer-
ican attitudes. His paintings are palim-
psests, with layer on layer of images,
usually in monochrome, interrupted by
apparently arbitrary areas of abstract
colour. The words express a folksy all-
American humour, and the same is true
of much of the imagery. One 1981
painting, *Charms and Strangeness for
Rude-Off*, shows Rudolph the Red-Nosed
Reindeer being psychoanalysed by Pro-
fessor Freud in person. Wiley's art ad-
mits the spectator to a quirky universe
with its own rules. Its mixture of per-
sonal obsession and satirical commen-
tary finds an unexpected parallel in the
work that Dali was producing at the
height of his most surrealist period in
the 30s, though otherwise the two art-
ists do not at all resemble one another in
style.

George Herms, who belongs to the
same generation as Wiley, owes allegi-
ance, not to Dali, but to Schwitters and
Miró. He is a maker of assemblages, and
the purpose of what he does is the
liberation of associative fantasy – his
own and that of the spectator. He says
his aim is:

To find a work, not just for my brain,
but my soul, hands, heart, balls, spirit,
senses. To find a vehicle or vessel into
which I could pour my every joy,
every discovery, thrill, chill, every
idea as it dawns on me, every doubt,
question, vision, dream, song, magic
encounters, every kiss, storm dance,
laugh, and sneeze.

86 Frank Lobdell, *July 1983*, 1983. Oil on canvas, 60 × 72 in (152 × 182·5 cm). Courtesy Oscarsson Hood Gallery New York.

87 William T. Wiley, *Charms and Strangeness for Rude Off*, 1981. Acrylic and charcoal on canvas, 71¾ × 95½ in (182 × 242 cm). Courtsey Allan Frumkin Gallery, New York.

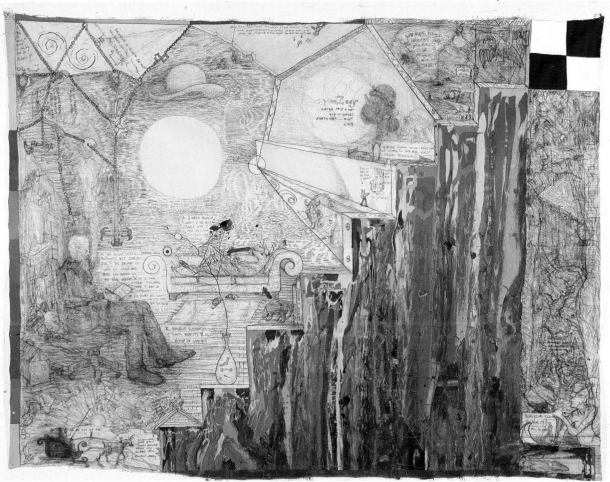

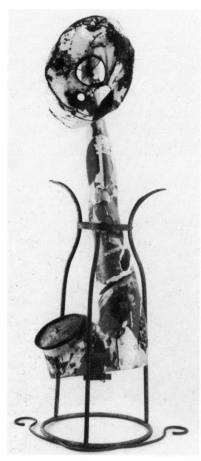

88 George Herms, *Gamba*, 1983. Mixed media assemblage, 49 × 20 in diam (124·5 × 51 cm diam.). Courtesey L. A. Louver Gallery, Venice, California.

89 Peter Shelton, *Majorpoints, Hangers and Squat*, 1984. Mixed media environment. Courtesy L. A. Louver Gallery, Venice, California.

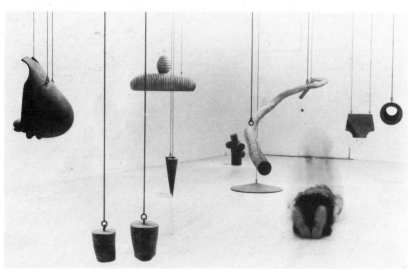

This instinctive, free-wheeling approach makes a striking contrast with the work of Peter Shelton, who creates, not assemblages of found material, but ambitious sculptural installations, where the component parts are made from industrially fabricated materials. His installations have been aptly described as 'the outward concretization of unseen, inner character'. It is not enough just to see what Shelton does. Often he demands that the visitor experience it in a literal, physical way – crawling through a tunnel, standing under a huge block of plaster supported by fragile spokes, where there is just room to put one's head. By doing these things, the visitor becomes at one with the artist, since much of Shelton's work is based on the proportions of his own body. One recent piece, *Majorpoints: hangers and squat*, was a cataloguing of clothing and body-parts, where each item – a shirt, a belly, shorts, genital organs, a length of intestine – was fabricated from iron and suspended separately in a neutral white space. What the artist seemed to be expressing here was a fantasy of dismemberment, whose threatening quality was also articulated by the menacing weight of the separate items, and tension of the wires from which they hung. Where Shelton differs from classic Surrealism is in his interest in 'type' forms, simplified and neutral till you meet them in the context he provides. He remarks:

I've always been interested in things that are not glaringly conscious or profoundly unconscious, 'gray areas', and it's there where everything un-

conscious and conscious slip into each other all the time. My work is based on this kind of slippage. There have been times when I have been intensely interested in dreams. I would record them scrupulously and consider them carefully. But they were much too hot for me, you know? Much too exotic as subject-matter, and much too 'natural'. Conversely, there have been times when I've been very interested in the analysis of the conscious mind, i.e. the impeccably constructed rationale ... but what ends up by being really attractive to me are things that are nearly common, nearly mundane, or slightly shifted; noticed or just – found.

These three artists by no means exhaust all the possible varieties of current West Coast Surrealism, sometimes this takes forms which are 'local' only in certain minor details. The small, minutely rendered tempera paintings which comprise Carolyn L. Cardenas' 'Self-Portrait' series are classic figurative Surrealism transplanted into domestic California settings and lit with hard, flat California light. Harold Moodie's abstract sculptures in Cor-Ten steel are a more obviously American development, as they can be referred to David Smith's work in welded steel which set the course for American sculptors during the 60s. But Moodie, an excellent craftsman with a gift for working difficult materials, uses forms which are very different from Smith's. In particular, he is less interested in the juncture of forms and more in the form itself, which often seems to be derived from veristic Surrealist painting. Looking at his sculptures one thinks, for example of the pierced bird-form in Dali's 1929 painting *Enigma of Desire*. The soft biomorphic shapes typcial of Dali and Tanguy in Moodie's hands become crisp and angular in response to the nature of the chosen material and the actual method of fabrication.

Surrealism in three dimensions

One of the most noticeable things about the new American Surrealism in general is its bias towards the three-dimensional object rather than the painting. Some of the artists involved with it produce both paintings and

90 (*Below left*) Carolyn L. Cárdenas, *Self-Portrait Series*, 1984. Egg and oil tempera on panel, $7\frac{3}{4} \times 9\frac{1}{2}$ in (19·5 × 24 cm). Courtesy Stella Polaris Gallery, Los Angeles.

91 (*Top right*) Harold Moodie, *Untitled Clevis*, 1978. Cor-Ten steel, 16 × 36 × 26 in (40·5 × 91·5 × 66 cm). Courtesy the artist.

92 (*Centre right*) John Buck, *Justasnag*, 1980. Pine, acrylic and graphite, 106 × 130 × 50 in (269 × 330 × 127 cm). Courtesy Fendrick Gallery, Washington DC.

93 (*Bottom right*) Rosemarie Castoro, *Shrines*, 1982–3. Installation, museum board, gesso and graphite. Courtesy Tibor de Nagy Gallery, New York.

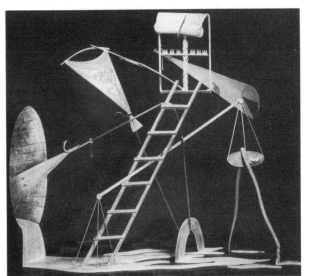

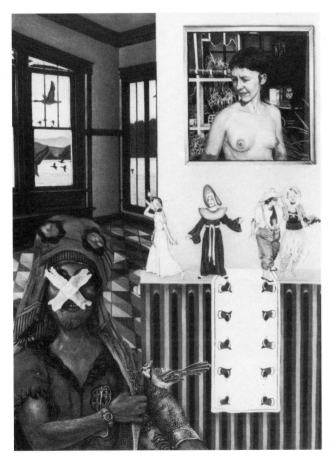

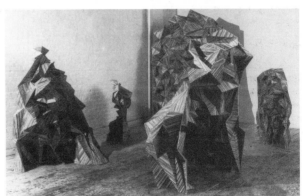

sculptures. One of the best-known is the prolific Nancy Graves, whose polychrome bronze sculptures have an exuberance not always matched by her other work – though it is also interesting to note that some of the sculptures look like a three-dimensional version of Arshile Gorky. By casting parts of her sculptures directly from natural objects – such as bean pods, small fish, chinese fans, palm fronds and lotus blossoms – Graves picks up the link between Surrealism and sixteenth-century Mannerism. For example, the Paduan bronze-makers of the period cast crabs and frogs directly in metal; and the French faïencier Bernard Palissy made similar casts of lizards and other creepy-crawlies to decorate his elaborate pottery.

'Real' objects also play an important role in the work of George Febres, who is one of the most stringently surrealist artists now working in America. Born in Ecuador, Febres received part of his education in France before settling in New Orleans, and pieces like his *Alligator Shoes* and *Finger Bowl* are reminiscent, not least because of their genuine power to disturb, of the celebrated *Fur Teacup* by Meret Oppenheim – the surrealist object *par excellence*.

The surrealist parentage of John Buck's wooden constructions is as obvious as that of Febres's objects, but the work is much larger in scale and more exuberant in tone – the comparison which suggests itself is with Miró. By contrast, Rosemary Castoro's faceted *Shrines* seem to trace their ultimate

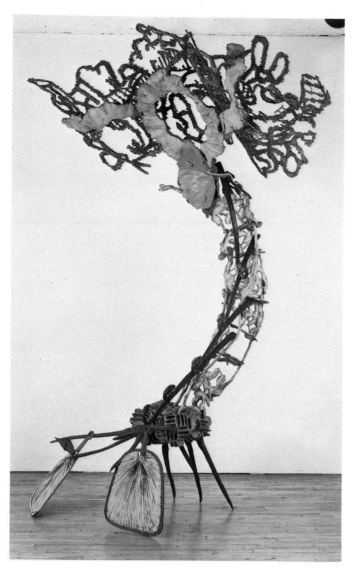

94 (*Left*) Nancy Graves, *Cantileve*, August 1983. Bronze with polychrome patina, 98¾ × 67 × 55 in (250·5 × 170 × 140 cm). Courtesy M. Knoedler & Co. Inc., New York.

95 (*Below right*) Georges Febres, *Finger Bowl*, 1977 Ceramic. Courtesy the artist.

96 (*Bottom*) John Hernandez, *Dog Chow*, 1984. Mixed media, 55 × 84 × 8 in (140 × 213 × 20 cm). Courtesy Moody Gallery, Houston.

97 (*Opposite*) Ted Rosenthal, *Pieta No. 5*, 1984. Acrylic enamel on steel, 55 × 61 × 39 in (140 × 155 × 100 cm). Courtesy Salvatore Ala, New York.

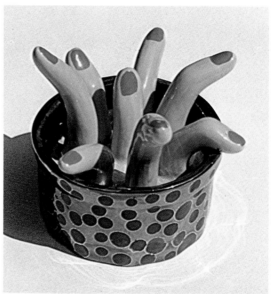

parentage to Arp. But Castoro's constructions have at least this much in common with those of Buck: one is aware of a deliberate hardening of the surrealist aesthetic – they are mannerist in a non-historical sense.

The wall-reliefs of John Hernandez and the sculptures of Ted Rosenthal represent a different aspect of American Surrealism. The basic influence comes from Masson, though the materials used make it clear that automatism, so

powerful in Masson, can only have been a very preliminary stage in the creative process. There is also an inescapable flavour of Pop in both artists, and one sees how the experience of American mass-culture must inevitably shape much of the imagery American surrealists choose to employ. Sometimes the shaping is purely negative. The artist reacts away from the American industrial world, and endeavours to produce totemic objects. Often there is an

attempt to bridge the gap between what is expected of fine art and what is usually defined as craft. Lee Mullican's *Bird Poles* are in a traditional material for the sculptor, cast bronze, but bronze also possesses craft overtones. His imagery, though not directly derivative from the tribal art of the American Indians of the North West Coast, suggests that he has studied Tlingit and Haida objects. Significantly, after working in bronze, Mullican is now

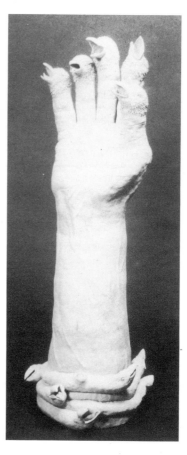
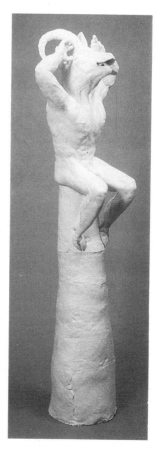

98 (*Left*) Lee Mullican, *Bird Pole*, 1983. Bronze. Left to right: No.2, 28 in (71 cm); No.1, 25½ in (64·5 cm); No. 4, 32 in (81 cm) high. Courtesy Herbert B. Palmer Co., Los Angeles.

99 (*Centre*) Frank Fleming, *Bird Hand*, 1982–4. Porcelain, 54 × 20 in (137 × 51 cm). diameter. Courtesy Moody Gallery, Houston.

100 (*Right*) Frank Fleming, *Hear No War*, 1982–4. Porcelain, 74 × 19 × 17 in (188 × 48 × 43 cm). Courtesy Moody Gallery, Houston.

experimenting with ceramics.

Frank Fleming has made his reputation with beautifully crafted sculptures in porcelain. He uses imagery which has overtones of black magic and witchcraft. A favourite subject is a goat-headed devil seated on a tree-stump; another is a variation on the traditional 'Hand of Glory', where the fingers, instead of being candles, turn into the heads of birds or dogs or horses. Fleming associates these images with Picasso's *Guernica* – his work, like that of an even more celebrated ceramicist, Robert Arneson (described in a later chapter), echoes the anti-war and anti-nuclear sentiment which is beginning to make itself felt in American art.

This feeling also manifests itself, though in much more violent form, in the work of Genna Watson, a young sculptor from Washington DC. Her 'War and Violence' series has been described as an 'anti-celebration of the gun' – toy guns melted, bedizened, pinned and painted, combined with cages, sharp sticks and shards of glass. Even more eloquent of contemporary malaise are

her life-size figures made of chickenwire and papier-mâché, surrounded and threatened by sticks, needles and other odds and ends which together make a potent visual metaphor for a host of private and public anxieties.

Neo-Surrealism in New York

One of the artists already described in this round-up of different types of American Surrealism in the 80s is closely connected with the new East Village art scene in New York. Ted Rosenthal held a solo show in 1984 at Gracie Mansion Gallery, and has featured in a number of shows devoted to the East Village phenomenon – in Chicago, Los Angeles, Rochester, Richmond (Virginia) and Cologne. He is also an accredited provocateur – his most notorious 'art event' took place when he installed realistic-looking remote-control bombs at various locations on the Lower East Side. This produced a full-scale bomb-alert and publicity which lasted for a full week – the triumphant artist was eventually asked to pay a $10 fine. The

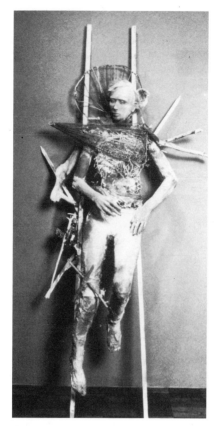

101 Genna Watson, *Mandolay-Mon-doll-ya*, 1982. Mixed media, 95 × 46 × 29 in (241 × 117 × 73·5 cm). Courtesy Fendrick Gallery, Washington DC.

original Surrealists, who insulted priests and addressed French academician Anatole France as *un cadavre* (a corpse), would certainly have relished the uproar.

The Neo-Surrealist movement in New York has also spawned a group of artists – painters rather than object-makers – whose concerns are more narrowly stylistic. Their leader, just as controversial as Rosenthal, but in a different way, is the Dutch-born Peter Schuyff. A meticulous craftsman, sometimes accused by critics of being slick and unfeeling, Schuyff paints Arp-like forms in feigned shallow relief, sometimes re-using junkshop canvases and leaving the original banal image still visible as a background to his own work. These extremely accomplished paintings seem to be designed as a deliberate reproach to the excesses of Neo-Expressionism, and this accounts for the hostility Schuyff has aroused. He has a crisp concision, a take-it-or-leave-it quality rare in very

young artists. The negative reactions he sometimes evokes are as flattering in their own way as the enthusiasm with which he has been received elsewhere. Certainly he appears to exercise an influence over artists of his own generation.

Cheryl Laemmle has much of Schuyff's polish, but her work is fully figurative – her manikin figures and stylized horses set in idyllic landscapes have a provocative chic. An obvious influence here is the later work of Giorgio de Chirico. It is no coincidence that this is currently being re-assessed owing to its connection with the triumphant Post-Modernist movement in architecture and design. Another of de Chirico's disciples is Jedd Garet, whose painting is an amalgam of a number of extremely fashionable elements – among them 50s design and the parody-revival of 50s taste engineered by Ettore Sottsass and his Memphis Studio. Garet throws in a dash of Neo-Expressionism for good measure.

Neo-Surrealism and the better-established Neo-Expressionism are by no means irreconcilable, as is proved by another young New York artist, David Humphrey, whose debt to Guston in particular is obvious, but who crops and distorts his boldly painted images in a way which suggests both his awareness of a new trend and his resolve to use it for his own purposes. One thing I find especially sympathetic is the note of humour in his canvases. Humphrey thumbs his nose at some of the more pretentious aspects of the New York art scene.

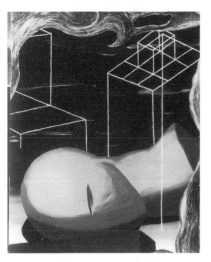

102 Jedd Garet, *What the Earth Is Really Like*, 1984. Acrylic on canvas, 105 × 84 in (266·5 × 213 cm). Courtesy Robert Miller Gallery, New York.

The revival of Surrealism in American art is all of a piece with the revivalist climate now prevalent in modernism generally. It not only follows neatly on the heels of Neo-Expressionism, it finds an even more specific place as a logical development of the hermetic side of New Image painting, since the original Surrealists were always fascinated by hidden meanings and visual puns of all kinds. Almost equally interesting is the fact that there here seems to be a strong current of influence from the West Coast to the East – a reversal of the generally accepted trend.

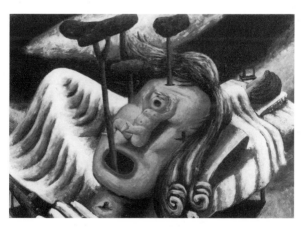

103 David Humphrey, *She Does, He Doesn't*, 1983. Oil on canvas, 75½ × 108 in (191·5 × 274 cm). Courtesy David McKee Gallery, New York.

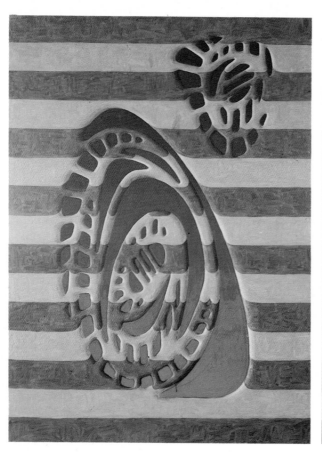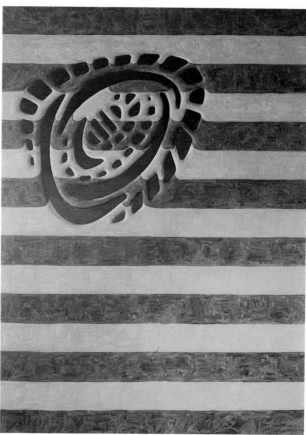

104 Peter Schuyff, *World of Yellowman* (diptych), 1984. Acrylic on linen, each 90 × 66 in (228 × 167·5 cm). Courtesy Pat Hearn Gallery, New York.

105 Cheryl Laemmle, *Empty Birdbath*, 1983. Oil on canvas, 56 × 84 in (142 × 213 cm). Courtesy Sharpe Gallery, New York.

CHAPTER EIGHT

FROM MOCK-ARCHITECTURE TO MOCK-SCIENCE

A marked characteristic of the American art of today – one which had already established itself in the 70s – is a tendency to borrow from related disciplines, even from those whose primary thrust is scientific rather than purely aesthetic. That is, the artist inhabits a neighbouring and related way of thinking, such as architecture or archaeology, in much the same way as a hermit crab inhabits a borrowed shell.

In part this way of thinking is an obvious extension of the conceptual and environmental modes which flourished in the late 60s and in the 70s. A link to Land Art, for example, can be found in the current work of Robert Irwin. Irwin belongs to a generation of California artists who believed fervently that the work of art should cease to be a material object, something which an individual could hope to control and possess. They saw two ways out of the dilemma. The first was to make the artwork purely conceptual, a theorem to be written on one side of a piece of paper. The other, more spectacular solution, was to make works of art which could exist only in public, though obtaining sites and finance for these often meant a reconciliation with the materialist structures of organized capitalism.

Irwin now makes works of art which are public without being either too solid or too specific. At the campus of the University of Southern California at San Diego, for instance, he built two overlapping V-shaped configurations of thirty-foot poles: cross-members starting at a height of eighteen feet carry multi-coloured netting. This netting, in turn, creates a haze of colour hovering mysteriously at treetop level, echoed by a ground cover of violet flowering iceplants. The two colour-areas, not the supporting structure, are the art-work.

Art as Architecture/ Architecture as Art

On the whole, public artworks of this sort have been growing more solid and thus more specifically architectural during the 80s. Artists such as Donna Dennis, Mary Miss and Siah Armajani propose deliberately irrational structures, set indoors or out, which modify the spectator's perception of space and its articulation. Increasingly these structures make pointedly architectural references, though they use architecture in a metaphoric, deliberately nonfunctional way. An example is Armajani's *Fireplace Mantel with Window*. This has a kind of historicism not present in Dennis's *Subway with Silver Girders*, but the two pieces follow the same strategy – both are deliberately fragmentary, and the viewer must use his imagination to complete the form as well as to divine the meaning.

This feeling of fragmentation and formal disjunction also appears in work where the dividing line between sculpture and architecture has become so extremely indistinct as to be almost invisible. Richard Fleischner's 1983 *Courtyard Project* for the Dallas Museum perhaps qualifies as sculpture, despite the fact that it is made up of what are recognizably architectural elements (pillars and lintels), while Michael Graves's in some ways similar design for Best Products is the work of someone regarded as being primarily an architect. The important thing, however, is that one recognizes a likeness – a shared aesthetic in which architectural ideas, rather than purely sculptural ones, are the dominant force.

Emerging in the wake of this development is a brisk market among art collectors for drawings of architectural projects. And this in turn has made viable what one might describe as a specialized second phase of Conceptual Art. Among these drawings are many which depict visionary structures never intended to be built. There is, of course, a good historical precedent for these – far more so than for earlier manifestations of Conceptual Art, which made a point of rejecting the past. The visionary designs now being made by Will Insley can be related to very similar designs made by late-eighteenth century neoclassicists such as Etienne-Louis Boullée (1728–99), and Futurists such as Antonio Sant' Elia (1888–1916).

Insley is always notably severe and restrained, even when he goes beyond drawing alone as a means of expression. Not all American artists affected by this tendency are content to be so purist. Thomas A. Rose's painting construction *It was Compounded by Small Movements and Adjustments* attempts a slightly unhappy compromise between genres. It borrows from architectural models in its suggestion of a staircase leading up between two blank walls, but the enclosing panels are relatively conventional abstract paintings.

Art as furniture

The idea of art as architecture – that is as something which constructs a space, either in reality or in the spectator's

106 (*Top left*) Mary Miss, *Sunken Pool, Tree View*, Greenwich, Conn.,1974. Steel, wood, water, 20 ft (6 m) diameter. Courtesy Max Protetch.

107 (*Top right*) Donna Dennis, *Subway with Silver Girders*, 1982. Mixed media, 144 × 144 × 162 in (365·5 × 365·5 × 411 cm). Courtesy Holly Solomon Gallery, New York.

108 (*Above left*) Siah Armajani, *Fireplace Mantel/Window*, 1982–3. Wood. Courtesy Max Protetch.

109 (*Centre right*) Richard Fleischner, *Courtyard Project*, Dalls Museum of Art, 1983. Courtesy Max Protetch.

110 (*Bottom right*) Will Insley, *One City: Building Room Elevation*, 1977–9. Courtesy Max Protetch.

111 Robert Wilhite, *Geometric Chairs and Table*, 1982. Maple, bubinga, anodized aluminium, glass and leather. Chairs 27 × 25 × 24½ in (68·5 × 63·5 × 62 cm); table 17½ × 40½ × 30 in (44 × 103 × 76 cm). Courtesy Asher/Faure, Los Angeles.

112 Albert Paley, *Exterior Sculpture*, 1982. Hollow Cor-Ten steel, 15 ft 6 in (4·7 m) high, 18 ft (5·5 m) wide, blade 31 ft (9·5 m) long. Commissioned by Margaret Woodbury Strong Museum, Rochester, New York. Courtesy Fendrick Gallery, Washington DC.

imagination – leads naturally to the idea of art as something which furnishes a space, and thus, by a kind of ellipsis, to the idea of art as furniture. The most celebrated exponent of this particular mode is Scott Burton, whose background is in the Performance and Conceptual Art scene of the 60s and 70s. His designs – in stone, steel, bronze-and-leather and acrylic – are of varying degrees of practicality. With some, the sculptural element is clearly uppermost: their primary purpose is not to be of use but to make an aesthetic statement, using furniture-forms as a metaphor. With other pieces, the order of priorities is reversed. Despite this, the audience is left in no doubt that Burton expects to be seen as a member of a continuing tradition of fine art – his ancestor is Canova not Thomas Chippendale.

The distinction is less clear in the work of Robert Wilhite, as here the demands of everyday life are more consistently catered for. The trouble is that Wilhite invites a comparison with designers rather than sculptors which he does not quite sustain. Some of his pieces might easily be mistaken for standard post-Bauhaus work if one found them in a department store. Others have the awkward irregularity which is handled with more panache in the output of Memphis Studio. It is chiefly the gallery context which persuades us to consider these pieces as sculptural statements, with the metaphoric and formal content we expect from more familiar kinds of sculpture.

The marriage of art and craft

Where sculpture disguises itself as furniture, the aesthetic claims of craft furniture are necessarily strengthened. The major stars of the American craft scene now find themselves on a par, both financially and in terms of prestige, with leading painters and sculptors. Two of the major beneficiaries of this revaluation have been the ironsmith Albert Paley and the furniture-maker Wendell Castle. Paley produces a wide range of objects – the items which emerge from his workshop range from 'pure' sculpture, such as his *Exterior Form* commissioned by the Margaret Woodbury Strong Museum in Rochester, New York, through architectural ironwork, often of a very elaborate and ambitious kind, to decorative items such as plant-stands, and iron-and-glass furniture. In making the *Exterior Form*, Paley ventured into a field where he had many competitors, but none of much distinction. There is a steady demand in America for abstract sculpture to be placed in juxtaposition with public buildings, but the majority of it is extremely conventional. This accounts for the rapid success of the 'architectural' sculpture already discussed, which stimulates interest through its use of paradox. Paley travelled a different route, making a sculpture which is primarily a statement

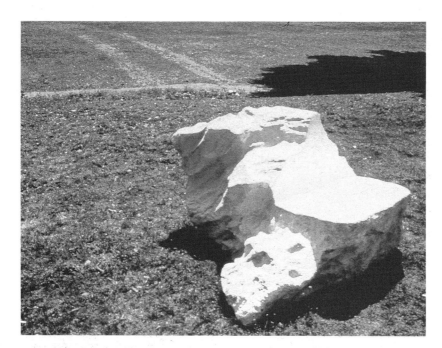

113 Scott Burton, *White Granite Chairs*, Atlanta, 1981. Courtesy Max Protetch.

about a process, the process itself being the forging of iron.

In keeping with the nature of his chosen material, Paley's work often has a strongly Art Nouveau character. The dynamism and frequently the sheer wilful extravagance of the forms he creates offer a commentary on the nature of Art Nouveau in keeping with the awareness of art history and self-conscious delight in quoting relevant precedents now manifesting themselves elsewhere in the American visual arts.

An equivalent impulse shows itself in the recent work of Wendell Castle. At one point in the 70s Castle was making carved furniture which toyed with various *trompe l'oeil* effects. He has now changed direction and is creating veneered and inlaid furniture of superb quality. Castle's new style, and the silken finesse of his workmanship, prompt a comparison with the greatest Art Deco cabinet-maker, Jacques-Emile Ruhlmann (1879–1933). But there is an important difference from Ruhlmann's work, which does not appear at first glance. Castle is not content to be a mere decorator: his work is full of symbolic meanings. A new series of clocks bear individual titles. One, for example, is called *The Magician's Birthday Clock*. This suggests that a piece of furniture can be as much a vehicle for complex meanings as a painting or a piece of sculpture. For pieces of this type Castle is now able to command prices which put

him, in the strictly financial sense at least, on the same level as the best-known American artists of the 80s.

Craft influence on fine art

Albert Paley and Wendell Castle create work of exceptional refinement and sophistication. Their very skills debar them from exercising certain kinds of influence, putting them out of reach of imitators. When artists rooted in the fine art tradition make overtures to craft, what generally seems to attract them is the rustic vigour of traditional folk art. Sometimes an artist will use the folk idiom as a means of conveying contemporary meanings. A case in point is Edward Larson, whose quilts and windjacks imitate (one might venture to say parody) the work of nineteenth-century American needlewomen and whittlers, but nevertheless have a satirical edge which makes them unmistakably contemporary. As a reviewer remarked, writing in *New York Magazine*: 'Art is still art – because it takes an intellectual position; even if that position is *about crafts*' (her italics). The effectiveness of Larson's work springs in large part from the spectator's consciousness of the discrepancy between the folk idiom and the content which it expresses.

Shari Urquhart makes hooked rugs – another traditional American craft, which in the nineteenth century was almost wholly identified with women.

114 Edward Larson, *Space Shuttle*, 1981. Oil on sculpted wood, 37 × 52 × 11 in (94 × 132 × 28 cm). Courtesy Monique Knowlton Gallery, New York.

115 Shari Urquhart, *Rape*, 1978. Wood, acrylic, fibre 84 × 87 in (213 × 221 cm). Courtesy Monique Knowlton Gallery, New York.

116 Wendell Castle, *Mystery Clock*, 1984. Bubinga, granite, curly maple and gold-plated brass, 84 × 24 in (213 × 61 cm). Courtesy Alexander F. Milliken, New York.

117 Barton Beneš, *Candy Box*, 1977. Shell piece. University of Iowa Museum of Art. Courtesy Fendrick Gallery, Washington DC.

118 Thomas Lanigan-Schmidt, *In a little corner Chapel to Mammon in the Cathedral of Moloch, greed makes Human Sacrifices expedient upon the Alter of Racism, Deplacement and Gentrification*, 1983. Installation at Holly Solomon Gallery, New York. Photo D. James Dee.

She uses this quintessentially 'female' medium to express the ideas of contemporary feminism. A reviewer spoke of her 'harmonious unrealities' which 'make each scene mythic', but recognized, too, that 'Urquhart presents her scenes as rituals, she recognizes that men and women "perform" certain "routines" together. Rape, a violent, criminal act, is for Urquhart, a stylized shtick in which the attacker holds his victim as she, in strappy high heels, kicks over a low table.'

The sheer gaudiness of folk art seems to be a liberation for certain contemporary creators. This is the case, for instance, with Barton Beneš. Beneš studied at the Pratt Institute in New York, but left because he never felt at ease there. What offended him was the narrow concept of professionalism which the school seemed to embody. Now he uses what have conventionally been thought of as typically amateur craft techniques – shellwork, rubber stamps, constructions made of wire and foil. Sometimes he crosses the frontier into another category: his smashed flowerpots with their fragmentary inscriptions allude to the contemporary cult of archaeology. They are an evocation not just of folk-roots, but of vanished cultures. A laurel wreath made of wire, foil and cut-up paper money evokes the gold foil wreaths found in ancient Greek tombs, and at the same time makes a wry comment about today's concept of an 'appropriate' reward.

Thomas Lanigan-Schmidt uses similar techniques, and expresses parallel sentiments. An elaborate installation shown at the Holly Solomon Gallery in February 1983 was entitled *In a little corner Chapel to Mammon in the Cathedral of Moloch, greed makes human sacrifices expedient upon the altar of Racism, Deplacement and Gentrification.*

Similar religious overtones can be felt occasionally in the work of Larry Fuente. He alludes both to the kitsch quality of contemporary Los Angeles culture, and to the innate gaudiness of working-class Hispanic taste, which often expresses itself most intensely in religious artifacts. Fuente's most ambitious creations are his decorated Cadillacs. The vehicles, themselves baroque moderne expressions of American mass culture, are decked out in a way which exaggerates their flamboy-

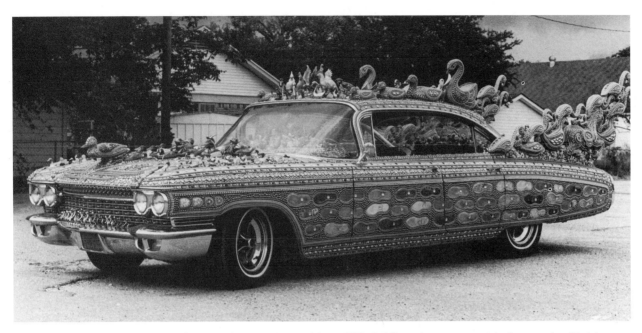

119 Larry Fuente, *Liberty*. 1983. Cadillac and various materials. Courtesy Ann Harithas.

ance, their surfaces encrusted with glass and plastic beads and fake jewels (identical materials to those used by Alfonso Ossorio in many of his assemblages). To these ingredients are added ready-made plastic and china ornaments – Fuente is especially fond of china swans. These ornaments become effective metaphors in the new context provided for them.

The sculpture of James Surls makes a different set of points, not only because of a different choice of material, but because there is something in it which is not merely popular but deliberately rustic. The found materials Surls uses are those provided by the countryside, not the chain-store. Strange, misshapen branches and roots are coaxed into becoming figures – the subject-matter is suggested by the shape taken by the wood itself. Surls's techniques are those of the rural carver and whittler, whose figures take on a life of their own as he turns them in his hands. But there is also a touch of Zen, the claim to be in touch with the inner rhythm of the cosmos. The sculptor here tries to embody two things: first, the kind of modern myth which has engaged so many modern artists; and secondly a specific sense of place – Surls belongs to East Texas and nowhere else, and is an example of the increasing emphasis on regional identity which can now be seen in so much American art.

Margaret Wharton is another craftsman in wood. Her artistic origins are

120 James Surls, *Tornado*, 1977. Sweet gum, oak, pine, 100 × 19 × 31 in (254 × 48 × 78·5 cm). Courtesy Fendrick Gallery, Washington DC.

121 Margaret Wharton, *Odalisque*, 1980. Wooden chair and mixed media, 51½ × 99½ × 2 in (130 × 252·5 × 5 cm). Courtesy Phyllis Kind Gallery, New York.

diverse. She owes a lot to Oldenburg's translations of everyday objects, and also to the feminism which affected so many women artists in the late 60s and early 70s. She has been influenced by the art-as-furniture/furniture-as-art of Scott Burton, with its hidden roots in performance and conceptualism. From the middle 70s onwards, Wharton's chosen medium has been the chair – ordinary wooden chairs, altered, ravaged, changed almost out of recognition. Increasingly the changes have shown not only virtuoso woodworking skills, but a quirkish sense of humour. Chairs become animal skulls, à la Georgia O'Keeffe or Picasso. They are half-changed into birds and odalisques while still retaining remnants of their original identity. The wit and lightheartedness of these transformations suggest comparison with folk-toys; the arbitrary rules the artist imposes on herself and the rigour with which she obeys them make it clear that she is also a disciple of Marcel Duchamp.

With certain American artists, the craft references are an important clue to comprehending what they do, but are nevertheless buried deep. Alan Shields is a maker of off-stretcher abstractions painted in acrylic. He often employs additional materials – woven cotton belting, pipe cleaners, wire and beads. Sometimes his creations are fully three-dimensional, and suggest tents, sacred enclosures and ceremonial canopies. In nearly all cases sewing plays an important role in the construction of the piece. This fact, and still more so the actual colours and patterns Shields uses, prompt comparisons with typical nomadic crafts – with embroideries on felt and with flat-weave kilims used as portières and hangings – though there are also obvious references to the main tradition of modern western painting, Klee and Kandinsky in particular. Shields acknowledges the ritual element in his work : 'Part of the magic of making art, or anything that excites the viewer's eyes, has to do with primitive feelings.'

One of the things which he has clearly been able to rely upon is the much broader cultural consciousness of the present epoch – our awareness, not merely of various levels of European and American civilization, and of the folk-culture which has at certain epochs subsumed them, but of all the other cultures whose products now fill our museums.

In the 80s American artists do not have to make a special effort to study these. Every aspiring painter and sculptor is necessarily aware of them. Hence, indeed, the blurring of categories which is one of the themes of this chapter.

Art as archaeology

Archaeology, from being a comparatively esoteric subject, the passion of a few antiquarians, has become very much a part of our contemporary consciousness. It supplies the subject-matter for television programmes addressed to the mass audience, for articles

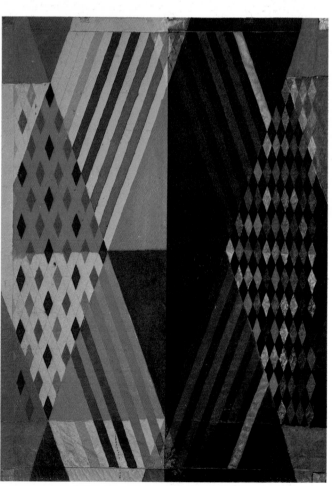

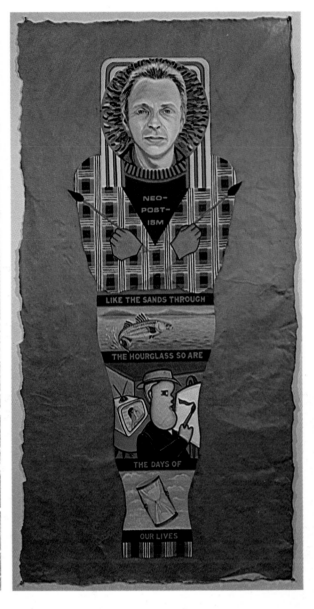

124 (*Above left*) Ann McCoy, *Barque with Sacre Coeur*, 1984. Coloured pencil, 84½ × 58 in (214 × 147 cm). Courtesy Brooke Alexander, New York.

125 (*Above right*) Malinda Beeman, *Sarcophagus Design for Artist: Age 38*. Acrylic and oil on paper, 36 × 72 in (91 × 182·5 cm). Courtesy the artist.

122 (*Opposite left*) Alan Shields, *Too die of Love*, 1980–3. Acrylic and thread on canvas, 83 × 60½ in (210·5 × 153·5 cm). Courtesy Paula Cooper Gallery, New York. Photo eeva-inkeri.

123 (*Opposite right*) Lari Pittman, *Hibernating*, 1982. Oil, acrylic, gold leaf and cork mounted on mahogany. Two panels, overall 68 × 54 in (172·5 × 137 cm). Courtesy Rosamund Felsen Gallery, Los Angeles.

in mass-circulation periodicals, and for exhibitions which attract larger audiences than the most successful musicals, or the most prestigious sporting contests. Egypt in particular has captured the public imagination, not least because it has been imbued with so many mystical connotations. It is therefore not surprising to find a number of contemporary American artists turning to Ancient Egypt for their themes. It has attracted artists working on both the East and the West Coast. Examples are Lari Pittman, Malinda Beeman and Ann McCoy. McCoy links her use of Egyptian and other symbolisms to Jungian psychology, and also makes use of sea imagery in a way which shows a knowledge of Minoan decoration as well as direct imput from her own undersea explorations. The mixture is highly personal and yet, through its extreme eclecticism, typical of the present day.

Perhaps it has something to do with the symbolic potency of water, but a number of leading 'mock-archaeological' artists concern themselves with boats. Texas-based Roy Fridge has made an Egyptian sun-ship, as well as practicable vessels which are echoes of other cultures – a proa based on those from Oceania, and a sampan from the China Seas. Fridge has also made shaman shrines which, like the paintings of

126 Roy Fridge, *The Flying Proa*, 1979. Mixed media, 180 × 216 × 96 in (457 × 548 × 244 cm). Courtesy Moody Gallery, Houston.

Alan Shields, show a keen awareness of the ritual element in contemporary art.

Robert Stackhouse's installations look to the prehistoric and early historic cultures of Northern Europe for their inspiration. In his work Stackhouse seems to be asserting that archaeological information – what one finds in the Viking Ship Museum in Oslo, for example – does not have to be treated in a completely pedestrian way. It is legitimate material for fantasy, and the facts established by the investigations of the archaeologists take on a poetic reverberation when the artist's imagination comes in contact with them. The artist expresses his sense of this reverberation by making his own free version of an archaeological display which in his hands makes reference to a past which never existed.

The most elaborate fantasies of this sort are those produced by Charles Simonds. Simonds imagines the existence of a race of 'Little People', who possess a rich civilization which has grown up over centuries. He provides evidence for the existence of this civilization, and traces its evolution, by means of a series of elaborate structures on a miniature scale, rather like the small-scale 'reconstructions' one finds in old-fashioned archaeological museums, designed to help the visitor envisage the original appearance of a particular site. Though the museum ethos now seems built in to his work, Simonds originally rejected it, making his models outdoors,

usually in derelict urban locations, as a way of suggesting that the Little People led a genuine existence which ran inconspicuously parallel to our own. Since then he seems to have become more deliberately didactic. The museum context, once accepted, enabled him to elaborate both the philosophical and the narrative content of his work. The models are philosophical in the sense that they are diagrams recording a set of speculations – Simonds asks himself questions about the nature of human society and about man's possible relationships to nature, then codifies his answers in this way. They are also narrative because they invariably suggest the passage of time and usually hint at some hidden epic story. Simonds likens some of his more elaborate models to old-fashioned picaresque novels. Like books of this type, his models bring together in one place a wide variety of different events.

Mock-science

Contemporary American art also masks itself in images borrowed from science, or more often from the history of science. In the Renaissance, as Alice Aycock reminds us with her *Great Explosion: Leonardo Swirl* (a three-dimensional version of one of Leonardo's 'Deluge' drawings), the

boundary between art and science was in any case not fixed. Other recent Aycock sculptures resemble bits of apparatus from an alchemist's laboratory. 'When I started working with machines,' she says, 'I didn't want to give them a real function or want them to be a cause-and-effect sort of thing – I wanted them to be more miracle machines – not religious or anything, but alchemical magic.' She likes 'false inventions, things that are impossible and inventions that don't work.'

Eugene Sturman's sculpture occupies a related area, though in his case the reference is to an imagined future, rather than to a half-glimpsed past. His work was well described by a Los Angeles reviewer: 'The drawings might be cross-section diagrams of deepest outer space; the constructions, fallen shards from a star-bound satellite; and the gleaming sculptures, man's lonely mark on a far distant planet.' One of the interesting things about Sturman's work is the way it signals a shift in the American sculpture of the 80s. It has increasingly turned away from an exploration of purely formal relationships to a fascination with myth and poetic metaphor.

Like Sturman, Chris Burden now bases himself on Los Angeles. During the 70s he was one of the best-known – indeed, probably the most notorious –

127 Charles Simonds, *People who Lived in a Circle (Picaresque Landscape)*, 1976. Miniature architectural model, mixed media. Photo Rudolph Burkhardt.

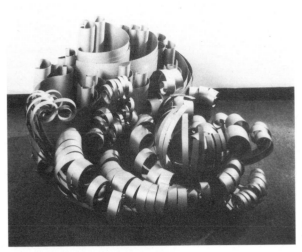

128 (*Above left*) Alice Aycock, *Greased Lightning*, 1984. Steel, paint, motors glass, 56 × 72 × 72 in (142 × 182·5 × 182·5 cm). Courtesy McIntosh/Drysdale Gallery, Houston.

129 (*Above right*) Alice Aycock, *Gigantic Explosion*, from the Leonardo Swirl series, 1984. Painted steel, 32½ × 53 × 51 in (82·5 × 134·5 × 129 cm). Courtesy McIntosh/Drysdale Gallery, Houston.

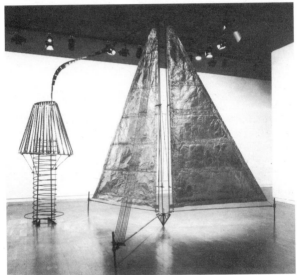

130 Eugene Sturman, *Delta and the Sphinx*, 1982. Installation, 12 × 15 in (30·5 × 38 cm). Courtesy Koplin Gallery, Los Angeles.

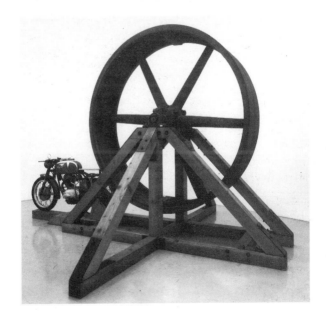

131 Chris Burden, *The Big Wheel*, 1979. Cast iron, fly wheel, wood and steel motorcycle. 112 × 175 × 132 in (284 × 444 × 335 cm). Courtesy Rosamund Felsen Gallery, Los Angeles.

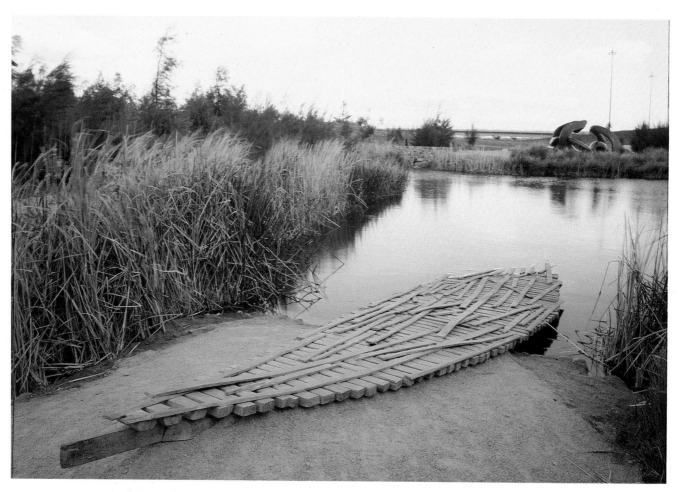

132 Robert Stackhouse, *On the Beach Again*, 1984. Bronze, 30 ft (9·1 m) long. Canberra, Australian National Gallery. Courtesy Max Hutchinson Gallery, New York.

performance artists in the United States. On one occasion he had himself shot in the arm; on another, he was locked in a small locker for a period of five days. These performances can be seen as exorcisms of childhood fears. Burden's *The Big Wheel* of 1979, which marked a change of direction in his work, still has links to these earlier rituals. The huge iron flywheel, activated by a motorcycle, has something distinctly menacing about it when it is in motion, a feeling of energy only precariously under control. It magnifies and makes threatening Duchamp's early readymade which consisted of a bicycle wheel mounted on a stool. Yet at the same time it speaks in simple and effective terms about the fascination of mechanical energy. Like Aycock, Burden is obviously intrigued by the queerness of primitive laboratory apparatus. Another sculpture is called *The Speed of light Machine*, and is based on memories of high school science classes.

In Burden's recent work, as in Aycock's, one senses a search for new relationships between form, content and image. The artist is trying to side-step conventional formats, so as to avoid the barrenness of Minimal Art. Aycock and Burden also want to find a metaphor for some of the forces which move the cosmos which avoids romantic grandiosity. Other artists included in this chapter are perhaps less ambitious in their aims, but all of them show a renewed respect for image-making as something central to their activity. With all of them the content goes well beyond the boundaries of the art-about-art which dominated the early 70s. Yet most of them still seem to feel a little nervous about their defiance of Minimalist shibboleths – nervous enough to disguise the art-work so that it looks at first glance like a folk toy, or a piece of laboratory equipment or an archaeological fragment. This is art which is half-ashamed to admit its own identity as art.

CHAPTER NINE

REPLICATION, TROMPE L'OEIL AND THE MURAL MOVEMENT

The Photo-Realism of the late 60s and early 70s suffered from an ambiguity of aim. It was never clear, either in the minds of the artists themselves, or in those of the people who promoted the style, where its real centre of gravity was to be found. Was it, for example, simply an extension and refinement of Pop Art, and thus to be identified with the worship of mass culture? Was it, on the other hand, a genuine revival of the deeply rooted tradition of American Realism? Or was it better thought of as being a specialized variant of Conceptual Art? As Photo-Realism recedes into the past, the various leading figures who played a part in it look more and more different from one another. One can, of course, say the same thing with equal justice about Impressionism. It is now quite difficult to see what Degas and Sisley had in common at the time of the First Impressionist exhibition of 1874. It is certainly very hard to perceive what the late Renoir (of the various versions of *The Judgement of Paris*) shares with the Monet of the *Waterlilies*.

Remaking the photograph

The most stringent of the Photo-Realists is Chuck Close, and it is a tribute to the intellectual rigour of his work that he, among all members of the Photo-Realist school, has most successfully survived its decline from favour. Like many contemporary artists, Close mines a narrow seam. He is known for his portrait heads, based on photographs taken by himself. His subjects are always shown in the same pose – full-face, staring directly at the spectator. The huge size of many of these images gives them great force – they have the 'iconic' feeling which has also been attributed to Mark Rothko's mature abstracts, with floating blocks of colour occupying most of the picture area.

The paradox of Close's work is that it is 'realistic' only in an extremely specialized way. He ignores any information about his subject-matter which cannot be found in the photograph which serves as a starting point for his picture – he deliberately refuses to correlate direct observation with the information provided by the lens, even though he is well aware that the lens does not see in the same way as the human eye. There is thus a strongly conceptual element even in his earlier work, made when the Photo-Realist movement was going full force. In more recent paintings this element is emphasized. Even an unsophisticated spectator will know that the *Self-Portrait* illustrated here cannot be thought of as a direct reflection of reality. True, the image is still based on a photograph, but the photograph has been replicated using a strangely awkward and clumsy process: its areas of tone are broken up into tiny squares of pulp paper, applied to the background but kept completely separate from one another. The method has obviously been suggested by mechanical half-tone reproduction, which translates the image into tiny dots that cluster together in varying densities. Close deliberately coarsens and exaggerates the effect this produces, so that looking at his picture is like looking at an image in a newspaper under extremely high magnification. The technique is related to that used by Roy Lichtenstein when

133 Chuck Close, *Self Portrait*, 1983. Pulp on canvas, 54 × 40 in (137 × 101·5 cm). Courtesy The Pace Gallery, New York.

making his giant replicas of crudely printed comic strips.

It is instructive to compare Close's work with the large drawings of Joseph Piccillo. These, too, are obviously based on photographs. They are found images, borrowed from various sources – contemporary magazine illustrations on the one hand, nineteenth-century photographs on the other. Sometimes there will be a small area where the replication of the image, otherwise incredibly precise, is deliberately contradicted or falsified. *F (10) – Study in August*, based on a photograph of the Austrian Emperor Franz Joseph, contains a mysterious irregular patch near the bottom right-hand corner, crossed with ruled horizontal lines and cancelled with an

X, which obviously has nothing to do with what appeared on the original photographic negative, though it may have been suggested by some damage to the print itself.

Piccillo, unlike Close, clearly thinks of his borrowed images as things which have inherent emotional value, and the occasional wilful disturbances of the image are tributes to that fact. Replication, here, is not a matter of finding ways to exclude unwanted emotion, as it may be with Close, but a struggle towards authentic feeling. Deliberate imperfections introduced by the artist can be read metaphorically – as acknowledgements that the completely authentic moment of vision remains forever out of reach.

Replication without deception

There is always a fine line to draw between replication, remaking something which exists, usually in a different material, sometimes on a different scale, and *trompe l'oeil*, which is something that tricks the eye, by whatever means, into believing that what is seen has not been digested and reconstituted but remains present in its original form. Replication without deception is essentially modernist, founded on Duchamp's doctrine of anti-art. *Trompe l'oeil*, on the other hand, has a long pre-modernist history, and is especially strongly rooted in nineteenth-century American art.

Most art works which put the primary stress on replication rather than deception tend to be three-dimensional. This

134 Joseph Piccillo, *Study: Charcoal (F–10)*, 1983. Charcoal on paper, 40 × 60 in (101·5 × 152 cm). New York, Metropolitan Museum of Art. Courtesy Monique Knowlton Gallery, New York.

135 Sharon Quasius, *Géricault's Raft of the Medusa*, 1977. Polyester fibre on wooden stretchers, 108 × 162 × 30 in (274 × 411 × 76 cm). Courtesy O. K. Harris Works of Art, New York.

136 (Above) Muriel Castanis, *Untitled*, 1983. Cloth and epoxy, lifesize. Courtesy O. K. Harris Works of Art, New York.

137 (Below) Fumio Yoshimura, *Tomato Plant*, 1982. Linden wood, 50 × 28 × 40 in (127 × 71 × 101·5 cm). Courtesy Nancy Hoffman Gallery, New York.

138 Victor Spinski, *V. W. Fountain*. Hand-hollowed bricks, full-size cast Volkswagen in clay, glaze and ceramics, lenth 144 in (365 cm), height 90 in (228 cm). Courtesy the artist.

is the case even when the artist is replicating a two-dimensional original. A classic example is Sharon Quasius's reconstruction of Géricault's *Raft of the Medusa*, where the painting is translated into a relief made of polyester fibre mounted on cotton duck. A classic of nineteenth-century Romanticism is transmuted using methods borrowed from Claes Oldenburg. Muriel Castanis's untitled figure is not quite so consistent from a stylistic point of view, in that she chooses to edit the nineteenth-century marble sculpture on which her work is based, in addition to replicating it in a different material. The figure is reduced to draperies only – it has no head and no hands. The editing implies a comment on the nature of the chosen original which is not made by Quasius in her version of Géricault's painting. What Quasius seems to be trying to produce is a feeling of alienation. She wants to make us look afresh at an overfamiliar masterpiece, and she reaffirms its stature rather than questioning it.

One has to approach the superficially similar carvings of Fumio Yoshimura from a different angle. Yoshimura replicates both natural and man-made objects in carved wood. These carvings have a startling virtuosity. Without asking us to believe his versions are in any way the real thing (they come unpainted, so that the true nature of the material is always apparent) Yoshimura challenges our perception of reality. Unlike Quasius and Castanis, he belongs to a long-established but extremely specialized tradition, with its roots in the crafts rather than the fine arts. His carvings make one think of the work of the seventeenth-century Englishman Grinling Gibbons, who worked as a decorative carver for Sir Christopher Wren and whose lace jabot in limewood in the Victoria and Albert Museum is an exercise of the same sort. Yoshimura's flowers also make one think, in a more general way, of certain objects from the Fabergé workshops – the snowdrops with gold stems, enamelled leaves and pearl blossoms planted in crystal vases filled with crystal water. Where Piccillo's drawings after photographs tell us how truly mysterious and ungraspable reality is in the deepest sense, Yoshimura's carvings make a much more superficial statement about man's ability to rival nature.

Deceptive replicas

Glazed clay is one of the most adaptable of all materials, and this is one reason why a number of American artists interested in replication have made it their preferred medium. Probably the most gifted of them all is Victor Spinski. Spinski describes what he does as being

139 Peter Saari, *Trompe l'Oeil Fragment*, 1983. Casein, gouache and plaster on canvas on wood, 82 × 47 × 7½ in (208 × 119 × 19 cm). Courtesy O. K. Harris Works of Art, New York. Photo D. James Dee.

'theater at the highest level'. His *V. W. Fountain* represents a Volkswagen car which has crashed through a washroom wall, displacing a sink as it does so. The only thing which is truly 'real' about the piece is the water which pours from the sink. Everything else is glazed clay, and the whole piece is hollowed out and made in sections, so that it is fully demountable – a fact which makes its lifelike quality even more astonishing. The 'theater' Spinski speaks of is more precisely described as a feeling of disorientation. The spectator already *knows* that what he is looking at is a fake, but his own eyes contradict this knowledge. He has to use other senses, such as the sense of touch, to confirm what the intellect tells him, and the contradiction between two modes of perception produces a sensation which is almost vertiginous.

Similar comments can be made about the 'Pompeian frescos' of Peter Saari (which might also have been included in the section on Mock-Archaeology). Saari himself describes the paintings as '*trompe l'oeil* fragments'. What takes them further than more usual kinds of *trompe l'oeil* is the fact that he does not rely on paint alone. The fragments are shaped so as to look exactly like the half-ruined Roman paintings we see in museums, even to their ragged edges. Only a close examination of these edges, as well as of the actual paint-surface, reveals that modern materials have

been employed – unlike the anonymous fakers who attempt precisely the same job Saari makes no effort to conceal his methods. The resonance in his work comes from the assault he makes, not merely on our physical senses, which are encouraged to contradict one another, but on our sense of the past – notions concerning what is 'ancient' and what is 'modern' are jarringly opposed to one another.

Replica figures

The idea of a sculpture as the simple replica of a human being is of course very old. The Greek myth of the sculptor Pygmalion, who fell in love with the figure he created, which then came to life and embraced him, is based on the idea that the statue was essentially the simulacrum of life. Just as ancient, however, and even more powerful, is the idea that a sculpture, whether naturalistic or not, is essentially a vessel inhabited by a spirit, either human or divine. This is certainly the view which has prevailed since the Middle Ages. The exceptions have been twofold. First there have been sculptures, Gothic, Renaissance or Baroque, made to excite fervent religious emotion. Typical are the images found in Spanish churches, meant to persuade the worshipper that he is in the actual presence of the Saviour, his Mother, or some saint. Secondly there are portrait effigies,

made to be carried in funeral processions, like the images of English kings and queens which still survive at Westminster Abbey, or the images of the famous and infamous shown for money by entrepreneurs such as Madame Tussaud. It has been generally accepted by orthodox art-theorists that the second category at least falls below the level of art. The distinction between waxworks, or their equivalent, and real sculpture was said to be the fact that the intense particularity of the former was inimical to the whole process of generalization and reformulation which was the essence of the artist's function.

The sculptors associated with the Photo-Realist movement, chief among them Duane Hanson and John De Andrea, apparently contradict this view. Following the example of George Segal, they build up their figures using body parts moulded from life. But unlike Segal, they are at great pains to get rid of any clumsiness or roughness resulting from this process – the result is refined until it comes as close as possible to the living model. Their figures are clothed in real garments, are surrounded with objects which the models might have handled or used, and are equipped with false hair and glass eyes. The flesh parts, wherever exposed, are painstakingly painted to resemble flesh.

As Hanson and De Andrea have pursued their separate careers, the differences between them have become more apparent, despite their apparent identity of method. Hanson is most easily interpreted as a social critic and satirist. His figures may be replicas of real people, but they intensify life – even venture into a kind of generalization – by bringing into sharp focus the characteristics which both define an individual and indicate his or her position within society. Each figure or group of figures is a treatise on psychiatry, economics and the class system, their intensity springs from the number of different observations and conclusions the artist makes available to us. One can even say that much of Hanson's work is too lifelike to be really like life.

De Andrea is more uneven, and in any case he pursues a different goal. He repeatedly raises the question of the gap between the ideal and what it is based on. His naked men and women – usually beautiful middle-class American co-eds in their late teens and early twenties –

140 Duane Hanson, *Bus Stop Lady* (detail), 1983. Polyvinyl polychromed in oil, lifesize. Courtesy O. K. Harris Works of Art, New York. Photo D. James Dee.

141 John De Andrea, *Dying Gaul*, 1984. Polyvinyl, polychromed in oil, lifesize. O. K. Harris Works of Art, New York. Photo D. James Dee.

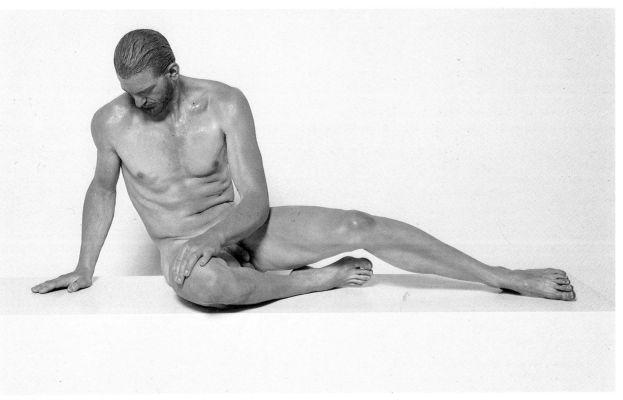

are nevertheless full of all the physical quirks and imperfections which traditionally idealizing sculptors are at great pains to remove. These minor eccentricities and defects spring not so much from the life-moulding technique itself (Segal has increasingly found ways to generalize the forms obtained from this), as from De Andrea's own acceptance of the idea that the truth of the mould is superior to any truth he himself may come up with independently.

In the past, the question has been one of De Andrea's awareness, as well as of his acceptance. Did he deliberately exploit the aesthetic discordancy the moulding process created, or did he simply regard this as inevitable? Whatever the answer may have been in the 70s, one can at least say that he is fully cognisant of the problem now. A recent piece – a new version of the Hellenistic *Dying Gaul* – is a didactic comment on it. De Andrea takes a great classical masterpiece and returns it to its presumed source in nature. His piece, which adroitly combines extremes of classicism and anti-classicism, raises issues which

go well beyond the boundaries of this chapter, and which will be discussed again later, in particular the continuing vitality of classicism and indeed of a kind of academicism in twentieth-century American art.

Segal, Hanson and De Andrea have now been joined by a fourth and much younger sculptor who makes use of the life-moulding technique. This is John Ahearn, one of the moving spirits in the Times Square Show of 1980. Ahearn follows Segal's example closely, working with sculptural fragments as well as with whole figures. Fragmenting the figure removes much of the *trompe l'oeil* element. So does an alternative strategy of mounting figures where they could not exist in life – for instance, high up on a wall. For Ahearn the replica-sculpture is chiefly a means of making a sociological report. At the same time he aims to reflect the image of a particular community to itself. Working in the deprived South Bronx district of New York, Ahearn makes portraits of people – poor Hispanics and blacks – who can expect no monument in the normal course of

things. Segal has on occasion been compared to Hopper, the great American realist of the 1920s and 1930s. Ahearn is more didactic – he presents us with an updated version of Marxist Social Realism.

Segal's figures, and those of Hanson and De Andrea, are 'realistic' with varying degrees of intensity. They are seldom or never interested in histrionic gestures or fleeting, momentary expression. Hanson is the only one of the three who flirts with these, and then mostly in his earlier work – in multi-figure compositions such as *Riot* (1967). Ahearn's sculptures are different: they often signal to us, in animated pantomime, the emotions felt by the models – or are these emotions the artist has imposed on them?

Trompe l'oeil painting

Trompe l'oeil and the expression of unambiguous emotional states are usually inimical. Marked expressions – joy, hate, fear – and emphatic gestures are by their nature momentary. However

142 John Ahearn, *Charlie I*, 1982. Painted cast plaster, 26½ × 17¾ in (67 × 45 cm). Courtesy Brooke Alexander, New York. Photo Ivan Dalla-Tana.

143 Audrey Flack, *Wheel of Fortune*, 1977–8. Oil over acrylic on canvas. Courtesy HHK Foundation for Contemporary Art Inc., Milwaukee.

144 Barbara Dixon Drewa, *C. O. D.*, 1984. Oil on wood, 30 × 24 × 1½ in (76 × 61 × 4 cm). Courtesy the artist.

cleverly they are caught and fixed, the lack of change kills the illusion at a second glance. There are American *trompe l'oeil* artists who combine *trompe l'oeil* technique with emphatic emotional content, but their strategy is different. They use sharp-focus illusionism to give an intensity to symbolic objects. Perhaps the best example is the work of Audrey Flack. *Wheel of Fortune* is an illusionistic painting based on a similar but not identical photograph – which is itself just as much an artificial construct as the final result. The artist set the photograph up in her studio following a design which already existed in her mind's eye, and the composition twists or contradicts many of the normal rules, treating the law of gravity, for instance, with fine indifference. The final result is thus an illusionistic representation of what was artificial from the srart – an illusion in its own right. But this is subsidiary to the fact that *Wheel of Fortune* is thronged with both traditional and modern emblems of time, chance and vanity. The skull, the mirror and the hourglass are standard properties from the Dutch *Vanitas* still-lifes of the seventeenth century. The lipstick and the powder compact are new twists on the traditional theme.

A somewhat more self-conscious use of traditional *trompe l'oeil* devices is made by Barbara Dixon Drewa, whose recent work presents masterpieces from the past in new situations. *C.O.D.* shows

a 'Holbein' portrait of Sir Thomas More bursting out of a paper parcel. Mrs Drewa writes:

I do not copy nature or record life as it is, but create another reality that extends the visible world. . . . I want to bring the view to the verge of illusionism, only to finally assert that the reality is the paint, the colour, the canvas, the perception. I like the deception, but I do not ultimately intend to deceive.

C.O.D. is a corridor of mirrors, and at the same time a comment on the aspirations of Western art and also on the way in which the Modern Movement has distorted our perception of the past.

One interesting thing about *trompe l'oeil* is its unexpected elasticity, the way in which it reacts to and accommodates the aspirations of the present moment. Two instances of this are worth citing – the work of Paul Sarkisian and that of Keung Szeto. Sarkisian's paintings are difficult to reproduce satisfactorily because the deception is so perfect. In general, painted *trompe l'oeil* becomes more and more deceptive as the picture-space becomes shallower. What Sarkisian paints is an imitation of collage – scraps of newsprint and strips of coloured paper stuck lightly to a surface (or are some of them floating just minimally in front of it?). An allusion is being made to Synthetic Cubism and to the Cubist invention of collage. But it is ironic as well as admiring. When Picasso and Braque introduced fragments of newsprint and patterned paper and scraps into Cubist compositions they were drawing a comparison between an elaborately coded representation of reality (the whole composition) and reality itself (of which the collage fragment was a representative specimen). Sarkisian's paintings abolish the distinction.

Keung Szeto is a little closer to traditional *trompe l'oeil*, for example to the letter-rack paintings of William Harnett. He too uses a very shallow space, depicting small items pinned to a back board and tapes and paper strips trailing across it. It is the tapes which catch one's attention because they seem to function a little like the free brush-strokes of Pollock and some of his contemporaries. The comparison is reinforced when one looks at the work of a compact school of American painters

145 Paul Sarkisian, *Untitled*, 1980. Acrylic on canvas, 103 × 79 in (261 × 200·5 cm). Courtesy Fendrick Gallery, Washington DC.

146 Keung Szeto, *Danger Hard Hat Area*, 1982. Acrylic on linen, 60 × 84 in (152 × 213 cm). Courtesy O. K. Harris Works of Art, New York. Photo D. James Dee.

whose work is simultaneously illusionist and abstract.

Abstract Illusionism

The Abstract Illusionists, as they have been called, occupy an isolated position in contemporary American art. The technical element in their work is so insistent that it is hard to see how any of them can develop or change without losing identity. Artists like James Havard, Jack Lembeck, George Green and Michael Gallagher are extreme mannerists, and like the mannerism of the late sixteenth century their work depends on a deliberate dislocation of the viewer's framework of perception. We expect painterly marks and brush-strokes, the elements from which free abstraction is made, to assert the in-

147 Michael Gallagher, *Untitled*, 1984. Acrylic on canvas, 72 × 60 in (182·5 × 152 cm). Courtesy Louis K. Meisel Gallery, New York.

148 Ron Davis, *Wedge Wave*, 1978. Acrylic on canvas, 71 × 66½ in (180 × 169 cm). Courtesy Asher/Faure Gallery, Los Angeles.

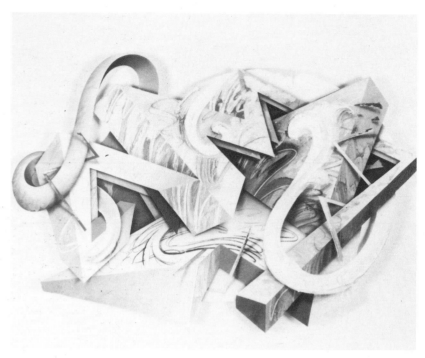

149 George Green, *Pacific Northwest: Neskowin*, 1984. Acrylic on canvas, 66 × 104 in (167·5 × 264 cm). Courtesy Louis K. Meisel Gallery, New York.

tegrity of the surface, even though there is sometimes also a suggestion that these brushstrokes have been layered and plaited, or even that the surface itself is not an absolutely rigid plane. These hints of instability are exaggerated, and become the primary subject of Abstract Illusionist painting. The brushstrokes and colour areas become independent, and hover, casting visible shadows on the canvas from which they seem to have detached themselves.

There are various versions of the single basic device. In Gallagher's case the brushstrokes often look as if they have been applied to sheets of perspex, layered one in front of the other, while George Green's work seems to be made of heavily painted layers of opaque paper, which form tongues of colour thrusting their way through an opening which lies close to the front plane but does not quite coincide with it.

What these and other artists have done is to combine apparently irreconcilable opposites – they are as much descendants of Harnett as they are of Pollock, and the obsessional precision of the one wars with the freedom of the other. The Abstract Illusionists, mannerist as they are, have also found a way to bring abstraction into the zone of popular taste – illusionism in painting is

nearly always, in one way or another, a kind of democratization, a reaching out to the mass audience.

West Coast illusionism

Gallagher and Green both have connections with the West Coast. Gallagher was born in Los Angeles, and Green in Portland, Oregon. But they are not usually thought of as 'West Coast artists'. The geographical association is

stronger in the case of Ron Davis and John Okulick. The classification of Davis, in particular, as an 'illusionist' may seem perverse. The formalist critic Michael Fried once compared him to Frank Stella. Today Davis seems more closely related to a sculptor like Caro than he does to any painter – he uses abstract sculptural forms as a basis for illusionist exercises, carefully placing these imaginary sculptures in settings which stress their plasticity. A favourite device is a tilted, chequerboard floor strongly reminiscent of those which appear so often in Dutch seventeenth-century genre painting, and which there serve as the basis for a whole elaborate perspective system. Obviously Davis is anxious to stress his rejection of the accepted norms of post-war abstract art, to which such devices are anathema.

Okulick makes shaped, painted reliefs. These employ traditional perspective devices to suggest that the forms zig-zag back into a space which doesn't exist, and whose existence is denied by the wall on which the relief itself is hung.

Surprising as it may seem at first glance, I believe both Davis and Okulick are connected with the visionary tradition which is typical of other kinds of Californian art. Their work simultaneously affirms and denies the solidity of the abstract forms which are its basic material.

Trompe l'oeil murals

There is a subterranean link, for inst-

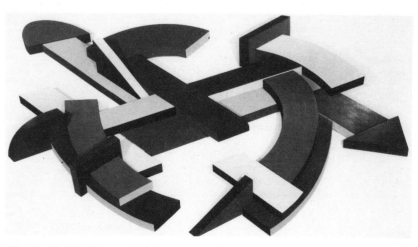

150 John Okulick, *Thruster*, 1983. Painted wood construction, 90 × 170 × 6 in (228 × 431 × 15 cm). Courtesy Asher/Faure Gallery, Los Angeles.

ance, between these two artists and the *trompe l'oeil* murals on a triumphantly vast scale which have also found favour in California. The most notable creator of these is Terry Schoonhoven. His earlier murals were produced when he was still a member of a group of muralists who sank their individual identities in order to become The Los Angeles Fine Arts Squad; the later ones have been painted as individual artworks, done under his own name. The best known of all his creations belongs to the earlier, semi-anonymous phase. This is *The Isle of California*, which shows California receding into the Pacific, having been shaken loose from the rest of the United States by an earthquake. It is easy to see why this mural soon became celebrated. It is vast and dramatic, directly comparable to a scene from the most orgasmically epic of epic movies. And it is also a witty tribute to the new, separatist California patriotism, just growing up as it appeared. It may not be a great painting, but more than most contemporary paintings it succeeds in expressing a popular mood. Schoonhoven's more recent *Saint Charles Painting* in Venice is less dramatic, but in its own way just as interesting. It disorients the viewer by dissolving a wall and extending the existing townscape – the painting is a huge mirror-image of what surrounds it. The physical elusiveness of much California art here manifests itself in deliberately didactic guise.

The mural movement and its consequences

Though only a small proportion of the large number of murals produced in the 70s flirted with *trompe l'oeil* – their makers were not, for the most part, skilful enough to attempt it – the mention of Schoonhoven's work offers a pretext for a brief digression on the subject of the American mural movement as a whole, which reached a high tide during the 70s which it had not experienced since the 30s.

It is now clear that the enthusiasm for murals is once again receding, and that the energy and inventiveness of young artists are being channelled elsewhere. The mural projects in rundown urban neighbourhoods which attracted so much attention in the early and middle 70s have been documented in a handful of books, as well as in the magazine articles which appeared at the time. But little attempt has been made to link the mural revival to the development of American art in general – indeed, the high priests of high art have often asserted that murals, whatever their merits in a strictly social context, are an aesthetic dead end. This is far from being the case: the mural movement foreshadowed many of the most conspicuous tendencies in the American art of the 80s. It seems, indeed, to have been the laboratory where new styles developed.

The defeat of Conceptual Art – for this is what it amounts to – was prepared using the opportunities muralism provided. Murals were usually about a search for identity, either regional identity (*The Isle of California* fits into this category) or more commonly ethnic identity. One sees this expressed very clearly in the Ocean Boulevard murals, also in Los Angeles, which make great play with Pre-Columbian and popular Mexican images. These were not painted by professional artists, but are decorations created by the inhabitants themselves, to beautify a drab low-cost housing project occupied by people of Hispanic origin. Both regionalism and the search for ethnic roots are important forces in the American art of the 80s.

More important even than this is the fact that murals are often committed to conveying non-art messages; they express feeling about a community or an ethnic group, for example. Thanks to the permission given by the muralists, both professional and amateur, gallery art feels free to range more widely. Murals, being either actual community projects or at any rate addressed to a community unfamiliar with aesthetic nuances, opted for expressiveness rather than refinement of surface; gallery art has followed suit. The Neo-Expressionism imported from Europe, and fêted in New York galleries, is generally held to have been the sole influence on young Americans who promptly followed the same path. These American painters do indeed like to see themselves as the equals and rivals of continental stars like Fetting, Kiefer and Baselitz. But American work of this type also has obvious roots in the forceful crudity of the images made to adorn ghetto walls, at a time when Neo-Expressionism was still virtually unknown in America.

151 (*Top*) Terry Schoonhoven, *L. A. Fine Arts Squad: Isle of California*, West Los Angeles, 1971–2. Enamel on stucco. Courtesy Koplin Gallery, Los Angeles.

152 (*Above*) Terry Schoonhoven, *St. Charles Painting*, Venice, Los Angeles, 1978–9. Enamel on stucco, 52 × 102 ft (15·8 × 31 m). Courtesy Koplin Gallery, Los Angeles.

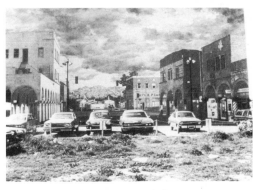

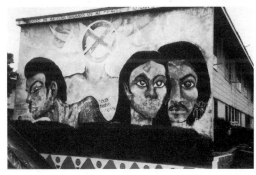

153–4 Anonymous Hispanic murals, c. 1975. Public housing project, Ocean Boulevard, Los Angeles. Photo the author.

CHAPTER TEN

AMERICAN REALISM: THE GENRES

Though American critics have been slow to develop a convincing theory of realism – at least one which can profitably be applied to the work of their own contemporaries – it is clear that a broadly realist impulse remains powerful in American painting. This impulse profits from photography on occasion, but also draws on an extremely varied range of sources which have little to do with the camera. To a European such as myself, the things which seem to differentiate American art from what is being produced on the other side of the Atlantic are not merely a tenacious attachment to realism, but a rootedness in both the American present and the American past which can only express itself through the use of realistic images.

One of the ways in which the modernist impulse first announced itself, long before Picasso and for that matter long before Cézanne, was through the collapse of the academic system of genres. This system encouraged painters to become specialists, confining themselves to history-painting, portraiture, landscape or still-life. No one would suggest that it is now, in all its rigour, being re-created by American artists. But there is some profit, nevertheless, to be found in examining separately the work now being done by Americans which fits some of the traditional categories. The two most instructive are landscape and still-life.

Contemporary American townscape

Artists who want to explore feelings about the nature of America (traditionally one of the major subjects of Ameri-can art just as it is of American literature) often do so by making the American landscape a major part of their subject-matter. Choosing to do this, they can hardly remain unaware of their predecessors – first the full range of American nineteenth-century landscape painting, running from the drama of Frederic Edwin Church and Bierstadt to the quieter statements of the Luminists; and second the work of the American Scene painters of the interwar period who re-interpreted the same landscape after it had been tamed or ruined by the hand of man.

Even today, when a European visits the United States for the first time, he is confronted with landscapes and townscapes strikingly different from anything he has seen before, and therefore particularly significant to him. Americans, too, are aware that certain aspects of their physical environment are unique, and it is not surprising to find that these are what a number of contemporary painters still choose to represent, as specifically as they can.

Richard Estes has generally been categorized as one of the leaders of Photo-Realism. He shares with Chuck Close the distinction of being singled out for praise when apparently similar painters are condemned. Yet it is rather doubtful whether Estes deserves to be called a Photo-Realist at all. His New York townscapes are indeed built up with the help of photographic documentation, but the information gleaned from photographs is altered and adjusted, subtly yet quite freely, to fit preconceived compositional ideas. Estes uses the modern reflex camera in the same way as his predecessors Vermeer and Canaletto used the camera obscura. The comparison which springs most insistently to mind is with Canaletto, the poet of eighteenth-century Venice, just as Estes is the poet of contemporary New York. Both artists are obsessed with cities which have unique physical characteristics. Canaletto used the water of the Venetian canals in the same way that Estes uses the glittering plate-glass windows of Manhattan. Looking at Estes's work one perceives the marriage of a special talent and an equally special environment.

It is interesting to compare Estes' urban paintings with those of the only contemporary townscapist who seems in any way to equal him: the Californian painter Robert Bechtle. The confrontation is fascinating. Bechtle catches the essential nature of Los Angeles just as accurately as Estes catches the nature of New York. The apparent neutrality of Bechtle's paintings is deceptive. It takes only a superficial examination to discover that they are the product of numerous aesthetic decisions, each directed towards finding and focusing a feeling of what urban California is like. Bechtle is especially expert at catching the cold bluish tinge of California light, which somehow contradicts near-tropical temperatures.

Sandra Mendelsohn Rubin's California landscapes have many of the same qualities, though architecture plays a less prominent role. Her *Santa Monica Canyon* clearly springs from the same kind of sensibility as Bechtle's *Sunset Intersection*.

Unlike Bechtle, Estes has no close colleagues or disciples. The nearest parallel is probably Robert Cottingham.

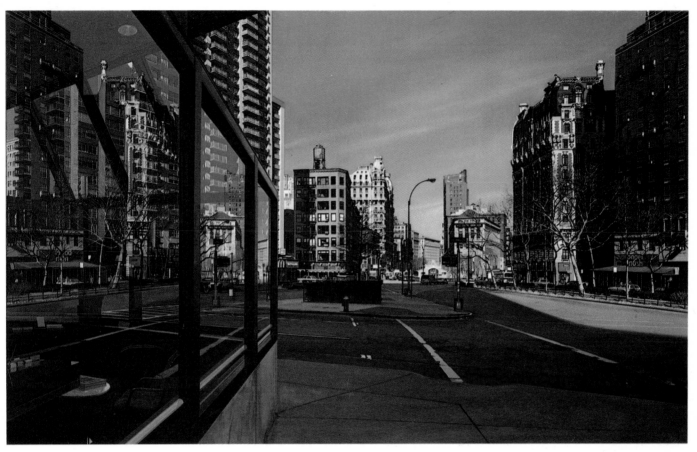

155 Richard Estes, *Macdonald's*, 1981. Oil on canvas, 36 × 55 in 91·5 × 139·5 cm). Private collection. Courtesy Allan Stone Gallery,
New York.

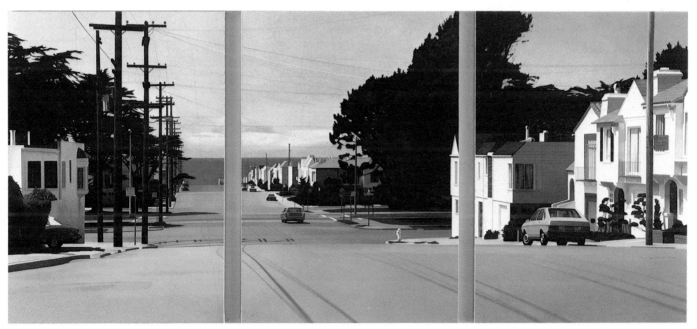

156 Robert Bechtle, *Sunset Intersection*, 1984. Triptych, oil on çanvas, each panel 56 × 40 in (142 × 101·5 cm). Courtesy O. K. Harris Works
of Art, New York. Photo D. James Dee.

157 (*Top left*) Sandra Mendelsohn Rubin, *Santa Monica Canyon* , 1982. Oil on canvas, 40 × 25 in (101·5 × 63·5 cm). Courtesy L. A. Louver Gallery, Venice, California.

158 (*Top right*) Robert Cottingham, *Ritz Hotel*, 1982. Acrylic on paper, 21 × 28¼ in (53 × 71·5 cm). Courtesy Fendrick Gallery, Washington DC.

159 (*Above left*) Harold Gregor, *Illinois Landscape*, 1982. Oil and acrylic on canvas, 60 × 82 in (152 × 208 cm). Courtesy Tibor de Nagy Gallery, New York.

160 (*Above right*) Chuck Forsman, *Divide*, 1981. Oil on masonite, 48 × 70 in (122 × 178 cm). Courtesy Tibor de Nagy Gallery, New York.

Cottingham's close-up angled views of New York signs and details of New York architecture are not strictly speaking townscapes, but they are loaded with comment about the nature of Manhattan, and the vision they present is related to what we see in Estes.

It would be possible to paint New York in a very different way – in the spirit of Kokoschka rather than of Canaletto – but as far as I know only one artist has so far attempted this. Lizbeth Mitty's *Halfway House for the Dead and Dying* is a view of a dreary tract of Queens, seen from an urban super-highway. The mood hovers uneasily between the journalistic and the apocalyptic. A novel like *Last Exit to Brooklyn* still has to find its equivalent in paint.

Rural landscape

Landscape painting in Europe almost inevitably contains an element of the nostalgic: the painter consciously links himself to the past and to an idea of nature which he perceives as something threatened. This element exists in many of the rural scenes now being painted by Americans, and strikes a responsive chord in the American audience. It helps to account for the enormous popularity of the work of Andrew Wyeth. But American landscapes convey other meanings as well, and this is especially true where the artist has consciously tried to depict what strikes him as peculiarly American.

Harold Gregor, for example, paints the broad, level landscape of the Mid-western prairies, which has no real parallel in Europe. His written description makes it clear that he sees his pictures as being primarily political statements:

All of these paintings consider, sug-gest or make evident the positive

sense of well-being discoverable in the Midwest landscape. In turn, I hope they will be seen as a reminder of one of our Constitutional guarantees that seems too often neglected: the pursuit of happiness. Despite the negatives that constantly make themselves felt in our daily existence, my paintings are intended as a reminder that at a core there is a positive and sustaining harmony of events that make the pursuit of happiness an immediately realized state, rather than a remote goal achievable only after hardship and denial. I recognize the sermonizing aspect in this, but experiencing the implied verities of the agriscene in the Midwest tends to induce a need to share the sense of affirmation it inspires.

It is perhaps mischievous to point out that, while the political values proposed are very different, the basic attitude put forward here concerning art and its purposes comes close to the Socialist Realism of the Soviet Union.

The Colorado landscapes painted by Chuck Forsman are specific in a similar way, but are also much less optimistic in tone. Their underlying purpose is to demonstrate the way in which modern man compromises nature by his own unconsidered additions to it. Like Gregor's paintings, these have a lesson to teach.

A number of other Midwestern painters create landscapes which are superficially similar to Gregor's, but interpret the same subject-matter in a far more lyrical way, and thus change the underlying meaning of the image. Among them are Keith Jacobshagen (whose subject is the Nebraska prairie, painted with *plein air* immediacy), James Butler

and James Winn. In the work of these artists the emphasis shifts from social relations to the artist's own individual response to momentary effects of light and colour. The drama of prairie skies is a major part of what these paintings have to communicate. One sees how, in America, certain parts of the pre-modern tradition continue to be of immediate use. The American landscapist can employ, without servile copying, ideas taken from classic Dutch art – from Koninck, for instance, and the two Ruysdaels – and he can also learn from Constable's sky-studies without making imitations of them.

Perhaps the most 'complete' of all the realist landscape painters now working in America is William Beckman. Beckman also has a quite separate reputation as a portraitist – his landscape pastels were a comparatively late development in his work. The terrain he depicts is of two kinds: Minnesota, near his parents' farm, and Dutchess County, New York, where he himself now lives. For Beckman, the American landscape is essentially a thing formed by man: 'I find the unity between man and the land is one of the only meaningful things to try and portray in landscape. I couldn't imagine doing a virgin forest.' Beckman's landscapes are above all specific. They give all the minute particulars, including those which make it clear that a modern working farm is a kind of factory, placed in a rural setting. His Dutchess County scenes are in their own way just as contemporary as Richard Estes's townscapes of New York.

Altoon Sultan paints landscapes which are rather similar, but more idyllic in tone. Sultan's *The Potato Field* has a spareness which echoes the eighteenth century. Yet the tautness of the

161 (*Top*) Keith Jacobshagen, *NW 84th St. & Agnew Rd.*, 1983. Oil on paper, 11 × 12 in (28 × 30·5 cm). Courtesy Roger Ramsay Gallery Inc., Chicago.

162 (*Above*) James Butler, *In Pelton's Pasture*, 1984. Pastel on paper, 36 × 48 in (91 × 122 cm). Courtesy Frumkin and Struve Gallery, Chicago.

163 (*Below left*) James Winn, *April Flood*, 1984. Acrylic on paper, 13½ × 27 in (34 × 68·5 cm). Courtesy Frumkin and Struve Gallery, Chicago.

164 (*Below right*) Altoon Sultan, *The Potato Field, Cutchogue, Long Island, New York*, 1982. Oil on canvas, 15 × 34 in (34 × 86 cm). Courtesy Marlborough Gallery, New York.

165 Lizbeth Mitty, *Halfway House for the Dead and Dying*, 1983. Acrylic on canvas, 71½ × 108 in (181·5 × 274 cm). Courtesy Rosa Esman Gallery, New York.

166 William Beckman, *The Building of a New Milk Barn*, 1983–4. Oil on museum board, 48¼ × 84¼ in (122·5 × 214 cm). Courtesy Allan Frumkin Gallery, New York.

composition stems in large part from the use the painter has made of a very modern feature – the pole in the foreground and the wires which it carries. These are used to divide the space in a way which refers to modern abstract painting – it is not too fanciful to discover an allusion to Ellsworth Kelly. Sultan also sees landscape painting as a statement about the presence of man in nature, and in this painting he makes the point in a neatly epigrammatic, totally unsentimental way.

Romanticism and realism

The landscapes painted by Beckman and Sultan are in the strict sense realistic. Other contemporary American landscapists are more inclined to use the 'real image' as a cloak, a metaphor for romantic feeling. One of the best-known artists working in this vein is Neil Welliver, whose wilderness scenes become more abstract, more detached from particular observation, the longer one looks at them – even though one

167 Sylvia Plimack Mangold, *Trees at the Pond*, 1984. Oil on linen, 60 × 80 in (152 × 203 cm). Courtesy Brooke Alexander, New York.

168 James Doolin, *Last Painter on Earth*, 1983. Oil on canvas, 72 × 120 in (182·5 × 304·5 cm). Courtesy Koplin Gallery, Los Angeles.

169 (*Above left*) Neil Welliver, *Brook Barrier*, 1984. Oil on canvas, 96 × 96 in (243·5 × 243·5 cm). Courtesy Marlborough Gallery Inc., New York.

171 (*Above right*) Gary Washmon, *Isolation*, 1983. Acrylic on canvas, 72 × 96 in (182·5 × 243·5 cm). Courtesy Frumkin and Struve Gallery, Chicago.

170 Albert York, *Landscape with Two Indians*, 1978. Oil on wood, 12½ × 10¾ in (31·5 × 27 cm). Courtesy Davis and Langdale Company Inc., New York.

knows that the pictures are based on the artist's backpacking expeditions into the remoter parts of Maine. The architecture of Welliver's pictures, the way the marks ripple from corner to corner, from edge to edge of the canvas, make it plain that Abstract Expressionism, as well as the romantic landscape painting of the nineteenth century, is part of his heritage.

Another artist who has fairly recently taken to landscape painting is Sylvia Plimack Mangold. In earlier work, Mangold concentrated on images which were intensely realistic but which functioned like abstracts. One group of paintings were views of wooden floors seen as 'planes without context' (the artist's phrase), filling the entire canvas. Her landscapes show the country round her home in Washintonville, New York, in evening light. Everything is in a state of transition – the artist's eye has no sooner begun to grasp the scene before it than this fades away. The equivocal nature of representing something so transitory is emphasized by the painted *trompe l'oeil* masking tape which frames the image. The representation thus goes through not one but two stages of removal. The spectator is looking at a painting of a landscape painting, just as Chuck Close paints, not people, but photographs of people.

Very different from Welliver and Mangold, but somehow connected to them psychologically, is Albert York, to my mind one of the most original figura-tive painters working in the United States. Whereas Welliver paints very large canvases, in the expected modern manner, York is a quietist, who works slowly and on a small scale. His paintings cover a range of subject-matter. There are pure landscapes, painterly and somewhat reminiscent of Corot. There are flower paintings, in which one might perhaps detect the influence of Chardin. There are pictures of cows. And there are figure-studies. A painting of *Two Indians Standing in a Landscape* deserves its place in this section for two reasons. Firstly, that the figures are clearly emanations of the *genius loci*; they personify the character of the place where they stand with naive literalism. Secondly, they demonstrate York's unique combination of apparent awkwardness and skill – the crudity, or at any rate the bluntness of the drawing is belied by the tender handling of the paint itself, where every brushmark is alive and rhythmic. It is as if one of the Impressionists had revised Edward Hicks's *The Peaceable Kingdom*.

Albert York escapes from all the usual categories. Other painters of what one might describe as 'metaphoric' landscape can be grouped together, not only because they at least superficially resemble one another, but because they can be related to a particular aspect of the American pictorial tradition. James Doolin and Gary Washmon are scions of Western and Southwestern art as this has developed over a period of more

than half a century. Their landscapes conceal the particular within the apparently abstract. The powerfully simplified forms they use are intrinsic – not imposed, but already part of what they have chosen to paint. Though they are specifically American in style, they also have a relationship with a universal romantic tradition. Doolin's *Last Painter on Earth*, for example, is a Western American version of a theme tackled by the greatest of all German landscapists, Caspar David Friedrich. Nearer to home, one notices the likeness between these paintings and the work of Georgia O'Keeffe and also of Alexandre Hogue. In fact, these painters reassert ideas and values prevalent in American art of the interwar period and afterwards submerged by the success of Abstract Expressionism.

American still-life

If American landscape painting continues to flourish, so too does still-life, though it is more difficult to pin this down as something which makes specific statements about American nationhood. One can, however, note what seem to be specifically American characteristics. Some of these are old, and some are new. Many Photo-Realist painters, for example, found still-life subject-matter congenial, and the style survives among painters who concentrate on arrangements of objects. Cunning selection can ensure that sharp focus realism links hands with a kind of abstraction, as it does in Charles Bell's paintings of enormously enlarged glass marbles. His pictures call attention to one striking but often misunderstood aspect of photography – the way in which it cultivates ambiguities of scale.

The work of Carolyn Brady and Janet Fish is less obviously photographic, but one is aware that the brightly lit, almost garish quality of their work derives from high-gloss study photographs rather than from anything in the fine art tradition. Both artists make great play with effects of transparency and reflection. In their pursuit of these they venture on to territory also explored by Richard Estes in his townscapes. Janet Fish deliberately exaggerates the flash of colour and reflection until the spreading highlights seem to contradict the nature of the underlying form. Her paint-surface, smooth at first glance, is in fact

172 Charles Bell, *Marbles VIII*, 1982. Oil on canvas, 54½ × 66¼ in (138 × 168 cm). Courtesy Louis K. Meisel Gallery, New York.

hyper-active, full of little flicks of the brush and miniature gestural works. Her paintings are in flux, one layer sliding over another, and the general effect is one of baroque restlessness.

Fish's work makes a striking contrast with that of William Bailey – one which indicates the wide range of possibilities and options still open to the still-life painter. Though he handles paint with extreme tightness and smoothness, Bailey seems to owe nothing to the camera. It is not merely that he represents his subject-matter as the eye sees it, rather than as the lens sees it – that is, without the aberrations of monocular vision – but there is never any ambiguity either of perspective or of scale. The

camera may, however, have had its say at one remove, since it is obvious that he has been influenced by American Precisionists, such as Charles Sheeler, who certainly owed a lot to photography.

The chief thing that makes Bailey's work memorable is the way in which a bland surface only half conceals fierce stylistic tensions. He is an extremely self-conscious artist, and he manipulates the grammar of representation in a very sophisticated way, alluding covertly to many different stylistic exemplars. If Sheeler and the Precisionists are very much present in his work, so too is Morandi. Like Morandi, Bailey uses the same group of banal objects again and again, varying the arrangement slightly from painting to painting. Unlike Morandi, he eschews painterly handling. The arrangement itself, not the surface which can be created by depicting the arrangement, is what matters.

One can also reach much further back into the past and suggest a comparison with Zurbarán. There are enough resemblances to ensure its legitimacy. Like Zurbarán, Bailey arranges his simple domestic objects in a solemn, hieratic way, at eye-level. But the final effect is very nearly the opposite of the one which Zurbarán creates – it is obstinately secular rather than mystical. What Bailey seems to want to tell us is that life itself contains nothing trans-

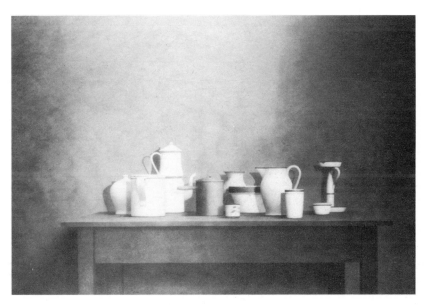

173 William Bailey, *Large Still-Life*, Rome, 1977. Oil on canvas, 52½ × 78 in (133 × 198 cm). Courtesy Fendrick Gallery, Washington DC.

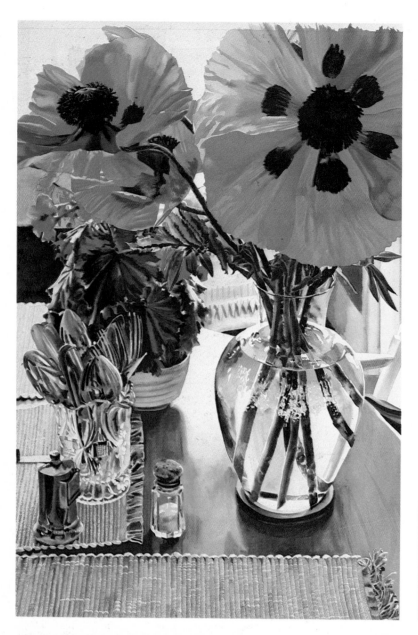

174 (*Left*) Carolyn Brady, *Large Red Orange Poppy with Blue Table Mats*, 1983. Watercolour on paper, 43 × 29 in (109 × 73·5 cm). Courtesy Nancy Hoffman Gallery, New York.

175 (*Bottom*) Janet Fish, *Chinoiserie*, 1984. Oil on canvas, 42 × 132 in (106·5 × 335 cm). Courtesy Robert Miller Gallery, New York.

176 (*Below*) Paul Wonner, *Imaginary Still-Life with Slice of Cheese*, 1977–81. Acrylic on canvas, 70 × 48 in (177·5 × 121·5 cm). Courtesy John Berggruen Gallery, San Francisco.

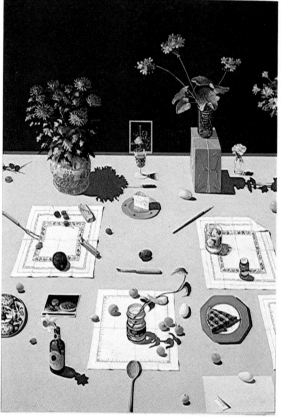

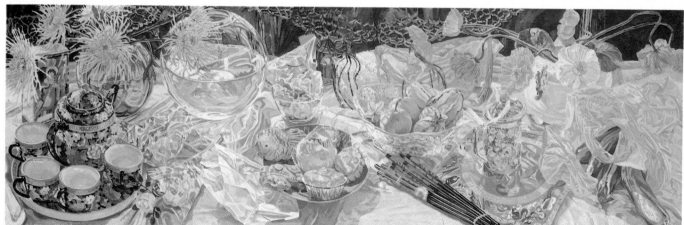

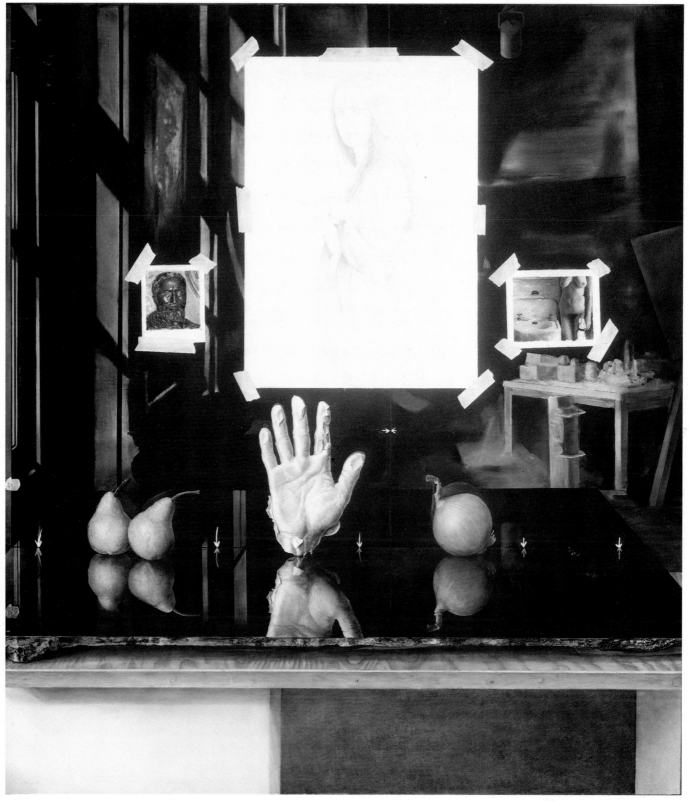

177 Steve Hawley, *Black Glass Still-Life*, 1983–4. Oil, wax, alkyd on board, 40½ × 36 in (103 × 91·5 cm). Collection Mr and Mrs Graham Gund.

178 Nick Boskovich, *Heart's Dilemma*,
1983. Oil on board, $3\frac{7}{8}$ in × $6\frac{1}{2}$ in
(10 × 16·5 cm). Courtesy Stella Polaris
Gallery, Los Angeles.

cendental; 'The world is everything that
is the case', as Wittgenstein put it. Bailey
combines secularism and puritanism in
a peculiarly twentieth-century form.

The stylistic manipulation which pro-
vides Bailey's work with its dynamic is
present in rather simpler form in the
work of a number of other American
still-life painters. Nick Boskovich, in his
small still-lifes, alludes to the art of
William Harnett and John Peto, yet his
paintings, with their spare clarity, be-
long unmistakably to the present time.
Paul Wonner prefers Dutch ancestors to
American ones. His paintings, table-
scapes of objects carefully spaced across
the picture-surface, are based on the

179 Donald Roller Wilson, *The late-night
Disappearance of Mrs Lamar Jenkins as she
was sucked down (and through) the cushion on
her chair where she has been simultaneously
eating her dinner and reading*

Mrs Jenkins found a book (she judged it
by its cover) the title *and* the text had been
reversed
She struggled through the words while
feeling certain they were a great and
ancient treatise on the Universe
She vaguely felt the words she read were
forecasts of warped space a black-hole
theory written in Greek Verse
And the more she read, the more she
ate, and as her weight increased she sank
and – bar her cushion – was submerged.

1983. Oil on canvas,
36 × 50 in (91·5 × 127 cm). Courtesy Moody
Gallery, Houston.

still-life paintings of the early seven-
teenth century, which separate the vari-
ous items in the same fashion, and use
the same kind of bird's-eye view. Yet
Wonner is not in any way a pasticheur –
his handling, choice of colour schemes
and style of drawing all relate him
unequivocally to the art of today.

The virtuoso still-life

Until recently modern American art,
like modern art everywhere, showed a
certain hesitancy about displays of vir-
tuosity. This, where it existed, was dis-
guised – the masking can be found in
different forms. One example is the
carefully-careless handling of Pollock.
Today, Neo-Expressionism is often a
technical paradox: the virtuosity of the
deliberately lumpish.

The dialectic of styles within modern-
ism nevertheless seems to demand that
every extreme should immediately
evoke its opposite. A new technical
bravura is therefore beginning to
emerge in American painting, and one
of the places where it displays itself most
clearly is in still-life. Steve Hawley is a
remarkable new American realist, with
links to the *trompe l'oeil* tradition which
has already been discussed. Not all of his
work is still-life – works involving the
figure play an important part in his total
oeuvre – but even here one finds a kind
of interplay of genres, with figure sub-
jects presented as pictures within pic-
tures. Three things are impressive about
Hawley's work. One is his skill in hand-
ling a wide range of difficult traditional
techniques: he draws in silverpoint and
paints both in egg tempera and in wax
encaustic. Another is the way in which
the picture becomes not merely a rep-
resentation but an actual equivalent of
what it depicts, such is the intensity
with which everything is seen. A third is
the poetic force of the imagery, which
always makes a coherent symbolic
statement.

Donald Roller Wilson is also the mas-
ter of a highly polished technique. He
uses this to generate incongruity, which
in turn induces unease and tension in
the spectator. In some ways, therefore,
he is like Salvador Dali, who used an
academic technique borrowed from
Meissonier for the same purpose. What
one may call Roller Wilson's stylistic

matrix, is an idea about Dutch still-life
painting: the most nearly exact descrip-
tion is to say that he creates an imitation
of an imitation, mimicking Dutch still-
life technique of the Golden Age as this
was perceived by nineteenth-century
eyes.

The still-lifes he paints are visible
moments in an otherwise hidden flow of
narrative – they refer to personages who
exist in the painter's imagination as
fully rounded personalities. This is why
the pictures often seem to allude to an
action which has just taken place, to
someone who has just left the room – we
are shown, for example, a cigarette butt
crushed out on an uneaten hamburger,
which is congealing slowly on its plate.
The detail arouses a certain queasiness
in the spectator, but also curiosity.
Similarly, the vulgar bad taste of many
of Roller Wilson's props alludes not to
the artist's own preferences, but to those
of some imagined character, whose per-
sonality they delineate. The meaning of
the imagery is elaborated by means of
circumlocutory titles, often many words
long, and by the use of kitsch frames –
some padded and mock-Victorian,
others parodying the frames used for
Dutch seventeenth-century paintings in
museums.

Roller Wilson has sometimes ven-
tured away from still-life, into territory
once occupied by Teniers, by making
paintings of animals winsomely dressed
as humans. These too form part of the
hidden narrative which is the essential
armature of his art.

It has been customary to suggest that
Roller Wilson is isolated – a cult figure.
On the contrary, he possesses qualities
which appear with increasing frequency
elsewhere in American art. He is obvi-
ously comparable to the Neo-Surrealists
who have already been discussed. His
private world, possessed of its own his-
tory, makes him a colleague of artists
like Charles Simonds, inventor of the
Little People, even though the narra-
tives Simonds elaborates are so different
both in content and in tone. Finally, he
is visibly a regionalist painter: he may
exhibit in New York but is unaffected by
the New York art world. Roller Wilson's
dreams and fantasies have a gothic
elaboration which is typical of the
American South – they are James Purdy
in paint. The new regionalist impulse
will be the subject of the concluding
chapters in this book.

CHAPTER ELEVEN

FIGURATION AND STYLE

Art history is a growth industry in the United States, and its discoveries as well as its disputes play an increasing role in the cultivated consciousness. Stylistic inflections carry messages which can be picked up and interpreted by a wide spectrum of art lovers. In addition, taste itself has become increasingly plural. Artists are not obliged to conform to a single stylistic orthodoxy, or else to rebel against it absolutely in the hope of imposing a new and different one. Our culture permits them to react in their own way to a wide variety of different stimuli. These factors help to account for the huge variety of different kinds of figurative painting now practised in America. Some of these choices have already been discussed, in the chapters devoted to New Image Painting, Neo-Expressionism, Replication and Illusionism.

My purpose now is to analyse the wide range of choice available in so-called 'realistic' painting, especially when this is not merely figurative but centred on the portrayal of the human figure. The painter or sculptor who represents not landscape or objects but mankind can never be entirely neutral. This applies even to artists whose imagery is drawn from photographs rather than from direct observation – there is, for instance, a world of difference between Andy Warhol's treatment of portrait heads and Chuck Close's.

Philip Pearlstein and Al Leslie

Two of the best-known painters of the figure in America are Philip Pearlstein and Al Leslie. Though often yoked together, they take completely opposite

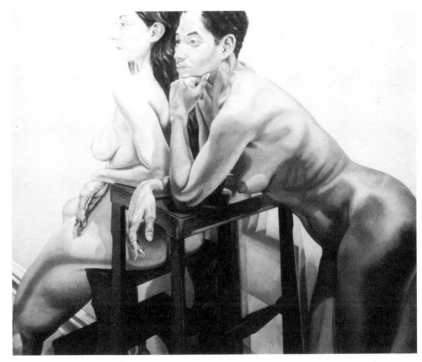

180 Philip Pearlstein, *Two Models with Library Ladder*, 1983. Oil on canvas, 60 × 72 in (152·5 × 182·5 cm). Courtesy Allan Frumkin Gallery, New York.

approaches to the representation of human beings. Pearlstein has painted landscapes, and a few portraits, notably those of his young daughters, but his most familiar paintings show nude models, male and female, accompanied by a few props – a patterned rug, a wicker chair. The most conspicuous feature of these paintings is a certain oddity of composition. The figures are strangely placed within the rectangle of the canvas, and are often brutally cropped. Pearlstein's method of work explains these characteristics – he

paints directly from the life, beginning with one figure and continuing, without revising the proportions he has begun with, until the space is filled. The composition is thus deliberately arbitrary – a slice of life in the strictest sense of that term. Pearlstein's paintings put forward the idea that contemporary visual experience is non-hierarchical: that the experiences which operate on us in the modern world are so overwhelming in their multiplicity that we cannot make choices, but must accept what is given. As so often, a studied refusal to com-

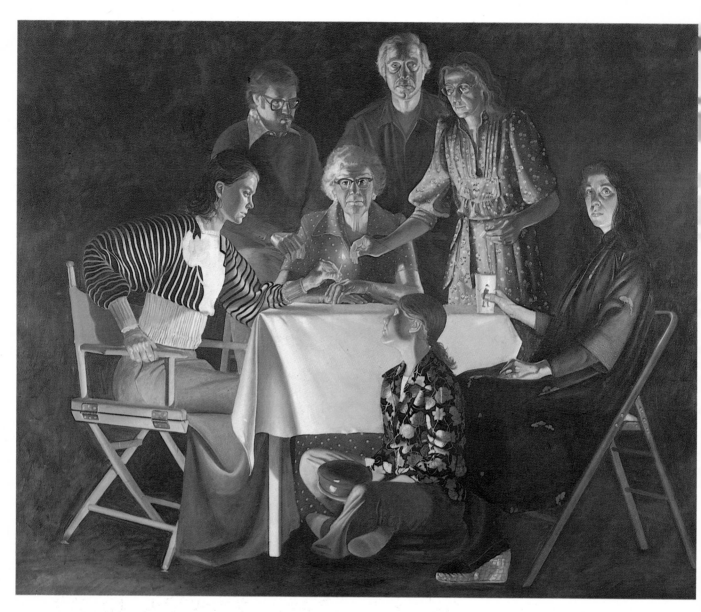

181 Al Leslie, *Birthday for Ethel Moore*, 1976.
Oil on canvas, 108 × 132 in (274 × 335 cm).
Courtesy Allan Frumkin Gallery, New
York. Photo eeva-inkeri.

ment becomes a judgement in itself.

Leslie, once an abstract artist, has reacted strongly against his own past, and at the same time come to challenge modernist assumptions in general. Like many American painters, he has a strong sense of history, and he is equally American in the way he tries to incorporate this instructive feeling into his own work, making it part of a personal myth. The art which seems to have moved him most is the art of the early Baroque period in Italy, of Caravaggio and his followers in particular. Yet the physical types and the psychological atmosphere of his work belong unmistakably to our own period. In Leslie's ambitious *A Birthday for Ethel*

Moore, the lighting is Caravaggesque, but furniture and clothes are contemporary. Equally contemporary is the painter's interest in the nuances of private relationships. The monumental scale (the picture is as large as most Baroque altarpieces) demonstrates the paramount importance he attaches to these, despite his wish to rival the Old Masters.

There is a tension in Leslie's work between private and public meanings. He sees his paintings as things designed essentially for exposure in museums, and as vehicles for moral statements. But they also contain emotional tensions and ambiguities whose causes are not fully exposed to the spectator. The

painting of the past may speak of private emotion (for example, Rubens's *Helena Fourment in a Fur Robe* – a tribute to his second wife), just as it often speaks of public concerns (for example, David's *Death of Marat*, which Leslie admires), but it seldom confuses the two.

American Post-Modernism

Leslie's work can be seen as a revival of 'history painting' in the traditional sense of that term, but modulated and inflected to suit a new set of circumstances. This is just one of the alternatives open to American painters of the figure, even within the boundaries of the realistic tradition, but a large number of artists have followed it. Jillian Denby's large realist compositions, for instance, hark back to the great academic 'machines' which featured so prominently in nineteenth-century Salons, but always contain a deliberately dissonant note which proclaims their modernist status. David Ligare's classical scenes are superficially similar, but more naïve in their approach – a strange mixture of the classicism of Leighton and Alma-Tadema and the more recent version of it purveyed by Cecil B. de Mille. It seems appropriate that Ligare lives and works in California.

A more easily definable kind of Post-Modernism, in line with current developments in architecture, appears in paintings by Martha Mayer Erlebacher. Her *Mars and Venus* of 1983 is directly

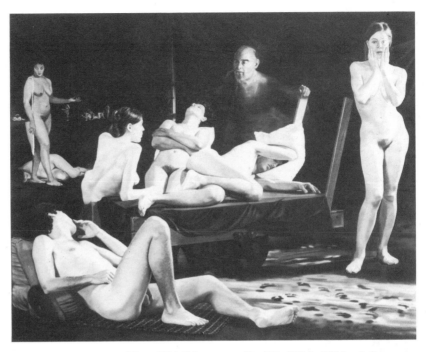

182 Jillian Denby, *House of Sleep*, 1976. Oil on canvas, 72 × 92 in (182·5 × 233·5 cm). Courtesy Alexander F. Milliken Inc., New York.

comparable to classical subject-pictures by J. L. David, particularly the late *Cupid and Psyche* in Cleveland. It borrows David's trick of compressing and flattening a group of figures within an architectural space which holds the grouping rigid for our inspection. But here, too, one catches a dissonant note: the contemporary quality of the two heads is unmistakable to the eye, though difficult

to define in words. Partly it is simply a matter of style – the way the hair is worn – partly something to do with lack of idealism in both heads and bodies.

Deliberate anachronism has become one of the weapons of the American realist painter. Sometimes we are challenged to recognize the model and distinguish it accurately from the pastiche. This is the case with Edward Schmidt's

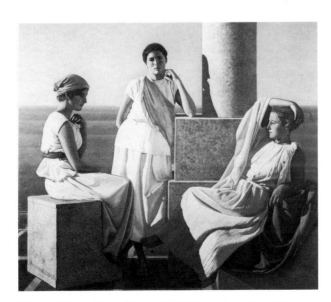

183 David Ligare, *Three Women*, 1983. Oil on canvas, 82 × 90 in (208 × 229 cm). Courtesy Koplin Gallery, Los Angeles.

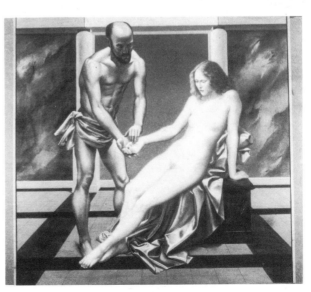

184 Martha Mayer Erlebacher, *Mars and Venus*, 1983. Oil on canvas, 52 × 52 in (132 × 132 cm). Courtesy Robert Schoelkopf Gallery, New York.

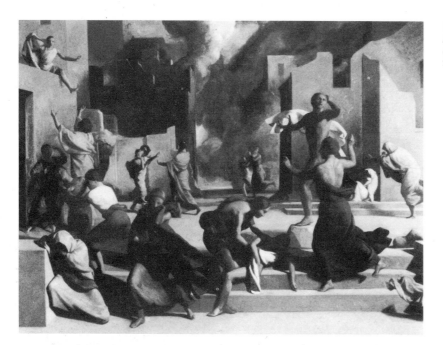

185 Edward Schmidt, *Destruction of a City–Dies Irae*, 1982. Oil on canvas, 36 × 48 in (91·5 × 122 cm). Courtesy Robert Schoelkopf Gallery, New York.

186 (*Far left*) Richard Piccolo, *Allegory of Painting*, 1982. Oil on canvas, 40 × 32 in (101·5 × 81 cm). Courtesy Robert Schoelkopf Gallery, New York. Photo eeva-inkeri.

187 (*Left*) Richard Piccolo, *Allegory of Sculpture*, 1982. Oil on canvas, 40 × 32 in (101·5 × 81 cm). Courtesy Robert Schoelkopf Gallery, New York. Photo eeva-inkeri.

188 (*Below left*) Bruno Civitico, *Mars and Venus*, 1982–3. Oil on canvas, 54 × 63 in (137 × 160 cm). Courtesy Robert Schoelkopf Gallery, New York. Photo eeva-inkeri.

189 (*Below right*) Milet Andrejevic, *Apollo and Daphne*, 1982. Egg tempera and oil on canvas. Courtesy Robert Schoelkopf Gallery, New York.

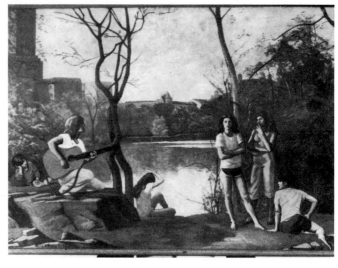

Destruction of a City: Dies Irae, which is a learned tribute to Poussin. It is also the case with Richard Piccolo's paintings, which allude to a later phase of the Italian Baroque than the one favoured by Al Leslie. Piccolo's *Allegory of Sculpture* and *Allegory of Painting* celebrate a variety of North Italian art known only to seventeenth-century specialists. It is only something about the actual rhythm of the brushwork which signals a difference from Piccolo's models.

Usually, in painting of this type, the clues are more obvious. Bruno Civitico's *Mars and Venus* contains subsidiary figures in modern dress, one of them a Balthus-like adolescent girl with an overlarge head which serves as a pointer to an additional source of inspiration. Balthus's influence on American figurative painting has yet to be assessed, but was certainly widespread long before the 1984 Balthus retrospective at the Metropolitan Museum in New York. Civitico speaks of his wish to 'salvage remnants of the Italian Renaissance and the Baroque', and stresses the narrative as well as the purely classical content of his work.

The wittiest and most playful practitioner of the game of deliberate anachronism is Milet Andrejevic, a Yugoslav immigrant who has lived in the United States since 1958. His range of subject-matter is narrow – he paints idyllic scenes set in New York's Central Park. The participants, though obviously contemporary figures, re-enact mythological scenes from the repertoire familiar to Poussin.

One further name must be added to this group of classicists: that of the New Orleans painter George Dureau. Dureau is a powerful but uneven artist whose recent reputation as a photographer is in some danger of overwhelming his much longer established career as a painter. Dureau's photographs are severe. His subjects, nearly all of them male, are shown stripped bare psychologically, and they are often physically nude as well. This is the more startling because many are maimed or deformed. The photographs, which Dureau now pursues as an independent art-form, were originally undertaken as studies for paintings. The paintings themselves, usually large in scale, have now taken on a flaunting exuberance which seems designed to show the spectator all the things the camera *cannot* do. Exuberant

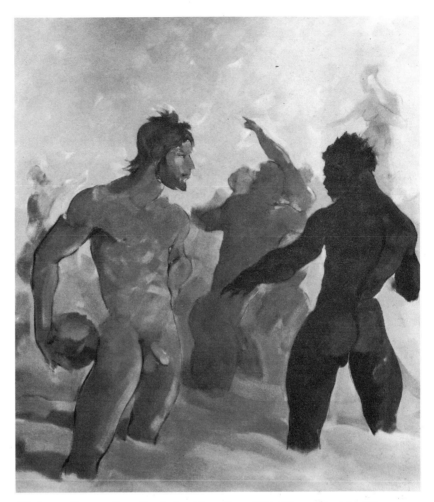

190 George Dureau, *Young Men Bathing Near a Shore*, 1984. Oil on canvas, 76 × 66 in (193 × 167·5 cm). Courtesy the artist.

and more than a little over-ripe, Dureau's mock-classical compositions express a spirit found in twentieth-century Southern literature – in Tennessee Williams, for example – but one which has until now lacked a convincing expression in art.

Another interesting feature of Dureau's art, more visible in work produced a decade ago than it is now, is its debt to Francis Bacon. Dureau was particularly impressed by Bacon's ability to find foundations in reality for the apparently grotesque and fantastic. An example is Bacon's use of Eadweard Muybridge's photographic studies of deformed children as a basis for paintings. These inspired Dureau to make photographs of handicapped people, such as the legless B. J., initially as studies for paintings, later as works of art in their own right.

Modernist historicism

American artists who paint the figure have been as ready to plunder the art of the twentieth century as that of the Renaissance and the Baroque. This corresponds to a general feeling in American art-historical studies: that the past finishes precisely where the contemporary begins, with no intervening epoch where things remain for the moment grey and undecided. The revival of interest in the art of the 30s is already making itself felt in the American painting of the 80s. Lance Richbourg's work owes something to Edward Hopper, though he tackles subjects, such as sportsmen in action, which did not interest the earlier artist. Perhaps one also sees here a current of influence from the photography of the period. Leonard Dufresne is a more complex and intriguing case. He uses a tubular style for the

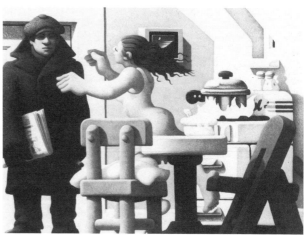

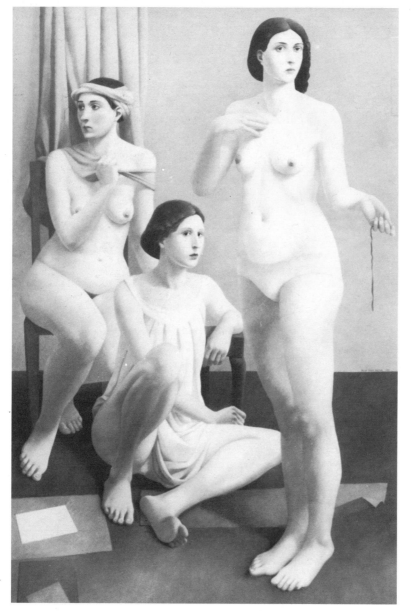

191 (*Above left*) Lance Richbourg, *Honus Wagner at Bat*, 1980. Oil on canvas, $62\frac{1}{4} \times 83\frac{1}{4}$ in (158 × 211 cm). Courtesy O. K. Harris Works of Art, New York. Photo D. James Dee.

192 (*Above right*) Leonard Dufresne, *Flames like Maple Leaves, A Woman goes for a Man*, 1983. Acrylic on canvas, 18 × 24 in (45·5 × 61 cm). Courtesy O. K. Harris Works of Art, New York. Photo D. James Dee.

193 (*Left*) Alan Feltus, *Three Figures*, 1981. Oil on canvas, 66 × 44 in (167·5 × 111·5 cm). Courtesy Forum Gallery, New York.

194 (*Opposite*) James Valerio, *Pat Combing her Hair*, 1983. Oil on canvas, 93 × 100 in (236 × 254 cm). Courtesy Allan Frumkin Gallery, New York.

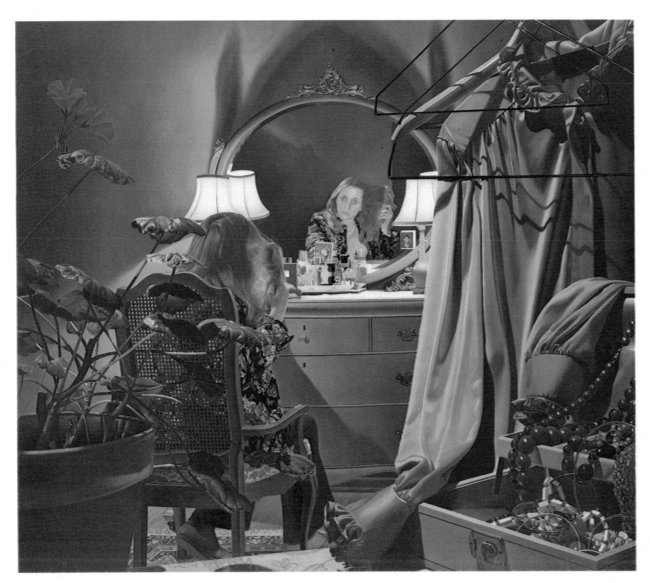

depiction of figures which inevitably calls to mind the work of Léger. Léger himself was often in the United States during the 30s, and had an impact on the American art-world second only to that of Diego Rivera, but at that time there was no artist who wholly absorbed his figurative style, though Stuart Davis learned much from the more abstract and classically Cubist elements in Léger's work. Dufresne's painting also resembles, and even more closely, that of the English painter William Roberts, who, after beginning his career as a Vorticist follower of Wyndham Lewis, spent a long career adapting Léger's quirks and mannerisms to the English taste for domestic narrative.

One of the subtlest and most elegant of all the artists classifiable in this fash-

ion is Alan Feltus, whose elegant groups of females, nude and partly clothed, convey reminiscences of Casorati and the Italian classical painters of the inter-war years. There are two lines of thought one can follow here. The first is that almost no epoch of the past is now safe from the investigations of contemporary artists. Because of their associations with Mussolini's Fascism, the artists of the Italian Novocento movement were neglected until very recently, and comparatively little of their work is available in reproduction. The second is that classicism is becoming all-pervasive in American figurative painting, especially among artists who paint figure itself. This classicism shows itself in one way in Feltus's work, and in quite another in that of Martha Mayer Erleba-

cher. The second line of investigation is the more important because it points, not just towards the recognition of a change in taste, but to a change in the whole climate of style.

The figure and narrative

Many of the paintings already discussed and illustrated in this chapter contain narrative overtones, and commentators have often found these more important than the stylistic manipulations which I have been considering up to this point. The narrative impulse can be perceived even more clearly in work which is not so insistently placed between quotation marks – for instance, in the solidly realistic figurative painting of James Valerio and Catherine Murphy. Neither

195 Catherine Murphy, *Elena, Harry and Alan in the Backyard*, 1978. Oil on canvas, $39\frac{1}{2} \times 45\frac{1}{2}$ in (100 × 115·5 cm). Courtesy Xavier Fourcade, New York.

196 (*Below left*) Lynn Randolph, *Sorcerer Facilitating*, 1983. Oil on canvas, 58 × 46 in (147 × 117 cm). Courtesy Graham Gallery, Houston.

197 (*Below right*) Eric Fischl, *Imitating the Dog—(Mother and Daughter II)*, 1984. Oil on canvas, 96 × 84 in (243·5 × 213 cm). Courtesy Mary Boone Gallery, New York.

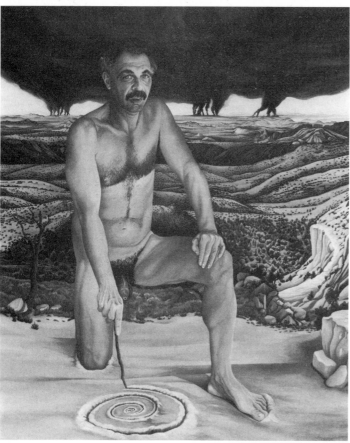

198 Robert Birmelin, *Handshake from a Stranger* (2nd version), 1981–2. Acrylic on canvas, 47 × 70 in (119 × 177·5 cm). Courtesy Fendrick Gallery, Washington DC.

artist is confined to the narrative mode – Murphy paints landscapes without figures, though even these often offer a hint of narrative content, and Valerio also ranges wide: he has produced an important series of still-life paintings. Valerio is a dazzlingly proficient artist whose work reveals both the strengths and some of the weaknesses of contemporary American realism. He shows both the willingness of American realists to work on an ambitious scale, and their frequent failure to justify this by the necessary charge of emotion.

A painting of Valerio's which does not suffer from this fault, and which shows his matchless technical skill to the full is *Pat Combing Her Hair*. The painting echoes a version of the *Vanitas* theme often found in seventeenth-century art, where the artist shows the repentant Magdalen holding a skull and gazing at herself in a mirror. Valerio's painting lacks the skull, but there are some traditional *Vanitas* symbols in addition to the mirror itself – the beads and baubles spilling from a drawer in the right foreground – and the model's face has a curiously sorrowful expression which reinforces the comparison. Valerio here distils a kind of pictorial magic which has little to do with the apparent ordinariness of its theme.

Some narrative artists dabble with the idea of magic in a more direct and specific fashion. One is the Houston-based painter Lynn Randolph, who says, 'I think that going from the particular physical to the metaphysical (via juxtapositions that form a metaphor) is a way to allow the content to bind itself to the structure of the context within which it appears.' An interest in transcendental content expressed in intensely realistic form also appears in the work of Jules Kirschenbaum, whose *Dream of a Golem* rivals Valerio's painting in the intensity of its vision.

The sharpness of focus to be found in all these artists – Valerio, Randolph and Kirschenbaum – makes them seem very different in spirit from Eric Fischl, who has become one of the most discussed of American narrative painters. Fischl's handling is, it is true, quite different from theirs – broader and blunter. But like them, he suggests that the painting is a kind of dream, shared by the artist and the spectator. His technical method, however, is different. Instead of sharply realized forms held in hallucinatory stillness, his forms seem subtly to waver and to be on the brink of dissolution. The tendency has been to try and bring Fischl into some kind of relationship with Neo-Expressionism, though it is hard to think of him as an artist who proceeds from a fundamentally expressionist base. His subjectivity is of a different kind. Narrative is fundamental to his work, as it seldom is in fully Expressionist painting, and equally fundamental is a kind of teasing mysteriousness. The directly magical references one finds elsewhere are not present. Instead the spectator is introduced to a looking-glass world, where no assumption, however well-founded in appearance, is entirely safe. Fischl, of all contemporary American artists, is the one who seems to have absorbed the lesson of the cinema most completely. He does not directly copy its images, but he finds an equivalent for the elliptical quality of movies by leading directors otherwise as different from one another as Fassbinder and Ingmar Bergman.

There are a number of contemporary American artists who have been inspired by still photography rather than by the movies in their search for a new kind of narrative expressiveness. Photographs are not necessarily a direct source, as they are with Chuck Close, but they suggest a way of seeing. Robert Birmelin's *Handshake from a Stranger* has some of Fischl's elusiveness. It implies momentary interaction through the very nature of the image, which is a development and indeed an exaggeration of Degas's use of the croppings and foreshortenings found in snapshot photography. Roger Essley's large drawings overlay images apparently taken from family snapshots, and allude to another aspect of the camera – not only its ability to produce strange croppings and unexpected distortions, but its power to single out a particular moment and

199 Roger Essley, *Under the American Side*, 1983. Conté and graphite, 57 × 60 in (144·5 × 152 cm). Courtesy Fendrick Gallery, Washington DC.

200 Jules Kirschenbaum, *Dream of a Golem*, 1980–1. Egg tempera and oil on panel, 45 × 40 in (114 × 101·5 cm). Courtesy Forum Gallery, New York.

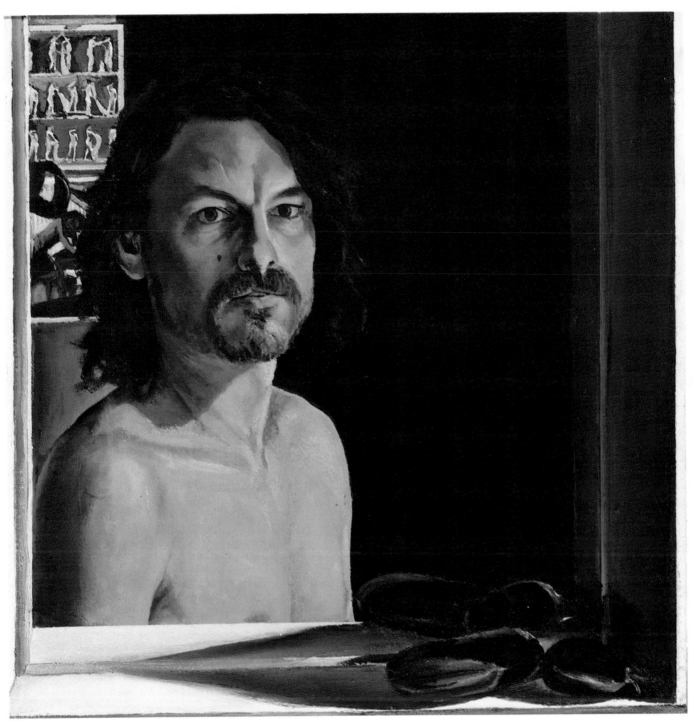

201 Richard Shaffer, *Self Portrait with Inro*, 1982–3. Oil on canvas, 23 × 22 in (58·5 × 56 cm). Courtesy L. A. Louver Gallery, Venice, California.

202 Paul Georges, *Standing Nude Self Portrait*, 1973. Oil on canvas, 81 × 58 in (205·5 × 141 cm). Courtesy Zolla/Lieberman Gallery, Chicago.

203 Daniel Dallmann, *Handling the Ferret*, 1983. Oil on canvas, 52 × 40 in (132 × 101·5 cm). Courtesy Robert Schoelkopf Gallery, New York.

preserve it arbitrarily, rescued from the flux of myriads of such moments.

The self-portrait

Roger Essley's work can be seen not only as narrative but as a kind of oblique self-portraiture. Granted the contemporary concern with selfhood, it is not surprising to find that self-portraits play a considerable role in the American realist art of the present day, sometimes the artist will literally strip himself naked, as in Paul Georges's *Nude Self-Portrait* (there is also an impressive nude double portrait by William Beckman of himself and his wife). Or sometimes the painter will portray himself with an enigmatic attribute, as Daniel Dallman does in his *Handling the Ferret*. In all of these portraits the viewer senses a personal mythology, and the insight is confirmed in Georges's case by the numerous paintings which show the artist in association with the Muse.

Two artists who have made a speciality of the self-portrait are Gregory Gillespie and Richard Shaffer. Gillespie once considered painting self-portraits to the exclusion of all else, and his renderings of his own image make a fascinating series. The early ones have an intensity which bring them close to Flemish and German painting of the late fifteenth and early sixteenth centuries, and to Dürer's self-portraits in particular. The more recent *Myself Painting a Self-Portrait* is more eclectic. The primary figure has a gothic angularity which nuances its apparent realism, but the picture within a picture is a grinning caricature, not gruesome enough to be a *memento mori* in full medieval style, but disconcerting enough in the setting provided for it.

Richard Shaffer is one of the most complex and fascinating of younger American painters, and, more than with most artists, it does him a serious injustice to take his *Self-Portrait with Inro* out of context. For Shaffer, his studio (a large industrial space) is the image of the world, and before he can use it to create paintings, he has first of all to create an appropriate setting. It is therefore an environmental artwork in a continual state of transformation as well as a place to work. The artist – and the privileged visitor – voyage from point to point of this environment rather like Tamino undergoing his ritual ordeals in Mozart's *Magic Flute*. Certain spots are reserved for activities which apparently have little to do directly with making art. There is, for example, a reading desk enclosed within its own cell which might have been borrowed from medieval representations of Saint Jerome in his study. Nearly all of Shaffer's paintings – self-portraits, shadowy interiors and still-lifes – as well as his prints and monotypes are reflections of this studio environment. They are also meditations on the artist's vocation. Realism is often held to be visual prose; Shaffer's alchemy transforms it into poetry.

Realist sculpture

Photo-Realism has not withstood the

competition offered by so many other varieties of realist painting. On the other hand, realist sculpture produced by the life-moulding process has largely driven out figurative sculpture made by more traditional means. The handful of American sculptors who have tried to revive the idealizing neo-classical tradition in the 70s and 80s have only succeeded in producing a series of academic pastiches, endowed with a vulgarity that nineteenth-century sculpture of the same variety succeeded for the most part in avoiding. The one artist who has succeeded in evolving a coherent classical style in sculpture is Robert Graham. Graham's development, from making minuscule wax models in doll's-house environments to his present work in cast bronze, has few links to that of any other American artist.

There are parellels with Giacometti – the more surprising because the two sculptors have such different ideas about surface. Giacometti was tactile and rough; Graham's sculpture is glacially smooth. What the two artists have in common is ideas about scale, and an ability to juggle with the notion of distance. Like Giacometti, though not to such an exaggerated extent, Graham makes his figures smaller than the viewer expects, and provides them with integral bases which are a major part of the piece, considered simply in terms of bulk. It is the plinth which keeps the viewer at a distance, because it provides the figure with an environment of its own, that sets a different scale. It suggests to us that we are in fact looking at a much larger object through the wrong end of a telescope.

In recent works, where the figures are somewhat larger, absolutely, than they used to be, Graham uses the integral plinth as a way of hovering between contradictory notions of life-size and not-life-size. A figure will now be the height of a man, or a little more, but only if the plinth is included in the measurement. A sculpture of this type acts on the surrounding space as powerfully as a full-scale statue, but lays claim at the same time to a special kind of purity, as if the grossness of life had somehow been whittled away. The isolated position which Graham occupies, not only on the American art scene, but in modern sculpture taken generally, demonstrates the difficulty of the path he has chosen to follow.

204 Gregory Gillespie, *Myself Painting a Self Portrait*, 1980. Mixed media, 58½ × 68¾ in (148 × 174·5 cm). Courtesy Forum Gallery, New York.

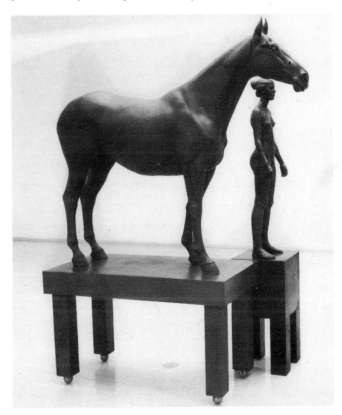

205 Robert Graham, *Spy*, 1981. Cast bronze (artist's proof), 71 × 56 × 14 in (180 × 142 × 35·5 cm); and *Stephanie*, 1981. Cast bronze, 61½ × 11½ × 7½ in (156 × 29 × 19 cm). Collection: Whitney Museum, New York. Courtesy Robert Miller Gallery, New York.

CHAPTER TWELVE

CAUSES

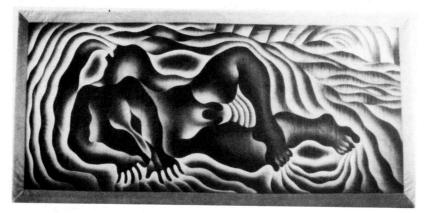

206 Judy Chicago, *Earth Birth*, from the Birth Project, 1982–3. Sprayed fabric paint and quilting (quilted by Jacquelyn Moore), 60 × 144 in (152 × 365 cm). Courtesy ACA Gallery, New York.

American art seems to have become substantially less, rather than more, politicized in the 80s. The decline of the mural movement, already discussed, is one symptom of this tendency to turn away from propaganda. Almost all the big issues of the 70s – feminism, gay rights, support for ethnic minorities – now seem to attract artists less, and to receive less support from them than was the case a decade ago. Those who espouse political causes more and more appear as isolated figures.

Feminist art

One reason for the decline of propaganda art is clearly the success achieved by campaigns in the past. It is very difficult, for example, to think of any leading woman artist in America who has remained untouched by feminism. The important role played by female artists in the contemporary American Art world is amply documented in all sections of this book. Their very success in achieving parity with male colleagues means that many of them are now anxious to dissociate themselves from an aggressively feminist image – one which might, in their view, impose meanings which are not the primary ones.

The leading feminist artist in the United States, Judy Chicago, is thus more and more isolated from the general context of American art. Chicago is not likely to be deterred by this. She is a person of enormous energy, whose celebrity comes as much from the scale of her enterprises, and from the number of people she manages to involve, as it does from the actual product. Her *Dinner Party* was, with Christo's *Running Fence*, the most ambitious art project of the 70s. And like the *Running Fence*, *The Dinner Party* was an exercise in democratization – it tried to involve people who might never normally enter an art gallery, and who had perhaps never thought of creating art themselves. More than this, it was a determined attempt to use contemporary art as a means both of communication and of indoctrination. Lucy R. Lippard, in a long article devoted to *The Dinner Party*, noted that it 'addresses both myth and reality and attempts to transform reality by the exemplary use of art as purveyor of myth'.

Its successor, *The Birth Project*, is in some ways equally ambitious – a nationwide attempt to provide women (and incidentally men) with images of a fundamental experience which has seldom been represented in western art. However, its components are more easily transportable and can be viewed in a more intimate way. It avoids the 'male monumentalism' which some radical feminists criticized in its predecessor.

The primary medium of *The Birth Project* is needlework, and by choosing this Chicago also aligns herself with the increasing tendency to break down barriers between art and craft. She does not do the stitchery herself, but provides designs which are made by a network of volunteer workers. Her art is 'political' not only in content, but because it brings women together and encourages an exchange of ideas and experiences. The designs remain firmly within the artist's own control, and to this extent *The Birth Project* is an autocratic as well as a democratic enterprise – the expression of an outsize ego. It is not surprising, granted the basic ideas underlying the work, that Chicago chooses a style which is probably widely at variance with the instinctive taste of the majority

of her helpers, whom she admits to be largely white and middle-class – 'who else has the leisure?' she asks. The images she uses in *The Birth Project* show many affinities with the work of the leading Mexican muralists of the 30s and 40s, and especially with the most Expressionist of them. José Clemente Orozco. By selecting the Mexicans for her mentors she shows a consciousness of her historical position – her feminism is a 'cause' as that word would have been understood in the 30s. But her underlying Expressionism also links her to one of the main stylistic trends of the early 80s.

The anti-nuclear movement

The anti-nuclear movement had a slower start in the United States than it did in Europe, where the campaign against the Bomb has long been one of the basic planks in a generalized anti-Americanism, as well as being, more intermittently, a major political issue. It thus comes as something of a surprise to discover that the most powerful Jeremiads against nuclear arms are now being preached by an American artist.

Robert Arneson is a ceramic sculptor who has more recently revealed himself as an extremely powerful draughtsman. Identified with California, and with San Francisco in particular, he is one of those artists who feel at odds with the New York art world, despite the fact that he exhibits periodically on 57th Street. He was originally one of the Bay Area ceramicists who occupied a kind of No-Man's Land between art and craft, seriousness and jokiness. His art has two basic characteristics. It is unabashedly self-concerned (many of his sculptures and drawings are self-portraits), and it is sensitively attuned to the media. In his introduction to Arneson's 1983 exhibition *War Heads and Others*, Jonathan Fineberg wrote:

Robert Arneson's sculpture and drawings express his subtle sensitivity to the way that the art object and even the artist himself is experienced through the media mentality which currently dominates our culture. Media thinking reduces ideas to literal qualities to make them reproducible; it is this literalness which Arneson is constantly pushing to extremes in his subject matter and in so doing he

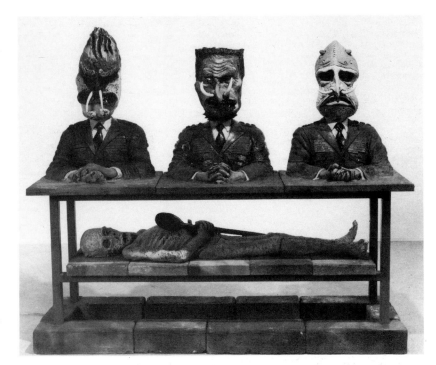

207 Robert Arneson, *Sarcophagus*, 1984. Ceramic, steel, polychrome glaze, 71 × 90 × 26 in (180 × 228·5 × 66 cm). Courtesy Frumkin and Struve Gallery, Chicago.

heightens our insight into the way that the prevailing modes of thought have altered our experience of events.

His anti-nuclear pieces are notably gruesome. The 'literalness' Fineberg speaks of is reinforced by the medium chosen – glazed clay can so easily be made to replicate other surfaces, even that of charred flesh. Arneson is not, however, chiefly a replicator, like Victor Spinski. He is increasingly influenced by primitive art, and especially by African tribal sculpture. He implicitly compares the savagery of modern industrial society to that of peoples who are still uncivilized.

The gay rights movement

Arneson has also spoken up for gay rights. In 1981 he produced a *Portrait of George (Moscone)* which commemorated the assassinated mayor of San Francisco. Originally commissioned by the city itself, the piece was rejected because of its too explicit references both to the bizarre murder and to the trial which followed it. In addition to making the sculpture, Arneson took Harvey Milk as the subject for a series of drawings. Milk, assassinated along with the mayor, was the openly homosexual city councilman

whose appointment triggered both murders. These works were not only controversial in themselves but distinctly unusual within their context.

Openly homosexual art suffered an eclipse for less obvious reasons. One was that it never, despite attracting a certain amount of media attention, succeeded in making its escape from the gay ghetto – homosexual artists exhibited at galleries which specialized in art with homosexual content. These galleries have been early victims of the change of climate – where there were three operating full-time in New York in the late 70s, none remains open today. The other reason was that homosexual art tended to be hedonistic rather than militant. Its mood is well summarized in Delmas Howe's 'Gay Rodeo' series – fantasies based on the painter's memories of being brought up in the West, on his interest in classical myth, and on the dream or nightmare experienced by many people, heterosexuals and homosexuals alike, of inexplicably finding oneself naked in public, when everyone else is clothed. Howe, who also paints landscapes and pursues a successful career as a muralist, says he has at the moment no intention of reverting to homosexual themes because he sees no outlet for his work in this vein.

208 Delmas Howe, *Zeus (Riding the Bull)*,
1981. Oil on canvas, 36 × 46 in
(91·5 × 116·5 cm). Courtesy the artist.

Photography

To include a section on photography in a chapter headed simply 'Causes' may seem deliberately provocative. It is certainly intended to provoke thought about the position of photography in relation to the world of fine art. In theory, the 70s saw an increasing acceptance of photography's claim to be a means of expression on the same level as painting or sculpture. No one writing a book on the present state of American art can hope to ignore it, and equally no one can hope to cover it adequately, since photography is above all prolific. Just as they always did, its practitioners continue to produce a relentless cascade of images, which fall into a multitude of different categories. To discuss and analyse them all would require a book at least twice the length of this one.

Yet there is one strange thing about contemporary photography – which is, that though it claims to be just another means of expression, it continues to generate polemic. It remains its own cause, and this suggests that its status as 'art' remains fundamentally in question. A minority of photographers succeed in getting themselves shown in regular commercial art galleries – places which show a full range of other art works rather than specializing in photography. In museums, they were until recently confined to specially organized departments of photography, and are seldom exhibited side by side with painting and sculpture. From the art world's point of view photography is like a fish slightly too large for a pelican's gullet. The bird can neither swallow it down nor manage to spit it out again. The photographers who have now won full acceptance as fine artists are a motley crew. The thing they most often have in common is the fact that, like George Dureau (who paints) or Robert Mapplethorpe (who used to make environmental collages), they practised some other form of fine art and had a footing in the art scene before they ever turned to the camera.

While American painting continues to show a surprising nervousness about

209 Robert Mapplethorpe, *Untitled*, 1981.
Gelatin silver print. Courtesy Robert
Miller Gallery, New York.

210 George Dureau, *Dwayne Robinson*,
1985. Gelatin silver print. Courtesy the
artist.

depicting the male nude, and galleries an equivalent nervousness about exhibiting such nudes, it is interesting to see that three of the American photographers now most completely accepted as 'artists' have made the male nude or at any rate the near-naked male something of a speciality. Dureau, Robert Mapplethorpe and Bruce Weber have this in common. They have other things in common as well. One is a discernible current of homo-erotic feeling, acceptable to a wide audience here, though apparently unacceptable in painting. Another is the fact that all three are the very opposite of spontaneous. Their images are always austerely disciplined. In this they may owe something to a shared ancestor – George Platt Lynes. But it is also clear that they owe a good deal in a more general sense to a tradition founded by Richard Avedon and Irving Penn, who were highly regarded fashion and advertising photographers long before claims were made for them as fine artists.

Another kind of fine art photography is distinguished not only by stringent control of the image but by a delight in recording situations which are deliberately and obviously artificial. William Wegman's colour polaroids in large for-

mat show situations which have been created for the purpose of the photograph. They put the 'reality' of the situation shown (guaranteed by the camera itself) within a set of quotation marks. The prevailing mood is urbanely humorous and ironic.

The French-born photographer Alain Clement, now resident in Houston, creates miniature stage-sets which he afterwards photographs. The rearing horse in the image shown here is a model; the mirror which reflects it is a piece of doll's-house furniture. Clement says:

If the photograph preserves the intrinsic qualities it has had since its invention, it has now been freed from its obligation to act as a witness and lends itself more freely to experimentation. I see it as a tool which is put at the service of an idea. Words cannot express the motions of the imagination, because it is unsatisfactory to have to put these into coded form; but the image becomes a marvellous means of communication. Rather than drawing from nature, which then has to be transcended, the images which will permit me to represent my thoughts, I prefer to construct images which are the reflection

211 (*Above left*) Bruce Weber, *Bill Scherr and Jim Scherr, Wrestling*, 1983. Gelatin silver print. Courtesy Robert Miller Gallery, New York.

212 (*Above right*) William Wegman, *Green Giant*, 1982. Coloured photograph, 20 × 24 in (50·5 × 61 cm). Polaroid Land camera using Polacolor II film. Courtesy Holly Solomon Gallery, New York.

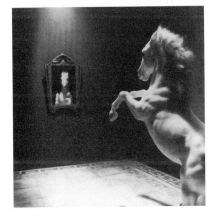

213 Alain Clement, *Horse and Mirror*, 1982–3. Gelatin silver print, 20 × 16 in (50·5 × 40·5 cm). Courtesy Graham Gallery, Houston.

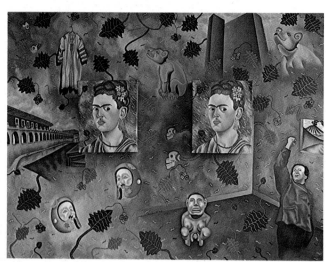

214 Francisco Alvarado-Juarez, *Frieda Kahlo: Her Dress Still Hangs Here*, 1984. Acrylic on canvas, 64¾ × 85½ × 6 in (164 × 217 × 15 cm). Courtesy the artist.

215 Rafael Ferrer, *Sueno—Rene—Dream*, 1983. Oil on canvas, 60 × 72 in (152 × 182·5 cm). Courtesy Nancy Hoffman Gallery, New York.

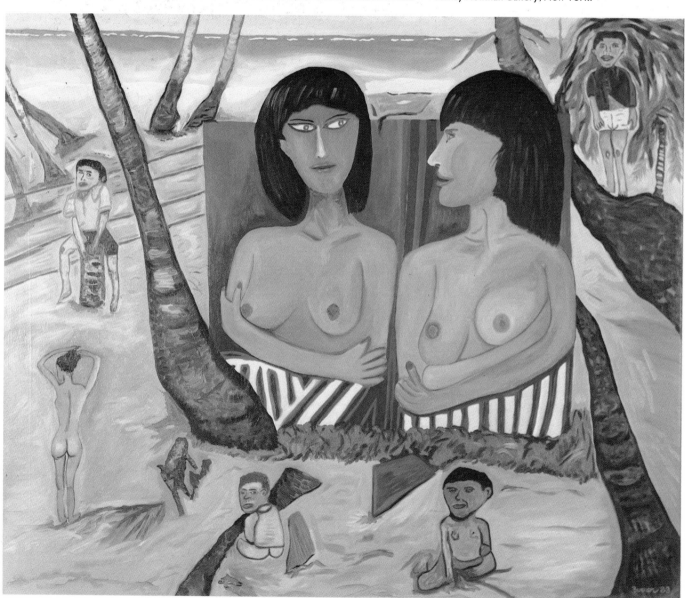

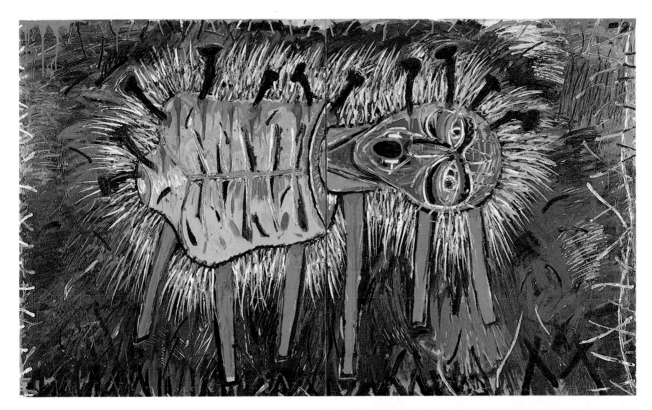

216 Luis Cruz Azaceta, *Homo Fragile*,
1983. Acrylic on canvas, 72 × 120 in
(182·5 × 304·5 cm). Courtesy Allan Frumkin
Gallery, New York.

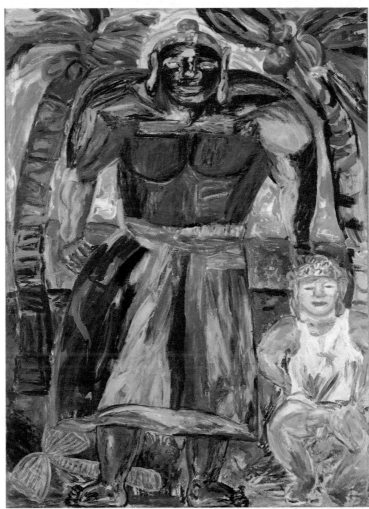

217 Roberto Juarez, *Mother Nature*, 1982.
Oil and acrylic on canvas, 96 × 72 in
(243·5 × 182·5 cm). Courtesy Robert Miller
Gallery, New York.

218 Cindy Sherman, *Untitled*, 1984. Colour photograph, 72 × 47½ in (182·5 × 120·5 cm). Courtesy Metro Pictures, New York.

of those contained within my sub-conscious. In this sense my procedure is scientific because I want to photo-graph these abstract visions as if they were seen through the lens of a super-microscope, capable of seeing beyond chemical reactions and of apprehend-ing them as if they were objects. Yet this pseudo-scientific approach is adopted in the name of art, because I attribute to these representations which come from the creative imagin-ation a value beyond their tangible qualities. My aim is to reach, through them, the eye of the spirit, and in this way to communicate to the spectator the sense of a different reality, inviting him or her into a metaphysical reverie.

Clement thus sees the camera chiefly as a convenient means of creating images, rather than of recording those which are already in existence. It seems likely that when the aesthetics of contempor-ary photography have been finally sorted out – a process which is still not complete despite the efforts of Susan Sontag and others – this will be the kind of photography which will most logic-ally align itself with fine art. Even when this problem has been resolved, a still more intractable one remains: that of the camera as a primary source of images where painting itself is con-cerned. Does a banal photographic

document become art simply because it has been copied, more or less exactly, by someone who describes himself as an artist?

One artist combines the impulse to invent images with a *sotto voce* claim that she is, after all, only documenting what exists everywhere in less sharply focused forms. This is Cindy Sherman, who uses herself as the subject of photo-graphic tableaux. In her earlier work she was seen in settings reminiscent of 50s movies – 'road' films and quickie thrillers. She appeared alone on a rail-way platform, or equally solitary in a gloomy restaurant. As with Wegman, the situation was deliberately placed within quotation marks. The clichés Sherman chose to re-create made the images a vehicle for feminist commen-tary. More recent photographs are more complex in their effect. They discard the setting, and present the image close-cropped, threateningly large within the space. Phyllis Rosenweig, writing of the presentation of Cindy Sherman's photo-graphs which formed part of the *Direc-tions 1983* exhibition at the Hirshhorn Museum, commented as follows in the catalogue:

The sharp emotional focus ... comes from an intelligent manipulation of the codes of melodrama. Her women, staring intensely into the camera ... are characters outside of, or breaking the norms of, traditional society. In the last analysis, Sherman's portraits reveal only a character portraying a film's portrayal of a woman. Their ambiguity parallels that of actual film stills, and their significance is often unclear.

Rosenweig seeks to defend Sherman's work from accusations of narcissism and exhibitionism. She also points out that there is, 'as in all melodrama, an element of complicity'. What she fails to tackle is the crippling self-consciousness of the result, its failure in the end to make us share the emotion stated in the image because of the manipulativeness of the presentation.

The art of ethnic minorities – the Hispanics

Art which makes reference to the special situation of the various ethnic minor-ities within America certainly seems to deserve a place in this chapter. Its right

to be there is much clearer than that of photography. When writing of the work of the Japanese-American painter Roger Shimomura I have already touched briefly on the problems and opportuni-ties of an artist who feels himself to be entirely American, but who is neverthe-less American in a rather specialized sense. Some readers of this book will no doubt be surprised to find that it con-tains no separate section devoted to art by American blacks, especially as this is the subject of an increasing number of studies. Rightly or wrongly, it seems to me that now, in the 80s, the idea of an Afro-American art, easily distinguish-able from what surrounds it, is a mirage. Some black artists in America find in-spiration in the primitive art of Africa, which they see as an essential part of their heritage, though the bulk of the African art they admire was probably produced no earlier than the middle of the nineteenth century. Other painters and sculptors have tried to interpret the story of the black man in America, and to present the society which surrounds them from a 'black' point of view. But others still practise styles which have nothing to do with racial origin and want to be judged on exactly the same basis as their white colleagues. The abstract painter Sam Gilliam is a case in point. Benny Andrews, who *has* pro-duced political art, nevertheless tackles themes which have a much broader frame of reference than a purely racial one. A spectator who encounters a work by a black artist in a gallery, without previous knowledge of the man or wo-man who made it, will usually be quite unable to distinguish, merely from the work itself, the colour of the artist's skin. In the case of some Chicago School figurative painters, for instance, there has even been a strong influence on whites from the work of 'primitive' – i.e. self-taught – black artists.

Most black painters and sculptors have many generations of purely American ancestry behind them, and most, like the two just mentioned, have names which do not immediately single them out as being black. These may seem relatively trivial points, until one compares the situation of black artists with that of Hispanic ones. Hispanic artists are usually immediately identifi-able as such, thanks simply to their names – their Hispanic identity permits them no choice. They are also usually

219 Benny Andrews, *Ms. Liberty*, 1978. Oil and collage on canvas. 48 × 36 in (122 × 91 cm). Courtesy Lerner-Heller Gallery, New York.

immigrants or members of the first generation born in the United States.

It would be a mistake, however, to think of Hispanic art as something homogeneous. For one thing, the artists themselves hail from all over the Spanish-speaking world, and they react in different ways to America itself. The young Honduran Francesco Alvarado-Juarez says: 'My work is the product of New York, Honduras and Washington – my work could never be what it is without having lived in New York.' His art speaks very often of the influence of the past on the present. It also speaks of pride in what artists of similar origins have already accomplished. One painting, for example, is a homage to the Mexican artist Frida Kahlo. The Puerto Rican Rafael Ferrer is more unified in style, though he too superimposes larger images on a background of smaller ones, as a way of expressing the dream-like nature of a divided experience. But the warm, rich colour makes it plain that he and Alvarado-Juarez share a common sensibility.

Less prominent in the work of these two painters, but conspicuous elsewhere, is a violence of temperament which relates the new Hispanic art to the prevailing Expressionist current – a conjunction which may fortuitously have gained it easier acceptance. This vehemence manifests itself in the work of the Cuban-born Luis Cruz Azaceta,

who did not come to America until he was eighteen, just as it does in that of the Chicago-born Roberto Juarez. Asked whether he sensed a genuine Latin movement on the current American art scene, Azaceta replied:

I would say, yes, there is a Latin 'presence' here, because every time you pick up an art-magazine, you see something about a Latin painter, but I would not call it a movement because it is so pluralistic. A lot of Latin painters deal with themes of social comment, they are doing what I call Baroque Expressionism. Our literature is like that, too, a kind of Surrealistic Baroque.

The Surrealist, rather than the Expressionist, strain makes itself strongly felt in the work of certain young Hispanic painters working in New York. An example is Jorge Salazar, who was born in Mexico in 1951, and began work in New York as late as 1974. Salazar's earlier paintings were colourful and folkloristic. More sophisticated later ones show a resemblance to the work of the great Cuban Surrealist Wilfredo Lam, whose power of inventing strange bird-like personages Salazar seems to share.

The most outspokenly 'public' Hispanic artist is the Texas-based sculptor Luis Jimenez Jr. What links Jimenez to other artists with a similar background is the baroque exuberance of his work. But there are many other elements as well. Jimenez is neither Expressionist nor Surrealist – what he offers is a Pop interpretation of 30s Regionalists like

220 Jorge Salazar, *Untitled*, 1983. Oil on canvas, 99 × 99 in (251 × 251 cm). Courtesy Germans van Eck, New York.

Thomas Hart Benton. He is fascinated by the myth of the American West – the cowboy and the pioneer, and he tries to give this a form which will allow it to communicate immediately to a wide public. Though the content of his work is so consciously American, its movement and colour give it a special flavour which prompt me to include it here, rather than in the chapter on Post Pop or on art in Texas, where it would have fitted equally well.

As these very different examples show, the Hispanic heritage represents a new and powerful influence in the American art scene. Its rise is not factitious – it reflects that of the Hispanic community as a whole within the United States. As such it is surely one of the most significant developments in contemporary American art.

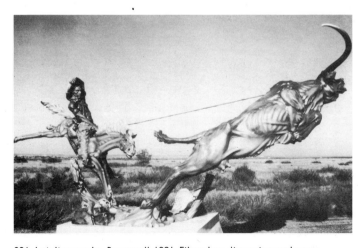

221 Luis Jimenez Jr., *Progress II*, 1981. Fibreglass, dimensions unknown. Courtesy Sebastian Moore Gallery, Denver.

CHAPTER THIRTEEN

CHICAGO AND THE SOUTH EAST

When I say that regionalism is now one of the most important tendencies in the American visual arts, I am merely, to my mind, pointing out the obvious. There is every reason for such a change of direction – the vastness of the American art world and the huge numbers of practising artists alone would tend to create a fragmentation of the kind which was once typical of the American crafts. To such factors we must add even more powerful ones, such as the upsurge of economic growth in the West and South-West of the United States, which has created a new public and (even more important) a new market for locally based artists. Add to this a negative factor, the overcrowding in Manhattan, and the steep rise in rents for working and living space, and one already has a whole series of good reasons why American artists should increasingly choose to base themselves away from SoHo and 57th Street, which were until recently the unchallenged arbiters of American art.

Yet this shift towards a regional focus remains highly controversial. Manhattan critics tend to decry or ignore the art connected with it, seeing it almost as a personal challenge to themselves. They feel that regionalism is often no more than a synonym for provincialism, and they make too direct a comparison with the very different Regionalism (this time with a capital 'R') practised by Thomas Hart Benton and his followers in the 30s. Jackson Pollock, once Benton's pupil, eventually overthrew the kind of art Benton produced, and to admit the claims of the new regionalism seems to many commentators a betrayal of the all-important heritage of Pollock, a sac-

rifice not only of national unity but of the international hegemony which Pollock and the Abstract Expressionists gave to American painting. The facts, nevertheless, speak for themselves. Everywhere one looks in American art, one finds distinguishable local schools of painting and sculpture.

The Chicago Imagists

The regional group which is most clearly defined and has been longest established is that of the Chicago Imagists. Its beginnings can be traced back as far as the 50s, when artists such as Leon Golub and H. C. Westermann were already at work in Chicago. The real flowering came in the 60s, with the appearance of groups such as the Hairy Who (1966), the False Image (1967) and the Non Plussed Some (1968). Essentially Chicago Imagist painting today consists of the survivors of these groups. Dennis Adrian, the accredited historian of the movement, lists some common characteristics: 'a high quotient of formal incident throughout the picture field'; intense colour, often used in unmodulated blocks; a refined and intricate technique with an avoidance of the gestural; an emphasis on the object-like character of the work, whether it is in three dimensions or two. Influences from high art and popular art are intermingled in Chicago Imagism. Among the former are Persian miniature painting, de Chirico and Magritte; among the latter, comic books, girlie magazines, amusement arcades and cheap toys. Ethnographical objects seen in the extensive collections of Chicago's Field Museum made a strong impact on many

of the artists; even more important were certain local self-taught artists, chief among them Joseph Yoakum, a black visionary landscapist who had worked in his youth with various travelling circuses (rising at one point to be John Ringling's personal valet), and who later travelled the world as a hobo. Yoakum and Westermann (who *did* attend an art school, though he successfully shed much of its influence) were the two chief father-figures of Chicago Imagism. The paradox which haunts the school is already fully visible in Westermann's work – he produced 'Outsider art' with professional stringency to fully professional standards of finish.

The major Chicago imagists who are still productive at the present time include Roger Brown, Art Green, Gladys Nilsson, Ed Paschke and Karl Wirsum. Between them they provide a very fair summary of what the movement was and is about. Green, Nutt, Nilsson and Wirsum were members of the Hairy Who. Of the four, Wirsum is the most closely connected to Pop Art, which certainly lies at the roots of Chicago Imagism. But, unlike classic Pop, his paintings are full of violent optical effects, thanks to a combination of brilliant hues and unstable figure–ground relationships. Art Green is also closely linked to Pop, and he too makes much play with visual ambivalence, but his work is subtler. He specializes in carefully constructed spatial ambiguities. The apparently logical structure of his compositions is always deceptive: they stubbornly refuse to come together to make something spatially coherent. Green's work reminds one of the para-

222 (*Above*) Art Green, *Critical Mass*, 1982.
Oil on canvas and wood, 55½ × 24 in
(141 × 61 cm). Courtesy Phyllis Kind
Gallery, New York.

223 (*Below*) Gladys Nilsson,
Pandemoneeum—A Trip–Dick, 1983.
Watercolour on panel, 51 × 101¼ in
(129·5 × 257 cm). Courtesy Phyllis Kind
Gallery, New York.

224 Karl Wirsum, *The Formally Young Salvador*, 1983. Acrylic on canvas, 36½ × 30½ in (92·5 × 77·5 cm). Courtesy Phyllis Kind Gallery, New York.

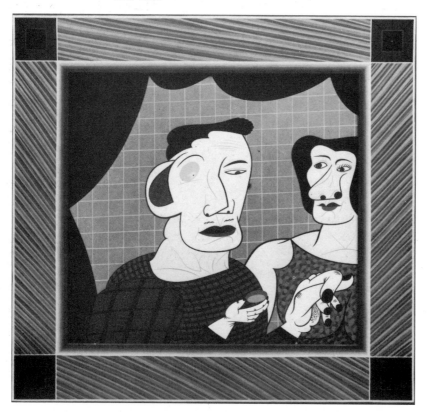

225 Jim Nutt, *Another Mistake*, 1983. Oil on canvas and wood, 14⅞ × 26¾ in (37·5 × 68 cm). Courtesy Phyllis Kind Gallery, New York.

doxical world of M. C. Escher, and also, in a remoter way, of the *pittura metafisica* of de Chirico.

Gladys Nilsson and Jim Nutt are closely linked to one another stylistically, and closer to Surrealism than they are to Pop. Nilsson generally works on a modest scale, and her colour is notably fresh and attractive, in contrast to the harsh hues favoured by most of her colleagues. Typically, the whole composition is filled with a swaying mass of figures, whose snaking, elongated limbs and long pointed noses make them look like Javanese shadow puppets. Nutt's figures are less crowded and attenuated, but equally flattened and insubstantial. There is a clear relationship to comic-strip drawings – but also a resemblance to some of the caricature-personages invented by Paul Klee. Both Nilsson and Nutt have a European air which is a reminder of Chicago's cultural cosmopolitanism. In particular, Nilsson demonstrates the continuing relationship between Chicago Imagism and the classic European Surrealism which has for long been strongly represented in Chicago private collections.

Both Ed Paschke and Roger Brown have evolved personal types of Post-Pop imagery, and both can be regarded as sources for recent Post-Pop painting elsewhere. Paschke, who began by painting circus freaks and other marginal people in harsh detail, now depicts depersonalized urban figures. These look as if they are wearing the knitted balaclava helmets favoured by terrorists or bank-raiders, and at the same time as if they have been transmitted from another planet by some radically imperfect electronic medium, which has reduced their flesh to a kind of phosphorescent ectoplasm. They make effective symbols for the speed and danger of contemporary life. In a recent brief essay Paschke wrote:

Perception, or what we experience through our sensory apparatus, is being affected by the rapid acceleration of media-related technology. Our view of the world is changing as the 'global-environment' expands through media-accessibility and the information reservoir gets deeper. My belief is that these elements (good or bad) have woven their way into the fabric of our lives. I also believe that an artist always works within the

context or conditions that are indigenous to his or her own time and, in doing so, reflects the energy, temperament and attitudes of that time.

This sums up very fairly the climate inhabited by his work.

Roger Brown offers a version of Benton's Regionalism which has passed through the transforming influence of Pop. He paints landscapes – the product of wide travels throughout America – as well as fantasy and genre scenes. The landscape and other forms are elaborately coded and patterned. Much of the fascination of the paintings lies in seeing how skilfully Brown deploys an apparently rigid vocabulary, so that it encompasses a wide variety of incident. Patterning plays an extremely dominant role in his art. Often, for example, a landscape will be arranged as a series of superimposed strips, and this, together with the mode of stylization adopted, makes Brown comparable to the New York Pattern painters – in general, he is more disciplined and orderly than they are. By linking the Regionalism of the inter-war years with the Pop of the 60s and the Pattern Painting of the present he touches the recent history of American art at many points, and it is not surprising that he is now the most widely recognized of all the members of the Chicago Imagist school.

Just because it found such a strongly developed identity at the beginning of its career, in the late 60s, the Chicago Imagist school has had some difficulty in developing further. Its most notable recent recruit is Dennis Nechvatal who lives, not in Chicago itself, but in Madison, Wisconsin. Nechvatal is a prolific painter who works in several related modes. There are powerful paintings of masks and mask-like heads, obsessionally detailed Rousseau-esque landscapes, and interiors with figures. Close examination of any of these compositions often reveals further, concealed images – for example, a massive head will have further small heads swimming to the surface in the flesh of cheeks and chin. The prevailing mood is one of intense unease. Nechvatal belongs to the generation which was hardest hit by the Vietnam War and sees himself as a survivor. He says:

I was born in 1948. My childhood was fine. In college, in 1966, a person was drafted and a whole new fear

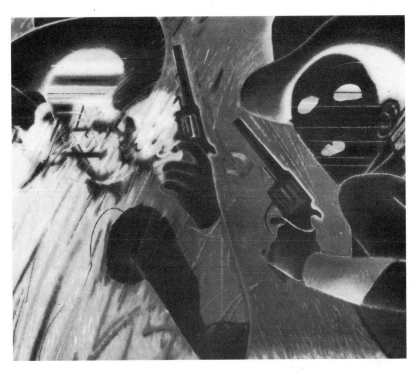

226 Ed Paschke, *Tropanique*, 1983. Oil on canvas, 80 × 96 in (203 × 243·5 cm). Courtesy Phyllis Kind Gallery, New York.

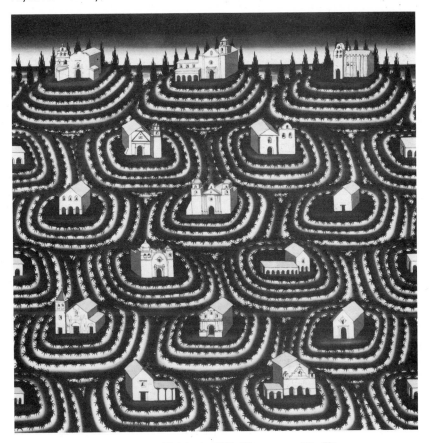

227 Roger Brown, *The Missions of California*, 1983. Oil on canvas, 72 × 72 in (182·5 × 182·5 cm). Courtesy Phyllis Kind Gallery, New York.

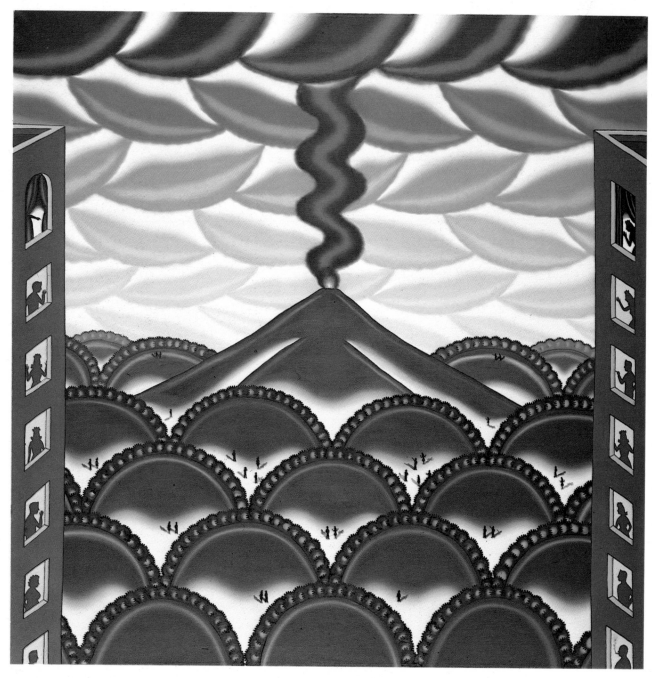

228 Roger Brown, *First Continental Eruption*, 1980. Oil on canvas, 72 × 72 in (182·5 × 182·5 cm). Courtesy Christie's.

229 (*Opposite*) Dennis Nechvatal, *Fusion*, 1983. Oil on canvas, 72 × 48 in (182·5 × 121·5 cm). Courtesy Zolla/Lieberman Gallery, Chicago.

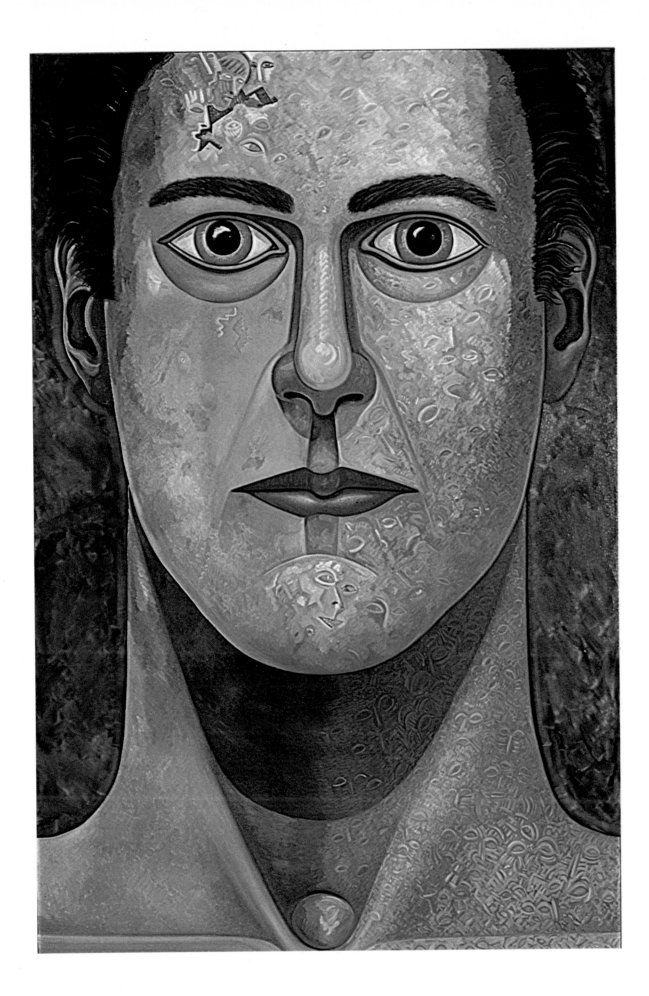

230 (*Top*) Dan Ramirez, *Contemplation of the Son by the Son*, 1982. 96 × 102½ in (243·5 × 260 cm). Courtesy Roy Boyd Gallery, Chicago.

231 (*Centre*) William Conger, *Lakeshore Chicago*, 1983. Oil on canvas, 60 × 72 in (152 × 182·8 cm). Courtesy Roy Boyd Gallery, Chicago.

232 (*Bottom*) Richard Loving, *Ascension*, 1983. Oil on canvas, 54 × 72 in (137 × 182·5 cm). Courtesy Roy Boyd Gallery, Chicago.

became evident. The world was going through this drama of life and death, right before us. I was almost involved because I was drafted but didn't pass the physical. The chances of me being here now, a person, a male, is incredible, a trauma that has never left. The fear of a holocaust is with us. We are the ones who control this world and we must be more intuned with it and with ourselves.

Inevitably, Nechvatal's way of seeing has been affected by the Neo-Expressionism imported from Europe and practised in New York by other painters of similar age. He thus represents the indigenous mid-western reaction to this powerful new stylistic current. His successful use of it, while retaining elements from the established tradition of Chicago Imagism, notably the fascination with a busy, image-crammed surface, makes him one of the most impressive younger painters now working in America.

Chicago Abstraction

A more recent development on the Chicago art scene has been the appearance of a group of abstract painters identified with the city. Just as Chicago Imagism was to some extent nurtured

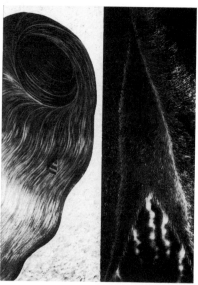

233 Susanne Slavick, *Valley Fire/Vortex*, 1983. Oil on canvas, 66 × 48 in (167·5 × 121·5 cm). Courtesy Frumkin and Struve Gallery, Chicago.

by the presence of fine European Surrealist paintings both in Chicago public collections and in accessible private ones, Chicago Abstraction often has a visible debt to the Bauhaus. This is not surprising, given the long residence of Mies van der Rohe in the city. In its most purely Bauhaus guise Chicago Abstraction is represented by the work of Dan Ramirez, with its play of a few simple elements. William Conger's work suggests that there is also a parallel among pure abstractionists to Chicago Imagism, and in particular to the work of Art Green. The hard-edged shapes and day-glo colours of his canvases are at any rate eloquent of what seems to be a certain kind of Chicago sensibility. Similar forms appear in the work of Richard Loving and in that of Susanne Slavick. The paintings of Frank Piatek, surprisingly modest in scale, have a more visceral quality which returns us once again to the underlying Surrealist tradition.

Abstract art is by its very nature less specific than figurative work, and it is therefore much more difficult to speak confidently of its relationship to a particular locality. Yet Chicago Abstraction, while obviously drawing on a different range of source material from the Chicago Imagists, does have a local flavour which distinguishes it both from abstract art in New York, and from what is being produced on the West Coast.

The South East

The strength of the connection between the art of the South-East and that of the Mid-West may come as a surprise until we recall the traditional ease of communication between the two regions. New Orleans, in particular, is a traditional playground for mid-westerners and a more congenial window on the outside world than New York or other eastern ports. The artist whose work most exactly summarizes the relationship is Robert Gordy, just as George Dureau summarizes the 'classical' element in Louisiana culture and George Febres its connection with Latin America.

Even at first glance the link between Gordy's painting and that of Roger Brown is obvious – they both have the same interest in stylization and heavy linear patterning. But there are also important influences on Gordy's work which have nothing to do with Brown's chief preoccupations, among them Matisse and Symbolists such as Gustave Moreau and Puvis de Chavannes. More recently, Gordy has been absorbing the influence of primitive art, which he collects. This phase is represented by a series of large male heads, drawings and monotypes. These have connections with the work of younger Chicago artists, such as Dennis Nechvatal.

Another Louisiana-based painter whose work has links with Chicago figuration is Robert Warrens, who teaches at Louisiana State University in Baton Rouge. Warrens is less formal, less interested in pattern and a good deal more exuberant and fantastic than Robert Gordy. His work introduces the spectator to a world where objects are in a constant state of transformation, and where the artist's impulse towards the fantastic is powered by a manic energy which is at variance with the traditional sleepy elegance of the Deep South.

New Orleans, long famous for the traditional elegance of its antique shops, now has new wealth from the oil industry and the beginnings of a flourishing commercial gallery scene. These bring new artists into the city – there is a strong emphasis on work from Latin America and from Texas – and create opportunities for younger local painters and sculptors. They may soon foster a regional style as distinctive as that to be found in Chicago, Houston or Los Angeles.

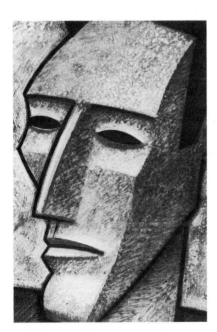

234 Robert Gordy, *Male Head*, 1983. Monotype, 28 × 17 in (71 × 43 cm). Courtesy the artist.

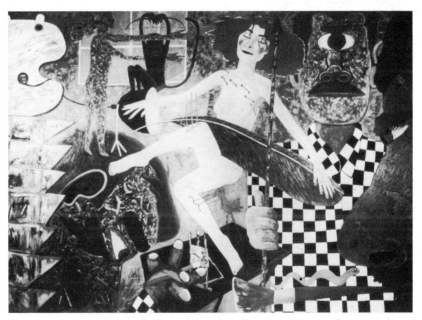

235 Robert Warrens, *Sweet and Sour*. Acrylic on canvas, 84 × 120 in (213 × 304·5 cm). Courtesy Galerie Simonne Stern, New Orleans.

CHAPTER FOURTEEN

NEW ART IN TEXAS

236 Jesus Bautista Moroles, *Inner Column Tower*, 1984. Texas granite, 20 ft (609 cm) tall. Commission for Riata Developments, World Towers One, Houston, Texas. Courtesy Davis/McClain Gallery, Houston.

A number of artists with a strong Texan identity have already been featured in other chapters of this book – one is James Surls, another is Earl Staley. The rapid economic expansion of the big cities of East Texas – of Houston, in particular – has brought with it a thriving market for art. Many Texas galleries make a policy of showing artists who are already established in New York, but it is equally natural, and in fact only equitable, that they should seek out and support local talent. Artists who base themselves in the state have a number of choices open to them. They can ignore the local environment completely, treating Texas as a kind of vacuum – a quiet place to work. They can try to absorb at least part of what it has to offer. Or they can make a direct attempt at interpreting it, at the risk of being thought provincial – though Texas, as Texans themselves never tire of pointing out, is a parish bigger than most nations.

Abstraction in Texas

The least specific art produced in Texas is abstract, since abstraction frees the painter or sculptor from the need for definable content. But even here there is a gradation. The Hispanic sculptor Jesus Bautista Moroles produces work whose Hispanic and Texan origins do not become visible even on close inspection. He pursues a purist vision which has its roots in the Concrete Art of Max Bill, though he has also been affected by the mock-archaeological and mock architectural tendencies described elsewhere. Perhaps the most essentially Texan thing about his work is its chosen material – frequently local granite. But in a country which at the moment has fewer good abstract sculptors than one might expect, especially in view of the numerous opportunities open to them, he is an outstandingly good one, who constantly comes up with original solutions to familiar problems – for example the witty relationship of his *Inner Column Tower* illustrated here with the rather banal building behind it.

Texan abstract painters, far from having Moroles's self-contained elegance, often manifest a kind of manic violence. This surfaces in recent work by Dick Wray, who is generally regarded as the Grand Old Man of Texas abstraction, with a direct link to the world of the Abstract Expressionists. There is also a strong feeling of violence in the work of Perry House. House's style is a combination of the graphic and the painterly – the brushstroke is, so to speak, 'frozen', a technique first used by Roy Lichtenstein in his parodies of the Abstract Expressionists and now to be seen in a different form in the work of the Abstract Illusionists. House uses the technique to generate a sense of barely contained energy. Like much post-Abstract Expressionist painting, the canvases are full of concealed images, and allusions to landscape. His paintings evoke the rampant back gardens of the Houston suburbs, with trellises, ladders, vines and hoses.

Personal mythologies

Just as it is elsewhere in American art, Texan figuration is often the vehicle for some kind of personal mythology. In Susan Smith's case it is a version of feminism. She places meticulously painted realist figures, portraits not of people but of shop-window dummies, amongst vehement abstract splashes. The pictures allude both to Texas consumerism, and to the female role as handmaid of the arts, and nurturer of the male ego – the machismo associated with the Cedar Bar in New York, and the first generation of Abstract Expressionists.

A much more complex personal mythology appears in the work of Melissa Miller, who is rapidly becoming one of the best-known artists with a specifically Texan identity. Miller's usual subject-matter is wild animals – 'critters', in Texan parlance. She depicts

237 Dick Wray, *Untitled*, 1983. Mixed
media on canvas, 96 × 156 in
(243·5 × 396 cm). Courtesy Moody
Gallery, Houston.

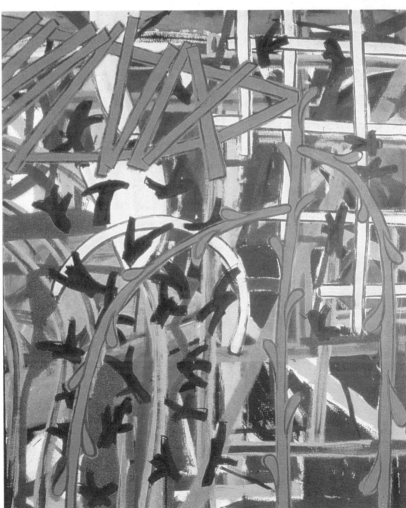

238 Perry House, *Untitled*, 1983.
Acrylic on canvas, 72 × 60 in
(182·5 × 152 cm). Courtesy Davis/
McClain Gallery, Houston.

239 Susan Smith, *Drips and Splatters the Gestural X*. Oil on canvas, 65 × 65 in (165 × 165 cm). Courtesy Harris Gallery, Houston.

them not for their own sake but as reflections of her own state of mind and as cryptical autobiographical comments. Her style was described by an *Artforum* reviewer as 'equidistant between Van Gogh and Maxfield Parrish'. In fact, Miller combines two well-established aspects of Texas taste, a lingering fondness for the more conservative aspects of the nineteenth century and a thirst for what is up-to-the-minute. Her animal scenes may remind the spectator of Van Gogh because of their bold brushwork, but in other respects they are more like paraphrases of Landseer. The blaring colours are pure celluloid. Her work participates in the dialogue between good taste and 'bad taste' which is now going on in American art, but it would be a pity if it were read only in that sense. There is something genuinely haunted about her paintings which accounts in large part for their impact.

Lee Smith's paintings, recalling incidents in his own youth, are even more

private in their symbolisms than Melissa Miller's. *Fire and Ice* recalls the hazing (bullying) which forms part of adolescent initiation ceremonies. This is the kind of introverted art which can be made almost anywhere. What gives it a connection to the rest of the Texas art scene is not merely the simple fact of the artist's residence in Dallas, but the slightly lurid colour which occurs sufficiently often in Texas painting to be described as a local characteristic.

Jim Poag deals, not with childhood and adolescent traumas, but with the conflict of man and nature. The artist says: 'I see this struggle as central to our predicament in these times – man's effort to conquer a physical world over which he has no control. This then becomes a metaphor for man's conflict between his rational and irrational selves.' He describes the paintings as specific statements evolving from his own everyday experience. The turbulent nature of much of his imagery thus reflects the direct stimulus of his immediate environment.

An ambitious recent installation by another Texan, Martin Delbano, shown first at the Amarillo Art Center, and then in revised form at the Tilden-Foley gallery, New Orleans, takes this concern with the power of nature a step further, by re-creating and adapting the rituals of ancient nature religions. Entitled *The Rites of Passage*, it is a procession of sculptured figures and animals escorting a cart which bears an iconic figure. Some of the imagery is borrowed from the Aztecs – a reminder that Texas is only just over the border from Mexico. The figures are shown moving towards a chamber which serves for 'ascension rites' – i.e. for burial and subsequent regeneration. The primitive style of the individual sculptures which go to make up the complete piece links Delbano's work to the 'folk' element to be found in much Texas art at the present time.

Being Texan

A number of Texas artists are openly 'regionalist', but in a much more humorous and exuberant fashion than their predecessors of the 30s (who are notably well represented in Texas museums). One such is David Bates, who celebrates everyday events in a Neo-Expressionist style adroitly adapted to Texas taste for the homey and the

240 Jim Poag, *Passage*, 1984. Acrylic and litho crayon on canvas, 70 × 90½ in (177·5 × 229·5 cm). Courtesy Davis/McClain Gallery, Houston.

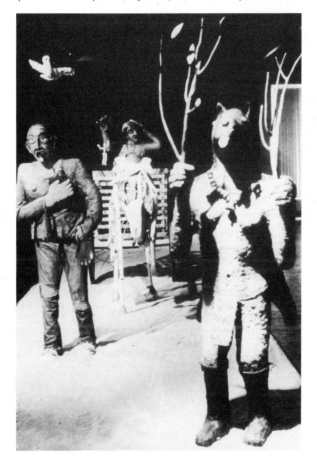

241 Martin Delbano, *The Rites of Passage*, 1981–4. Mixed media, 60 × 8 × 79 in (152 × 20 × 200·5 cm). Courtesy Tilden–Foley Gallery, New Orleans.

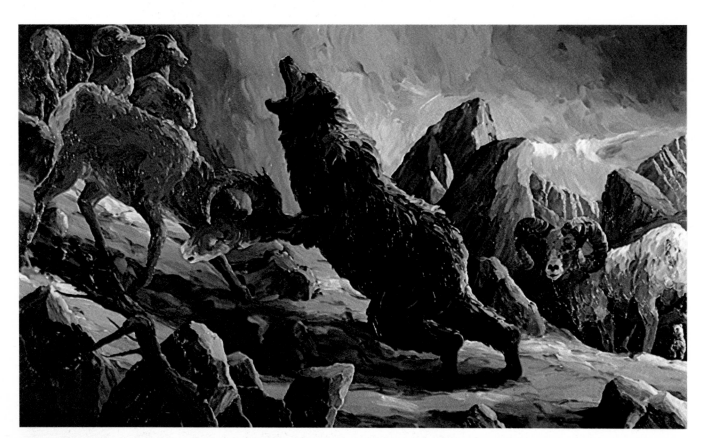

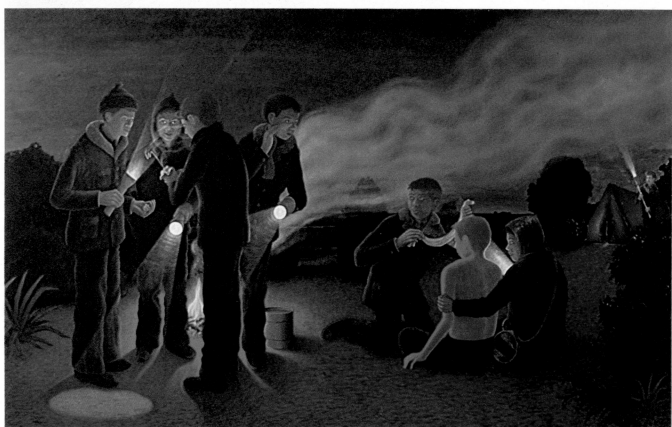

242 (*Opposite above*) Melissa Miller, *Territory*, 1983. Oil on linen, 69 × 116 in (175 × 294 cm). Courtesy Texas Gallery, Houston.

243 (*Opposite below*) Lee Smith, *Fire and Ice*, 1984. Oil on canvas, 78½ × 127½ in (199 × 323·5 cm). Courtesy Texas Gallery, Houston.

244 (*Right*) David Bates, *Butchering the Hog*, 1984. Oil on canvas, 96 × 78 in (243·5 × 198 cm). Courtesy Texas Gallery, Houston.

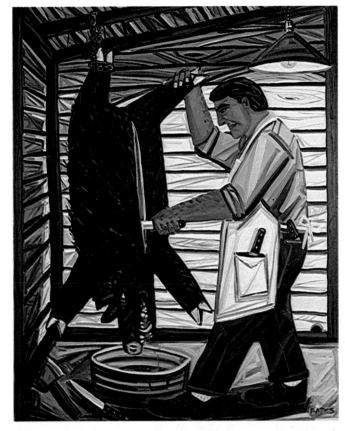

245 (*Below*) Robert Levers, *Potesting the Referee's Call as the Stadium Fire Takes Hold*, 1982. Watercolour and pen and ink on paper, 20 × 26¼ in (50·5 × 67 cm). Courtesy Watson/de Nagy and Co., Houston.

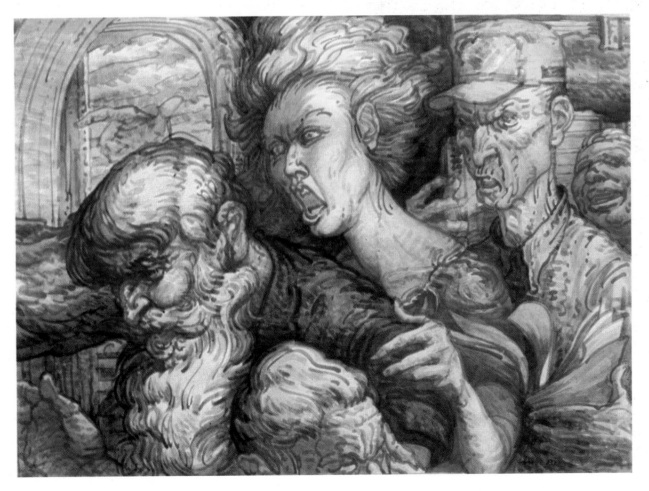

246 Ron Hoover, *It Never Seems to Change*,
1983. Oil on canvas, 50 × 45 in
(127 × 114 cm). Courtesy Graham Gallery,
Houston.

247 Jeff DeLude, *Them Good Ole Boys*, 1983.
Oil on canvas, 56 × 34½ in (142 × 87·5 cm).
Courtesy Graham Gallery, Houston.

homely. Perhaps more than any other artist now living and working in Texas he fulfils outsiders' expectations of what a truly Texan art ought to be like. This does not invalidate his claim to be one of the most immediately attractive painters the region has recently produced.

Another painter who portrays Texas scenes, but with a much sharper satirical edge, is Jeff DeLude. One of his most outspoken canvases is *Them Good Ole Boys*, with its naked humans being herded to the slaughter like cattle or hogs, by figures in traditional stetsons, check shirts and boots. This bitter denunciation of Southern manipulation is something which can be immediately understood by Texans and non-Texans alike, because of the specific and familiar nature of its imagery. Ron Hoover, also a visual satirist, is more difficult for the non-Texan spectator to construe. *It Never Seems to Change* satirizes the vulgar opulence of nouveau-riche urban Houston. Hoover speaks as an insider to insiders, and is capable of causing very specific offence – his grotesquely caricatured figures are often immediately recognizable to readers of Houston gossip-columns. His paintings – a strange combination of Georg Grosz and Pointillism – do not fit any stereotype of Southern or Texan art, but nevertheless reflect the realities of the society which they portray. In general, one of the striking things about the art now being made in Texas is that it finds so much which is specific to communicate – compared with the characteristic art of Chicago or California it is overflowing with content.

The subtlest and most amusing satirist now working in Texas – and he is also much more than that – is Brooklyn-born Robert Levers, who lives in Austin. Levers makes paintings, drawings and constructions: the last of these are a little like the work of Red Grooms. His subject-matter is wide-ranging. Some of his work is at first glance local not merely to Texas but to Austin itself. One painting is called *The LBJ Library under Siege*, a reference to Austin's most con-

spicuous public building. Other paintings and drawings in the same series refer to the burning (imaginary) of the Memorial Stadium of the University of Texas. The images, as it turns out, were inspired by a dream:

One night [the artist writes] I had a dream about Memorial Stadium burning down. In my dream, it had been capable of accommodating a million people, all of whom were scurrying round, many with banners. It was a troubling dream; I had no idea of what it meant or why I had it, but since I usually make art to find out what I think and feel, I began a painting. In the process of painting it I realized something fairly obvious, I guess – the apocalyptic metaphor – and I saw that it would be necessary to document everything that went on in the Stadium as it burned – riots, orgies, the summary execution of the presumed arsonist, lights flickering in the stadium steamroom.... One thing seemed to lead to another. I developed among other things a whole sub-culture of bogus, berserk and violent referees doing vaudeville turns. By fits and starts this world would be funny and then sad and sometimes both at the same time. I sensed people locked into rituals of behaviour – loveable in a way, pitiable in other ways, maybe like all of us.

Levers's nervous, flickering line is like nothing else in American art. His great loves, he says, are Tiepolo – 'his sense of light, his sense of movement, the way the figures are so confidently next to one another and aware of one another', – Rubens and Goya. To this list one is tempted to add the name of Thomas Rowlandson. Levers's watercolours in particular are very like Rowlandson in their bright, transparent colouring and busy line. The presence of a visionary satirist of this quality in the ranks of Texan artists is one of the great surprises of an art scene which is surprising in many other ways as well.

CHAPTER FIFTEEN

THE WEST COAST

248 Craig Antrim, *The Unknowable God*, 1981. Vinyl and acrylic on canvas, 20 × 18 in (50·5 × 45·5 cm). Courtesy Stella Polaris Gallery, Los Angeles.

migrant constructs a new, subjective 'California' for himself, partly made from the things he carries there, and partly from a characteristic rejection of the already known.

At the same time, however, the West Coast remains in close, constant communication with the East. California, from the point of view of the passage of ideas, is much closer to New York than the Mid West and South West. The artists who live there are much more intimately aware of New York art fashions. They are seduced by these, and yet they often have a paranoid conviction that they are being simultaneously patronized and rejected by East Coast scene-chiefs and taste-makers.

Los Angeles abstraction

There is a notion – one that seems to have some substance to it – that abstraction currently survives better in California than it does anywhere else in America. It is certainly true that survey exhibitions of Californian art, of which there have recently been quite a number, contain a higher proportion of abstract artists than similar surveys in New York. Chicago or Houston. For a long time, Los Angeles abstraction had the reputation of being a vehicle for the 'laid back' spirit of the city – hedonistic, fluent and facile. Today these generalizations do not carry conviction. Craig Kauffman, whose smoothly lacquered boards, to be leant against walls rather than hung on them, were among the chief embodiments of California minimalism, now creates restless painterly compositions where figurative references, particularly to still-life, seem

249 Kady Hoffman, *Letters*, 1984. Paper, ink, gesso, 76 × 60 in (193 × 152 cm). Courtesy the artist.

to hover just below the surface. The effect is like a mating of recent Frank Stella and recent Richard Diebenkorn.

Kauffman's evolution has been echoed by that of many other California abstractionists. Similar themes can be found, for example, in the paintings of Craig Antrim, though the references are to architecture rather than to still-life. A group of fine paintings by Kady Hoffman illustrate a different but related aspect of the California experience. The graphism shows her close affinity to the art of the Far East. Her recent works echo the bold forms of Zen drawings, and the allusion to oriental calligraphy is made even more obvious by the fact that the series is collectively entitled *Letters*.

Many attempts

Many attempts have been made to define the California art scene, and almost as many more have been made to draw a viable distinction between the art of the Bay Area and that of Los Angeles. The differences between the conclusions reached by individual critics are striking; so too is the fact that the critic often seems less interested in the object itself than in the life-style he may feel he sees reflected in it or through it. The confusions caused by this are increased by other factors. One of the most important is that California, both north and south, is typically inhabited by people who come from elsewhere. Artists arrive in the region bringing cultural and emotional baggage with them. Each im-

250 Craig Kauffman, *Cocque and Bell Jar*, 1981. Mixed media, 84 × 60 in (213 × 152 cm). Blum Helman Gallery, New York.

251 Jack Reilly, *Passion*, 1983. Acrylic polymer, canvas, wood, epoxy resin, acrylic lucite, polyester resin, milled glass fibres and silica dust, 95 × 120 × 12 in (241 × 304·5 × 30·5 cm). Courtesy Stella Polaris Gallery, Los Angeles.

252 Franklyn Liegel, *Sandy Gulch*, 1982. Acrylic, tempera, gouache, glass, string and cheesecloth on rag board, 40½ × 53 in (102·5 × 134·5 cm). Courtesy Ulrike Kantor Gallery, Los Angeles.

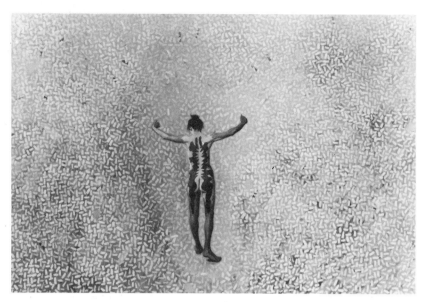

253 Tom Wudl, *Yoga*, 1983. Oil on canvas, 6 × 9 in (15 × 23 cm). Courtesy L. A. Louver Gallery, Venice, California.

254 Astrid Preston, *Dark Palms*, 1983. Enamel on gatorboard, 48 × 48 in (121·5 × 121·5 cm). Courtesy the artist.

Much new California abstraction shows impatience with both conventional formats and conventional materials. Jack Reilly's paintings have layered, irregular forms, and the materials used include acrylic polymer, canvas, wood, epoxy resin, acrylic lucite, polyester resin, milled glass floss and silica dust. In Franklyn Liegel's work the forms are supported on mesh, so that the splashily abstract shapes acquire an independence of the support. Both Reilly and Liegel show a baroque restlessness which is typical of one aspect of Southern California. This restlessness manifests itself in a different but related way in the work of Ron Davis and John Okulick, who have already been dealt with in the chapter on illusionism.

Hedonistic Figuration

The hedonistic character so often attributed to Californian abstraction is more clearly perceptible in certain kinds of figurative art with abstract roots. Typical are the *Sunsets* of Peter Alexander, who worked as a purely abstract artist until 1972. His shift to figuration and his choice of subject-matter were dictated by the wish to explore an established visual cliché which was closely linked to the whole history of American landscape painting. Sunsets are part of the imagery used by nineteenth-century romantic masters such as Thomas Cole, Frederick Church and Martin Johnson Heade. In addition, they were much portrayed by the California landscapists of the 20s and 30s, whose work is now being re-explored by art historians. But there is another element as well. Alexander's work shows an unselfconscious acceptance of the norms of popular culture of a kind already remarked upon in the work of Ed Ruscha. In addition to painting the *Sunsets*, Alexander has explored other 'popular' and cliché ideas in his use of velvet and other materials such as lurex to make abstract works which allude ironically to cheap department-store home furnishings.

Tom Wudl's use of figurative imagery in recent paintings shows that he shares Alexander's wish to explore popular stereotypes, and yet another example of the same tendency can be found in Astrid Preston's simplified Los Angeles townscapes with their deliberately lurid colours.

made in the studio rather than on location, and models were in great demand for trick effects. This legacy makes itself visible in the intricate work of Michael McMillen – for example in a fragmentary wrecked ship, minutely detailed, entitled *Witch of Draconis*. The title suggests a link with the current cycle of SF movies, reinforcing the connection with the great studio model-shops of the past.

Similar skills, and a similar kind of rather literary imagination, are at work in Jeffrey Vallance's intricate mechanical constructions. Vallance's one-man show held in 1982 at the University Art Museum, Santa Barbara, was called 'Jeffrey Vallance, Social Historian'. This hints at the way in which the intricate mechanical wonders he creates are also meant to convey a moral point. Work of this kind has none of the slickness of which Californian artists are sometimes accused. It puts mechanical inventiveness and craftsmanly dexterity at a premium.

California narrative

One can think of the movies as having had another and further-reaching, though less specific influence on Californian art. The primary purpose of the popular film is to tell a story through the use of images, and it is therefore not surprising to find that many Californian artists are much concerned with narrative. Sometimes this expresses itself in stringent form, as, for instance, in Alexis Smith's didactic installations. At other times it is more poetic – sometimes literally so. Mike Kelley's bold cartoon-style drawings are illustrations to his own poems. *The Baggy Pants Comedian* shown here illustrates a section of Kelley's text *Monkey Island*:

Crazy man crazy
ha ha, ha ha
a baggy pants comedian
his bladder smacks you on the head
whole body a bladder
an obnoxious asshole
infected and spreading
hitting you over the head
over and over
over and over
ALL RIGHT ALREADY!
I got the joke
I got it
I got it
I got it
the bladder infection
I got it

The style of discourse is clearly contemporary and yet it is also 'historical', since Kelley combines the world of the comic-strip and that of Jarry's *Ubu Roi*.

Gary Panter, a Texan now working in California, continues more directly the tradition of the underground comics which first appeared in the 60s, and

255 Michael C. McMillen, *Witch of Draconis*, 1983. Mixed media construction, approx. 6 in (15 cm) long × 4 in (10 cm) high × 2 in (5 cm) wide. Courtesy Asher/Faure Gallery, Los Angeles.

Hollywood model-makers

It is not surprising to find that Californian artists draw on certain reserves of skill which are traditionally connected with the movie industry – notably the patient model-making skills inherited from the time when almost all films were

256 Alexis Smith, *Hello, Hollywood (Burma Shave 1)*, 1980. Five-part collage, each part 9¼ × 21 in (23·5 × 53 cm). Courtesy Rosamund Felsen Gallery, Los Angeles.

257 Mike Kelley, *Travelogue: 8 Drawings, The Baggy Pants Comedian*, 1982–3. Acrylic on paper, 24 × 19 in (61 × 48 cm). Courtesy Rosamund Felsen Gallery, Los Angeles.

which were then rightly regarded as a West Coast rather than an East Coast phenomenon. Panter is the originator of the 'punk' style of comic-strip drawing which surfaced in the late 70s in Los Angeles. He is now a regular contributor to *Raw*, which describes itself as 'the graphic magazine which overestimates the taste of the American public'. *Raw* offers a home to Panter's strip 'Jimbo'. In turn, frames from 'Jimbo' provide a basis for paintings that possess a gleeful savagery of colour and design which makes New York graffiti artists look a little tame. Panter has a low opinion of the contemporary avant-garde, as well as a keen awareness of the way in which it is developing. Item One

from his 'Rox-Tox Manifesto' issued in 1984 reads as follows:

The avant-garde is no corpus. It merely lies in shock after an unfortunate bout with its own petard. It feigns sleep but one eye glitters and an involuntary twitch in the corner of the mouth belies a suppressed snicker. The giggle of coming awake at one's own funeral dressed in atomic TV beatnik furniture. A mutant with a museum.

Dematerialization

Hostility to the museum is not new among Californian artists. The material-

258 Peter Alexander, *Puerto Penasco*, 1984. Acrylic and oil on canvas, 36 × 40 in (91 × 101·5 cm). Courtesy the artist.

259 (*Opposite above*) Jeffrey Vallance, *C–82*, 1976–8. Wood, metal, rocks, bones, papier–maché, paint, 24½ × 36¼ × 33½ in (62 × 92 × 85 cm). Courtesy Rosamund Felsen Gallery, Los Angeles.

260 (*Opposite below*) Gary Panter, *Wrestler*, 1984. Acrylic and rhoplex on cheesecloth and bed-sheets. Courtesy Tilden–Foley Gallery, New Orleans.

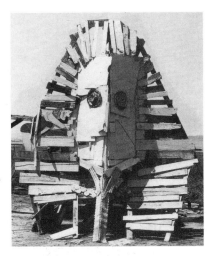

261 Anonymous driftwood sculpture on the beach of Emeryville. Photo Horst Schmidt-Brummer, 1981. Courtesy Gebr. König, Cologne.

263 Joan Brown, *In the Studio*, 1984. Enamel and acrylic on canvas, 96 × 78 in (243·5 × 198 cm). Courtesy Allan Frumkin Gallery, New York.

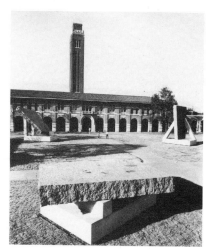

262 Michael Heizer, *45°, 90°, 180°*, 1984. Granite and concrete, 45° element 21 ft 6 in (655 cm) high × 18 ft (548 cm) wide 22 ft (670 cm) deep; 90° element 23 ft 6 in (716 cm) × 12 ft (366 cm) × 18 ft (548 cm); 180° element 8 ft 6 in (259 cm) × 18 ft (548 cm) × 20 ft (609 cm). Rice University, Houston, Texas. Given in tribute to George and Alice Brown by their family. Photo Ivan Dalla-Tana. Courtesy Xavier Fourcade, New York.

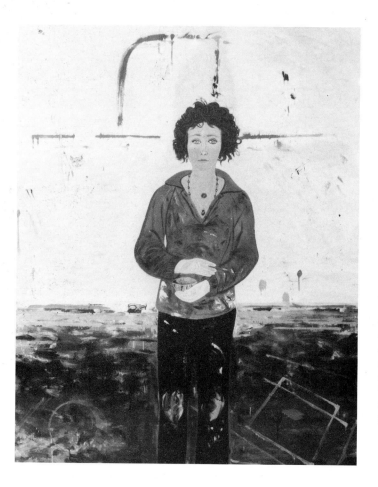

ism of the California life-style on the one hand, and its physical ease and casualness on the other, led a number of artists there to rebel against the idea of the material, possessable work of art. This rebellion was part of the radicalism of the 70s, and it has left a number of legacies – some quite frivolous. In the early 80s, for example, there was a fashion for making large sculptures out of driftwood and found objects on the beach at Emeryville. Often quite elaborate, these had a humorous twist which their makers would not perhaps have allowed themselves in other circumstances – yet they were also quite impressive as works of art.

Michael Heizer's 'land art', though rooted in the now-fading Conceptual Art movement of the late 60s and early 70s, retains impact and vitality because it still possesses a genuine relevance to the Californian situation. When the Los Angeles Museum of Contemporary Art played host to one of Heizer's installations in 1984, it seemed to fulfil a purpose which no Eastern museum could have tackled. Heizer's replica of a mountain, made of painted hardboard shapes, retained the impressiveness of the remote sites where he has also worked.

Two other artists with more specifically local reputations have recently produced work which has done much to extend this particular tradition of the 'non-material' art object. One is Lita Albuquerque. Typical of her activity is *Spine of the Earth*, a piece made at El Mirage Dry Lake. The basic material is dry powder pigment, laid on the dry bed of the lake in geometric patterns which can be related to Tantric diagrams. The pigment is not fixed in any way, and the elements – the wind especially – begin to blur the diagram as soon as it is created. The only permanent record of the piece are the photographs which the artist herself takes of it.

Eric Orr, one of the most impressive of contemporary Californian artists, has also worked extensively in the area of environment and process. *Time Shadow*, an environmental work of 1981, is described thus in the catalogue of the 'Twenty-year Survey' of Orr's work mounted by the University Art Gallery, San Diego, in April/May 1984:

One opened a lead-wrapped door in a lead wall to enter a short dark cor-

ridor insulated for silence and lined with grey scrim. Walking towards a lighted space at the other end of the corridor, one found an empty seat in a recessed niche; the source of light was directly ahead, at eye-level. One seemed at first to be looking out a window, but quickly realized that it was not a window: its skin was too smooth and sleek; and furthermore it showed only the sky. One was gazing in fact, into a highly polished gold mirror which reflected upward through channels in the ceiling to the open sky. In the dark silent space the light lay on the golden mirror with a fascinating solidity and peacefulness.

In recent years, Orr has tended to return to more conventional formats, while at the same time trying to retain things learned during his years of multiple experiment. He has made an elegant series of fountains and water-pieces, where the water clings rippling to a metal surface as it descends, thanks to a cunning exploitation of capillary action; and he has created an outstanding series of monochrome canvases which seem to offer a challenge to the work of Rothko and Barnett Newman, though they are usually on a modest scale. Minimal in one sense, the paintings are figurative in another, since the metaphor of a window is retained, by the use of integral lead frames wrapped in gold leaf. Many of the paintings employ symbolic collage elements – Orr's materials include meteorite dust, human blood (his own), human hair and human bone ash. These are some of the most sensuous yet subtly disturbing artworks produced by a contemporary American.

Bay Area statements

A number of the most distinguished artists to emerge from the Bay Area have already been discussed in earlier chapters of this book. Among them are Robert Arneson, William T. Wiley and Paul Wonner. But it is increasingly difficult to perceive a marked difference beteen Bay Area art and that produced in the rest of California. Perhaps, indeed, the most striking thing about a number of leading Bay Area artists is their insistence on human individuality and their rejection of any sort of grouping. Joan Brown is universally recognized as a leading painter from San Francisco –

but does this mean that the place itself is the largest component in her artistic identity? She is an intensely autobiographical artist who is anxious to preserve a certain even-handedness between the requirements of picture-making and the demands of personal feeling. In a 1981 statement she says:

I strive for that delicate balance between reason and feeling, knowing that sometimes the pictures will lean one way or the other. I'm constantly trying to pull out new information from my intuitive self, which results in the surprises that I discover in my work, and which keeps me ever stimulated. (*50 West Coast Artists: a critical selection of painters and sculptors working in California*, by Henry Hopkins, San Francisco 1981.)

Viola Frey's large ceramic figures have the same reliance on intuition and the same sharpness of observation that one finds in paintings by Joan Brown. In addition, they conform to at least one established expectation concerning the art of Northern California, because they are an ambitious marriage between art and craft. One might equally say, however, that they dissolve barriers in another and quite different fashion. Their bright colours mean that they can be thought of as a mixture between painting and sculpture.

The metaphoric imagination

In direct contrast to the essentially social art of Joan Brown and Viola Frey is another and very different kind of Californian manifestation – art which is the ambitious embodiment of metaphor. It seems fitting to conclude this survey of present-day American art with two examples – appropriately, one is the work of an artist from Los Angeles, and the other that of an artist from San Francisco. Neither work could in any sense be described as typical of the current state of the visual arts in America. Yet in a more fundamental way each seems to be typical of things which contemporary American artists possess almost without being aware of it, and which their European counterparts often seem to lack – the refusal to acknowledge boundaries, the confidence that what can be imagined can be embodied in a way which will make it eloquent to an audience. David Best's *Father of Dark-*

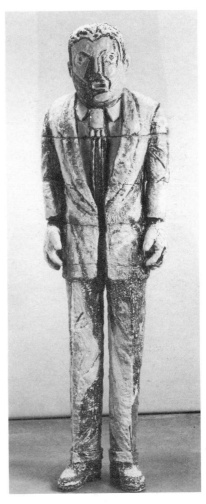

264 Viola Frey, *Man in Blue Suit I*, 1983. Ceramic, 108 × 32 × 26 in (274 × 81 × 66 cm). Courtesy Asher/Faure Gallery, Los Angeles.

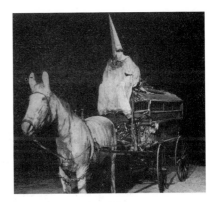

265 David Best, *Father of Darkness, Mother of Madness, Gatherer of Birds*, 1984. Mixed media, 144 × 168 × 72 in (365 × 426 × 182·5 cm). Photo Bob Murray. Courtesy Ann Harithas.

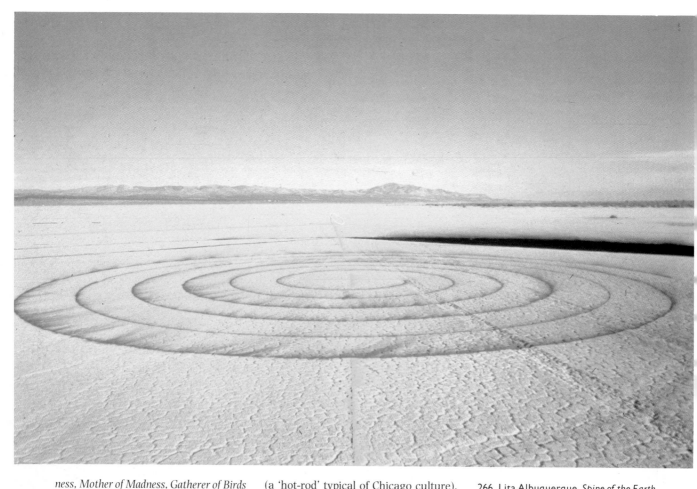

266 Lita Albuquerque, *Spine of the Earth*, 1980. Pigment, wood, stone, whole piece 50 × 50 ft (15·2 × 15·2 m). El Mirage, Dry Lake. Courtesy the artist.

ness, *Mother of Madness, Gatherer of Birds* was created for the exhibition 'Collisions', curated by Ann Harithas at the Lawndale Alternative, University of Houston. A photograph of the whole piece unfortunately gives little idea of the minute detail of Best's craftsmanship. The ornamentation on the wagon makes use of a wide range of materials – plastic, bone, glass, ivory, wood and steel. Examined at close range it looks like an excerpt from a painting by Gustave Moreau. Considered in another way, much of Best's imagery echoes Hieronymous Bosch, and is full of references to Bosch's *Garden of Earthly Delights* in particular. But the whole piece is nevertheless completely and courageously contemporary in its direct reference to the Klansmen who marched through the centre of Houston only weeks before 'Collisions' opened.

James Croak's *Pegasus: Some Loves Hurt More than Others* juxtaposes the winged horse of Greek mythology with what the artist sees as its modern counterpart – a 1963 Chevvy lowrider

(a 'hot-rod' typical of Chicago culture). Both the horse and the car through whose roof it bursts serve as symbols of renegade personal freedom. The combination is heroic, overweening, ironic and consciously absurd – modern without a doubt, but also Post-Modern in its insouciant renewal of an apparently exhausted myth. Much of this book is about renewals of a similar sort, about the irresistible vitality within America which enables its artists to produce such a cornucopia of images, in such a wide variety of styles.

There is no book which could give a complete account of all these efforts. What this one offers is merely a sampling – a personal one at that. Croak's quadruped thrusting its way through the roof of an automobile must also serve as a symbol for something its maker did not have in mind. It summarizes my own inability always to keep the rich materials available to me completely within bounds. But a tidier book would give a less truthful impression of the nature of American art.

267 (*Opposite*) Eric Orr, *Without Red*, 1983. Lead, gold leaf, mixed media, 53 × 44 in (134·5 × 112 cm). Courtesy Ovsey Gallery, Los Angeles.

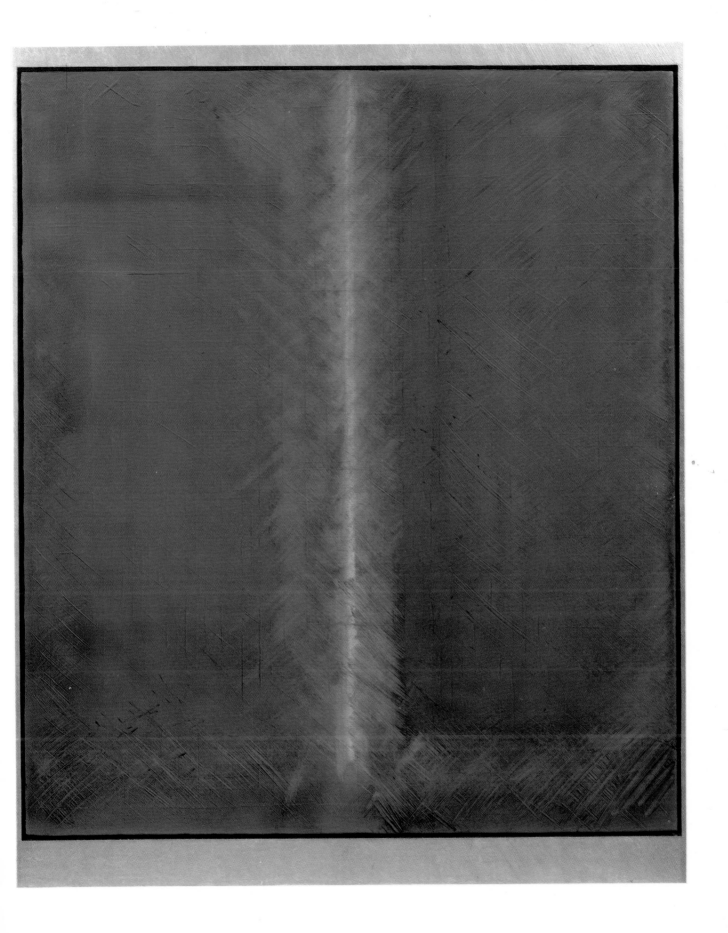

BIOGRAPHICAL INDEX OF ARTISTS

Note: In spite of all the author's efforts, full information on some artists has proved unobtainable. This explains why some entries are incomplete.

The italic number at the end of each entry is the index to the text reference for that artist.

List of abbreviations

Exh. exhibition(s); one-person unless otherwise stated

(g) group exhibition

Coll. works exhibited in the collections listed

Africano, Nicholas. b. 1948, Kankakee, Ill. Illinois State Univ., Normal, 1970(BFA), 1974(MA), 1975(MFA). Exh. incl. 1976, 1977 Nancy Lurie Gall., Chicago; 1977, 1979, 1980, 1981, 1982 Holly Solomon Gall., NY; 1978 Walker Art Center, Minneapolis; 1979, 1981 Asher/Faure Gall., LA; 1979 Mayor Gall., London, Galerie Farideh Cadot, Paris; 1981 Middendorf/Lane Gall., Wash. DC; 1982 American Graffiti Gall., Amsterdam, Dart Gall., Chicago, Greenberg Gall., St Louis. *35.*

Ahearn, John. b. 1951, Binghampton, NY. Cornell Univ., Ithaca, NY, 1973(BFA). Exh. 1979 Fashion Moda, Bronx Mus., NY; 1982 Galerie Rudolph Zwirner, Cologne; 1983 Brooke Alexander, NY. *84.*

Albuquerque, Lita. b. 1946, Santa Monica, Cal. UCLA, 1968(BA); Otis Art Inst., LA, 1971. Exh. incl. 1978 Casat Gall., La Jolla, Cal., Univ. of Cal., Santa Barbara, Long Beach City College, Cal.; 1979 Janus Gall., LA. *144.*

Alexander, Peter. b. 1939, LA. UCLA, 1964-8(BA,MFA). Exh. 1968, 1970 Robert Elkon Gall., NY; 1969 Janie C. Lee Gall., Dallas, Locksley/Shea Gall., NY; 1970 Nicholas Wilder Gall., LA; 1971 Michael Walls Gall., San Francisco; 1972 Akron Art Inst., Ohio. *140.*

Alvarado-Juarez, Francisco. b. (?). SUNY at Stony Brook, 1974(BA); Internat. Center of Photography, NY, 1975. Exh. 1976 Internat. Center of Photography, NY; 1980 Mus. Mod. Art of Latin America, Org. of American States, Wash. DC, Cayman Gall., SoHo, NY, Fondo del Sol Visual Art and Media Center, Wash. DC, Rotunda Gall., Pan American Health Org., Wash. DC, Martin Luther King

Mem. Lib. Gall., Wash. DC; 1981 Galeria Inti, Wash. DC, Federal Communications Commission, Wash. DC, Colorfax Gall., Wash. DC; 1984 The Midtown Gall., Wash. DC. *121.*

Amenoff, Gregory. b. 1948, St Charles, Ill. Beloit College, Wisc.(BA,Hist.) Exh. 1972 Brockton Art Center, Mass.; 1976 Hayden Corridor Gall., MIT, Cambridge, Mass.; 1977, 1978, 1980 Nielsen Gall., Boston, Mass.; 1981, 1983 Robert Miller Gall., NY; 1983 Stephen Wirtz Gall., San Francisco, Fayerweather Gall., Univ. of Virginia, Charlottesville. *40.*

André, Carl. b. 1935, Quincy, Mass. Phillips Acad., Andover, Mass. Exh. incl. 1965, 1966 Tibor de Nagy Gall., NY; 1967 Dwan Gall., LA and NY, Konrad Fischer Gall., Düsseldorf; 1968 Heiner Friedrich Gall., Munich; 1969 Gemeentemuseum, The Hague; 1970 Solomon R. Guggenheim Mus., NY; 1971 Galerie Yvon Lambert, Paris; 1972 Lisson Gall., London; 1973 Mus. Mod. Art, NY, Gian Enzo Sperone, Turin; 1974 Wide White Space, Antwerp; 1975 Mus. Mod. Art, Oxford, England; 1977 Sperone Westwater Fischer Gall., NY; 1978 Art Agency Co Ltd, Tokyo; 1980, 1981, 1983 Paula Cooper Gall., NY. *21-2.*

Andrejevic, Milet. b. 1925, Petrovgrad, Yugoslavia. Sch. Applied Arts, Belgrade, 1941-4; Acad. Fine Arts, Belgrade, 1944-50(BFA), 1951(MFA). Exh. 1953, Belgrade; 1961, 1963 Green Gall., NY; 1970, 1972, 1976 Bellamy-Goldowsky Gall., NY; 1980 Robert Schoelkopf Gall., NY. *105.*

Andrews, Benny. b. 1930, Georgia. Founder Black Emergency Cultural Coalition. Exh., NY; Atlanta; Sarasota, Florida; Hartford, Conn. *120.*

Antrim, Craig. b. 1942. Coll. incl. Corcoran Gall. Art, Wash. DC; UCLA; Claremont Graduate Sch., Cal.; Security Pacific Bank (9 branches), Cal.; LA County USC Medical Credit Union, LA; Citicorp, LA; Sohio Corp., San Francisco. *137.*

Armajani, Siah. b. 1939, Teheran. Exh., Philadelphia; Columbus, Ohio; NY; Kansas City. *67.*

Arneson, Robert. b. 1930, Benicia, Cal. California College of Arts and Crafts, Oak-land, 1954(BA); Mills College, Oakland, Cal., 1958(MFA). Exh. incl. 1967 San Francisco Mus. Art; 1974 Mus. Contemp. Art, Chicago, Nat. Collection of Fine Arts, Wash. DC; 1975, 1977, 1979 Allan Frumkin Gall.,

NY; 1976, 1978 Allan Frumkin Gall., Chicago; 1980, 1984 Frumkin and Struve Gall., Chicago. *115, 145.*

Aycock, Alice. b. 1946, Harrisburg, Penn. First exh. 1972 Halifax, Nova Scotia; Exh. since, NY; Cambridge, Mass.; Williamstown, Mass. *76-8.*

Azaceta, Luis Cruz. b. 1942, Havana, Cuba. Sch. Visual Arts, 1969(BA). Exh. 1978 Allan Frumkin Gall., Chicago, Cayman Gall., NY, New World Gall., Miami-Dade Community College, Florida; 1979, 1982, 1984 Allan Frumkin Gall., NY; 1981 Richard L. Nelson Gall., Univ. of Cal., Davis. *121.*

Baechler, Donald. b. 1956, Hartford, Conn. Maryland Inst., College of Art, Baltimore, 1974-7; Cooper Union Sch. Art, NY, 1977-8; Staatliche Hochschule fur Bildende Kunste, Frankfurt, W. Germany, 1978-9. Exh. 1979 Galerie Patio, Frankfurt; 1980 Enzo Cannaviello, Milan; 1981 Giuseppe Manigrasso, Naples; 1982 Hallwalls, Buffalo, NY; 1983 Tony Shafrazi Gall., NY. *41.*

Bailey, William. b. 1930, Council Bluffs, Iowa. Univ. of Kansas, Sch. Fine Arts, 1948-51; Yale Univ., Sch. Art, New Haven, Conn., 1955(BFA), 1957(MFA). Exh. incl. 1956 Robert Hull Fleming Mus., Univ. of Vermont; 1963 Indiana Univ. Mus. Art, Bloomington; 1967 Kansas City Art Inst., Missouri; 1968, 1971, 1974, 1979, 1982 Robert Schoelkopf Gall., NY; 1973 Galleria La Parisina, Turin, Galleria dei Lanzi, Milan, Galleria Il Fante de Spade, Rome; 1978 Galerie Claude Bernard, Paris; 1979 Fendrick Gall., Wash. DC; 1980 Galleria d'Arte il Gabbiano, Rome; 1983 Meadows Gall., Owen Art Center, Southern Methodist Univ., Dallas. *97,100.*

Bartlett, Jennifer. b. 1941, Long Beach, Cal. Mills College, Oakland, Cal., 1963(BA); Yale Sch. Art and Architecture, New Haven, Conn., 1964(BFA), 1965(MFA). Exh. incl. 1963 Mills College, Oakland; 1970 119 Spring St., NY; 1972 Reese Palley Gall., NY; 1974, 1978 Saman Gall., Genoa; 1976, 1977, 1979, 1983 Paula Cooper Gall., NY; 1979, 1983 Margo Leavin Gall., LA; 1980 Galerie Mukai, Tokyo, Albright-Knox Art Gall., Buffalo, NY; 1982 Tate Gall., London; 1984 Long Beach Mus. Art, Cal. *35.*

Basquiat, Jean Michel. b. 1960, Brooklyn, NY. Ed., various public schools in NY. Exh. incl. 1981, 1982 Annina Nosei Gall., NY; 1982 Marlborough Gall., NY; 1983 Kunst-

museum, Lucerne, Kassel, W. Germany (g), Whitney Mus. American Art, NY (g). *49.*

Bates, David. b. 1952, Dallas, Texas. Southern Methodist Univ., Dallas, 1975(BFA), 1976(MFA); Whitney Mus. American Art, NY,(Independent Study). Exh. incl. 1976 Allen St. Gall., Dallas; 1976, 1978 Eastfield College, Dallas; 1978 Univ. Gall., Southern Methodist Univ., Dallas; 1981, 1982, 1983 DW Gall., Dallas; 1983 Charles Cowles Gall., NY; 1984 Texas Gall., Houston. *133-6.*

Beauchamp, Robert. b. 1923, Denver, Col. Colorado Springs Fine Arts Center, 1946-7; Cranbrook Art Acad., Bloomfield Hills, Michigan, 1947-8; also studied with Hans Hofmann, Provincetown, Mass. Exh. incl. 1953, 1955 Tanager Gall., NY; 1958 March Gall., NY; 1959, 1960 Great Jones Gall., NY; 1961, 1963 Sun Gall., Provincetown; 1963, 1964 Green Gall., NY; 1964 Richard Grey Gall., Chicago, Felix Landau Gall., LA; 1965 American Gall., NY; 1966, 1967, 1969 Graham Gall., NY; 1971 Tirca Karlis Gall., NY; 1972 French and Co., NY, Dain Gall., NY; 1978, 1979, 1983 Monique Knowlton Gall., NY. *37.*

Bechtle, Robert. b. 1932, San Francisco. First exh. 1959, San Francisco. Exh. since in Berkeley; Sacramento; San Francisco; NY; San Diego. Coll. incl. Crocker Art Mus., Sacramento; Lib. of Congress, Wash. DC; Mus. Mod. Art, NY; Neue Galerie, Aachen; St Louis Art Mus.; Mus. Art, San Francisco; Whitney Mus. American Art, NY. *90.*

Beckman, William. b. 1942, Maynard, Minn. St Cloud State Univ., Minn.(BA); Univ. of Iowa, Iowa City(MA,MFA). Exh. 1969 Univ. of Iowa, Hudson River Mus., Yonkers, NY; 1970, 1971, 1974, 1976, 1978, 1980 Allan Stone Gall., NY; 1982 Allan Frumkin Gall., NY. *93-5, 112.*

Beeman, Malinda. b. 1949, Pomona, Cal. Cal. State Univ., San Diego, 1971(BFA); San Francisco Art Inst., 1973(MFA). Exh. 1976 Contemp. Arts Mus., Houston; 1981 Main Gall., Houston, Texas. *75.*

Bell, Charles. b. 1935, Tulsa, Okl. Univ. of Oklahoma(BBA). Exh. 1972, 1974, 1977, 1980, 1983 Louis K. Meisel Gall., NY; 1976 Morgan Gall., Shawnee Mission, Kansas; 1983 Hokin/Kaufman Gall., Chicago. *97.*

Benes, Barton. b. 1942, Westwood, NJ. Exh. incl. 1976, 1977, 1978, 1979 Fendrick Gall., Wash. DC; 1977 Renwick Gall., Smithsonian Inst., Wash. DC; 1979 Dayton Art Inst., Ohio, Victoria and Albert Mus., London; Cooper Union, NY. *72.*

Benglis, Lynda. b. 1941, Lake Charles, La. Newcomb College, New Orleans, 1964(BFA); Yale Summer Sch., Norfolk, Conn., 1963; Brooklyn Mus. Art Sch., NY, 1964-5. Exh. incl. 1982 Paula Cooper Gall., NY; 1982-3 Kestner-Gesellschaft, Hanover (g); 1983 Margo Leavin Gall., LA, Kunstmuseum, Lucerne (then in (g) in U.S.), Neuberger Mus., Purchase, NY. *56-7.*

Best, David. b. 1945, San Francisco. College of Marin, Kentfield, Cal., 1970; San Francisco Art Inst., 1974(BFA), 1975(MFA). Exh. 1973 de Saisset Art Gall. and Mus., Univ. Santa Clara, Cal.; 1975 Smith-Andersen Gall., San Francisco; 1976, 1980 Smith-Andersen Gall., Palo Alto, Cal.; 1978 Gall. Paule Anglim, San Francisco. *145-6.*

Birmelin, Robert. b. 1933. Cooper Union Sch. Art, NY; Yale Univ. Sch. Art and Architecture, New Haven, Conn.(BFA,MFA). Exh. incl. 1960 Kanegis Gall., Boston; 1960, 1964, 1967 Stable Gall., NY; 1962 Usis Gall., Milan; 1965 Jason-Teff Gall.,

Montreal; 1973 Rose Mus., Brandeis Univ., Waltham, Mass.; 1975 Terry Dintenfass Gall., NY; 1981 Odyssia Gall., NY; 1982 Fendrick Gall., Wash. DC; 1984 Montclair Art Mus., NJ, Sherry French Gall., NY. *109.*

Borofsky, Jonathan (Jon). b. 1942, Boston, Mass. Carnegie Mellon Univ., Pittsburgh, Penn., 1964(BFA); École de Fontainebleau, France, 1964; Yale Sch. Art and Architecture, New Haven, Conn., 1966(MFA). Exh. incl. 1975, 1976, 1979, 1980 Paula Cooper Gall., NY; 1977 Univ. of Cal., Irvine; 1978 Univ. Art Mus., Berkeley, Cal., Corps de Garde, Groningen; 1979 INK, Halle für Internationale Neue Kunst, Zurich; 1981 Galerie Rudolph Zwirner, Cologne, Kunsthalle, Basle, Inst. Contemp. Art, London; 1982 Mus. Boymans-Van Beuningen, Rotterdam, E. and O. Friedrich Gall., Bern; 1983 Kunstmuseum, Basle; 1984 Kunstverein, Hamburg. *57.*

Boskovich, Nick. b. 1949, San Pedro, Cal. California State Univ., Long Beach, 1980(MFA). Exh. 1977, 1980, 1981 Ball State Univ., Muncie, Ind.; 1982 Mills House Arts Complex, LA County Mus., Orange County Center for Contemp. Art, Santa Ana, Cal.; 1983 Union League Club, Chicago; 1983, 1984 Stella Polaris Gall., LA. *100.*

Bosman, Richard. b. 1944, Madras, India. Byam Shaw Sch. Painting and Drawing, London, 1964-9; NY Studio Sch., 1969-71; Skowhegan Sch. Painting and Sculpture, Maine, 1970. Exh. incl. 1980, 1981, 1982, 1983, 1984 Brooke Alexander, NY; 1982 Fort Worth Art Mus., Texas, Dart Gall., Chicago, Thomas Segal Gall., Boston, Mass.; 1983 Mayor Gall., London, Reconnaissance, Melbourne, Australia. *37-8.*

Bourgeois, Louise. b. 1911, Paris. Sorbonne, Paris, 1932-5; École de Louvre, Paris, 1936-7; Académie des Beaux-Arts, Paris, 1936-8; Atelier Bisserie, Paris, 1936-7; Académie de la Grande Chaumiére, Paris, 1937-8; Académie Julien, Paris, 1938. Exh. 1945 Bertha Schaefer Gall., NY; 1947 Norlyst Gall., NY; 1949, 1950, 1953 Peridot Gall., NY; 1953 Allan Frumkin Gall., NY; 1959 Cornell Univ., Ithaca, NY; 1964, 1975 Stable Gall., NY; 1964 Rose Fried Gall., NY; 1974 Greene St. Gall., NY. *12.*

Brady, Carolyn. b. 1937, Chickasha, Okl. Oklahoma State Univ., Stillwater, 1955-8; Univ. of Oklahoma, Norman, 1958-9(BFA), 1959-61(MFA). Exh. 1975 Nancy Singer Gall., St Louis; 1977, 1980, 1983 Nancy Hoffman Gall., NY; 1977 Art Gall., Univ. of Rhode Island, Kingston; 1978 Univ. of Missouri, St Louis and Kansas City; 1980 Pittsburgh Art Center, Penn.; 1982 Columbia Mus. Arts and Sciences, SCar, Thomas Segal Gall., Boston, Mass., Mint Mus., Charlotte, NCar. *97.*

Brown, James. b. 1951, LA. Immaculate Heart College, Hollywood, 1970-2, 1975(BFA); École Superieure des Beaux-Arts, Paris, 1973-5; Instituto Michelangelo, Florence. Exh. 1978 Gemeentemuseum, Arnhem, Holland; 1983 Lucio Amelio Gall., Naples, American Graffiti Gall., Amsterdam, Nature Morte Gall., NY, Tony Shafrazi Gall., NY. *41-2.*

Brown, Joan. b. 1938, San Francisco. Exh. incl. NY; San Francisco; Chicago. Coll. incl. Mus. Mod. Art, NY; Albright-Knox Art Gall., Buffalo, NY; County Mus., LA. *145.*

Brown, Roger. b. 1941, Hamilton, Ala. Amer. Acad. Art, Chicago, 1962-4; Sch. Art Inst. Chicago, 1964-8(BFA), 1968-70(MFA). Exh. incl. 1971, 1973, 1974,

1976, 1977, 1979, 1984 Phyllis Kind Gall., Chicago; 1975, 1977, 1979, 1981, 1982, 1984 Phyllis Kind Gall., NY; 1980, Montgomery Mus. Fine Art, Ala., Mus. Contemp. Art, Chicago; 1981, Mayor Gall., London; 1983 Asher/Faure Gall., LA; 1984 Nexus Gall., Atlanta, Georgia. *122-5, 129.*

Buck, John. b. 1946, Iowa. Kansas City Art Inst. and Sch. Design, Missouri, 1964-8(BFA); Univ. of Cal., Davis, 1970-2(MFA); Gloucestershire College of Art and Design, Cheltenham, England, 1972-3. Exh. 1974 Mira Costa College, Carlsbad, Cal.; 1975 Univ. of Kentucky, Lexington; 1979, 1981 Hanson Fuller Goldeen Gall., San Francisco; 1981 Morgan Gall., Kansas City; 1982 Mandeville Art Gall., Univ. of California, Davis; 1983 Fuller Goldeen Gall., San Francisco, Zolla/Lieberman Gall., Chicago; 1983-4 Travelling exh. in U.S. *61-3.*

Burden, Chris. b. 1946, Boston, Mass. Pomona College, Claremont, Cal., 1969(BA); Univ. of California, Irvine, 1971(MFA). Exh. incl. 1974, 1975 Riko Mizuno Gall., LA; 1974, 1975, 1976, 1977, 1979, 1980, 1983 Ronald Feldman Fine Arts, NY; 1975 Galleria Allesandra Castelli, Milan, Galleria Schema, Florence, Galerie Stadler, Paris, De Appel, Amsterdam; 1977 Jan Baum/Iris Silverman Gall., LA; 1979, 1982, 1984 Rosamund Felsen Gall., LA; 1980 Whitney Mus. American Art, NY. *76-8.*

Burton, Scott. b. 1939, Greensboro, Ala. Studied with Leon Berkowitz, Wash. DC, 1957-9, and Hans Hofmann, Provincetown, Mass. Exh. 1971 Finch College, NY; 1972 Whitney Mus. American Art, NY; 1975 Idea Warehouse, Inst. Art and Urban Resources, NY, Artists Space, NY; 1976 Solomon R. Guggenheim Mus., NY; 1977 Droll/ Kolbert, NY; 1978 Brooks Jackson Iolas Gall., NY; 1979 Protech MacIntosh, Wash. DC; 1980, 1982 Daniel Weinberg Gall., San Francisco; 1980 Univ. Art Mus., Univ. of California, Berkeley; 1981 Dag Hammarskjold Plaza, NY; 1981, 1982 Max Protetch Gall., NY; 1983 Contemp. Arts Center, Cincinnati, Fort Worth Arts Mus., Texas (travelling exh.). *69.*

Butler, James. b. 1945, Fort Dodge, Iowa. Univ. of Nebraska, Omaha, 1963-7(BS); Univ. of Nebraska, Lincoln, 1967-70(MFA). Exh. incl. 1970 Blanden Mem. Art Gall., Fort Dodge; 1973 Deson-Zaks Gall., Chicago; 1982 Miami Univ., Oxford, Ohio; 1983 Visual Arts Center, Anchorage, Alaska. *93.*

Butterfield, Deborah. b. 1949, San Diego, Cal. San Diego State Univ., 1966-8; Univ. of Cali-fornia, San Diego, 1969; Big Creek Pottery Summer Ceramic Workshop, Santa Cruz, 1969; Univ. of Cal., Davis, 1972(BA), 1975(MFA); Skowhegan Sch. Painting and Sculpture, Maine, 1972. Exh. incl. 1976 Madison Art Center, Wisc.; 1976, 1977, 1979, 1983 Zolla/Lieberman Gall., Chicago; 1978, 1979, 1982, 1983 O.K. Harris Works of Art, NY; 1978 Hanson Fuller Gall., San Francisco; 1981 Israel Mus., Jerusalem, Galerie Zwirner, Cologne; 1982 Asher/Faure Gall., LA, Dallas Mus. Fine Arts, Texas, Mayor Gall., London; 1983 Chicago Cultural Center. *41.*

Cardenas, Caroline. b. (?). Univ. of Kansas, Lawrence, 1976(BFA); Drake Univ., Des Moines, Iowa, 1979(MFA); Univ. of Arizona, Tucson, 1982 (postgraduate work). Exh. 1979 Art Gall., Harmon Fine Arts Center, Drake Univ., Des Moines; 1982 Sunnyvale Creative Arts Center Gall., Cal. *60.*

Castanis, Muriel. b. 1926, NY. High Sch., NY, 1940-44 (Music and Art). Exh. 1968 Ruth White Gall., NY; 1972 Caravan House, NY; 1974 James Yu Gall., NY; 1978 Gouglass College Art Gall., NY; 1980, 1983 O.K. Harris Works of Art, NY; 1981 O.K. Harris West, Scottsdale, Arizona. *81.*

Castle, Wendell. b. 1932, Emporia, Kansas. Trained as sculptor at Univ. of Kansas. Now one of America's best known craftsman furniture-makers. Exh. numerous (g). Coll. incl. Metropolitan Mus. Art, NY; Mus. Contemp. Crafts, NY; Philadelphia Mus. Art, Penn. *69-70.*

Castoro, Rosemary. b. 1939, Brooklyn, NY. Mus. Mod. Art, NY, 1954-5 (scholarship in painting); Pratt Inst., NY, 1956-63(BFA). Exh. incl. 1971, 1972, 1973, 1975, 1976, 1978, 1980 Tibor de Nagy Gall., NY; 1973 Lubin House Gall., Syracuse Univ., NY; 1976, 1978, 1979, 1980, 1983 Hal Bromm Gall., NY; 1977 Univ. of Colorado, Boulder; 1978 P.S.1 Gall., Long Island City, NY; 1978, 1979 Julian Pretto Gall.; NY; 1979 Artpack, Lewiston, NY; 1983 American Center, Paris, Duane Park, NY. *61-3.*

Chase, Louisa. b. 1951, Panama City. Syracuse Univ., NY, 1973(BFA); Yale Univ. Sch. Art, New Haven, Conn., 1975(MFA). Exh. incl. 1975 Artists Space, NY; 1978 Edward Thorp Gall., NY; 1981, 1982, 1984 Robert Miller Gall., NY; 1982 Harcus-Krakow Gall., Boston, Mass.; 1983 Galerie Inge Baeker, Cologne; 1984 Mira Godard Gall., Toronto. *32.*

Chicago, Judy, (Judy Cohen Gerowitz). b. 1939, Chicago. First exh. 1966 Los Angeles. Exh. since incl. Tokyo, Osaka, London, San Francisco, Chicago. 1970, organized first Feminist Art Program in U.S. 1982-1985, 'The Dinner Party', touring environmental exh. 'The Birth Project', over 100 needleworks on the theme of Birth and Creation, conceived for multiple installations in museums and alternative spaces. *114-5.*

Christenberry, William. b. 1936, Tuscaloosa, Ala. Univ. of Alabama, 1954-8(BFA), 1958-9(MFA). Exh. incl. 1961 Univ. of Ala. Gall. Art, Tuscaloosa; 1970, 1973 Henri Gall., Wash. DC; 1971, 1974 Henri II Gall., Wash. DC; 1973 Jefferson Place Gall., Wash. DC, Octagon House, U.S. Inst. Architects, Wash. DC; 1973, 1983 Corcoran Gall. Art, Wash. DC; 1974 Henri I Gall., Wash. DC; 1976 Zabriskie Gall., NY; 1977 Univ. Art Gall., SUNY, Albany; 1980 Cronin Gall., Houston, Texas; 1983 Middendorf/Lane Gall., Wash. DC; 1984 Southern Monuments and Photographs, Moody Gall., Houston, Texas. *52.*

Civitico, Bruno. b. 1942, Dignano D'Istria, Italy. Pratt Inst., NY, 1966(BFA); Indiana Univ., Bloomington, 1968(MFA). Exh. incl. 1973, 1976, 1978, 1980 Robert Schoelkopf Gall., NY; 1982 Univ. of South Florida, Tampa, Tyler Sch. of Art, Sklar Gall., Florida. *105.*

Clement, Alain. b. 1945, Dijon, France. Univ. Dijon (LLB); also studied art history with Jacques Thuiller. Exh. incl. 1977, 1981 Galerie Jacques Bosser, Paris; 1978 Galerie L'Orange, Le Havre; 1978, 1979 Galerie Ghislain Mollet-Vieville, Paris; 1979 Galerie Renée Laporte, Antibes; 1979, 1980 D. Clayton and Co., Houston; 1981, 1983 Graham Gall., Houston; 1981 Mus. Fine Arts, Houston; 1982 Houston Arts Calendar and Directory Exhibition, Houston, Stavanger, Norway (and throughout Scandinavia); 1984 San Antonio Art Inst., Texas,

Texas Christian Univ., Fort Worth. *117-20.*

Close, Chuck. b. 1940, Monroe, Washington. First exh. 1967 Univ. of Massachusetts Art Gall., Amherst. Coll. incl. Mus. Mod. Art, NY; Whitney Mus. American Art, NY; Neue Galerie, Aachen; National Gall. Canada, Ottawa. *79.*

Conger, William. b. 1937, Dixon, Ill. Sch. Art Inst. Chicago, 1956-7; Univ. New Mexico, Albuquerque, 1957-60(BFA); Univ. of Chicago, 1964-6(MFA). Exh. incl. 1974, 1976 Douglas Kenyon Gall., Chicago; 1978, 1980, 1982 Zaks Gall., Chicago. *129.*

Cottingham, Robert. b. 1935, NY. Pratt Inst., NY, 1959-64 (degree in advertising art). Exh. incl. 1968, 1969, 1970 Molly Barnes Gall., LA; 1971, 1974 O.K. Harris Works of Art, NY; 1975 D.M. Gall., London. *90-2.*

Croak, James. b. 1951, Cleveland, Ohio. Inst. Cultural Affairs, 1974 (MA); Univ. Illinois, Chicago (BA). Exh. 1978 Century City Gall., Cal., Janus Gall., Venice, Cal.; 1980 Riverside Art Center and Mus., Cal., Kirk de Gooyer, LA; 1982 San Diego State Univ., Cal.; 1983 Otis Art Inst., Parsons Sch. Design, LA. *146.*

Cutrone, Ronnie. b. 1948, NY. Sch. Visual Arts, NY, 1966-70. Exh. 1978-9 Mudd Club, NY; 1979 Robert Freidus Gall., NY, 112 Workshop, NY; 1982 Lucio Amelio Gall., Naples, Tony Shafrazi Gall., NY. *53.*

Dallman, Daniel. b. 1942, St Paul, Minn. State Univ. St Cloud, Minn., 1965(BS); Univ. of Iowa, Iowa City, 1968(MA), 1969(MFA). Exh. 1972 Philadelphia Print Club; 1973 Kramer Gall., St Paul, Hemingway Gall., Nantucket, West Chester State College, Penn.; 1974, 1976 Gall. Four, Alexandria, Virginia; 1974 Ronnie Brenner Gall., New Orleans; 1976 Tyler Sch. Art, Temple Abroad, Rome; 1977 Mint Mus. Art, Charlotte, NCar.; 1980, 1984 Robert Schoelkopf Gall., NY; 1982 Philadelphia College of Art. *112.*

Davis, Brad. b. 1942. Exh. incl. 1972, 1975 NY; 1972 98 Greene St. Loft, NY; 1975, 1977, 1979 Holly Solomon Gall., NY; 1980 Toni Birkhead Gall., Cincinnati. *45.*

Davis, Ron. b. 1937, Santa Monica, Cal. First exh. 1965 LA. Exh. since frequently in NY and Cal. Exh. also in Milan and Toronto. *88, 140.*

de Andrea, John. b. 1941, Denver, Col. First exh. 1970 NY. Coll. incl. Neue Galerie, Aachen; Everson Mus., Syracuse, NY. *82-4.*

de Kooning, Willem. b. 1904, Rotterdam. Akademie voor Beeldende Kunsten, Rotterdam, 1916-24. Exh. incl. 1948 Charles Egan Gall., NY; 1953, 1956, 1972 Sidney Janis Gall., NY; 1961, 1965 Paul Kantor Gall., Beverly Hills; 1968 M. Knoedler et Cie., Paris; 1971 Allan Stone Gall., NY; 1975 Fourcade, Droll, NY. *9-12.*

Delbano, Martin. b. 1957, Dallas, Texas. East Texas State Univ., Commerce, 1980(BFA); Univ. of New Mexico, Albuquerque, 1982(MA). Exh. 1980, 1983 DW Gall., Dallas; 1981 Amarillo Art Center, Texas; 1984 Waco Art Center, Texas, Tilden-Foley Gall., New Orleans. *133.*

DeLude, Jeffrey. b. 1955, Tennessee. Cleveland State Community College, Tenn., 1975; Middle Tennessee State Univ., Murfreesboro, 1978(BFA); Univ. of Houston, Central Campus, 1981(MFA). Exh. incl. 1980 Houston Public Lib.; 1981 Galveston Arts Center, Texas, Sarah Campbell Blaffer Gall., Univ. of Houston, Two Plain Feet Gall., Chicago; 1982, 1983 Lawrence Oliver Gall., Philadel-

phia; 1982 Carol Newall Gall., Houston; 1984 Houston Center, Houston. *136.*

Denby, Jillian. b. 1944. Exh. incl. 1974, 1975, 1977 A.M. Sachs Gall., NY; 1981 Alexander F. Milliken, NY. *103.*

Dennis, Donna. b. 1942, Springfield, Ohio. Exh. incl. 1973 Westbroadway Gall., NY; 1974 Swarthmore College, Penn.; 1976, 1978 Holly Solomon Gall., NY; 1978 Adler Gall., LA. *67.*

de Palma, Brett. b. 1949, Lexington, Kentucky. Peabody College, Nashville, Tenn., 1970(BA); Nashville Univ., 1970; Boston Sch. Mus. Fine Arts, Mass., 1972(BFA); Tufts Univ., Medford, Mass., 1973(MFA). Exh. 1975 Sarratt Art Center, Vanderbilt Univ., Nashville; 1978 Martin-Wiley Gall., Nashville; 1982, 1983 Emilio Mazzoli Gall., Modena, Italy. *42.*

Diebenkorn, Richard Clifford. b. 1922, Portland, Oregon. Stanford Univ., Cal., 1940-3(BA); Cal. Sch. Fine Arts, San Francisco, 1946-7; Univ. of New Mexico, Albuquerque, 1950-2(MA). Exh. incl. 1948 Cal. Palace of the Legion of Honour, San Francisco; 1952 Paul Kantor Gall., LA; 1958, 1963, 1971 Poindexter Gall., NY; 1964 Washington Gall. Mod. Art, Wash. DC; 1965 Jewish Mus. NY; 1967 Waddington Gall., London; 1969 LA County Mus. Art, Cal.; 1972 San Francisco Mus. Art, Cal.; 1973, 1974 Marlborough Fine Art, London, NY, Zurich; 1975 James Corcoran Gall., LA, John Berggruen Gall., San Francisco. *17-19.*

Dine, Jim. b. 1935, Cincinnati, Ohio. Univ. of Cincinnati, 1953-7; Boston Mus. Sch.; Ohio Univ., Athens, Ohio, (BFA). Exh. incl. 1959 Judson Gall., NY; 1962 Galleria dell' Ariete, Milan; 1963 Galerie Zwirner, Cologne; 1963, 1975 Galerie Sonnabend, Paris; 1965 Galleria Gian Enzo Sperone, Turin, Robert Fraser Gall., London; 1967 Stedelijk Mus., Amsterdam; 1969 Kunstverein, Munich; 1970 Whitney Mus. American Art, NY, Dunkelman Gall., Toronto; 1972 Galerie Gerald Cramer, Geneva, Sonnabend Downtown Gall., NY; 1974 Knoedler Prints Gall., NY, Inst. Contemp. Arts, London; 1976 Neue Galerie, Graz, Austria. *16.*

Doolin, James. b. 1932, Hartford, Conn. Philadelphia College of Art, 1954(BFA); UCLA, 1971(MFA). Exh. 1966 Gall. A, Melbourne; 1967, 1970 Central St. Gall., Sydney; 1974 Boise State Univ., Idaho; 1977 LA Municipal Art Gall.; 1978-9 travelling exh. in Australia; 1982 Cerro Coso College, Ridgecrest, Cal. *96-7.*

Dreiband, Lawrence. b. 1944, NY. Chouinard Art Inst., LA; Art Center College of Design, Pasadena, Cal., 1968(MFA). Exh. 1970, 1972 David Stuart Galleries, LA; 1980 LA Inst. Contemp. Art; 1981 Alexander Carlson Gall.,NY; 1983 Janus Gall., LA. *40.*

Drewa, Barbara Dixon. b. 1936, St Louis. Univ. of Texas, Austin, 1958(BFA). Exh. incl. 1982, 1983, 1984 Sarah Campbell Blaffer Gall., Univ. of Houston; 1983 Lawndale Annexe, Univ. of Houston, Univ. Center Gall., Univ. of Houston; 1984 Art League of Houston, Texas, Wilhelm Gall., Houston. *85.*

Dufresne, Leonard. b. 1941, Fall River, Mass. Skain Sch. Design, New Bedford, Mass., 1967(MA); Maryland Inst., Baltimore, 1970(MD,BFA,MFA). Exh. 1974 First St. Gall., NY; 1975, 1978, 1980, 1983 O.K. Harris Works of Art, NY; 1978 Bennington College, Vermont. *105-7.*

Dureau, George. b. 1930, New Orleans.

Louisiana State Univ., 1952; Tulane Univ., New Orleans, 1955. Exh. incl. 1977 Contemp. Arts Center, New Orleans; 1982 Galerie Jules Laforgue, New Orleans; 1983 Leinster Fine Art, London, Lauren Rogers Mus., Laurel, Miss.; 1984 Nexus Gall., Atlanta, Georgia, Louisiana State Mus., New Orleans, Corcoran Gall., Wash. DC. *105, 116-7, 129.*

Erlebacher, Martha Mayer. b. 1937, Elkins Park, Penn. Gettysburg College, Penn.,1955-6; Pratt Inst., NY, 1956-60(B Industr. Design), 1961-3(MFA in Ed.). Exh. incl. 1973, 1975, 1978, 1979, 1982 Robert Schoelkopf Gall., NY; 1976 Dart Gall., Chicago; 1978 Penn. Acad. Fine Arts; 1983 Weatherspoon Art Gall., Univ. of NCar., Greensboro. *103, 107.*

Essley, Roger. b. 1949, Rochester, NY. Syracuse Univ., NY, 1966-9(BFA); Goddard College, Plainfield, Vermont, 1979(MA). Exh. 1973 Focus Gall., Lane Community College, Eugene, Oregon; 1975 Severance Gall., College of Wooster, Ohio; 1976 Tower Gall., Glen Echo, Maryland; 1982 Fendrick Gall., Wash. DC. *109-12.*

Estes, Richard. b. 1936, Evanston, Ill. Art Inst. Chicago, 1952-6. Exh. incl. 1963 Allan Stone Gall., NY, Hudson River Mus., Yonkers, NY; 1968 Vassar College, Poughkeepsie, NY; 1970 Riverside Mus., NY; 1971 Corcoran Gall. American Art, Wash. DC, Galerie Bremen, W. Germany; 1972 Kassel, W. Germany; 1975 Boston Mus. Fine Arts, Mass. *90, 97.*

Febres, George. b. 1943, Guayaquil, Ecuador. Univ. of New Orleans, 1972(BA); Louisiana State Univ., Baton Rouge, 1974(MFA). Exh. incl. 1972, 1978 Univ. of New Orleans; 1973 La. State Univ., Baton Rouge; 1974 Haus International, Munich; 1974, 1975 Circle Gall., New Orleans; 1977 Johnson-Witty Gall., New Orleans, French Cultural Centre, Guayaquil; 1979 La Chinche Galeria, Mexico City; 1980 Nicholls State Univ., Thibodaux, La., Trition Mus. Art, Santa Clara, Cal.; 1981 Photo Exchange Gall., New Orleans, New Orleans Acad. Fine Art; 1984 Southeastern Center for Contemp. Art, Winston-Salem, NCar., Museo de Guayaquil, and Museo de Quito, Ecuador. *61, 129.*

Feltus, Alan. b. 1943, Wash. DC. Cooper Union for Advancement of Science and Art, NY, 1966(BFA); Yale Univ., Sch. Art and Architecture, New Haven, Conn., 1968(MFA). Exh. 1972 American Acad. in Rome; 1973 Jacob's Ladder Gall., Wash. DC; 1976 Northern Virginia Community College, Annandale; 1977, 1980, 1983 Forum Gall., NY. *107.*

Ferrer, Rafael. b. 1933, San Juan, Puerto Rico. Exh. incl. 1964 Univ. of Puerto Rico, Mayaguez; 1966 Pan American Union, Wash. DC; 1969, 1970 Galerie M.E. Thelen, Cologne; 1970 Leo Castelli Gall., NY, Galerie Michery, Amsterdam; 1971 Whitney Mus. American Art, NY; 1972 Mus. Contemp. Art, Chicago; 1974, 1975, 1977, 1978, 1984 Nancy Hoffman Gall., NY; 1974 Phoenix Gall., San Francisco; 1977 Galerie Darthea Speyer, Paris, Marianne Deson Gall., Chicago, Albright-Knox Art Gall., Buffalo, NY; 1980 Hamilton Gall. Contemp. Art, NY; 1980, 1982 Frumkin and Struve Gall., Chicago; 1983 El Museo del Barrio, NY. *121.*

Fischl, Eric. b. 1948, NY. California Inst. Arts, Valencia, 1972(BFA). Exh. incl. 1975 Dalhousie Art Gall., Halifax, Nova Scotia;

1976 Studio, Halifax, Nova Scotia; 1976, 1978 Galerie B, Montreal; 1980, 1981, 1982 Edward Thorp Gall., NY; 1980 Davis Art Gall., Univ. of Akron, Ohio; 1981, 1982 Sable Castelli Gall., Toronto; 1982 Univ. of Colorado Art Galleries, Boulder. *109.*

Fish, Janet. b. 1938, Boston, Mass. Smith College, Northampton, Mass., 1960(BA); Skowhegan Art Sch., Maine, 1961; Yale Univ., Sch. Art and Architecture, 1963. Exh. incl. 1971, 1972, 1973, 1974, 1975, 1976 Kornblee Gall., NY; 1972 Pace College, NY, Russell Sage College, Troy, NY; 1974 Galerie Alexandra Monett, Brussels; 1975, 1977 Tolarno Gall., Melbourne; 1975 Hogarth Gall., Paddington, Australia; 1976 Phyllis Kind Gall., Chicago; 1978, 1979, 1980, 1983 Robert Miller Gall., NY; 1983 Texas Gall., Houston. *97.*

Flack, Audrey. b. 1941, NY. First exh. 1959 NY. Coll. incl. Mus. Mod. Art, NY; Whitney Mus. American Art, NY; Allen Mem. Art Mus., Oberlin College, Ohio. *85.*

Fleischner, Richard. b. 1944, NY. Exh. incl. 1971 Hopkins Art Center, Dartmouth College, Hanover, NH; 1971, 1973, 1975 Terry Dintenfass Gall., NY; 1976 Dag Hammarskjold Plaza, NY; 1977 Univ. Gall., Univ. Massachusetts, Amherst; 1979 Max Protetch Gall., NY. *67.*

Fleming, Frank. b. 1940, Bear Creek, Ala. Florence State College, Ala., 1962(BS); Univ. of Alabama, Tuscaloosa, 1969(MA), 1973(MFA). Exh. incl. 1974, 1982 Birmingham Mus. Art, Ala.; 1975 Univ. College Art Gall., Univ. of Alabama, Birmingham; 1978 Univ. of Montevallo Art Gall., Ala.; 1979, 1981, 1982 Morgan Gall., Kansas City, Missouri; 1979 Heath Gall., Atlanta, Georgia, Univ. of Alabama, Huntsville, Appalachian Center for Contemp. Art, Charleston, W. Virginia; 1980 Hunter Mus. Art, Chattanooga, Tenn.; 1981 Fendrick Gall., Wash. DC, Alexander F. Milliken Gall., NY; 1983 Moody Gall., Houston, Texas. *64.*

Forsman, Chuck. b. 1944, Nampa, Idaho. Univ. of California, Davis, 1967(BA), 1971(MFA); Skowhegan Sch. Painting and Sculpture, Maine, 1970. Exh. incl. 1971 Reese Palley Gall., San Francisco; 1972 Fine Arts Dept., Univ. of Colorado, Boulder; 1973, 1975, 1977, 1979, 1981, 1983 Tibor de Nagy Gall., NY; 1976 Watson/de Nagy and Co., Houston, Texas; 1983 Yellowstone Art Center, Wyoming. *93.*

Francis, Sam. b. 1923, San Mateo, Cal. Univ. of California, Berkeley, 1941-3, 1948-50(BA,MA); Académie Fernand Léger, Paris, 1950. Exh. incl. 1952 Galerie Nina Dausset, Paris; 1956, 1970 Martha Jackson Gall., NY; 1957, 1974 Gimpel Fils Ltd., London; 1958 Galerie Olaf Hudtwalcher, Frankfurt; 1960 Kunsthalle, Bern; 1961 Galerie de Seine, Paris, Minami Gall., Tokyo; 1967 Houston Mus. Fine Arts, Univ. Art Mus., Berkeley, Cal.; 1968 Galerie du Bac, Paris; 1969 Felix Landau Gall., LA; 1973 Kornfeld Gall., Bern; 1975 Robert Elkon Gall., NY, Idemitsu Gall., Tokyo. *9.*

Frey, Viola. b. 1933, Lodi, Cal. Tulane Univ., New Orleans, 1956(MFA). Exh. 1974, 1975 Wenger Gall., San Francisco; 1975 Hank Baum Gall., San Francisco and Century City, Cal.; 1977 Wenger Gall., La Jolla, Cal.; 1980, 1983 Quay Gall., San Francisco; 1981 travelling exh. in U.S.; 1982 Mark Twain Bank, Kansas City, Missouri, California State Univ., Fullerton; 1984 Asher/Faure Gall., LA. *145.*

Fridge, Roy. b. 1927, Beeville, Texas. Univ.

of Texas, 1944-6; Baylor Univ., Waco, Texas, 1948-50(BA). Exh. incl. 1957, Baylor Theatre, Waco; 1959 Waco Mus. Art, Texas; 1966, 1967, 1969 David Gall., Houston, Texas; 1976 Robinson Gall., Houston, Texas; 1977 DW Co-op, Dallas, Texas. *75-6.*

Fuente, Larry. b. (?). Exh. incl. 1971, 1972 San Francisco Art Commission; 1973 Berkeley Art Center, Cal.; 1974 San Francisco Mus. Art; 1977, 1980 Nat. Coll. Fine Art, Smithsonian, Wash. DC; 1978 LA Municipal Art Gall.; 1979 Everson Mus., Syracuse, NY, Contemp. Arts Mus., Chicago; 1980 Palacia de Mineria, Mexico City, Internat. Sculpture Conference, Wash. DC; 1981 Fondo del Sol, Wash. DC; 1982, Alternative Mus., NY, Clocktower Gall., P.S.1, NY, Ronald Feldman Gall., NY. *72-3.*

Gallagher, Michael. b. 1945, LA. Univ. of Southern California, LA, 1968(BFA); Yale Univ., Sch. Art and Architecture, New Haven, Conn., 1970(MFA). Exh. 1979, 1980, 1981 Louis K. Meisel Gall., NY. *85, 88.*

Garabedian, Charles. b. 1923, Detroit. UCLA, 1961(MA). Exh. 1965, 1966, 1967 Cejee Gall., LA; 1966, 1981 La Jolla Mus. Art, Cal.; 1970 Eugene Butler Gall., LA; 1974 Cal. State Univ., Northridge; 1975 College of Creative Studies, Univ. of Cal., Santa Barbara; 1976 Whitney Mus. American Art, NY; 1977 American River College, Sacramento, Cal.; 1979, 1980, 1983 L.A. Louver Gall., Venice, Cal.; 1982 Holly Solomon Gall., NY. *36.*

Garet, Jedd. b. 1955, LA. Exh. 1979, 1981, 1983, 1984 Robert Miller Gall., NY; 1979 Felicity Samuel Gall., London; 1980 Galerie Bischofberger, Zurich; 1981 Larry Gagosian Gall., LA, Hallwalls, Buffalo, NY; 1982 Texas Gall., Houston, John Berggruen Gall., San Francisco; 1983 Michael Lord Gall., Milwaukee; 1984 Stephen Wirtz Gall., San Francisco, Betsy Rosenfield Gall., Chicago. *65.*

Georges, Paul. b. 1923, Portland, Oregon. Univ. of Oregon, Eugene; Paris, with Hans Hofmann and Fernand Léger. Exh. incl. 1948, 1956, 1961 Reed College Art Gall., Portland; 1955, 1957 Tibor de Nagy Gall., NY; 1959 Virginia Zabriskie, NY; 1960, 1961 Great Jones Gall., NY; 1962, 1963, 1966, 1968 Allan Frumkin Gall., NY and Chicago; 1968, 1969 Dorsky Galleries, NY; 1974, 1976 Fischbach Gall., NY; 1975 Green Mountain Gall., NY; 1979 Tomasulo Gall., Union College, NJ, Meghan Williams Gall., LA. *112.*

Gillespie, Gregory. b. 1939, NJ. Cooper Union Sch. Art, NY; San Francisco Art Inst.; Fulbright Fellowship to Italy, 1962. Exh. incl. NY; Italy; Hirshhorn Mus., Wash. DC. *112.*

Gilliam, Sam. b. 1933, Tupelo, Miss. Univ. of Louisville, Kentucky, 1952-5(BA, Fine Art), 1961(MA). Exh. incl. 1956 Univ. of Louisville; 1963 Adams-Morgan Gall., Wash. DC; 1965 Jefferson Place Gall., Wash. DC; 1968 Byron Gall., NY; 1970, 1973 Galerie Darthea Speyer, Paris; 1971 Mus. Mod. Art, NY; 1973 Maison de la Culture, Rennes; 1973, 1974, 1975 Fendrick Gall., Wash. DC; 1974 Phoenix Gall., Seattle. 1975 Mus. Art, Philadelphia. *23-4, 120.*

Gorchov, Ron. b. 1930, Chicago. Univ. of Mississippi; Art Inst. of Chicago; Univ. of Illinois. *25.*

Gordy, Robert. b. 1933, Jefferson Is., La. Louisiana State Univ., Baton Rouge-

(BA,MA); Yale Univ., New Haven, Conn., 1953(Yale-Norfolk Fellowship). Exh. incl. 1965 Emily Lowe Gall., New Orleans; 1967, 1968 Glade Gall., New Orleans; 1971 Cranfill Gall., Dallas; 1972 Glasgow College of Arts, Scotland; 1973 Hank Baum Gall., San Francisco; 1975 Long Beach Mus. Art, Cal.; 1976, 1979, 1985 Phyllis Kind Gall., NY; 1977 Delahunty Gall., Dallas; 1980, 1981, 1983 Galerie Simonne Stern, New Orleans. *129.*

Graham, Robert. b. 1938, Mexico City. San José State College, Cal., 1961-3; San Francisco Art Inst., 1963-4. Exh. incl. 1970, 1974 Galerie Neuendorf, Hamburg; 1970 Galerie Mollenhoff, Cologne, Galerie René Block, Berlin, Whitechapel Gall., London; 1971 Sonnabend Gall., NY, Kunstverein, Hamburg; 1972 Galerie Herbert Meyer-Ellinger, Frankfurt, W. Germany, Dallas Mus. Fine Arts, Texas; 1974, 1977 Nicholas Wilder Gall., LA; 1974 Galerie Zwirner, Cologne, Texas Gall., Houston, Felicity Samuel Gall., London; 1974, 1975 Gimpel and Hanover Gall., Zurich; 1975 Greenberg Gall., St Louis; 1976 Gimpel Fils, London; 1977 Robert Miller Gall., NY, John Stoller Gall., Minneapolis. *113.*

Graves, Michael. b. 1934, Indianapolis. Univ. of Cincinnati, Ohio; Harvard Univ., Cambridge, Mass.(1960, Prix de Rome); American Acad., Rome. Exh. incl. 1967, 1975, 1979 Mus. Mod. Art, NY; also Cooper-Hewitt Mus., NY, Max Protetch Gall., NY. *67.*

Graves, Nancy. b. 1940, Pittsfield, Mass. Exh. 32 between 1968 and 1979, in NY, Dallas, San Francisco, Houston, Cleveland, Ottawa, Zurich, etc. *61.*

Green, Art. b. 1941, Indiana. Sch. Art Inst. Chicago, 1965(BFA). Exh. 1973 Owens Art Gall., Mt Allison Univ., Sackville, New Brunswick; 1973, 1983 Bau-Xi Gall., Toronto; 1976 Peale House, Penn. Acad. Fine Arts, Philadelphia; 1976, 1978, 1979, 1980, 1983 Phyllis Kind Gall., NY and Chicago; 1979 Burnaby Art Gall., British Columbia, Univ. of Waterloo Gall., Ontario, The Gallery Stratford, Stratford, Ontario. *122-4, 129.*

Green, George. b. 1943, Portland, Oregon. Oregon State Univ., Corvallis, 1961-2; San Miguel, Mexico, 1963(independent study); Univ. of Oregon, 1965(BS); Washington State Univ., 1968. Exh. incl. 1967 Whitman College, Walla Walla, Washington; 1969 Winn Galleries, Austin, Texas, Lawson Galleries, San Francisco; 1970 Comara Gall., LA; 1974 Artists Space, NY; 1975-6 Hansen Galleries, NY; 1977, 1979 Triangle Gall., San Francisco; 1978 Everson Mus. Art, Syracuse, NY; 1978, 1979, 1981-2 Louis K. Meisel Gall., NY. *85, 88.*

Gregor, Harold. b. 1929, Detroit. Wayne State Univ., Detroit, 1951(BS); Michigan State Univ., 1953(MS); Ohio State Univ., Columbus, 1960(PhD). Exh. incl. 1973 Countryside Gall., Ill.; 1974, 1976, 1977, 1978, 1979, 1982, 1983 Nancy Lurie Gall., Chicago; 1975 Central Michigan Univ.; 1977, 1978, 1979, 1982 Tibor de Nagy Gall., NY; 1983 Richard Grey Gall., Chicago. *92-3.*

Grooms, Red. b. 1937, Nashville, Tenn. Sch. Art Inst. Chicago, 1955; Peabody College, Nashville, New Sch. Social Research, NY, 1956; Sch. Fine Arts, Provincetown, Mass., 1957. Exh. incl. 1958 Sun Gall., Provincetown; 1963 Tibor de Nagy Gall., NY; 1967 Allan Frumkin Gall., Chicago; 1975 88 Pine

St., NY; 1976, 1981 Marlborough Gall., NY; 1977 Galerie Roger d'Amecourt, Paris; 1978 SUNY at Purchase; 1982 Seibu Art Mus., Tokyo, Hirshhorn Mus. and Sculpture Garden, Wash. DC; 1983 Unicorn Gall., Aspen, Col., Anderson Ranch, Aspen, Col. *56.*

Grosvenor, Robert. b. 1937, NY. First exh. 1965 NY. Exh. since in NY, LA, Cologne, Milan, Basle, Paris, Naples. Coll. incl. Mus. Mod. Art, NY; Whitney Mus. American Art, NY; MIT; Walker Art Center, Minneapolis. *21.*

Guston, Philip. b. 1913, Montreal. d. 1980. First exh. 1944. Coll. incl. Albright-Knox Art Gall., Buffalo, NY; Art Inst., Chicago; Solomon R. Guggenheim Mus., NY; Metropolitan Mus. Art, NY. *12, 29-30.*

Hanson, Duane. b. 1925, Alexandra, Minn. First exh. 1951 Mus. Art, Cranbrook Academy, Bloomfield Hills, Michigan. Exh. since in NY, Cologne, Chicago, Hamburg, Stuttgart. 1974-5 retrospective travelling exh. in Germany and Denmark. Coll. incl. Wallraf-Richartz Mus., Cologne; Adelaide Mus., Australia; Caracas Mus., Venezuela; Milwaukee Art Mus., Wisc. *82-4.*

Haring, Keith. b. 1958, Kutztown, Penn. Sch. Visual Arts, NY, 1978-9. Exh. 1981 Westbeth Painters Space, NY, Club 57, NY; 1982 West Beach Cafe, Venice, Cal., Rotterdam Arts Council, Rotterdam Kunststichting; 1982, 1983 Tony Shafrazi Gall., NY; 1983, Fun Gall., NY, Galerie Watari, Tokyo, Lucio Amelio Gall., Naples, Matrix 75, Wadsworth Atheneum, Hartford, Conn., Robert Fraser Gall., NY. *49.*

Havard, James. b. 1937, Galveston, Texas. First exh. 1965 Dallas. Exh. since in Philadelphia, Wash. DC, Cologne, Copenhagen, Lund, Stockholm, Chicago, Heidelberg, NY. Coll. incl. Philadelphia Mus. Art; Moderna Museet, Stockholm; Solomon R. Guggenheim Mus., NY. *85.*

Hawley, Steve. b. 1950, Brooklyn, NY. Sch. Mus. Fine Arts, Boston, 1973(Graduate Diploma, 5th year). Exh. 1978 Shore Gall., Boston, Mass.; 1981, 1984 Alexander F. Milliken, NY. *100.*

Heizer, Michael. b. 1944, Berkeley, Cal. Exh. incl. 1969 Heiner Friedrich Gall., Munich; 1970 Dwan Gall., NY; 1971 Detroit Inst. Arts; 1974 Fourcade, Droll, NY; 1974, 1977, Ace Gall., LA and Venice, Cal.; 1976, 1977, 1979, 1980, 1982, 1983 Xavier Fourcade, NY; 1977 Galerie am Promenadeplatz, Herzer und Kinnius, Munich; 1979 Folkwang Mus., Essen, Germany, Kroeller-Mueller Mus., Otterlo, Holland; 1980 St Louis Art Mus.; 1981 Janie C. Lee Gall., Houston; 1982 Flow Ace Gall., Venice, Cal.; 1983 Barbara Krakow Gall., Boston, Mass., Patricia Heesy Gall., NY. *144.*

Held, Al. b. 1928, NY. Exh. numerous since 1965. Coll. incl. Albright-Knox Art Gall., Buffalo, NY; Whitney Mus. American Art, NY; Metropolitan Mus., NY; Kunstmuseum, Basle; Kunsthaus, Zurich; Mus. Mod. Art, NY. *24.*

Herman, Roger. b. 1947, Saarbrücken, W. Germany. Kunstakademie, Karlsruhe, W. Germany, 1972-6. Exh. 1973 Galerie am Neumarkt, Saarbrücken; 1974 Galerie K, Darmstadt, Galerie 'Galg', Mannheim; 1977 Goethe Inst., San Francisco; 1979 Dana Reich Gall., San Francisco; 1980 Jetwave Inc., San Francisco; 1981 Art Inst., San Francisco; 1981, 1982, 1983, 1984 Ulrike Kantor Gall., LA; 1982 Akademie der Kunst, Karlsruhe; 1983, 1984 Eaton/Shoen Gall.,

San Francisco; 1983 La Jolla Mus. Contemp. Art, Cal., Univ. Gall., Redlands, Cal.; 1984 Hal Bromm Gall., NY, Roger Ramsay Gall., Chicago, Patti Aande Gall., San Diego. *37-40, 42.*

Herms, George. b. 1935, Woodlands, Cal. Exh. incl. 1961 Batman Gall., San Francisco; 1963 Rolf Nelson Gall., LA; 1965 Stryke Gall., NY; 1969 Molly Barnes Gall., LA; 1972 Cal. State Univ., LA; 1975 Nicholas Wilder Gall., LA; 1978 Arco Center for Visual Arts, LA; 1980 Stage One Gall., Orange, Cal.; 1981 Univ. of Denver Art Gall., Col., Ruth Schaffner Gall., Santa Barbara, Cal.; 1982 Beyond Baroque, Venice, Cal., L.A. Louver Gall., Venice, Cal.; 1984 Art Gall., Cal. State Univ., Fullerton. *58.*

Hernandez, John. b. 1952, San Antonio, Texas. Our Lady of the Lake Univ., San Antonio, 1975(BA); North Texas State Univ., Denton, 1980(MFA). Exh. incl. 1977 North Texas State Univ., Denton; 1982, 1983 DW Gall., Dallas; 1983 2639 Elm St., Dallas; 1983, 1984 Art Mus. South Texas, Corpus Christi; 1984 Moody Gall., Houston. *63.*

Hoffman, Kady. b. 1949, LA. Otis Art Inst., LA, 1971(BFA); San Diego State Univ., Cal. Exh. 1984 LA Contemp. Exhibitions (Artist Select Artist Series). *137.*

Hoover, Ron. b. 1944, Liberty, Texas. Lee College, Baytown, Texas, 1970; Univ. of Houston, 1975(BFA); Univ. of Oklahoma, Norman, 1977(MFA). Exh. 1981, 1982, 1984 Graham Gall., Houston. *136.*

House, Perry. b. 1943, Orange, Texas. Cal. College of Arts and Crafts, Oakland, 1969(BFA), 1971(MFA). Exh. incl. 1974 Nicholls State College, Thibodaux, La.; Cal. State College, Bakersfield; 1978 Humboldt State Univ., Arcata, Cal., Univ. of St Thomas, Houston; 1983 Graham Gall., Houston; 1984 Davis/McClain Gall., Houston. *130.*

Howe, Delmas. b. 1935, El Paso, Texas. Trained as a musician, but became a professional artist in 1966. Established the Delmas Studio of Art and Design in Amarillo, Texas, in 1973, which has since undertaken numerous commissions, including a number of large murals. *115.*

Humphrey, David. b. 1955. Maryland Inst. College of Art, Baltimore, 1973-7(BFA); NY Studio Sch. Painting, Drawing and Sculpture, 1976-7; NY Univ., NY City, 1977-80(MA). Exh. 1979 Washington Square Gall., NY; 1983 Pittsburgh Plan for Art, Penn.; 1984 David McKee Gall., NY. *65.*

Insley, Will. b. 1929, Indianapolis. First exh. 1965 NY. Exh. since in Minneapolis; Buffalo, NY; Cologne; Krefeld; Stuttgart. *67.*

Irwin, Robert. b. 1928, Long Beach, Cal. Otis Art Inst., LA, 1948-50; Jepsom Art Inst., LA, 1951; Chouinard Art Inst., LA, 1953-4. Exh. 1957 Felix Landau Gall., LA; 1959, 1962, 1964 Ferus Gall., LA; 1960, 1968 Pasadena Art Mus., Cal.; 1966, 1968, 1969, 1971, 1973, 1974 Pace Gall., NY; 1968 Jewish Mus., NY; 1970 Mus. Mod. Art, NY; 1971 Walker Art Center, Minneapolis; 1972 Sonnabend Gall., Paris, Ace Gall., LA, Fogg Art Mus., Cambridge, Mass.; 1974 Wright State Univ., Dayton, Ohio, Univ. of Cal., Santa Barbara. *67.*

Jacobshagen, Keith. b. 1941, Wichita, Kansas. Art Center College of Design, Cal., 1963-4; Kansas City Art Inst., 1964-5(BFA); Univ. of Kansas, Lawrence, 1966-8(MFA). Exh. incl. 1969 Sheldon Mem. Art Gall., Lincoln, Nebraska; 1972 Alfred Univ., NY; 1975 Robert Mondavi, Oakville, Cal.; 1976, 1980,

1982 Charles Campbell Gall., San Francisco; 1979, 1982 Robert Schoelkopf Gall., NY; 1981 Minneapolis Inst. Art; 1983 Dorry Gates Gall., Kansas City, Missouri, Joslyn Art Mus., Omaha, Nebraska. *93.*

Jensen, Bill. b. 1945, Minneapolis. Univ. of Minnesota, Minneapolis, 1968(BFA), 1970(MFA). Exh. 1973, 1975 Fischbach Gall., NY; 1974 Gall. of July and August, Woodstock, NY; 1980, 1981, 1982, 1984 Washburn Gall., NY. *28.*

Jimenez, Luis. b. 1940, El Paso, Texas. Univ. of Texas, Austin, 1964(BS); Ciudad Univ., Mexico, 1964. Exh. incl. 1969-70 Graham Gall., NY; 1972-5 O.K. Harris Works of Art, NY; 1973-5 Bienville Gall., New Orleans; 1974 Contemp. Arts Mus., Houston; 1979 Landfall Press Gall., Chicago; 1981 Frumkin and Struve Gall., Chicago; 1984 Phyllis Kind Gall., NY, Alternative Mus., NY. *121.*

Johns, Jasper. b. 1930, Augusta, Georgia. Univ. of Southern Carolina, Columbia. Exh. incl. 1958, 1960, 1970 Leo Castelli Gall., NY; 1959, 1961 Galerie Rive Droite, Paris; 1959 Galleria d'Arte del Naviglio, Milan; 1964 Jewish Mus., NY; 1965, Minami Gall., Tokyo; 1968 Galerie Ricke, Cologne; 1969 Kunstmuseum, Basle; 1971 Kunsthalle, Bern; 1974 Galerie de Gestlo, Hamburg; 1975 Serpentine Gall., London. *13, 17.*

Juarez, Roberto. b. 1952, Chicago. San Francisco Art Inst.,(BFA); UCLA, 1978-9 (Graduate Studies). Exh. 1977 San Francisco Art Inst.; 1983 Belleville Arts Commission, Ill., Mira Godard Gall., Toronto; 1984 Betsy Rosenfield Gall., Chicago. *121.*

Kauffman, Craig. b. 1932, Eagle Rock, Cal. Univ. of Southern Cal., LA, 1950-2(BA); Univ. of Cal., 1952-6(MA). Exh. 1953 Felix Landau Gall., LA; 1958, 1960 Dilexi Gall., LA; 1960, 1962, 1963, 1965, 1967 Ferus Gall., LA; 1965, 1966, 1967, 1969, 1970, 1973 Pace Gall., NY and LA; 1970 Pasadena Art Mus., Cal.; 1975 Riko Mizuno Gall., LA. *137.*

Kelley, Mike. b. 1954, Detroit. Univ. of Michigan, Ann Arbor, 1976(BFA); California Inst. Arts, Valencia, 1978(MFA). Exh. 1981 Mizuno Gall., LA; 1982, 1984 Metro Pictures, NY; 1983, 1984 Rosamund Felsen Gall., LA; 1983 Hallwalls, Buffalo, NY. *141.*

Kienholz, Edward. b. 1927, Fairfield, Washington. Eastern Washington State College, and Whitworth College, Spokane, Washington, 1945. Exh. incl. 1955 Coronet Louvre, LA, Cafe Galeria, LA; 1956 Syndell Studios, LA; 1959, 1960, 1961, 1963 Ferus Gall., LA; 1963, 1965 Dwan Gall., NY; 1966 Univ. of Saskatchewan, Regina; 1967 Washington Gall. Mod. Art, Wash. DC; 1968 Gallery 669, LA; 1969 Ateneumin Taidemuseo, Helsinki; 1970 Wide White Space Gall., Antwerp, Onnasch Gall., Cologne, Moderna Museet, Stockholm; 1973 Akademie der Künste, Berlin; 1974 Galleria Bocchi, Milan; 1977 Centre National d'Art et de Culture Georges Pompidou, Paris; 1979 Louisiana Mus., Humblebaek, Denmark; 1982 Dibbert Gall., Berlin. *52.*

Kirschenbaum, Jules. b. 1930, NY. Brooklyn Mus. Art Sch., NY; Fulbright Scholarship in Italy, 1956-8. Exh. incl. 1965, 1969, 1972, 1985 Forum Gall., NY; 1984 Des Moines Art Center, Iowa. *109.* Kushner, Robert. b. 1949, Pasadena, Cal. Univ. of California, San Diego, 1970(BA). Exh. incl. 1976, 1977, 1979, 1981, 1982 Holly Solomon Gall., NY; 1977 Philadelphia College of Art; 1978 Mayor Gall., London; 1979 Galerie

Daniel Templon, Paris; 1980 Dart Gall., Chicago; 1981 Asher/Faure Gall., LA, Galerie Bruno Bischofberger, Zurich, Akira Ikeda Gall., Nagoya, Japan; 1982 Marconi Gall., Milan, American Graffiti Gall., Amsterdam, Galerie Rudolf Zwirner, Cologne. *45.*

Laemmle, Cheryl. b. 1947, Minneapolis. Humboldt State Univ., Arcata, Cal., 1974(BA); Washington State Univ., Pullman, 1978(MFA). Exh. incl. 1980 P.S.1, Special Projects Room, Long Island, NY; 1982, Texas Gall., Houston; 1983 Barbara Toll Fine Arts, NY. *65.*

Lanigan-Schmidt, Thomas. b. 1948, Elizabeth, NJ. Exh. incl. 1973 98 Green St. Loft, NY; 1974 Artists Space, NY; 1975 Emily Lowe Gall., Hofstra Univ., Hempstead, NY; 1975, 1977, 1978 Holly Solomon Gall., NY. *72.*

Larson, Edward. b. 1931, Joplin, Missouri. Univ. of Oklahoma, Norman, 1951; Art Center Sch., LA, 1958(BFA). Exh. 1977, 1979 Joy Horwich Gall., Chicago; 1978 One Illinois Center, Chicago; 1980, 1981, 1984 Monique Knowlton Gall., NY; 1980 Chicago Public Lib., Chicago Cultural Center; 1981 Bank of America, San Francisco; 1982 Evanston Art Center, Ill., Suburban Fine Art Center, Chicago, Zolla/Lieberman Gall., NY. *70.*

Lembeck, Jack. b. 1942, St Louis. First exh. 1972 NY. Exh. since, numerous in U.S.; also in Paris and Heidelberg. Coll. Solomon R. Guggenheim Mus., NY. *85.*

Leslie, Alfred. b. 1927, Bronx, NY. NY Univ., NY City; Art Students' League, NY. Exh. incl. 1976-7 Boston Mus. Fine Arts, Mass., Hirshhorn Mus. and Sculpture Garden, Wash. DC, Mus. Contemp. Art, Chicago. *101-3.*

Levers, Robert. b. 1930, Brooklyn, NY. Yale Univ., New Haven, Conn., 1952(BFA), 1961(MFA). Exh. incl. 1959 Columbia Mus., SCar.; 1960 Stratford Art Gall., Conn.; 1968 Southwestern Univ., Georgetown, Texas; 1969 Concordia Lutheran College, Austin, Texas; 1970, Winn Gall., Austin; 1971 Southwest Texas State Univ., San Marcos, Beaumont Art Mus., Texas, Kilgore Junior College, Texas; 1971-2 Univ. of Texas Alumni Center, Austin; 1973 St Stephen's Episcopal Sch., Austin; 1975 Tibor de Nagy, Houston; 1978 Watson/de Nagy, Houston. *136.*

Lichtenstein, Roy. b. 1923, NY. Ohio State Univ., Columbus, 1946-9(BFA,MFA). Exh. incl. 1951 Carlebach Gall., NY; 1952, 1957 John Heller Gall., NY; 1962, 1965 Galerie Ileana Sonnabend, Paris; 1964 Galleria Il Punto, Turin; 1967 Leo Castelli Gall., NY; 1968 Stedelijk Mus., Amsterdam, Tate Gall., London; 1969 Solomon R. Guggenheim Mus., NY; 1970 Univ. of Puerto Rico, Mayaguez; 1971 Irving Blum Gall., LA; 1973 Galerie Beyeler, Basle; 1974 Mayor Gall., London; 1975 Centre Nationale d'Art Contemporain, Paris. *14-16, 49, 130.*

Liegel, Franklyn J. b. 1950, Richland Center, Wisc. Minneapolis College of Art and Design, 1974; Otis Art Inst., LA, 1977. Exh. 1983 Koplin Gall., LA. Also exh. (g) in LA; NY; Palm Springs, Cal.; Pasadena, Cal.; Claremont, Cal. *140.*

Ligare, David. b. 1945, Oak Park, Ill. Art Center College of Design, LA. Exh. 1969 Wickersham Gall., LA; 1970 Monterey Mus. Art, Cal.; 1974, 1978 Andrew Crispo Gall., NY; 1977 Phoenix Art Mus., Ariz.; 1983 Koplin Gall., LA. *103.*

Lobdell, Frank. b. 1921, Kansas City. St Paul Sch. Fine Art, Minn., 1938-9; California

Sch. Fine Arts, San Francisco, 1947-50. Exh. 1958, 1960, 1963, 1972, 1974 Martha Jackson Gall., NY; 1960 M.H. de Young Mem. Mus., San Francisco; 1962 Ferus Gall., LA; 1964 Galerie D. Benador, Geneva; 1965 Galerie Anderson-Mayer, Paris; 1966 Pasadena Art Mus., Cal.; 1969, 1983-4 San Francisco Mus. Art; 1971 St Mary's College Art Gall., Moraga, Cal.; 1977 Smith-Andersen Gall., Palo Alto, Cal.; 1981 College of Notre Dame Art Gall., Belmont, Ind., Smith-Andersen Gall., San Francisco; 1983-4 Oscarsson Hood Gall., NY. *58.*

Longo, Robert. b. 1953, Brooklyn, NY. State Univ. College, Buffalo, NY, 1975(BFA). Exh. incl. 1976 Hallwalls, Buffalo, Visual Studies Workshop, Rochester, NY, Artists Space, NY; 1978 Franklyn Furnace, NY (perf.); 1979, 1982 The Kitchen, NY (perf); 1980 Studio Cannaviello, Milan, Moderna Museet, Stockholm, Amerika-Haus, Berlin, American Center, Paris, van Abbemuseum, Eindhoven, Holland (perf); 1981, 1983, 1984 Metro Pictures, NY; 1981 Corcoran Gall. Art, Wash. DC, Larry Gagosian Gall., LA; 1982 Texas Gall., Houston; 1983 Brooke Alexander Gall., NY, Leo Castelli, NY, Galerie Schellman und Kluster, Munich. *56.*

Loving, Richard. b. 1925, Vienna. NY Medical Sch., Cornell Univ., Ithaca, 1945; Bard College, Annandale-on-Hudson, NY, 1943-4; New Sch. for Social Research, NY, 1946. Exh. incl. 1960 Shop One, Rochester, NY; 1963 Lawrence College, Appleton, Wisc.; 1973 Gall. Bernard, Chicago; 1978 Barat College, Lake Forest, Ill.; 1981 Jan Cicero Gall., Chicago; 1982 Lerner Heller Gall., NY. *129.*

MacConnel, Kim. b. 1946, Oklahoma City. Univ. of California, San Diego, 1969(BA), 1972(MFA). Exh. incl. 1975, 1976, 1979, 1980, 1982 Holly Solomon Gall., NY; 1976 La Jolla Mus. Contemp. Art, Cal.; 1978 Galerie Bruno Bischofberger, Zurich, Mayor Gall., London, Univ. Art Mus., Univ. of California, Berkeley; 1979 Dart Gall., Chicago; 1982 James Corcoran Gall., NY. *44-5.*

McCoy, Ann. b. 1946, Boulder, Col. Univ. of Colorado, Boulder, 1969(BFA); UCLA, 1972(MA). Exh. 1974 Fourcade, Droll, NY; 1975 Inst. Contemp. Art, Boston, Harcus-Krakow-Rosen-Sonnabend Gall., Boston, Betty Gold Fine Mod. Prints, LA; 1976, 1979 Margo Leavin Gall., LA; 1977 Wallraf-Richartz Mus./Mus. Ludwig, Cologne; 1978 Chandler Coventry Gall., Paddington, Australia; 1978, 1979, 1981, 1982, 1984 Brooke Alexander, NY; 1979 Thomas Segal Gall., Boston, Roy Boyd Gall., Chicago, Arts Club of Chicago; 1982 Metropolitan Mus. Art, NY; 1983 Galerie Kornfeld, Bern, Fine Arts Center, SUNY at Stony Brook. *75.*

McMillen, Michael. b. 1946, LA. San Fernando Valley State College, Northridge, Cal., 1969(BA); UCLA, 1972(MA), 1973(MFA). Exh. 1969 Bay Cities Jewish Community Center, Santa Monica, Cal.; 1973 Venice, Cal.; 1977 LA County Mus. Art; 1978 Whitney Mus. American Art, NY, Cerro Coso College, Ridgecrest, Cal.; 1980, 1982 Asher/ Faure Gall., LA; 1980, 1982 Macquarrie Galleries, Sydney, Australia, Art Gall. of New South Wales, Sydney; 1981 Pittsburgh Center for Arts, Penn.; 1983 Univ. of Southern Cal., LA. *141.*

McNeil, George. b. 1908. Pratt Inst., NY, Art Students League, NY, Hans Hofmann Sch., Columbia Univ., NY. Exh. incl. 1966 Univ. Art Mus., Univ. of Texas, Austin; 1969 Des Moines Art Center, Iowa; 1981, 1983

Gruenbaum Gall., NY; 1982 Mus. Art, Fort Lauderdale, Florida, Jorgensen Gall., Univ. of Conn., Storrs; 1984 Artists Choice Mus., NY. *37.*

Mangold, Robert. b. 1937, North Tonawanda, NY. First exh. 1964 NY. Exh. since in Wash. DC; San Francisco; Paris; Milan; London; Zurich; La Jolla, Cal. Coll. incl. Solomon R. Guggenheim Mus., NY; Mus. Mod. Art, NY; Whitney Mus. American Art, NY; County Mus. Art, LA. *20-1.*

Mangold, Sylvia Plimack. b. 1938, NY. Cooper Union Sch. Art, NY; Yale Univ., New Haven, Conn., 1961(BFA). Exh. incl. 1974, 1975 Fischbach Gall., NY; 1975 Daniel Weinberg Gall., San Francisco; 1978, 1980 Droll/Kolbert Gall., NY; 1978 Annemarie Verna, Zurich; 1980 Ohio State Univ., Columbus, Young Hoffman Gall., Chicago; 1981 Wadsworth Atheneum, Hartford, Conn., Contemp. Arts Mus., Houston; 1982 Madison Art Center, Wisc., Duke Art Mus., Duke Univ., Durham, NCar. *96.*

Mapplethorpe, Robert. b. 1946. First exh. 1976 NY. Exh. since in NY; Wash. DC; Paris; San Francisco; Norfolk, Virginia; Oxford, England; London, England. His work incl. in 1977 Kassel Documenta, W. Germany. *116-7.*

Marden, Brice. b. 1938, Bronxville, NY. First exh. 1968 NY. Exh. since in NY; Paris; Milan; Düsseldorf; Turin; Minneapolis; Houston; St Louis; Fort Worth; London. Coll. incl. Mus. Mod. Art, NY; Walker Art Center, Minneapolis; Fort Worth Mus. Art, Texas; Mus. Art, San Francisco; Stedelijk Mus., Amsterdam. *20.*

Meneely, Ed. b. 1927, Wilkes-Barre, Penn. Murray Art Sch., Wilkes-Barre, 1952-6; Sch. Visual Arts, NY, 1957-8. Exh. incl. 1952 Donovan Gall., Philadelphia; 1962 Parma Gall., NY; 1966 Frederick Teuscher Gall., NY; 1968 Loft Show, NY (Private View); 1971 Inst. Contemp. Arts, London; 1972 Grabowski Gall., London; 1973 Whitechapel Art Gall., London; 1975 Univ. College, Dublin; 1976 Susan Caldwell Gall., NY, Desmos Gall., Athens. *24.*

Miller, Melissa. b. 1951, Houston, Texas. Univ. of New Mexico, Albuquerque, 1974(BFA). Exh. incl. 1983 Whitney Mus. American Art, NY; 1984 Holly Solomon Gall., NY, Venice Biennale, Italy. *130-2.*

Miss, Mary. b. 1944, NY. First exh. 1971 NY. Represented in Coll. of Mem. Art Mus., Oberlin, Ohio. *67.*

Mitchell, Joan. b. 1926, Chicago. Smith College, Northampton, Mass., 1942-4; Art Inst. Chicago, 1944-7(BFA); Columbia Univ., NY, 1950; Art Inst. Chicago, 1950(MFA). Exh. incl. 1950 St Paul, Minn.; 1951 New Gall., NY; 1953 Stable Gall., NY; 1960 Galerie Neufville, Paris, Galleria dell' Ariete, Milan; 1961 B.C. Holland Gall., Chicago; 1962 Galerie Jacques Dubourg, Paris, Galerie Lawrence, Paris, Klipstein and Kornfeld, Bern; 1967, 1969, 1971, 1976, 1978, 1980 Galerie Jean Fournier, Paris; 1974 Whitney Mus. American Art, NY; 1980 Xavier Fourcade, NY; 1982 Musée d'Art Moderne de la Ville de Paris. *9-12.*

Mitty, Lizbeth. b. 1952, NY. SUNY at Stony Brook, 1969-71; Univ. of Wisc., Madison, 1973(BS), 1975(MFA). Exh. 1982, 1983 Rosa Esman Gall., NY. *92.*

Moodie, Harold. b. (?). San José State Univ., Cal.(MA). Exh. 1977 Bridge Gall., Univ. of California, Santa Cruz; 1980 Palo Alto Cultural Center, Cal.; 1981 Harrison Paul Gall., San José, Jackson St. Gall., Seattle, Wash-

ington. *60.*

Morley, Malcolm. b. 1931, London. Camberwell Sch. Arts and Crafts, London; Royal College of Art, London. Emigrated to U.S., 1958. First exh. 1964 NY. Represented in coll. of Whitney Mus. American Art, NY. *29-30.*

Moroles, Jesus Bautista. b. 1950, Corpus Christi, Texas. El Centro College, Dallas, Texas, 1975(AA); North Texas State Univ., Denton, 1978(BFA); apprenticed to Luis Jimenez, 1978-9; Worked in Carrara, Italy, 1979-80. Exh. 1981 Hill's Gall., Santa Fé, NMex., El Centro College, Dallas; 1982, 1984 Davis/McClain Galleries, Houston, Texas, Mattingly Baker Gall., Dallas; 1982 Neve Mus., Victoria, Texas, Amarillo Art Center, Texas; 1983 Koehler Cultural Center, San Antonio College Gall., Texas; 1984 Janus Gall., Santa Fé, NMex., Bonner White Gall., Corpus Christi, Texas. *130.*

Moskowitz, Robert. b. 1935, NY. Exh. 1962 Leo Castelli Gall., NY; 1970 French and Co., NY; 1971 Hayden Gall., MIT, Cambridge; 1973, 1974 Nancy Hoffman Gall., NY; 1977 Inst. Art and Urban Resources, Clocktower, NY; 1979, 1980 Daniel Weinberg Gall., NY; 1980 Margo Leavin Gall., LA; 1981 Walker Art Center, Minneapolis; 1983 Blum-Helman Gall., NY. *32.*

Motherwell, Robert. b. 1915, Aberdeen, Washington. California Sch. Fine Arts, Valencia, 1935; Harvard Univ. Graduate Sch. Arts and Sciences, Cambridge, Mass., 1937-8; Columbia Univ., NY, 1940. Exh. incl. 1944 Art of this Century, NY; 1953 Kootz Gall., NY; 1957, 1959, 1961 Sidney Janis Gall., NY; 1965 Phillips Collection, Wash. DC; 1966 Palais des Beaux-Arts, Brussels; 1968 Whitney Mus. American Art, NY; 1971 Galerie im Erker, St Gallen, Switzerland; 1972 Metropolitan Mus. Art, NY; 1974 Brooke Alexander, NY; 1975 Waddington Gall., London, Mus. Mod. Art, Mexico City; 1976 Knoedler Contemp. Art, NY. *9.*

Mullican, Lee. b. 1919, Chickasha, Okl. Univ. of Oklahoma, Norman ; Kansas City Art Inst., Missouri. Exh. 1961 Pasadena Art Mus., Cal.; 1965 San Francisco Mus. Art; 1950-67(numerous) Willard Gall., NY; 1967 Okl. Art Center, Oklahoma City; 1968 Museo Nacional de Belles Artes, Santiago, Chile; 1969 UCLA Art Galleries; 1973, 1976 Santa Barbara Mus. Art, Cal.; 1980 LA Municipal Galleries, Barnsdall Park; 1985 Herbert Palmer Gall., LA. *63-4.*

Murphy, Catherine. b. 1946. Pratt Inst., Brooklyn, NY,(BFA); Skowhegan Sch. Painting and Sculpture, Maine. Exh. 1972 First St. Gall., NY, Piper Gall., Mass.; 1975 Fourcade, Droll, NY; 1976 Phillips Collection, Wash. DC, Inst. Contemp. Arts, Boston; 1979 Xavier Fourcade, NY. *107-9.*

Murray, Elizabeth. b. 1940, Chicago. Art Inst. Chicago, 1962(BFA); Mills College, Oakland, Cal., 1964(MFA). Exh. 1974 Jacobs Ladder Gall., Wash. DC(with Joseph Zucker); 1975(with James Dearing), 1976, 1978, 1981, 1983 Paula Cooper Gall., NY; 1975 Jared Sable Gall., Toronto; 1978 Ohio State Univ., Columbus, Phyllis Kind Gall., Chicago; 1980 Galerie Mukai, Tokyo, Susanne Hilberry Gall., Birmingham, Mich.; 1982 Smith College Art Gall., Northampton, Mass., Daniel Weinberg Gall., LA; 1983 Portland Center for Visual Arts, Oregon. *25-6.*

Natkin, Robert. b. 1930, Chicago. Art Sch. of Art Inst. Chicago, 1948-52. Exh. incl. 1958 Wells St. Gall., Chicago; 1959, 1961,

1963, 1965, 1967, 1968 Poindexter Gall., NY; 1961 Ferus Gall., LA; 1970, 1973, André Emmerich Gall., NY; 1974, 1977 Galerie André Emmerich, Zurich; 1974 Galerie Merian, Krefeld, W. Germany, Il Cerchio, Milan, Galleria d'Arte Moderna-Ravagnam, Venice, Italy; 1977, 1980 Gimpel Fils, London; 1978 Galerie Pudelko, Bonn; 1979 Galerie Brusberg, Hanover; 1980 Manus Presse GmbH, Stuttgart. *23-4.*

Nechvatal, Dennis. b. 1948, Dodgeville, Wisc. Loras College, Dubuque, Iowa, 1966-7; Stout State Univ., Menomonie, Wisc.,1967-71(BS,BA); Indiana Univ., Bloomington, 1971-4(MFA). Exh. 1977 Univ. of Col., Colorado Springs; 1977, 1979 Water St. Art Center, Milwaukee; 1979 Triton Mus., Santa Clara, Cal.; 1980, 1982, 1984 Zolla/ Lieberman Gall., Chicago; 1981 Center for Visual Arts Gall., Illinois State Univ., Normal; 1983 Herron Gall., Indianapolis; 1984 Siegel Contemp. Art, NY. *125-9.*

Neel, Alice. b. 1900, Merion Square, Penn. d. 1984. Philadelphia Sch. Design for Women, 1921-5. Exh. incl. 1938 Contemp. Arts Gall., NY; 1950 A.C.A. Gall., NY; 1963, 1966, 1968, 1974 Graham Gall., NY; 1974 Whitney Mus. American Art, NY; 1978 Skidmore College, Saratoga Springs, NY; 1980 Boston Univ. Art Gall., Boston; 1981 Artists Union, Moscow; 1982 Robert Miller Gall., NY; 1983 Loyola Marymount Univ., LA, Grimaldi's Gall., Baltimore, Maryland. *19.*

Nevelson, Louise. b. 1899, Kiev, Russia. Art Studies League, NY, 1929-30; Munich 1931-2. Exh. incl. 1941 Karl Nierendorf Gall., NY; 1950 Lotte Jacobi Gall., NY; 1958 Esther Stuttman Gall., NY; 1959 Martha Jackson Gall., NY; 1960 Daniel Cordier Galerie, Paris; 1964 Gimpel-Hanover Galerie, Zurich; 1965 Galerie Schmela, Düsseldorf; 1969 Museo Civico, Turin; 1972 Dunkelman Gall., Toronto; 1973 Moderna Museet, Stockholm; 1974 New National Galerie, Berlin, Musée d'Art Moderne de la Ville de Paris; 1975 Minanu Gall., Tokyo, Galleria d'Arte Spagnoli, Florence. *12-13.*

Nice, Don. b. 1932, Visalia, Cal. Univ. of Southern California, LA, 1950-4(BFA); Yale Univ., New Haven, Conn., 1962-4(MFA). Exh. incl. 1963 Richard Feigen Gall., NY and Chicago; 1967, 1969, 1971 Allan Stone Gall., NY; 1973 Gall. A, Sydney, Australia, Galerie Alexandra Monett, Brussels; 1974 Arnhem Mus., Holland; 1975 DM Gall., London; 1975, 1980, 1981, 1983, 1984 Nancy Hoffman Gall., NY. *52.*

Nilsson, Gladys. b. 1940, Chicago. Sch. Art Inst. Chicago, 1962. Exh. incl. 1969 San Francisco Art Inst., Clay St. Gall.; 1971 Chico State College Gall., Cal.; 1973 Candy Store Gall., Folsom, Cal., Whitney Mus. American Art, NY; 1974, 1975, 1977, 1978, 1979 Phyllis Kind Gall., NY and Chicago; 1977 Susan B. Anthony Gall., Univ. of Wisconsin, Madison; 1979 Portland Visual Art Center, Oregon; 1980 Wake Forest Univ. Fine Arts Gall., Winston-Salem, NCar. *122-4.*

Noland, Kenneth. b. 1924, Asheville, NCar. Black Mountain College, NCar., 1946-8. Exh. incl. 1949 Galerie Creuze, Paris; 1956 Tibor de Nagy Gall., NY; 1959 French and Co., NY; 1960 Galleria dell' Ariete, Milan; 1961 Galerie Neufville, Paris; 1962 Galerie Schmela, Dusseldorf; 1963, 1968 Kasmin Gall., London; 1964 Jewish Mus., NY; 1965 David Mirvish Gall., Toronto; 1971 André

Emmerich Gall., NY; 1972 Galerie Mikro, Berlin; 1974 Rutland Gall., London; 1975 Sch. Visual Arts, NY. *20.*

Northerner, Will. b. 1954, Indianapolis, Ind. Herron Sch. Art, Indianapolis, 1979 (scholarship). Exh. 1981 Peter Miller Gall., Chicago; 1982, 1984 Zolla/Lieberman Gall., Chicago. *40-1.*

Nutt, Jim. b. 1938, Pittsfield, Mass. Sch. Art Inst. Chicago, 1960-5. Exh. 1971, 1972, 1973 Candy Store Gall., Folsom, Cal.; 1974 Mus. Contemp. Art, Chicago, Whitney Mus. American Art, NY, Walker Art Center, Minneapolis; 1975 Portland Center for Visual Arts, Oregon, San Francisco Art Inst.; 1970, 1972, 1976, 1977, 1979, 1980, 1982 Phyllis Kind Gall., NY and Chicago; 1980 Rotterdam Kunststichting, Holland. *122-4.*

Okulick, John. b. 1947, NY. Univ. of California, Santa Barbara, 1969(BA); Univ. of California, Irvine, 1974(MFA). Exh. incl. 1973 Cal. State Univ., Long Beach; 1973, 1974, 1975, 1977, 1978, 1979, 1980, 1981, 1983 Nancy Hoffman Gall.; NY; 1974 Jack Glenn Gall., Corona del Mar, Cal.; 1975 Dwight Boehm Gall., Palomar College, San Marcos, Cal.; 1976 LA Inst. Contemp. Art, Phyllis Kind Gall., Chicago; 1977 Cal. State Univ., Fullerton; 1978, 1979 Grapestake Gall., San Francisco; 1980, 1981, 1983 Asher/Faure Gall., LA. *88, 140.*

Oldenburg, Claes Thure. b. 1925, Stockholm. Yale Univ., New Haven, Conn.,1950-2(BA); Chicago Art Inst., 1952-4. Exh. incl. 1959 Cooper Union Art Sch. Lib., NY, Judson Gall., NY; 1961 Reuben Gall., NY; 1962 Dallas Mus. Contemp. Art, Texas; 1963 Dwan Gall., LA; 1964 Galerie Sonnabend, Paris; 1966 Moderna Museet, Stockholm; 1967 Mus. Contemp. Art, Chicago; 1969 Mus. Mod. Art, NY; 1971 Pasadena Art Mus., Cal.; 1974 Leo Castelli Gall., NY; 1975 Kunsthalle, Tubingen, W. Germany, Kunstmuseum, Basle, Mayor Gall., London; 1976 Museum des 20 Jahrhunderts, Vienna. *13, 48, 74.*

Orr, Eric. b. 1939, Covington, Ken. Univ. of California, Berkeley; Univ. of Mexico; New Sch. Social Research, NY; École de Pataphysique, Paris; Univ. of Cincinnati, Ohio. Exh. incl. 1968 Eugenia Butler Gall., LA; 1973 Univ. of California, Irvine; 1974 Cirrus Gall., LA; 1975 Salvatore Ala Gall., Milan; 1976 'Sunrise' Cirrus Gall., LA; 1979 Janus Gall., LA; 1980 LA Inst. Contemp. Art, LA Mus. Art; 1981, 1982, 1984 Neil G. Ovesey Gall., LA; 1982 Taylor Gall., Taos, NMex.; 1983 Foster Goldstrom Fine Arts, San Francisco; 1984 San Diego State Univ., Cal. *144-5.*

Ossorio, Alfonso. b. 1916, Manila, Philippines. Harvard Univ., Cambridge, Mass., 1934-8(BA); Rhode Island Sch. Design, Providence, 1938-9. Exh. incl. 1941, 1943 Wakefield Gall., NY; 1945 Mortimer Brant Gall., NY; 1951 Studio Facchetti, Paris; 1951, 1953, 1956, 1958, 1959 Betty Parsons Gall., NY; 1960 Stadler Gall., NY; 1961 Stadler Gall., Frankfurt, W. Germany; 1963, 1968, 1972 Cordier-Ekstrom, NY; 1974 Yale Univ. Divinity Sch., New Haven, Conn.; 1980 Guild Hall, East Hampton, NY; 1982 Oscarsson Hood Gall., NY. *19, 73.*

Otterness, Tom. b. 1952, Wichita, Kansas. Art Students League, NY, 1970; Whitney Mus. American Art, NY, 1973. Exh. 1983, 1984 Brooke Alexander, NY. *57.*

Paley, Albert. b. 1944, Philadelphia. Tyler Sch. Art, Temple Univ., Philadelphia, 1962-6(BFA), Graduate Teaching Assistantship 1967-9, 1966-9(MFA). Exh. incl. 1969

Philadelphia Art Alliance; 1970 Nova Scotia College of Art and Design, Halifax; 1974 California State Univ., Long Beach; 1976, 1977 Helen Drutt Gall., Philadelphia; 1977 Renwick Gall., Smithsonian Inst., Wash. DC, Theo Portnoy Gall., NY; 1979, 1981-2 Fendrick Gall., Wash. DC; 1980 John Michael Kohler Art Center, Sheboygan, Mich., Hunter Art Mus., Chattanooga, Tenn., Columbus Gall. Fine Arts, Ohio; 1983 Univ. of Iowa Mus. Art, Iowa City. *69-70.*

Panter, Gary. b. 1930, Durant, Okl. East Texas State Univ., Commerce(BFA); Yale Summer Sch. Music and Art; Public Sch., Sulphur Springs, Texas. Exh. incl. 1977 Jones, LA; 1978 Fiorucci, LA; 1979 SHOFA, LA; 1981 City Cafe, LA, France Aline, LA; 1982 Danceteria, NY; 1983 Future Perfect, LA, Overart, Tokyo; 1984 Onyx Cafe, LA, Tilden-Foley Gall., New Orleans, Gary Panter Square (video bar), Nagoya, Japan. *141-2.*

Paschke, Ed. b. 1939, Chicago. Art Inst. Chicago, 1961(BFA), 1970(MFA). Exh. incl. 1973 Richard De Marco Gall., Edinburgh; 1974 Contemp. Arts Center, Cincinnati, Ohio; 1976 Marion Locks Gall., Philadelphia; 1977, 1979, 1980, 1982, 1983 Phyllis Kind Gall., Chicago; 1981 Galerie Darthea Speyer, Paris; 1982 Renaissance Soc., Univ. Chicago; 1983 Hewlett Gall., Carnegie-Mellon Univ., Pittsburgh, Penn., Kalamazoo Inst. Arts, Mich. *122-5.*

Pearlstein, Philip. b. 1924, Pittsburgh, Penn. Carnegie Inst. Technology, Pittsburgh, 1946-9(BFA); Inst. Fine Arts, NY Univ., 1951-5(MA). Exh. incl. 1955, 1959 Tanager Gall., NY; 1962 Kansas City Art Inst., Missouri; 1965, 1967, 1974 Allan Frumkin Gall., Chicago; 1970 Georgia Mus. Art (touring exh.); 1972 Galerie M.E. Thelen, Cologne, Galleri Ostergren, Malmo, Sweden, Galerie Kornfeld, Zurich, Staatliche Museen-Kupferstichkabinett, Berlin, Kunstverein, Hamburg; 1973 Editions La Tortue, Paris; 1975 Gimpel Fils, London. *101-2.*

Piatek, Frank. b. 1944, Chicago. Sch. Art Inst. Chicago, 1967(BFA), 1971(MFA). Exh. 1969 Hyde Park Art Center, Chicago; 1972 Phyllis Kind Gall., Chicago; 1974 Merrimac College, St Louis, Missouri; 1975 N.A.M.E. Gall., Chicago; 1981 Richard Gray Gall., Chicago; 1984 Roy Boyd Gall., Chicago. *129.*

Piccillo, Joseph. b. 1941, Buffalo, NY. State Univ. College, Buffalo, NY, 1961(BS), 1964(MS). Exh. incl. 1966, 1968, 1970 Banfer Gall., NY; 1969, 1981 Albright-Knox Gall., Buffalo; 1971-2, 1973, 1974-6, 1977, 1978 Krasner Gall., NY; 1973, 1974 4th and 5th Internat. Art Fair, Basle; 1978, 1979 Galerie Loyse Oppenheim, Geneva; 1980, 1981, 1983 Monique Knowlton Gall., NY; 1981 Betsy Rosenfield Gall., Chicago; 1983 Galleria Forni, Bologna, Italy. *79-80.*

Piccolo, Richard. b. 1943, Hartford, Conn. Pratt Inst., NY; Art Students League, NY; Brooklyn College, NY. Exh. 1975, 1977, 1978, 1983 Robert Schoelkopf Gall., NY; 1977 American Acad., Rome; 1979 Galleria Temple, Rome. *105.*

Pittman, Lari. b. 1952, LA. UCLA, 1970-3; California Inst. Arts, Valencia, 1974(BFA), 1976(MFA). Exh. 1982 LA Contemp. Exhibitions; 1982-3 Newport Harbor Art Mus., Newport Beach, Cal.; 1983 Rosamund Felsen Gall., LA. *75.*

Poag, Jim. b. 1954, Columbia, Tenn. Middle Tennessee State Univ., Murfreesboro, 1977(BFA); Univ. of Houston, Texas,

1982(MFA). Exh. incl. 1983 Almeda Project for Arts, Houston; 1984 Lawrence Oliver Gall., Philadelphia. *133.*

Porter, Katherine. b. 1941, Iowa. Exh. in Boston, Wash. DC, NY. Coll. incl. Cal. Palace of Legion of Honour, San Francisco; Fogg Art Mus., Cambridge, Mass.; Carnegie Inst., Pittsburgh, Penn.; Whitney Mus. American Art, NY; Worcester Art Mus., Mass. *26.*

Preston, Astrid. b. 1945, Stockholm. UCLA, 1967(MA). Exh. incl. 1975 Tortue Gall., Santa Monica, Cal., Broxton Gall., LA, Aerospace Corp., LA; 1976 Marion Koogler McNay Art Inst., San Antonio, Texas; 1977 Loyola Marymount Univ., Malone Art Gall., LA, Long Beach City College, Fine Arts Gall., Cal., LA Inst. Contemp. Art; 1977, 1978 Cedars-Sinai Medical Center, LA; 1978 Univ. Art Gall., Cal. State Univ., Dominguez Hills, Art Gall., San Diego State Univ., Cal., A.C.T., Toronto. *140.*

Quasius, Sharon. b. 1948, Sheboygan, Wisc. Univ. of Wisconsin, Oshkosh, 1967-72(BFA); Univ. of Oklahoma, Norman, 1973-5(MFA). Exh. 1979 N.A.M.E. Gall., Chicago; 1980, 1982 O.K. Harris Works of Art, NY; 1981 The Queen's Mus., Flushing, NY. *81.*

Ramirez, Dan. b. 1941, Chicago. Chicago City College, 1971-2; Univ. of Illinois, Circle Campus, Chicago, 1972-5(BA); Art Inst. Chicago, 1975; Univ. of Chicago, 1975-7(MFA). Exh. 1974 Don Roth's Blackhawk, Chicago; 1975 Social Science Admin. Building, Univ. of Chicago; 1976 Chicago Gall.; 1977, 1980 Marianne Deson Gall., Chicago; 1977 Krannert Center for Performing Arts, Univ. of Ill., Champaign/ Urbana; 1979 Renaissance Gall., Chicago; 1981 Three Ill. Center Plaza, Chicago, Art Inst. Chicago, Ball State Univ. Art Gall., Muncie, Ind.; 1982, 1982-3, 1983 Roy Boyd Gall., LA and Chicago; 1983 St Xavier College, Chicago. *129.*

Randolph, Lynn. b. 1938, NY. Moved to Texas, 1940. Univ. of Texas, Austin, 1961(BFA). Exh. incl. 1969 Southwestern Univ., Georgetown, Texas; 1984 Graham Gall., Houston, Texas. *109.*

Rauschenberg, Robert. b. 1925, Port Arthur, Texas. Kansas City Art Inst. and Sch. Design, Missouri, 1946-7; Black Mountain College, NCar., 1948-50. Exh. incl. 1951 Betty Parsons Gall., NY; 1953 Stable Gall., NY, Galleria d'Arte Contemporanea, Florence, Italy; 1958, 1972 Leo Castelli Gall., NY; 1959 Galleria la Tartaruga, Rome, Galerie 22, Düsseldorf; 1961 Galerie Daniel Cordier, Paris; 1963 Jewish Mus., NY; 1963, 1971, 1973 Galerie Sonnabend, Paris; 1964 Whitechapel Gall., London; 1965 Moderna Museet, Stockholm; 1966, 1968 Mus. Mod. Art, NY; 1968 Kunstverein, Cologne, Musée Nationale d'Art Moderne, Paris; 1973 Ace Gall., LA; 1974 Graficstudio Tampa, Univ. of South Florida, Tampa. *13, 17.*

Reilly, Jack. b. 1950. A.A. Daytona Beach College, Florida, 1971-3; American Acad. Art, Paris, 1973; Florida State Univ., Tallahassee, 1974-6(BFA), 1976-7(MFA). Exh. incl. 1979 Carter Sarkin Gall., LA; 1980, 1981 Molly Barnes Gall., LA; 1980, 1981, 1983 Foster Goldstrom Fine Arts, San Francisco; 1980 Fine Art Center, Yuma, Ariz.; 1981 Aaron Berman Gall., NY, Marilyn Butler Gall., Scottsdale, Ariz., Matthews Center Mus., Ariz. State Univ., Tempe, Charleston Heights Arts Center, Las Vegas, Northern Ariz. Univ. Gall., Flagstaff; 1982

GMB Gall., Birmingham/Detroit, Mich.; 1983 Stella Polaris Gall., LA, Acad. Art College, San Francisco; 1984 Long Beach City College, Cal. *140.*

Richbourg, Lance. b. 1938, Florida. UCLA, 1960(BA), 1963(MA), 1967(MFA). Exh. 1965, 1968 Cejee Galleries, LA; 1966 Cal. State College, Northridge, La Jolla Mus. Art, Cal.;1967 Dwight Boehm Gall., Pomona, Cal.; 1969 Long Beach Mus. Art, Cal.; 1970 Palos Verdes Art Center, Rancho Palos Verdes, Cal.; 1976, 1980, 1982 O.K. Harris Works of Art, NY; 1981, 1982 Arco Center for Visual Arts, LA; 1983 Middendorf-Lane Gall., Wash. DC. *105.*

Rockburne, Dorothea. b. 1921, Verdun, Quebec. École des Beaux-Arts, Montreal; Black Mountain College, NCar.,(BA). Exh. incl. 1982 Xavier Fourcade Gall., NY. First exh. 1970 NY. Exh. since in Paris, London, Milan, Brussels, Florence, San Francisco, Houston. *20-1.*

Rodart, George. b. 1943, LA. UCLA, 1972(MFA). Exh. 1976 Fine Arts Gall., Cal. State Univ., LA, Tortue Gall., Santa Monica, Cal.; 1982 Ulrike Kantor Gall., LA. *36.*

Rose, Thomas A. b. 1942, Wash. DC. Univ. of Illinois, Urbana, 1965(BFA); Univ. of Cal., Berkeley, 1967(MA); Study Grant, Lund Univ., Sweden, 1967-8. Exh. incl. 1967 Richmond Mus., Cal.; 1969, 1973 Bolles Gall., San Francisco; 1972, 1974 Gilman Gall., Chicago; 1973 Contemp. Gall., Dallas, Texas; 1975 Grapestakes Gall., San Francisco; 1977, 1979 Truman Gall., NY; 1977 The Clocktower, NY; 1977, 1978, 1979 Walter Kelley Gall., NY; 1979 Quay Gall., San Francisco; 1980, 1982 Rosa Esman Gall., NY; 1983 Paul Klein Gall., Chicago. *67.*

Rosenquist, James. b. 1933, Grand Forks, NDak. First exh. NY. Exh. since in LA, Paris, Stockholm, Turin, Baden-Baden, Bern, Humblebaek (Denmark), Amsterdam, Ottawa, Cologne, Hamburg, Munich, Berlin, Portland (Oregon), Wash. DC, Toronto. Coll. incl. Art Gall. Ontario, Toronto; Mus. Mod. Art, NY; Stedelijk Mus., Amsterdam; Musée Nationale d'Art Moderne, Paris. *13.*

Rosenthal, Ted. b. 1958, Ohio. Chicago Art Inst.,(BFA). Exh. 1984 Galleria Salvatore Ala, Milan, Gracie Mansion Gall., NY. *63-4.*

Rothenberg, Susan. b. 1945, Buffalo, NY. Exh. 1975-9 Four times in NY; also numerous (g). Coll. incl. Mus. Mod. Art, NY; Albright-Knox Art Gall., Buffalo, NY. *32.*

Rubin, Sandra Mendelsohn. b. 1947, Santa Monica, Cal. UCLA, 1976(BA), 1979(MFA). Exh. 1982 L.A. Louver Gall., Venice, Cal. *90.*

Ruscha, Edward J. b. 1937, Omaha, Nebraska. Chouinard Art Inst., 1956-60. Exh. incl. 1963 Ferus Gall., LA; 1967 Alexander Iolas Gall., NY; 1970 Galerie Heiner Friedrich, Munich; 1972 DM Gall., London; 1973 Projection Ursula Wevers, Cologne, Leo Castelli Gall., NY, Galerie Françoise Lambert, Milan, Ace Gall., LA; 1974 Hamilton College, Clinton, NY, Texas Gall., Houston; 1975 Galerie Ricke, Cologne, Jared Sable Gall., Toronto, Univ. of NDak, Grand Forks, Univ. of Ariz., Tempe. *52, 140.*

Ryman, Robert. b. 1930, Nashville, Tenn. Tenn. Polytechnic, Cookville, 1948-9; George Peabody College for Teachers, Nashville, Tenn., 1949-50. Exh. incl. 1967 Paul Bianchini Gall., NY; 1968, 1973 Konrad Fischer Gall., Düsseldorf; 1968 Galerie Heiner Friedrich, Munich; 1969 Fischbach Gall., NY, Galerie Yvon Lambert, Paris;

1971 Dwan Gall., NY; 1972 John Weber Gall., NY, Solomon R. Guggenheim Mus., NY, Galerie Annemarie Verna, Zurich, Lisson Gall., London, Galleria del Cortile, Rome; 1973 Art and Project, Amsterdam; 1974 Stedelijk Mus., Amsterdam, Palais des Beaux-Arts, Brussels; 1975 Kunsthalle, Basle. *20.*

Saari, Peter. b. 1951, NY. Yale Univ. Sch. Art, Graduate Sch., New Haven, Conn.; C.W. Post College, Long Island, NY, 1974(BFA); Tyler Sch. Art, Temple Abroad, Rome, 1973; Sch. Visual Arts, NY. Exh. incl. 1974 New Gall., Huntington, NY; 1974, 1976 Lamagna Gall., NY; 1977-8 O.K. Harris Works of Art, NY. *82.*

Salazar, Jorge. b. 1951, Guadalajara, Mexico. Exh. 1973, 1976 Bellas Artes, Guadalajara; 1981 Mission Cultural Center, San Francisco; 1983 P.S.1, Long Island City, NY; 1984 Germans Van Eck Gall., NY, Miami-Dade Community College Art Gall., Miami, Florida, Kunsthandel P.B. Van Voorst van Beest, The Hague. *121.*

Salle, David. b. 1952, Norman, Okl. Cal. Inst. Arts, Valencia, 1973(BFA), 1975(MFA). Exh. incl. 1975 Claire S. Copley Gall., LA; 1976 Artists Space, NY, Foundation Corps de Garde, Groningen, Holland; 1977 Foundation de Appel, Amsterdam; 1977, 1979 The Kitchen, NY; 1980 Galerie Bruno Bischofberger, Zurich, Annina Nosei Gall., NY; 1981, 1982 Mary Boone Gall., NY; 1981 Larry Gagosian Gall., LA; 1982 Leo Castelli Gall., NY. *33.*

Sarkisian, Paul. b. 1928, Chicago. Sch. Art Inst. Chicago, 1945-8; Otis Art Inst., LA, 1953-4; Mexico City College, 1955-6. Exh. incl. 1958 Nova Gall., Boston, Mass.; 1962 Aura Gall., Pasadena, Cal.; 1963 La Jolla Art Center, Cal.; 1969 Corcoran Gall. Art, Wash. DC; 1970, 1973 Michael Walls Gall., San Francisco; 1972 Mus. Contemp. Art, Chicago; 1975, 1977 Mus. Contemp. Arts, Houston, Texas; 1978, 1980, 1982 Nancy Hoffman Gall., NY; 1979 Arts Club of Chicago; 1981 Fendrick Gall., Wash. DC, Arco Center for Visual Arts, LA. *85.*

Saul, Peter. b. 1934, San Francisco. First exh. 1962 NY. Exh. since numerous in NY and Chicago; also in LA, Rome, Turin, Cologne, Paris. Coll. incl. Mus. Mod. Art, NY; Art Inst. Chicago; Whitney Mus. American Art, NY. *56.*

Scharf, Kenny. b. 1958, LA. Sch. Visual Arts, NY, 1980(BFA). Exh. 1979 Paintings at Fiorucci, NY; 1981 Nat. Studio Artists, P.S.1, Long Island City, NY; 1981, 1982 Fun Gall., NY. *53-6.*

Schmidt, Edward. b. 1946, Ann Arbor, Mich. Pratt Inst., NY, 1964-71(BFA,Hons); Art Students League, NY, 1966-71; Skowhegan Sch. Painting and Sculpture, Maine, 1967; École des Beaux-Arts, Paris, 1967-8; Brooklyn College, City Univ., NY, 1972-4(MFA); Atelier 17, Paris, 1978. Exh. incl. 1968 Le Salon National des Beaux-Arts, Paris; 1973 Viterbo College Art Gall., La Crosse, Wisc.; 1975, 1981, 1982 Robert Schoelkopf Gall., NY; 1978 Federal Mem. Nat. Hall, NY; 1979 Musée de la Grande Combe (Louvre), Ales, France; 1980 Salve Regina Gall., Catholic Univ., Wash. DC. *103-5.*

Schnabel, Julian. b. 1951, NY. Univ. of Houston, Texas, 1972(BFA); Whitney Mus. American Art, NY, 1973-4. Exh. incl. 1976 Contemp. Arts Mus., Houston; 1979, 1981 Mary Boone Gall., NY; 1979 Daniel Weinberg Gall., San Francisco; 1980 Galerie

Bruno Bischofberger, Zurich, Young/Hoffman Gall., Chicago; 1981, 1983 Leo Castelli Gall., NY; 1982 Margo Leavin Gall., LA, LA County Mus. Art, Stedelijk Museum, Amsterdam, Tate Gall., London. *19, 33.*

Schoonhoven, Terry. b. 1945, Freeport, Ill. Univ. of Wisconsin, 1967(BS); UCLA, 1967-9 (graduate work). Exh. 1975 Newport Harbor Art Mus., Newport Beach, Cal.; 1976 Colorado Springs Art Center, Univ. Art Gall., Tempe, Ariz.; 1977 Crocker Art Mus., Sacramento, Cal., California State Univ. Art Gall., Chico; 1980 Arco Center for Visual Arts, LA, Hogarth Gall., Sydney, Australia. *89.*

Schuyff, Peter. b. 1956, Baarn, Holland. Exh. incl. 1982 White Columns, NY; 1983, 1984 Pat Hearn Gall., NY. *65.*

Schwartz, Mark. b. 1948, NY. Hunter College, NY, 1982(MFA). Exh. 1982, 1983, 1985 Semaphore Gall., NY; 1983, 1984 Peter Miller Gall., Chicago. *35-7.*

Scully, Sean. b. 1945, Dublin. Croydon College of Art, London; Newcastle Univ., England; Harvard Univ., Cambridge, Mass. Exh. 1973, 1975, 1977, 1979, 1981 Rowan Gall., London; 1975, 1976 Tortue Gall., Santa Monica, Cal.; 1977 Duffy-Gibbs Gall., NY; 1979 Nadin Gall., NY, The Clocktower, NY; 1980, 1981 Susan Caldwell Gall., NY; 1981 Museum für (Sub-)Kultur, Berlin, Ikon Gall., Birmingham, England, McIntosh-Drysdale Gall., Wash. DC. *26.*

Segal, George. b. 1924, NY. Pratt Inst. Design, NY, 1947-8; NY Univ., NY City, 1948-9(BS); Rutgers Univ., New Brunswick, NJ, 1961-3(MFA). Exh. incl. 1956 Hansa Gall., NY; 1960 Green Gall., NY; 1963 Galerie Ileana Sonnabend, Paris, Schmela Gall., Düsseldorf; 1965 Sidney Janis Gall., NY; 1968 Mus. Contemp. Art, Chicago; 1969 Galerie Darthea Speyer, Paris; 1971 Kunsthaus, Zurich(travelling exh.); 1975 André Emmerich, Zurich; 1977 Art Galleries, Cal. State Univ., Long Beach(travelling exh.); 1982 Seibu Art Mus., Tokyo(travelling exh.); 1983 Bezalel Nat. Art Mus., Jerusalem. *16-17, 82-4.*

Shaffer, Richard. b. 1947, Fresno, Cal. Univ. of Cal., Santa Cruz, 1969(BA); New Sch. for Social Research, NY, 1969-71; San Francisco Art Inst., 1971-3; Stanford Univ., 1975(MFA). Exh. 1975 James Willis Gall., San Francisco; 1979 Texas Christian Univ., Fort Worth; 1981 Dallas Mus. Fine Arts; 1984 L.A. Louver Gall., Venice, Cal. *112.*

Shapiro, Joel. b. 1941, NY. Exh. 1970-9 20 incl. NY, Milan, London, Chicago, Wash. DC, Buffalo, Detroit. Coll. incl. Whitney Mus. American Art, NY; Israel Mus., Jerusalem; Nat. Gall. Australia, Canberra; Yale Univ. Art Gall., New Haven, Conn.; Metropolitan Mus., NY; Albright-Knox Art Gall., Buffalo, NY; Stedelijk Museum, Amsterdam. *22.*

Shelton, Peter. b. 1951, Troy, Ohio. Pomona College, Claremont, Cal., 1973(BA); Hobart Sch. Welding Technology, Troy, Ohio, 1974; UCLA, 1979(MFA). Exh. 1980 Chapman College, Orange, Cal.; 1981 Malinda Wyatt Gall., Venice, Cal.; 1982 Artists Space, NY, Santa Barbara Contemp. Arts Forum, Cal., Open Space Gall., Victoria, British Columbia. *60.*

Sherman, Cindy. b. 1945. SUNY at Buffalo, NY, 1976(BA). Exh. incl. 1980 Contemp. Arts Mus., Houston, Texas; 1982 Stedelijk Museum, Amsterdam (and travelling in Belgium, England, W. Germany, Switzerland, Norway, Denmark); 1983 St Louis Art Mus., Missouri, Musée d'Art et d'Industrie de St Etienne, France; 1984 Laforet Mus., Tokyo,

Hampden Gall., Univ. of Mass., Amherst, Akron Art Mus., Ohio (and travelling in U.S.). *120.*

Shields, Alan. b. 1944, Herington, Kansas. Kansas State Univ., Manhattan, 1963(Civil Engineering). Exh. incl. 1969, 1970, 1972, 1974, 1983 Paula Cooper Gall., NY; 1971 Galerie Sonnabend, Paris; 1972, 1975 Galleria dell' Ariete, Milan; 1973 Galerie Aronowitsch, Stockholm, Mus. Contemp. Art, Chicago; 1974 Richard Gray Gall., Chicago; 1975 Galerie Daniel Templon, Paris; 1976 Musée d'Art et d'Industrie, St Etienne, France, Museu de Arte Moderna do Rio de Janeiro; 1977 Musée d'Art Moderne de Strasbourg, France; 1978 Galerie Munro, Hamburg; 1979 Gimpel-Hanover and André Emmerich Galleries, Zurich; 1983 Gall. Ueda, Tokyo. *74.*

Shimomura, Roger. b. 1939, Seattle, Wash. Univ. of Washington, Seattle, 1961(BA); Cornish Sch. Allied Arts, Seattle, 1964; Stanford Univ., Palo Alto, Cal., 1967; Cornell Univ., Ithaca, NY, 1968; Syracuse Univ., NY, 1969(MFA). Exh. incl. 1967 Earl Ballard Gall., Seattle; 1969 Ithaca College Mus. Art, NY; 1976 Franell Gall., Akasaka, Tokyo, Gall. Heian, Nakagyo-ku, Kyoto, Alberta College of Art, Calgary; 1977 Univ. of Cal., Davis; 1979 Kiku Gall., Seattle; 1981 Elaine Horwitch Gall., Scottsdale, Ariz.; 1982 Birmingham Art Mus., Ala.; 1984 Univ. of Utah, Salt Lake City, Morgan Gall., Kansas City, Kansas. *53, 120.*

Simonds, Charles. b. 1945, NY. Exh. 7 since 1975 in Paris, Genoa, NY, Buffalo. Coll. incl. Centre d'Art Contemporain, Paris; Mus. Mod. Art, NY; MIT; Allen Mem. Art Mus., Oberlin College, Ohio. *76.*

Slavick, Susanne. b. 1956, South Bend, Ind. Yale Univ., New Haven, Conn., 1978(BA); Tyler Sch. Art, Temple Abroad, Rome, 1978-9. Exh. 1980 Governor's Exh., State of Maine, Augusta; 1982 Fuller Fine Arts, Philadelphia, Art Registry of Minnesota, Minneapolis; 1983 Prairie State College, Chicago Heights, Ill.; 1984 Maxwell Davidson Gall., NY, Frumkin and Struve Gall., Chicago. *129.*

Smith, Alexis. b. 1949, LA. Univ. of Cal., Irvine, 1966-70(BA). Exh. incl. 1974 Riko Mizuno Gall., LA; 1975 Univ. of Cal., Santa Barbara, Whitney Mus. American Art, NY, Long Beach Mus. Art, Cal.; 1976 Cal. State Univ., San José; 1977 Nicholas Wilder Gall., LA; 1977, 1978, 1979, 1980, 1981, 1983 Holly Solomon Gall., NY; 1978, 1980, 1982 Rosamund Felsen Gall., LA; 1979 De Appel, Amsterdam, Steirescher Herbst, Graz, Austria; 1982 Clocktower, NY, Margo Leavin Gall., LA. *141.*

Smith, Lee. b. 1950, New Orleans. Exh. incl. 1978 Eastfield College, Mesquite, Texas; 1979 Mountain View College, Dallas, Texas, Univ. of Texas, Arlington; 1980, 1982 DW Gall., Dallas, Texas; 1981 Fort Worth Art Mus., Texas, Texas Christian Univ., Fort Worth; 1984 Art Center, Waco, Texas. *132-3.*

Smith, Susan. b. 1947, Worchester, Mass. Univ. of Houston, Texas, 1976(BFA), 1978(MFA). Exh. incl. 1979 Alley Theatre, Houston; 1979, 1980, 1983 Univ. of St Thomas, Houston; 1980 Univ. of Houston, Jung Inst., Houston; 1981 Harris Gall., Houston; 1982 Stavanger, Norway(travelling); 1983 Philadelphia/Houston. *130.*

Smyth, Ned. b. 1948. Kenyon College, Gambier, Ohio, 1970(High Hons. in Art). Exh. 1974 112 Greene St., NY; 1976, 1977 Holly

Solomon Gall., NY; 1978 Dag Hammarskjold Plaza Sculpture Garden, NY; 1980 Mayor Gall., London, Galerie Bischofberger, Zurich. *44.*

Spinski, Victor. b. 1940, Kansas City. Indiana Univ.,(MFA); Kansas State Teachers College, Emporia,(BSE). Exh. 1969 Parrish Mus. Art, Southampton, NY, Agra Gall., Wash. DC; 1977 Theo Portnoy Gall., NY. *81-2.*

Stackhouse, Robert. b. 1942, Bronxville, NY. Exh. 1972-9, 9 in Wash. DC, NY, Chicago. Coll. incl. Walker Art Center, Minneapolis; Corcoran Gall., Wash. DC. *76.*

Staley, Earl. b. 1938, Oak Park, Ill. Illinois Wesleyan Univ., 1960(BFA); Univ. of Arkansas, Fayetteville, 1963(MFA); Prix de Rome, 1981. Exh. 1965 Downstairs Gall., St Louis, Missouri; 1967 Louisiana Gall., Houston; 1967, 1982 Rice Univ., Houston; 1968 Cedar Rapids Art Gall., Iowa; 1970 Meredith Long Gall., Houston; 1972 David Gall., Houston; 1974 Sarah Campbell Blaffer Gall., Univ. of Houston; 1976 Loft-on-the-Strand, Galveston, Texas; 1978-9 Texas Gall., Houston; 1980 Contemp. Art Mus., Houston; 1983 Watson/de Nagy Gall., Houston, Phyllis Kind Gall., NY. *40, 130.*

Stella, Frank. b. 1936, Malden, Mass. Phillips Acad., Andover, Mass.; Princeton Univ., NJ. Exh. incl. 1960, 1969, 1973 Leo Castelli Gall., NY; 1961, 1964 Galerie Lawrence, Paris; 1965 Ferus Gall., LA; 1966 David Mirvish Gall., Toronto, Pasadena Art Mus., Cal.; 1967 Galerie Bischofberger, Zurich; 1968 Gall. Mod. Art, Wash. DC, Kasmin Gall., London; 1969 Univ. of Puerto Rico, Mayaguez; 1970 Mus. Mod. Art, NY, Hayward Gall., London; 1971 Lawrence Rubin Gall., NY; 1974 DM Gall., London, Knoedler Gall., NY; 1975 Castelli Downtown, NY. *17, 19, 20, 26.*

Stephan, Gary. b. 1942, Brooklyn, NY. Parsons Sch. Design, NY; Arts Students League, NY; Pratt Inst., NY; San Francisco Art Inst. *30-2.*

Sturman, Eugene. b. 1945, NY. Alfred Univ., NY, 1967(BFA); Univ. of New Mexico, Albuquerque, 1969(MA); Tamarind Lithography Workshop, NMex., 1970(Master Printer). Exh. 1972, 1974, 1975, 1976, 1978 Cirrus Gall., LA; 1976, 1979, 1981 Grapestaks Gall., San Francisco; 1976 Galerie Krebs, Bern, Galleria del Cavallino, Venice, Italy, Galerie Stevenson-Palluel, Paris; 1977 Occidental College, LA; 1978 Pepperdine Univ., Malibu, Cal.; 1982 Atlantic Richfield Center for Visual Arts; 1983 Palos Verdes Art Center, Rancho Palos Verdes, Cal.; 1984 Koplin Gall., LA, Mattingly Baker Gall., Dallas, Texas. *76.*

Sultan, Altoon. b. 1948, Brooklyn, NY. Brooklyn College, NY, 1969(BFA), 1971(MFA); Skowhegan Art Sch., Maine, 1970; South Dakota Arts Council, 1975-7(Artist-in-Residence). Exh. 1971, 1973, 1975 First St. Gall., NY; 1975 Univ. of South Dakota, Vermillion, Mt. Marty College, Yankton, SDak.; 1976 Oscar Howe Cultural Center, Mitchell, SDak., Sioux Falls Civic Art Center, SDak.; 1977, 1979, 1982 Marlborough Gall., NY. *93-5.*

Sultan, Donald. b. 1951, Asheville, NCar. Univ. of NCar., Chapel Hill, 1973(BFA); Sch. Art Inst. Chicago, 1975(MFA). Exh. 1976 N.A.M.E. Gall., Chicago; 1977 Artists Space, NY, Inst. Art and Urban Resources, P.S.1, Long Island City, NY; 1979 Young, Hoffman Gall., Chicago; 1979, 1980 Willard Gall., NY; 1981 Daniel Weinberg Gall., San Fran-

cisco; 1982 Hans Strelow Gall., Dusseldorf; 1982, 1984 Blum-Helman Gall., NY; 1983 Akira Ikeda Gall., Tokyo. *33.*

Surls, James. b. 1943, Terrell, Texas. Houston State College, 1966(BS); Cranbrook Acad. Art, Bloomfield Hills, Mich., 1969(MFA). Exh. incl. 1974 Tyler Mus. Art, Texas; 1975, 1977, 1979 Contemp. Arts Mus., Houston, Texas; 1977, 1979, 1981 Delahunty Gall., Dallas, Texas; 1979 Robinson Galleries, Houston; 1980, 1982 Allan Frumkin Gall., NY; 1981 Daniel Weinberg Gall., San Francisco; 1982 Akron Art Mus., Ohio. *73, 130.*

Szeto, Keung. b. 1948, Canton, China. Nat. Taiwan Normal Univ., Taiwan, 1973(BFA); Hong Kong Univ., 1973-4(painting); First Inst. Art and Design, Hong Kong, 1973-5; Pratt Inst., Sch. Art and Design, Brooklyn, NY, 1979(MFA). Exh. 1971 Liang's Gall., Taipei, Taiwan; 1973-4 U.S. Information Service, Taipei, Taiwan; 1976 Schenectady Civic Player, NY; 1982, 1984 O.K. Harris Works of Art, NY. *85.*

Thorne, Joan. b. 1943, Brooklyn, NY. NY Univ., NY City, 1965(BA); Hunter College, NY, 1968(MA). Exh. incl. 1979 The Clocktower, Inst. Art and Urban Resources, NY. *26-8.*

Twombly, Cy. b. 1929, Lexington, Virginia. Boston Mus. Sch. Fine Art, Mass.; Washington and Lee Univ., Lexington; Art Students League of NY; Black Mountain College, NCar., with Franz Kline and Robert Motherwell. Since 1957 lives and works in Rome. Exh. incl. 1951 Kootz Gall., NY, Seven Sisters Gall., Chicago; 1964, 1966, 1967, 1968, 1972, 1974, 1976 Leo Castelli Gall., NY; 1966 Stedelijk Museum, Amsterdam, Kunstverein, Freiburg; 1968 Milwaukee Art Center; 1973 Kunstmuseum, Basle, Kunsthalle, Bern, Städtische Galerie im Lenbachhaus, Munich; 1975 San Francisco Mus. Art; 1976 Musée d'Art Moderne de la Ville de Paris; 1979 Whitney Mus. American Art, NY; 1981 Newport Harbor Art Mus., Newport Beach, Cal. *45.*

Urquhart, Shari. b. 1940, Racine, Wisc. Univ. of Wisconsin, Madison, 1958(BFA), 1966(MS), 1967(MFA). Exh. 1968 Western Ill. Univ., Macomb; 1970, 1976 Madison Art Center, Wisc.; 1972 Wisc. Union Main Gall., Madison; 1979 Nancy Lurie Gall., Chicago; 1981, 1983 Monique Knowlton Gall., NY; 1984 Kansas City Art Inst., Missouri. *70-2.*

Valerio, James. b. 1938, Chicago. Sch. Art Inst. Chicago,(BFA,MFA). Exh. 1971, 1972 Gerard John Hayes Gall., LA; 1973 Tucson Art Center, Ariz.; 1974 Michael Walls Gall., NY; 1977 John Berggruen Gall., San Francisco; 1981 Frumkin and Struve, Chicago; 1983 Delaware Art Mus., Wilmington, Allan Frumkin Gall., NY. *107-9.*

Vallance, Jeffrey. b. 1955, Torrance, Cal. Cal. State Univ., Northridge, 1979(BA); Otis Inst., Parsons Sch. Design, LA, 1981(MFA). Exh. incl. 1975 Zody's Dept. Store, Canoga Park, Cal.; 1977 LA County Mus. Art; 1978 LA Inst. Contemp. Art, Washington Project for Arts, Wash. DC; 1980 Daniel Sorano Hall of Nat. Treasure, Dakar, Republic of Senegal; 1981, 1983 Rosamund Felsen Gall., LA; 1982 Univ. Art Mus., Univ. of Cal., Santa Barbara. *141.*

Warhol, Andy. b. 1928, McKeesport, Penn. Carnegie Inst. Technology, Pittsburgh, Penn., 1945-9(BFA). Exh. incl. 1952 Hugo Gall., NY; 1956 Bodley Gall., NY; 1962 Ferus Gall., LA; 1964 Galerie Sonnabend,

Paris; 1965 Galerie Rubbers, Buenos Aires, Galerie M.E. Thelen, Essen, W. Germany, Gian Enzo Sperone Arte Moderna, Milan; 1966 Galerie Hans Neuendorf, Hamburg; 1967 Galerie Rudolf Zwirner, Cologne; 1968 Kunstnernes Hus, Oslo, Moderna Museet, Stockholm; 1969 Irving Blum Gall., LA; 1970 Galerie Folker Skulima, Berlin, Mus. Contemp. Art, Chicago, Musée d'Art Moderne de la Ville de Paris; 1971 Galerie Bruno Bischofberger, Zurich; 1972 Multiples Gall., NY; 1974 Mayor Gall., London, Musée Galliera, Paris; 1975 Baltimore Mus. Art, Maryland; 1976 Wurttemburgischer Kunstverein, Stuttgart, W. Germany. *13-16.*

Warrens, Robert. b. 1933, Sheboygan, Wisc. Univ. of Wisc., Milwaukee,(BS); State Univ. of Iowa, Ames,(MFA). Exh. 1972 New Orleans Mus. Art; 1972, 1974, 1977, 1980, 1982 Galerie Simonne Stern, New Orleans; 1974, 1979 Allan Frumkin Gall., Chicago; 1976 Allan Frumkin Gall., NY; 1977 Pyramid Galleries, Wash. DC. Mural commissions incl. Centroplex Building, Baton Rouge, La., 1977, and Pan American Building, New Orleans, 1981. *129.*

Washmon, Gary. b. 1955, Tucson, Ariz. Univ. of New Mexico, Albuquerque, 1976(BFA); Univ. of Illinois, Champaign, 1978(MFA). Exh. 1981 Southwestern Univ., Georgetown, Texas; 1983 Univ. of Southwestern Louisiana, Lafayette; 1984 Air Gall., Austin, Texas. *96-7.*

Watson, Genna. b. 1948, Baltimore, Maryland. Maryland Inst., College of Art, Baltimore, 1966-70(BFA); Washington Univ., St Louis, 1971-3; Univ. of Wisc., Madison, 1976(MFA). Exh. 1978 Washington Project for Arts, Wash. DC. *64.*

Weber, Bruce. b. 1946. The New Sch.,(with Lisette Model); Hun Sch., Princeton, NJ; Denison Univ., Granville, Ohio. Exh. 1974 Razor Gall., NY; 1982 Grey Art Gall., NY; 1983 Jennifer Dumas Gall., LA; 1984 Hokin/Kaufman Gall., Chicago. *117.*

Wegman, William. b. 1943, Holyoke, Mass. Mass. College of Art, Boston(BFA, painting); Univ. of Illinois, Urbana(MFA, painting). Exh. incl. 1971, 1972 Sonnabend Gall., NY; 1971 Pomona College Art Gall., Cal.; 1973 LA County Mus. Art; 1979 Holly Solomon Gall., NY, Arnolfini Gall., Bristol, England, Fine Arts Galleries, Univ. of Wisc., Milwaukee; 1980 Univ. of Colorado Art Galleries, Boulder, Aspen Center for Visual Arts, Col.; 1982 Southeastern Center for Contemp. Art, Winston-Salem, NCar., Anderson Gall., Virginia Commonwealth Univ., Richmond, Walker Art Center, Minneapolis, Fort Worth Art Mus., Texas, De Cordova and Dana Mus. and Park, Lincoln, Mass., Contemp. Arts Center, Cincinnati, Corcoran Gall. Art, Wash. DC, Newport Harbor Art Mus., Newport Beach, Cal.; 1983 Fine Arts Gall., Univ. of Mass., Amherst; 1984 Norman Mackenzie Art Gall., Univ. of Regina, Canada. *117.*

Welliver, Neil. b. 1929, Millville, Penn. Philadelphia Mus. College of Art, 1953(BFA); Yale Sch. Art, New Haven, Conn., 1955(MFA). Exh. incl. 1954 Alexandra Grotto, Philadelphia; 1962, 1963, 1964 Stable Gall., NY; 1967, 1968, 1969, 1970 Tibor de Nagy Gall., NY; 1973 Parker St. 470 Gall., Boston, Mass.; 1974, 1976, 1979, 1981 Fischbach Gall., NY; 1978 Brooke Alexander, NY; 1983 Marlborough Gall., NY. *95-6.*

Wharton, Margaret. b. 1943, Portsmouth, Virginia. Univ. of Maryland, College Park,

1965(BS); Sch. Art Inst. Chicago, 1975(MFA). Exh. 1976, 1977, 1978, 1979, 1980, 1981, 1983 Phyllis Kind Gall., Chicago and NY; 1981-2 Mus. Contemp. Art, Chicago(travelling exh.). *73-4.*

Wiley, William T. b. 1937, Bedford, Ind. San Francisco Art Inst., 1960(BFA), 1962(MFA). Exh. incl. 1968-79 Hansen-Fuller Gall., San Francisco, Allan Frumkin Gall., NY and Chicago; 1971 Univ. Art Mus., Berkeley, Cal.; 1972 Documenta V, Kassel, W. Germany, Venice Biennale, Italy; 1973 Stedelijk van Abbemuseum, Eindhoven, Holland; 1976 Mus. Mod. Art, NY; 1979 Walker Art Center, Minneapolis; 1980 Realities Galleries, Melbourne, Australia, Inst. Mod. Art, Brisbane, Australia; 1981 Univ. Fine Arts Galleries, Florida State Univ., Tallahassee. *58, 145.*

Wilhite, Robert. b. 1946, Santa Ana, Cal. Univ. of Cal., Irvine, 1970(BA), 1971(Masters Program). Exh. 1973 Newspace Gall., Newport Beach, Cal.; 1975 Studio Show, LA; 1976 Broxton Gall., Westwood, Cal.; 1980 College of Creative Studies, Univ. of Cal., Santa Barbara; 1981, 1982 Asher/Faure Gall., LA; 1982 Stephen Wirtz Gall., San Francisco; 1983 Susanne Hilberry Gall., Birmingham, Mich. *69.*

Willis, Thornton. b. 1936, Pensacola, Florida. Auburn Univ., Ala., 1957-8; Univ. of Southern Mississippi, Hattiesburg, 1962(BS); Univ. of Alabama, 1966(MA). Exh. incl. 1966 Stillman College Art Gall., Tuscaloosa, Ala.; 1968 Henri Gall., Wash. DC; 1970 Paley and Lowe, NY; 1971 Simonne Stern Gall., New Orleans; 1972 New Orleans Mus. Art; 1979 55 Mercer St. Gall., NY; 1980 Ericson Gall., NY; 1980, 1983 Galerie Nordenhake, Malmo, Sweden; 1980, 1981, 1982, 1984 Oscarsson Hood Gall., NY; 1981 Marianne Deson Gall., Chicago; 1983 Galerie Engstrom, Stockholm; 1984 The Warehouse Gall., Orlando, Florida. *24-5.*

Wilson, Donald Roller. b. 1938, Houston, Texas. Kansas State Univ., Manhatten,(MFA). Exh. incl. 1966 Wichita Art Mus., Kansas, Wichita State Univ., Kansas; 1970 City Art Mus., St Louis, Missouri, David Gall., Houston; 1972 French and Co. Galleries, NY; 1973 Tibor de Nagy Gall., Houston; 1974 La Jolla Mus. Contemp. Art, Cal.; 1975 David Findlay Gall., NY; 1977, 1979, 1981 Moody Gall., Houston; 1978 John Berggruen Gall., San Francisco; 1982 Fendrick Gall., Wash. DC; 1984 Holly Solomon Gall., NY. *100.*

Winn, James. b. 1949, Hannibal, Missouri. Illinois State Univ., Normal, 1975-82(BS,MS, MFA). Exh. incl. 1981 Illinois Central College, East Peoria; 1982 Sangamon State Univ.; 1983 Frumkin and Struve Gall., Chicago; 1984 CIAE, Frumkin and Struve Gall., Navy Pier, Chicago. *93.*

Winsor, Jacqueline. b. 1941, Newfoundland, Canada. Yale Summer Sch. Art and Music, New Haven, Conn., 1964; Mass. College of Art, Boston, 1965(BFA); Rutgers Univ., New Brunswick, NJ, 1967(MFA). Exh. 1968 Douglass College Gall., New Brunswick; 1971 Nova Scotia College of Art and Design, Halifax; 1973, 1976, 1982 Paula Cooper Gall., NY; 1976 Contemp. Arts Center, Cincinnati, Portland Center for Visual Arts, Oregon; 1977 Mus. Mod. Art, San Francisco; 1978 Wadsworth Atheneum, Hartford, Conn.; 1979 Mus. Mod. Art, NY, Art Gall. of Ontario, Toronto, Fort Worth Art Mus., Texas; 1981 Virginia Mus., Richmond;

1982 Akron Art Mus., Ohio. *21.*

Wirsum, Karl. b. 1939, Chicago. Sch. Art Inst. Chicago, 1966(BA). Exh. 1967 Dell Gall., Chicago; 1970 St Xavier College, Chicago; 1971 Wabash Transit Gall., Chicago; 1974, 1976, 1977, 1978, 1979, 1980, 1981, 1982, 1983 Phyllis Kind Gall., Chicago and NY; 1981 Mus. Contemp. Art, Chicago. *122.*

Wonner, Paul. b. 1920, Tucson, Ariz. Cal. College of Arts and Crafts, Oakland, 1941(BA); Univ. of Cal., Berkeley, 1952(BA), 1953(MA), 1955(MLS). Exh. incl. 1955 M.H. de Young Mus., San Francisco; 1959, 1960, 1963, 1964, 1971 Felix Landau Gall., LA; 1960 Santa Barbara Mus. Art, Cal.; 1962 Poindexter Gall., NY; 1965 Waddington Galleries, London; 1967 Landau-Alan Gall., NY; 1972 Charles Campbell Gall., San Francisco; 1975 Art Mus. Galleries, Cal. State Univ., Long Beach; 1979, 1980 James Corcoran Gall., LA; 1981 San Francisco Mus. Mod. Art; 1982 LA Municipal Art Gall. *100, 145.*

Wray, Dick. b. 1933, Houston, Texas. Univ. of Houston Sch. Art, 1955-8; Kunstakademie, Düsseldorf, W. Germany, 1958. Exh. incl. 1975 Contemp. Arts Mus., Houston; 1976, 1977 Pelham-Von Stoffler Gall., Houston; 1977 Lerner-Heller Gall., NY; 1978 Tyler Mus. Art, Texas; 1979 Roberto Molina Gall., Houston, Galveston Arts Center Gall., Texas; 1981, 1983, 1984 Moody Gall., Houston; 1981 Patrick Ryan Gall., Bryan, Texas. *130.*

Wudl, Tom. b. 1948, Cochabama, Bolivia. Chouinard Art Inst., LA, 1970(BFA). Exh. incl. 1971 Eugenia Butler Gall., LA; 1971, 1972, 1975 Mizuno Gall., LA; 1973 Ronald Feldman Gall., NY; 1974 Dayton's Gall. 12, Minneapolis; 1976 Krebs Gall., Bern; 1978 Janus Gall., LA, Mandeville Art Gall., Univ. of Cal., San Diego; 1979 College of Creative Studies, Univ. of Cal., Santa Barbara; 1980 Malibu Art and Design Center, Cal., Annina Nosei Gall., NY, Libra Gall., Claremont Graduate Sch., Cal.; 1981 Ruth S. Schaffner Gall., Santa Barbara; 1982 Arco Center for Visual Arts, LA. *140.*

York, Albert. b. 1928, Detroit, Mich. Ontario College of Art; Soc. Arts and Crafts, Detroit. Exh. 1963, 1964, 1966, 1968 Davis Galleries, NY; 1975, 1977, 1978 Davis and Long Co., NY; 1982 Davis and Langdale, NY; 1982-3 Mus. Fine Arts, Boston. *96.*

Yoshimura, Fumio. b. 1926, Kamakura, Japan. Tokyo Univ. Art, 1949(MFA). Exh. 1970 Penn. Acad. Fine Arts, Philadelphia; 1971 Wichita Art Mus., Kansas; 1972, 1977 Marian Locks Gall., Philadelphia; 1973, 1976, 1979, 1982, 1983 Nancy Hoffman Gall., NY; 1974 Galleriet Arneson, Copenhagen; 1975 Gallerie, Lund, Sweden; 1976 Squibb Gall., Princeton, NJ; 1977-8 Norton Gall. Art, West Palm Beach, Florida; 1979 Mead Mus., Amherst College, Mass.; 1981 Dartmouth College Galleries and Collections, Hanover, NH. *81.*

Zakanitch, Robert S. b. 1935, Elizabeth, NJ. Exh. incl. 1965 Henri Gall., Alexandria, Virginia; 1968 Stable Gall., NY; 1970, 1971 Reese-Palley Gall., NY; 1973, 1974 Cunningham Ward, NY; 1977 Holly Solomon Gall., NY; 1978 Galerie Lintowitsch, Basle; 1978, 1979, Robert Miller Gall., NY. *44-5.*

Zucker, Joseph I. b. 1941, Chicago. First exh. 1961 Miami Univ., Oxford, Ohio. Exh. since in Chicago, Minneapolis, Wash. DC, NY, San Francisco, Baltimore, Houston, Paris, London. *45.*

INDEX